Monet in the '90s

THE SERIES PAINTINGS

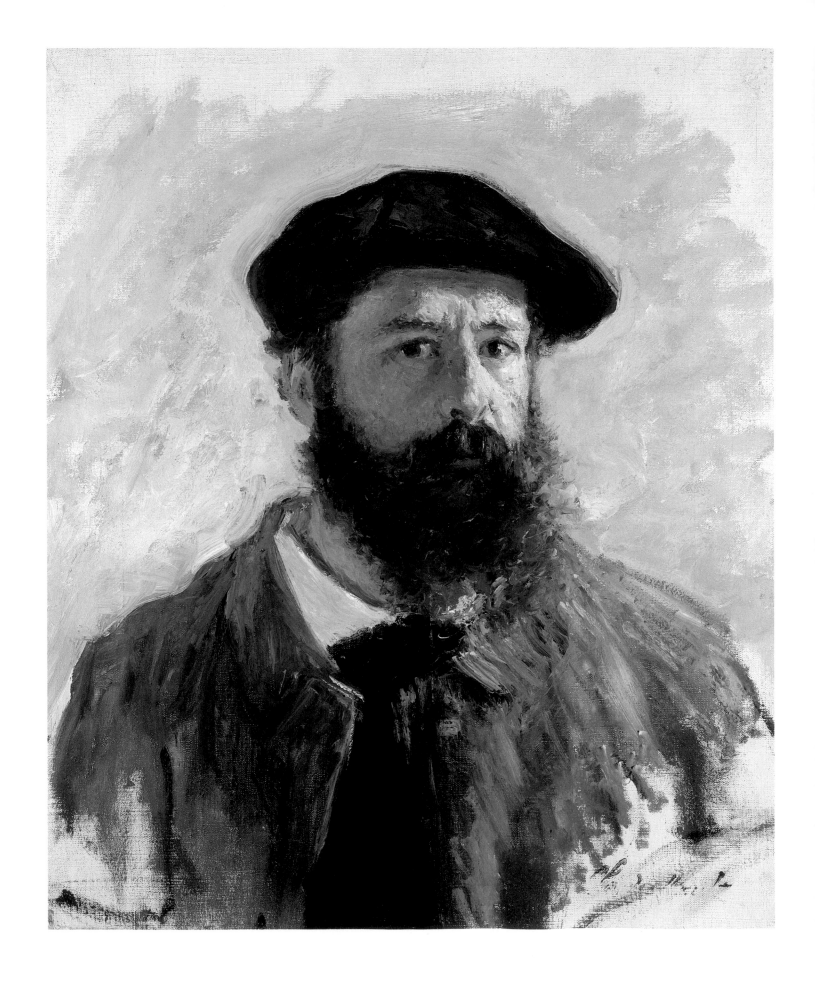

Plate 1. (not in exhibition) *Self-Portrait*, 1886. Private Collection

Paul Hayes Tucker

Monet in the '90s

THE SERIES PAINTINGS

Museum of Fine Arts, Boston

in association with

Yale University Press · New Haven and London

The exhibition and catalogue are made possible by Digital Equipment Corporation. **digital**™

Additional support was provided through indemnities from the Federal Council on the Arts and Humanities and Her Majesty's Government under the National Heritage Act 1980 and the Museums and Galleries Commission.

Edited by Stephen Robert Frankel

Designed by Carl Zahn

Typeset and printed in U.S.A. by Acme Printing Co., Wilmington, Massachusetts.

Bound by Acme Bookbinding Co., Charlestown, Massachusetts.

Library of Congress catalogue card no. 89-063207

ISBN 0-300-04659-6 (cloth)

ISBN 0-87846-313-5 (paper)

The exhibition was organized by the Museum of Fine Arts, Boston.

Contents

Foreword

The Museum of Fine Arts is honored that Digital Equipment Corporation has chosen to sponsor the exhibition and catalogue *Monet in the '90s: The Series Paintings*. This unprecedented exhibition presents 90 series paintings created by the great Impressionist master in the 1890s. Featuring such famous images as Grainstacks, Poplars, and Rouen Cathedral, the paintings were revolutionary and represented the culmination of Monet's life-long concern with the beauties of his native land. Digital Equipment Corporation's generous sponsorship of the exhibition and catalogue enables the public to see many of the most beautiful Impressionist paintings in the world and to learn more about one of the greatest periods in art history.

On behalf of the trustees, overseers, and staff of the Museum of Fine Arts, I extend our deep gratitude for the vision and civic leadership Digital Equipment Corporation has demonstrated by this extraordinary support.

GEORGE PUTNAM
President
Museum of Fine Arts

Digital Equipment Corporation is proud to be associated with the Museum of Fine Arts, Boston in the presentation of *Monet in the '90s: The Series Paintings*. Through the Museum's efforts and the participation of The Art Institute of Chicago and the Royal Academy of Arts, London, visitors to these three leading museums will have an opportunity to catch a rare glimpse of what the public saw a century ago when Claude Monet exhibited his work in France.

We believe that supporting quality arts programming is an opportunity to enhance the cultural enrichment of our employees, their families and the community at large. This exhibition is an outstanding achievement that will have an impact on us all.

We hope you enjoy *Monet in the '90s* and encourage your ongoing support of the Arts.

KENNETH H. OLSEN
President
Digital Equipment Corporation

Preface

IN OUR CENTURY few works of art have proved to be more consistently popular than Monet's series paintings. With their divided light and color, momentary effects of atmosphere, and richly encrusted surfaces, Monet's series paintings are a triumph of the master's mature Impressionist style. Until now, however, modern viewers have been offered at best an incomplete or selective exposure to this achievement; it is a rare museum or exhibition that includes more than two or three paintings from any one series.

It gives us great pleasure therefore to present "Monet in the '90s", the most comprehensive exhibition of Monet's series ever assembled. Mounted on the centennial of the artist's inaugural work on these unique pictures, the show recreates as fully as possible Monet's own exhibitions of the 1890s. For the first time viewers will be able to assess the works' collective impact, notably their effect of ensemble, and to investigate fully the role of serialized imagery in Monet's art.

Highlighting Monet's most famous series – the Grainstacks, Poplars, Rouen Cathedral, Mornings on the Seine, and the Japanese Bridge – the show also explores the lesser known series, such as images of the Creuse Valley, Mount Kolsaas in Norway, Ice Floes (Bennecourt), the Falaises (Pourville, Varengeville, and Dieppe) and scenes of London. The culmination of nearly fifty years of Monet's artistic career, the series from the 1890s had a revolutionary and lasting impact. The exhibition and this book not only examine Monet's stylistic and conceptual innovations but also investigate the significance of his thematic concerns within the larger context of French culture and society.

The exhibition was organized by the Museum of Fine Arts in Boston, in collaboration with the Art Institute of Chicago and the Royal Academy of Arts in London. It was conceived and guest-curated by the noted Monet specialist, Professor Paul Hayes Tucker of the University of Massachusetts, Boston. In addition to selecting the paintings with Peter C. Sutton, Baker Curator of European Paintings, Museum of Fine Arts, Boston, who supervised and administered the show, Professor Tucker wrote this insightful and eminently readable book which serves as the exhibition's accompanying publication and sheds much new light on this essential moment in the history of Impressionism.

The exhibition was made possible by the generosity of lending institutions and private collectors. Ever mindful of the sacrifice involved in being separated even temporarily from works central to one's collection, we wish to express our heartfelt thanks to all the lenders.

When Monet first exhibited his series paintings, there were calls to buy the lots to keep them together for posterity. Those pleas went unheeded and the paintings were soon dispersed throughout the world. They have now finally been reunited through the unique event of this exhibition, an occasion of great historic and aesthetic distinction.

ALAN SHESTACK
Director
Museum of Fine Arts, Boston

JAMES N. WOOD
Director
The Art Institute of Chicago

ROGER DE GREY
President
Royal Academy of Arts, London

Lenders

PUBLIC COLLECTIONS

THE ART INSTITUTE OF CHICAGO
Chicago, Illinois

THE ART MUSEUM, PRINCETON UNIVERSITY
Princeton, New Jersey

THE AUSTRALIAN NATIONAL GALLERY OF ART
Canberra

THE FITZWILLIAM MUSEUM
Cambridge, England

FOGG ART MUSEUM, HARVARD UNIVERSITY
Cambridge, Massachusetts

THE HERMITAGE MUSEUM
Leningrad

HIROSHIMA MUSEUM OF ART
Hiroshima

THE HUGH LANE MUNICIPAL GALLERY OF
MODERN ART
Dublin

MEAD ART MUSEUM, AMHERST COLLEGE
Amherst, Massachusetts

THE METROPOLITAN MUSEUM OF ART
New York, New York

MOA MUSEUM OF ART
Atami

THE MONTREAL MUSEUM OF FINE ARTS
Montreal

MUSÉE D'ART MODERNE
Strasbourg

MUSÉE D'ORSAY
Paris

MUSÉE D'UNTERLINDEN
Colmar

MUSÉE MARMOTTAN
Paris

MUSEUM OF FINE ARTS
Boston, Massachusetts

MUSEUM OF MODERN ART
Saitama

NATIONAL GALLERIES OF SCOTLAND
Edinburgh

NATIONAL GALLERY OF WALES
Cardiff

THE NATIONAL MUSEUM OF WESTERN ART
Tokyo

NORTH CAROLINA MUSEUM OF ART
Raleigh, North Carolina

PHILADELPHIA MUSEUM OF ART
Philadelphia, Pennsylvania

THE PHILLIPS COLLECTION
Washington, D.C.

SANTA BARBARA MUSEUM OF ART
Santa Barbara, California

SHELBURNE MUSEUM
Shelburne, Vermont

SMITH COLLEGE MUSEUM OF ART
Northampton, Massachusetts

STERLING AND FRANCINE CLARK ART INSTITUTE
Williamstown, Massachusetts

THE TRUSTEES OF THE NATIONAL GALLERY
London

THE TRUSTEES OF THE TATE GALLERY
London

THE WHITE FUND
Lawrence, Massachusetts

PRIVATE COLLECTIONS

ACQUAVELLA GALLERIES, INC.
New York

COLLECTION DURAND-RUEL
Paris

COLLECTION ERNST BEYELER
Basel

COLLECTION OF HER MAJESTY QUEEN ELIZABETH,
THE QUEEN MOTHER
London

COLLECTION PIERRE LAROCK-GRANOFF
Paris

GALERIE KATIA GRANOFF
Paris

ISE CULTURAL FOUNDATION
Tokyo

AND OTHER COLLECTORS WHO WISH TO REMAIN
ANONYMOUS

Acknowledgments

This book would not have been possible without the generous support of many institutions and individuals. I would like to express my thanks first to the University of Massachusetts at Boston from whom I received Healy, Public Service, and Faculty Development Grants in 1988 and 1989, and continued understanding from Dean Richard Freeland and his staff. I am also indebted to the American Council of Learned Studies and the Florence Gould Arts Foundation, Inc. whose grants allowed me to conduct initial research in 1983-85 and to begin writing this book. The book would not have appeared as quickly if it were not for the kind invitation from Peter Sutton, Jan Fontein, and Alan Shestack of the Museum of Fine Arts to organize an exhibition of Monet's paintings of the 1890s, which Digital Corporation generously supported together with this accompanying publication. I am very grateful to Alan, one of my former graduate professors at Yale and to Peter, a graduate school colleague and friend, for the unique opportunity to reunite these canvases for the first time since Monet exhibited them at the end of the 19th century and for the privilege of working with the Museum's fine staff.

Most of the book was written in the Writer's Room of the Massachusetts Artist's Foundation between October 1988 and June 1989. I am deeply indebted to the Board of the Foundation and to the other writers in that very special space. The book was mapped out and begun during the summers of 1987 and 1988 in offices of the English Department at Skidmore College. To its Chair Phyllis Roth, Terrance Diggory, Robert and Peggy Boyers, Barry Goldensohn, Robert Faulke, Philip Boshoff, Sue Stein, and Richard Upton, I am very grateful. The Skidmore College Computer Laboratory also provided much appreciated assistance.

I would like to thank Kirk Varnadoe and the Institute of Fine Arts for the opportunity to try out the material in this book in a seminar that they invited me to teach in the spring of 1987 and the students of that class for their many contributions. I would also like to recognize my colleagues in the Art Department of the University of Massachusetts for their support, particularly, Ruth Butler and Ron Polito. Critical information for the book was patiently gathered by Michelle O'Malley, Carol Scollans, Mary-Ann Winkelmes, William Walsh, and Priscilla Myrick Diamond, to whom I am most grateful. My thanks as well to Janice Sorkow, Mary Lyons, Susan Orr, Nicole Luongo, Helen Chillman, An-

drew Huston, Patricia Boyer, Herbert Schimmel, Norman Kleeblatt, Jacques Vilan, Ay-Wang Hsia, and Money Hickman for their help with photographs, to Victoria Gardner for innumerable details, to Patrick Hirshler for solving some linguistic difficulties, to Guido Goldman and the Center for European Studies at Harvard for permission to reproduce their World War I poster, to the Getty Archives and JoAnne Culler Paradise for assistance with Monet letters, to Margaret Jupe and Chiyo Ishikawa for last minute proofreading, to the staffs of the Clark Art Institute and the Williams College Graduate Program particularly Mary Ann McSweeny, Verna Paquin, Dustin Wees, Elizabeth Kieffer, Elaine Yanow, Regina Murphy, Susan Roeper, Sam Edgerton, Karen Kowitz, and JoAnn Bates, and to Roy and Doris Moss for their many gestures of kindness. I owe a particular debt to George Heard Hamilton for his groundbreaking work on Monet's *Cathedrals* and for his foresight to purchase the superb example of that series for the Clark Art Institute, where as an undergraduate at Williams College I romanticized about this project. I am also pleased to express my gratitude to John Nicoll of Yale University Press for his encouragement during the course of the project, and to Carl Zahn, Director of Publications at the Museum of Fine Arts, Boston, for the book's very handsome design. Linda Nochlin merits a special note of thanks for alerting me to the poplar's heritage as the tree of liberty and for the material she shared from her unpublished article on Courbet's *Great Oak*.

I profited from the comments of Irit Rogoff, Maggie Moss-Tucker, and Molly Nesbit, who kindly read parts of the manuscript at various stages in its preparation, and from William D. Tucker, Jr. who devotedly reviewed every draft and always made insightful observations. Steven Frankel applied his editorial acumen to the text with great effect while Bruce Garr read the proofs with a remarkably sharp eye. My largest debt in terms of the content and shape of the book is to Robert L. Herbert who read the whole manuscript despite many other obligations and made essential suggestions. He continues to be a model for our profession.

For their assistance in the preparation of the exhibition "Monet in the '90s", I am deeply indebted to the Directors and staff of the three participating museums. At the Museum of Fine Arts, Boston, I would like to thank Linda Thomas, Patricia Loiko, Desiree Caldwell, Ross Farrar, Clementine Brown, Janet Spitz, Lisa Har-

ris, Tom Wong, Linda Patch, Joan Norris, William Burback, Joan Hobson, Barbara Martin, Gilian Wohlauer, Barbara Shapiro, Bill Buckley, Tom Lang, John Woolf, John Lutsch, and the Department of Paintings, Brigitte Smith, Jean Woodward, Rhona MacBeth, Rita Albertson, Margot Brown, Irene Konefal, Alain Goldrach, Michael Morano, Tricia Cyman, Marci Rockoff, Barrett Tilney, Charlotte Emans, Elizabeth Siler, Eric Zafran and Trevor Fairbrother.

I would like to recognize those colleagues and friends who provided essential assistance at different points in the organization of the exhibition: Charles S. Moffett, Richard R. Brettell, Norman Rosenthal, Martha Wolff, MaryAnne Stevens, Philip Conisbee, Robert Gordon, Gary Tinterow, Joseph Rishel, Christina Orr-Cahall, Ted Pillsbury, Marianne Delafond, François Daulte, Ivan and Jacqueline Phillips, Niaomi Miller, Susan Scovil, Jack and Julie Corroon, David Solkin, Sally Kolker, Marie B. Etienne, and Madame Blatas. I especially want to thank Morihiro Ogawa for his help with Japanese collections. This exhibition would never have been possible without the generosity of the many private collectors who unselfishly lent their paintings to the show. My thanks to Her Majesty the Queen Mother, and to her assistant, Sir Alistair Aird; The White Fund of Lawrence, Massachusetts; Pierre Larock-Granoff; Mr. Hikonobu Ise; Mme. Charles Durand-Ruel; Ernst Beyeler, and to all of the other collectors who wish to remain anonymous. Thanks as well to many individuals who facilitated loans, including Caroline Godfroy Durand-Ruel, Nick Hubbie, Leslie Waddington, Sarah Waddington Shott, Franklin W. Robinson, Marjie Sands, Jonathan Phillips, Brigitte Esser, Laura Sueoka, and Marti Perreard.

Museums throughout the world have been especially cooperative. I would like to thank individuals associated with these institutions who assisted in arranging critical loans; Jeffrey Abt, Acting Director and Richard Born, Curator, The David and Alfred Smart Gallery, University of Chicago; Susan Ferleger Brades, Exhibition Organizer for the Arts Council of Great Britain; Professor Michael Jaffe, Director, and David Scrase, Keeper of Paintings, Drawings and Prints, Fitzwilliam Museum; Edgar Peters Bowron, Elizabeth and John Moors Cabot Director of the Fogg Art Museum; Frank Trapp, former Director, Mead Art Museum, Amherst College; Boris Piotrovsky, Director, and Vitali Suslov, Curator, The Hermitage, G. Popov, USSR Ministry of Culture; the late Isao Ito, Director, and Koichiro Morikawa, Chief Curator, Hiroshima Museum of Art; Ethna Waldron, Curator, Hugh Lane Municipal Gallery of Modern Art; Everett Fahy, John Pope-Hennessy Chairman, Department of European Paintings, Katharine Baetjer, Curator of European Paintings, Metropolitan Museum of Art; Yoji Yoshioka, Director, and Hidenobu Kujirai, Curator and Chief, Research and Properties Section, MOA Museum of Art, Atami; Yves Brayer, former Conservateur, Arnaud d'Hauterives, Curator, Musée Marmottan; Pierre Theberge, Director, Frederik J. Duparc, Conservateur des anciens maîtres, Janet Brook, Curator, Musée des Beaux-Arts, Montreal; François Cachin, Inspecteur General des Musées, Directeur, and Caroline Mathieu, Conservateur, Musée d'Orsay; Roland Recht, Conservateur en Chef, and Nadine Lehni, Conservateur, Musée d'Art Moderne, Strasbourg; Masayoshi Homma, Director, and Tei Hasegawa, Curator, Museum of Modern Art, Saitama; James Mollison, Director, Michael Lloyd, Curator of International Art, National Gallery of Australia, Canberra; Homan Potterson, Director, National Gallery of Ireland; Timothy Stevens, Keeper of Art, Tim Egan, Registrar, National Museum of Wales, Cardiff; Michael Pantazzi, Curator of European Paintings, National Gallery of Canada, Ottawa; Neil MacGregor, Director, John Leighton, Curator, National Gallery, London; Michael Clarke, Hugh McAndrews, Keeper, National Galleries of Scotland, Edinburgh; Koji Yukiyama, Director, Curator of Paintings, National Gallery of Western Art, Tokyo; Richard F. Schneiderman, Director, Susan Barnes, Chief Curator, North Carolina Museum of Art, Raleigh; Laughlin Phillips, Director, Sir Lawrence Gowing, former Curatorial Chairman, Eliza Rathbone, Curator, Phillips Collection, Washington, D.C.; Allen Rosenbaum, Director, Princeton Art Museum, Princeton University; Hubert Landais, Directeur des Musées de France, Réunion des Musées Nationaux; Richard Vinsent West, Director, Barry Heisler, Curator of Collections, Santa Barbara Museum, Santa Barbara; Brian Alexander, Director, Pauline Mitchell, Registrar, Shelburne Museum, Shelburne, Vermont; Edward Nygren, Director, Smith College Museum of Art, Northampton, Massachusetts; David S. Brooke, Director, Steven Kerns, Curator, Stephen D. Paine, Trustee, Sterling and Francine Clark Art Institute, Williamstown; Sir Alan Bowness, Director, Tate Gallery.

Many people in the trade have also greatly contrib-

uted to the success of this show, including William and Nicolas Acquavella, Joseph Baillio, Timothy Bathurst, William Beadleston, Marc Blondeau, Patrick Cooney, Desmond Corcoran, Stuart Deneberg, Lucy Dew, Jacques Durand-Ruel, Richard Feigen, Walter Feilchenfeldt, Michael Findlay, Kazuo Fujii, Phyllis Goldman, Ay-Wang Hsia, Barbara Kornblatt, Yasunari Kumon, Diana Kunkel, Pierre Larocke, Nancy Little, Tokuzo Mizushima, Dr. Peter Nathan, Edward Nahem, Angela Rosengart, James Roundell, Robert Schmit, Sharon Schultz, Susan Seidel, Martin Sommers, Michel Strauss, John Tancock, and Guy Wildenstein. I am particularly indebted to M. Daniel Wildenstein and the staff of Wildenstein and Co. and to David Nash and Diana Hamilton-Jones of Sotheby's New York for their innumerable kindnesses.

I am also immensely grateful to Priscilla Myrick Diamond, my steadfast assistant in this project, whose tireless and intelligent efforts truly made the exhibition possible.

Finally, I would like to thank my children, Jonathan and Jennie, who gave me such joy during the years required to realize this book and accompanying exhibition, and my wife, Maggie, who continues to be my best critic, supporter and friend. As I return to enviable family responsibilities, I dedicate this book to my parents, who taught me about the value of family life and education, and to Robert Herbert, who opened my eyes to Monet and the intricacies of art and history.

PAUL HAYES TUCKER

Monet in the '90s

THE SERIES PAINTINGS

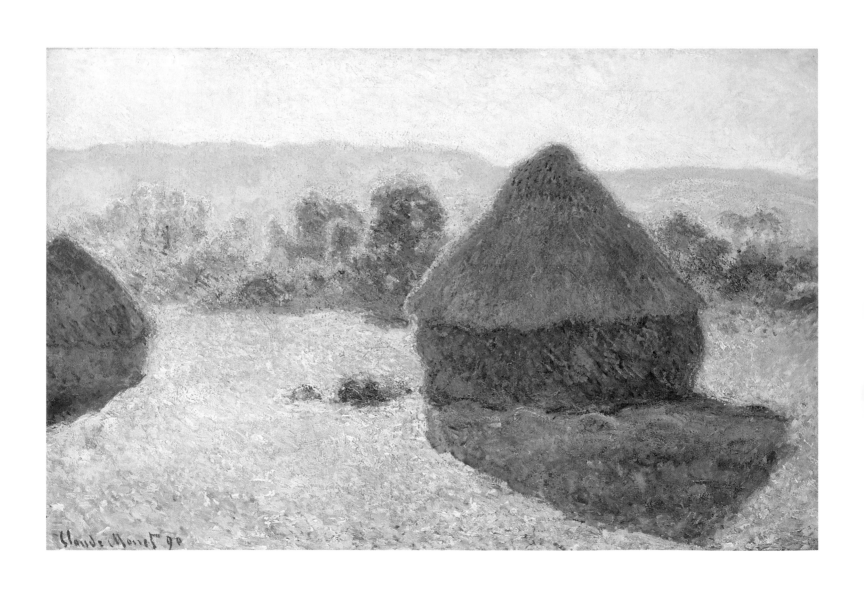

2 Plate 2. (cat. 19) *Grainstacks. (Mid-day.)*, 1890. Australian National Gallery, Canberra

Introduction

On October 7, 1890, just as Claude Monet was negotiating the purchase of his house and garden in the rural town of Giverny, he wrote his future biographer, Gustave Geffroy, a now often-quoted letter outlining his activities. "I am grinding away," he said, "bent on a series of different effects, but at this time of year, the sun goes down so quickly that I cannot keep up with it. . . . I am becoming a very slow worker, which depresses me, but the further I go, the more I understand that it is imperative to work a great deal to achieve what I seek: 'instantaneity,' above all. . . the same light present everywhere and more than ever easy things that come in a single stroke disgust me. In the end, I am excited by the need to render what I feel and vow to live on not too unproductively because it seems to me that I will make progress."[1]

With rare exception, this famous declaration of purpose has been taken as a veritable dictum for Monet's efforts of the 1890s; indeed, it has often been applied to his work as a whole. And not illogically. After all, Monet said precious little about his art; to have such a full and specific description of his intentions for a group of canvases at the very moment he was painting them is extraordinary, the very stuff art historians seek. In addition, his statement was made in apparent confidence to someone who admired and respected the artist and who had firsthand knowledge of his aims and aspirations. It was also laden with feeling and a sense of deep dedication, elements we like to read into Monet's work and believe were a part of his life as an artist, corroborated as they are by other passionate remarks about his devotion to nature that he and his circle of friends made. Finally, Monet's statement seems particularly fitting for the *Grainstack* paintings (plates 2, 5, and 20-32), with their encrusted surfaces and unique color harmonies that so magically and yet so faithfully appear to capture the evanescent qualities of light and atmosphere. The fact that many other critics were impressed by precisely these qualities when the paintings were shown in 1891 only contributes to the statement's evident importance.

Some of those same critics were likewise impressed by other aspects of Monet's efforts – his sensitivity to time and place, to the seasons and the sounds of the earth, his ability to evoke the poetry and metaphysical qualities of nature, and the fact that the paintings suggested the magnitude and beauty of the French countryside. "We must recognize him as a subtle artist and a powerful poet of nature," wrote Desiré Louis in *L'Événement* on May 19, 1891. "His skies, whether pure or cloudy, gay or melancholic, resonate with the mysterious sounds of the universe. He forces the spirit to think and to soar above these magisterial representations . . . of reality. . . . In front of this seductive painting, you have the impression of a full and benevolent life which makes you recall the intoxication one feels with the dawning of a new

day."[2] There were even those such as Marcel Fouquier, critic for *Le Dix-neuvième siècle,* who after seeing the *Grainstacks* exhibition declared that Monet was not only "a dazzling and powerful poet," but also "a naive, sincere, emotive, lyrical painter of nature and the life of things" who "will take his place among the greatest artists who painted the landscape of France."[3]

These are provocative statements. They suggest that Monet's critical public saw rich and varied meanings in these paintings. They also indicate that public's radical reassessment of Monet's art and status. In 1874, less than two decades earlier, Monet and his Impressionist colleagues had provoked considerable controversy by staging the first Impressionist exhibition. Although many critics supported the movement from the start and continued to write favorably about it, Monet did not begin to enjoy such broad-based support until 1889, when he mounted a huge retrospective (a joint exhibition with Rodin) in which he included two of those *Grainstack* pictures.

What circumstances permitted such a change in opinion? Did it have to do with changes that may have occurred in Monet's art or life? Was it perhaps due to an evolution in public taste or to a reassessment of what French art should be? Was it prompted by historical events or by the maturation of certain concerns about France and her place in the world?

These questions and Monet's altered status are worth considering in depth, as they can tell us a great deal about the nature of contemporaneous French culture and the place of a once-ostracized avant-garde artist. Monet's newfound popularity was not evanescent. Critical acclaim for his work in fact increased during the 1890s, to a point, by the turn of the century, that writers could actually hail him as "the great national painter."

Despite their implied significance, comments of this kind and Monet's rise in popularity have not been explored. Nor have his efforts of the 1890s in particular been systematically evaluated. These issues are intimately related, of course, and as such form the basis of this investigation.

PAUL HAYES TUCKER

Monet and fin-de-siècle France

POPULARLY referred to as the *fin de siècle*, the last two decades of the 19th century in France in actuality were not the end of some clearly defined time period. Calendars, parish priests, commemorative medals, and popular prints (fig. 1) could remind people that the century was coming to a close, just as new inventions, ideas, modes of dress, and ways of life left little doubt in anyone's mind that a new world was rapidly replacing the old. Gaslights along Paris streets were electrified, overnight it seemed, while pedestrians and horsedrawn vehicles suddenly had to compete with automobiles and streetcars. Stores during the period were stocked with goods from places that people had never heard of a few decades earlier, while women, trading their hooped skirts for can-can outfits and cycling costumes, were demanding their rightful place at the voting booths.[1]

The changes were many and pervasive and, as we shall see, they had a profound effect on the country. But the phenomenon of change was not new to France. Indeed, from mid-century onward, the nation had experienced radical alterations of all kinds, from the enormous growth of Paris and its suburbs to the rapid development of industry and technology, all of which created new environmental conditions, life styles, and perceptions about the world.

There are several considerations, however, that bear upon the *fin de siècle*, particularly on the 1890s, and that give those last years of the century a distinct, if not problematic, character. The first and most important actually imprinted itself on the consciousness of all natives of France long before the last decade dawned; it also haunted them well into the 20th century. And that was the painful loss of pride, money, land, and men in the Franco-Prussian War of 1870-71 and the equally exacting embarrassment of the Commune insurrection, with its ugly and bloody ending. Not since Waterloo had Marianne been so humiliated as she was when Napoleon III was defeated at Sedan and the Prussians laid siege to Paris until its final capitulation after the suppression of the Commune (fig. 2). Even Napoleon I's defeat had not been as costly to the nation's vision and self-esteem. For instead of facing all of Europe at the armistice table as occurred in 1815, the makeshift French government in 1871 was forced to sit in the Hall of Mirrors at Versailles and accept excruciating terms of settlement from a single, upstart nation no larger than than one-fourth the size of France and possessing nothing that could compare with France's history, wealth, and culture – or so all good French patriots thought.

How the nation dealt with this bitter defeat and internal tragedy is critical to understanding France in the late 19th century. For the Third Republic continually defined itself, sometimes overtly, more often

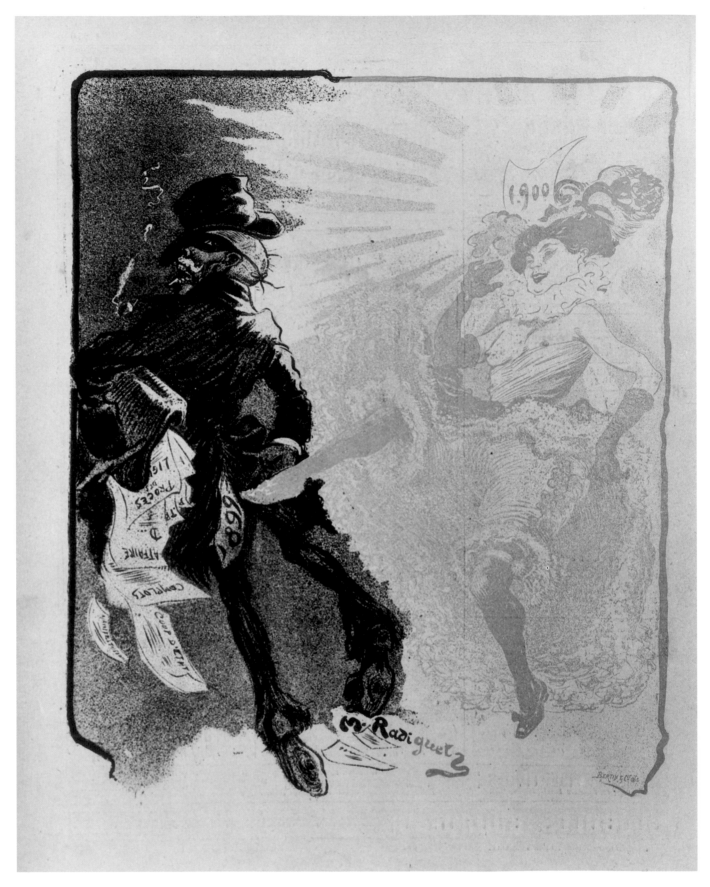

Fig. 1. M. Riadiguet, Untitled, 1900. From *Le Rire*, 6 January 1900.

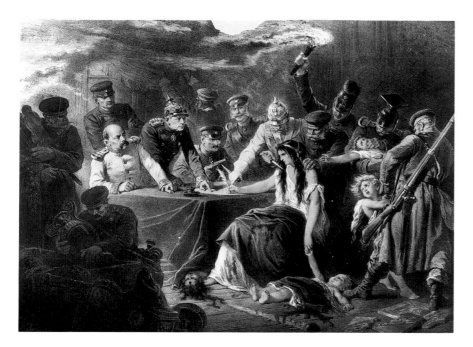

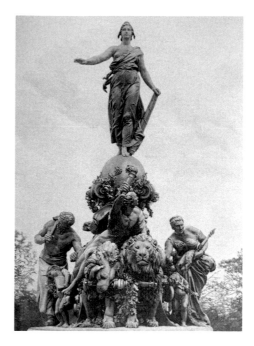

Fig. 2. Janet Lange, *France signs the preliminary Armistice* [Franco-Prussian War]. 1870.

Fig. 3. Jules Dalou, *The Triumph of the Republic*. (Inaugurated November 17, 1899.) Place de la Nation, Paris.

backhandedly, in relation to these disasters and their enduring legacies. Thus, when soldiers marched off to the front in 1914 to face their "hereditary enemy," their hearts were filled with hopes of retribution while their spirits were incited by songs such as Théodore Botrel's "C'est ta gloire qu'il nous faut" whose refrain of "France! We need a victory to revenge our flag" invoked the bitter memory of "l'année terrible," as Victor Hugo called that fateful year of 1870-71.[2]

Primarily because of this defeat and insurrection, the last years of the century were also characterized by France's persistent fears about her position in the European community. She was never quite certain whether she could legitimately claim the same leadership role that she had enjoyed prior to 1870, or whether she was in a state of decline because of forces beyond her control. At the same time, she did not want to admit to being in a dilemma. Her worries were heightened not only by the advances that her neighbors made in everything from technology to the arts, but also by the omnipresent threat of socialism and by the sudden appearance of anarchism, with its accompanying violence.

Equally disturbing were the political crises and divisive scandals that seemed to come in endless succession in the *fin de siècle*. Although Republicans held sway from 1879 to the Great War, their reign was anything but stable. In addition to stockmarket fluctuations that shook the nation's confidence and compromised its position in the international marketplace, the government was constantly under siege, from the collapse of the Union générale bank in 1882 to the Wilson Scandal in 1887, the Boulanger Affair of 1889, the Panama Canal Scandal in 1892, and the Fashoda Crisis in 1898. So significant were these difficulties that ministries changed no less than thirteen times between 1881 and 1889. In the 1890s, the number of new administrations declined slightly because of a rapprochement between the Left and the Right that became known as the *ralliement*, but by the end of the decade, the country had still witnessed four different presidents and more than twice as many new cabinets. It had also experienced the worst scandal of the century, the heinous Dreyfus Affair, which engendered such reactionary behavior that it tore the country apart, beginning in 1898 when Zola wrote his famous condemnation of the government which Georges Clemenceau published under the title *J'accuse*.[3]

The Dreyfus Affair was a national bloodbath that stained every French citizen. It also revealed the severe divisions that existed in French society at the end of the century and the extremes to which things could be carried. Such extremes, in fact, were another characteristic of the times and were evident in many other aspects of French life from religion to literature. Mysticism, for example, rose to challenge the Church in the 1890s at the same time that pantheism and sorcery were attracting converts. Material stuffs and services flooded major cities of the country in unprecedented quantity, although abject poverty and insalubrious living conditions continued to plague large portions of the population. In the world of French culture, younger Neo-Impressionists and Symbolist artists tried to dislodge the Impressionists; novelists interested in fanciful worlds rose to challenge those who grounded their writings in fact; poets in the South vied for recognition with their counterparts in the North, while intellectuals argued about the origins of creativity and the foundations on which French culture stood, some claiming that the 17th century was better than the 16th, others that the 13th was superior to them all. There were heated debates as well about strategic questions: How large should the army be, how long should the term of duty be, and what weapons should be developed? There were disagreements about how to handle the "social question" and about the importance of cultural centers. Was Paris really better than the provinces; did it take second place to Rome? Similar debates had occurred earlier, of course, just as similar anxieties and extremes had existed before, but it seemed to many in the 1890s that there had never been so many conflicting elements to deal with in all aspects of art and life.

This condition naturally provoked questions about the nature of France. Was the country indulging in unprecedented hedonism, as exemplified by her increased consumption of drugs and alcohol, the spread of prostitution, and the skyrocketing divorce rate? Or was she striving for grandeur and glory, the promises of progress, as the organizers of the World's Fair in Paris in 1900 wanted visitors to surmise from the lavishness of the exposition or the monumentality of Jules Dalou's statue, entitled *The Triumph of the Republic*, which had been cast in bronze for the occasion (fig. 3) Was it, in short, a *belle époque*, as it is so frequently characterized today? Or was it a time for disillusionment and skepticism, as Gauguin and other contemporary critics asserted?

"It is very difficult to judge an epoch as diversified as ours," one social observer claimed in 1893. "The extreme confusion of phenomena and people, the apparent contradictions of social facts, the impossibility of taking in the multiplicity of events, all of this makes it difficult to know what kind of a road we are on. What is French society becoming? Is it decadence or progress?"[4]

The answer, of course, depended on where one stood, because *fin-de-siècle* France was both exclusionary and all-accommodating, reassuring and disjointed, a country in which everything could seem to be progressing toward common goals and at the same time retreating so confusedly as to make those goals appear illusory. Fraught with contradictions and in search of a center, haunted by memories of 1870-71 and driven by pride, France approached the end of the century on many bifurcated paths. Along the way, she discovered the power of Monet's paintings and the value of his vision.

MONET's prodigious talents had actually been recognized from the outset of his career, as the first paintings he submitted to the Salon in 1865 had been accepted and praised. Paul Mantz, the art critic for the conservative *Gazette des Beaux-Arts*, had even singled him out that year as a painter to watch.[5] During the next two decades, despite negative remarks that recalcitrant observers of the artistic scene made about his work, Monet received considerable support from astute critics, dealers, and collectors – to such an extent that, in the 1870s and '80s, he was able to earn as much money as doctors and lawyers in Paris. Thus, contrary to popular opinion, his often-quoted cries of poverty during the period were due to his extravagant living habits, not to his complete rejection by the Parisian public. Although he remained on the fringes of acceptability during these years, he methodically negotiated his way toward the unbounded success that would come to him at the end of the century.[6]

Long before the 1890s, he made it clear that such success was what he wanted. During the first two decades of his career, he devoted himself to painting modern subjects, a necessary preoccupation for any artist who aspired to be a leading member of the avant-garde. He also set out to develop new forms of visual expression and to enjoy all of the benefits that his progressive world offered. Eugène Boudin, his first teacher, confirmed these goals as early as 1872, when the older artist told a friend that he had "dined in fine spirits with [Monet] at his new house in Argenteuil. He has a splendid place and appears to relish the notion of establishing a certain position for himself . . . I think he is destined for the highest rank of our movement."[7]

In addition to being a gifted painter with a unique sensitivity to nature, Monet was able to realize these goals in the 1890s in part because he was attuned to conditions of contemporary society and possessed a superb sense of the art market in which he was operating. He was thus able to select subjects that resonated with meaning and to render them in ways that acknowledged established norms for French painting, but which pushed beyond those rules into new and engaging territory.

Most of the subjects that Monet chose to paint in the 1890s, for example, were drawn from rural France, a critical factor in his eventual triumph. He had treated many of them prior to the 1890s, although rural motifs became the primary focus of his attention only after 1878 when he left the town of Argenteuil, moving first to Vétheuil and then to Giverny, where in 1883 he rented the house and property that he would occupy until his death in 1926. After his departure from Argenteuil, his art changed dramatically. Instead of scenes of modern suburban life with Parisian pleasure-seekers, recreational activities, smoking factories, and the railroad, he restricted himself to painting untrammeled nature – sun-dappled fields, unpopulated stretches of the Seine, and the uninhabited coast of Normandy (figs. 4 and 5).

This change has long been interpreted as Monet's declaration of indifference to the events and opinions of his day, a conclusion that is tenable if one reads his work literally. Obviously, he was not dealing with contemporary developments in any overt way in these paintings. What comes across instead is a sense of an individual removed from the demands of time and space and immersed in his own aesthetic affairs, an impression that in large part explains Monet's popularity today.

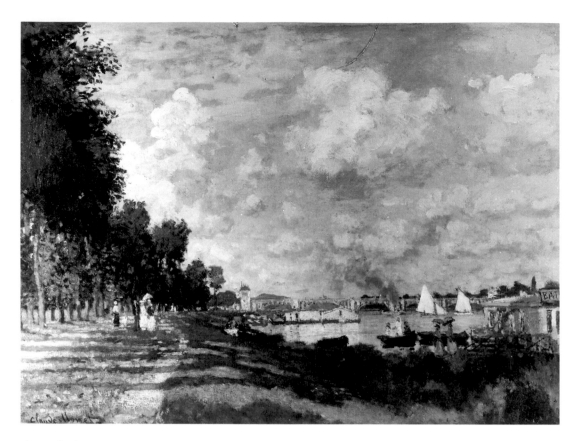

Fig. 4. Claude Monet, *Bassin at Argenteuil*, 1872. [W.225]. Musée d'Orsay, Paris.

Fig. 5. Claude Monet, *Sea Coast at Trouville*, 1881. [W.687]. Museum of Fine Arts, Boston.
John Pickering Lyman Collection.

Monet's letters of the period seem to corroborate the conclusion that his work appears to offer, if taken at face value. Predictably, they too avoid direct references to contemporaneous problems, except for Monet's own, which generally involve painting campaigns or personal finances. If he is not negotiating some monetary arrangement, most often with his dealer Charles Durand-Ruel, he is complaining about his inability to finish certain canvases. He seems to care little about the world or about Paris, the former core of his art and life, as he made clear in a letter of February 15, 1889 to his friend and fellow painter Berthe Morisot, the wife of Eugène Manet. "I don't have anything really interesting to tell you," he admitted. "I go less and less to Paris, where the only thing people talk about is politics," a subject that apparently held little interest for him.[8]

Such a reading of his art and efforts after Argenteuil, however, is too simplistic. It smacks of the limiting assumption that Monet was an unthinking artist concerned only with rendering his personal impressions in front of nature's changing scene. In fact, he read newspapers, subscribed to journals, moved in informed circles, attended Paris dinners, and had many friends who held important cultural or political positions, the statesman Clemenceau being the most notable. We should also be aware of the lesser-known fact that at Giverny, Monet built an enormous library, containing over 600 titles by the time he died. Well stocked with books by Zola, Flaubert, Goncourt, Hugo, Balzac, and Baudelaire, Monet's collection also boasted works by such diverse authors as Tacitus and Hardy, Aristophanes and Montaigne, Dante and Taine.[9] Although it is difficult to know precisely when Monet acquired certain books, it is fair to say that his interest in literature, drama, poetry, history, and earlier art was far more substantial than has been generally suspected.

In addition to being well read, Monet was very well informed about how his own work was received, primarily because, in the post-Argenteuil decades, he subscribed to two Parisian clipping services – la maison Bonneau and le Courrier de la Presse. Through these agencies, he was able to assemble an enormous number of critical reviews of his exhibitions and activities, all of which he kept until his death, confirming Geffroy's assertion that Monet was "preoccupied with what the press could say about him."[10]

Monet's interest in public opinion went beyond a concern for what his own work provoked. For despite his less frequent trips to the capital, and his often-expressed disdain of politics, he kept abreast of current events. For example, he was well aware of election peculiarities in 1888, despite the fact that he was on a painting campaign in Antibes, when they were developing; he was also familiar with the infamous Colonel Boulanger, whom he derogatorily referred to in 1889 as "sieur"; he even took his second wife Alice Hoschedé to Cherbourg in 1893 to watch the maneuvers of the Russian fleet during Czar Alexander I's first visit to France. And when the Dreyfus Affair broke in 1898, he was one of the first to write Zola a letter of support.[11]

Monet's political awareness is important to recall, as it attests to his complex personality and suggests the multiple dimensions that his art possessed. It also reminds us of his ties to history and his engagement with contemporary life, a fact that is made particularly apparent by political actions that he

took on his own, such as the subscription he initiated in 1889 to purchase Manet's *Olympia* for the nation. This important effort [discussed further in Chapter 3] developed into a year-long, pitched battle, with government officials expressing their opposition to the offer on the front pages of Parisian newspapers. Monet won the "war," as he described it, by his tenacity, political savvy, and hard work. And when he saw the painting hanging on the walls of the Musée Luxembourg in 1890, he boasted that it "never looked better."[12] His pride derived from the fact that he had been solely responsible for engineering the donation and that he had been able to convince a cross-section of people to contribute to the subscription, ranging from the academic artist Jean Béraud to officials such as Roger Marx, something that Monet referred to as having a "certain significance."[13] It also stemmed from the landmark nature of the event, as the government had long been opposed to such "radical" art. His success in coercing the State to accept the *Olympia* was particularly rewarding for Monet because, more than the other Impressionists, he had set out in the 1860s to challenge Manet – going so far as to attempt his own *Déjeuner sur l'herbe* in response to the older artist's famous canvas – and had been principally responsible for his colleague's lighter palette in the 1870s.

But undoubtedly what gave Monet the greatest sense of pride was the fact that he, more than Pissarro, Sisley, or Renoir, was carrying on the modern tradition that Manet and the *Olympia* represented by continuing to explore the possibilities of Impressionism and, as one critic noted in 1889, by being "a disciple of change like Manet."[14] Pissarro had abandoned the style for Neo-Impressionism; Sisley had fallen into an aesthetic rut; and Renoir, claiming he had wrung the style dry, had returned to Italy to study Raphael and the antique. Monet had had his doubts throughout the 1880s, frequently complaining that he was no longer able to finish his pictures and that he was dissatisfied with what he was doing. But, as Alice Hoschedé often reminded him, being disgruntled was part of his nature. In addition, by the latter part of that decade, such disparaging remarks had diminished considerably. His efforts to secure Manet a place in the halls of the Louvre and thus in the annals of art history in fact coincided with his own extremely successful painting campaign in the Creuse Valley and his equally profitable joint retrospective with Rodin, the confluence of which proved decisive. They suggested to Monet goals that he may have set for himself much earlier but which now appeared attainable – to establish Impressionism as a national style and to become one of the country's greatest painters.

Monet never stated these goals explicitly, although his tenacious independence, his steadfast devotion to his work, the constant challenges he posed for himself, and the attention he paid to his own place in history all suggest something more than an artist with a narrow interest in painting fleeting moments in time. This is underscored when his efforts of the 1890s are set into the context of contemporaneous concerns, particularly the country's quest for cultural identity. It is also supported by the historicism that quickly cloaked Impressionism and by the changes other practitioners of the style underwent during the decade, particularly Pissarro. It derives as well from suggestions that Monet's friends and critics made during the period, from the increased acclaim Monet received from 1889 onward, and from the fact that Monet ultimately achieved these goals, even before the century turned. "Monet is a simple,

loyal, and tender artist," wrote Georges Lecomte in 1898, "not because he is naive and ignorant but, on the contrary, because of his knowledge of men and life as well as of nature."[15] Sought out by collectors, dealers, and amateur artists, even by the Crown Prince of Norway, exhibited internationally and already very wealthy, Monet knew his stature and understood the responsibilities and rewards it carried, just as he knew the path he was on and recognized the magnitude of what lay in front of him. Thus, his series paintings of the 1890s are not just about atmospheric envelopes or instantaneity. They operate on a larger level "beyond their apparent subjects," as Desiré Louis suggested above. They are, as we shall see, Monet's deeply personal, but highly informed, responses to the challenges of *fin-de-siècle* France.

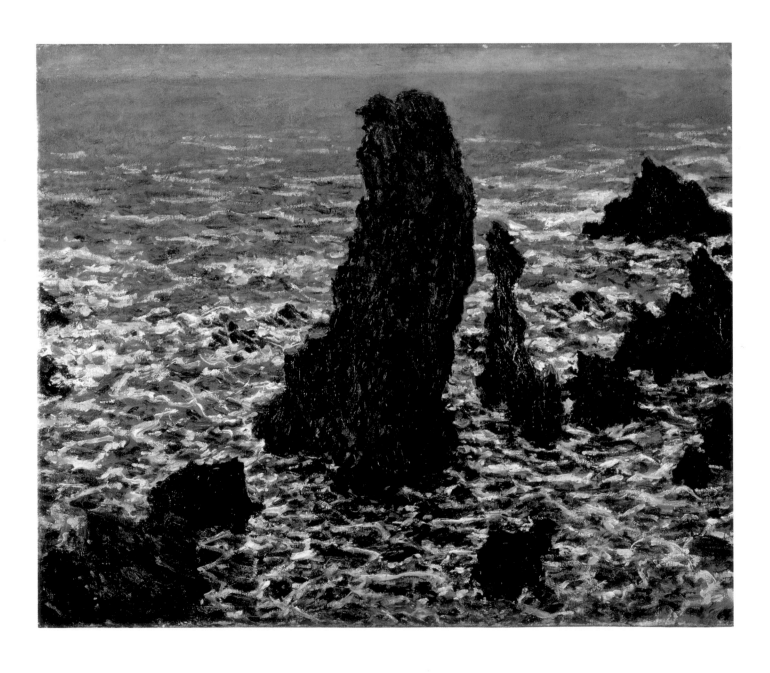

Plate 3. (not in exhibition). *The "Pyramids" of Port-Coton, Belle-Isle-en-Mer*, 1886. Ny Carlsberg Glypotek, Copenhagen

OF all the issues pertaining to the *Grainstack* paintings that Monet so eloquently discussed in his letter to Gustave Geffroy of October 1890, none perhaps are more important – and more overlooked – than the following: first, that Monet began a group of them two years earlier; and second, that he was forty-eight years old at the time, and thus not a young man.[1] The importance of these facts cannot be underestimated. For if we are to find explanations for Monet's serial efforts of the 1890s, we must first examine his work of the previous decade, a time in which serious questions about narrative and continuity, tradition and contemporaneity were being asked generally of avant-garde painting. If we pose these questions anew, we find that certain notions about the avant-garde tradition, as represented by Impressionism, need to be revised. Equally significant and equally problematic is the realization that Monet had been on the Paris scene for more than twenty years. He had earned an international reputation, as well as a great deal of money, and had rightfully been singled out as the leader of the Impressionists. Thus, to understand the *Grainstack* series fully, we would want to know what it meant for an artist of his age and stature to embark on such a novel path and what it says about the pressures of cultural production at the time.

The issue of pressure in this regard is extremely important. In most writings on Impressionism, the notion of pressure is understood as self-generated – that is, the product either of each artist's creative urge or of the shared desire to combat the status quo as represented by the Academy and the state-run Salon. But in the 1880s, as Impressionism and its practitioners matured, there were other external factors that developed, market factors in particular, that may be the key to understanding what really happened to the movement in that decade. They may also help to explain why Monet began painting *Grainstack* pictures in 1888.

To frame this issue, we should recall that the history of Impressionism in the 1880s has long been understood as a history of crisis.[2] After forging a novel alliance in the previous decade and making enormous strides toward establishing an alternative to the official Salon, the Impressionists essentially scattered, each artist going his separate way in search of himself, it is said, and of new forms of personal expression. Whether this constituted a crisis or not is open to debate. What is certain is the fact that the group became even more fractured than it had been previously and that fewer of the original members participated in the so-called Impressionist exhibitions, which continued to be staged until 1886. What is also true is the fact that each member's style underwent some form of change, and that by the middle

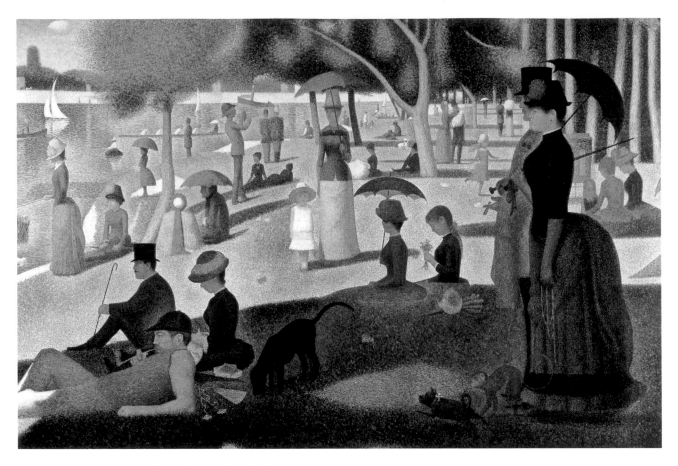

Fig. 6. Georges Seurat, *A Sunday on the Island of the Grande Jatte*, 1884-86. Art Institute of Chicago, Chicago.

of the 1880s the movement, as represented by its original practitioners, no longer occupied such a unique position in the Parisian art world. The divisive formal strategies, which had stood out so boldly against the hegemony of contemporaneous Salon art, had become familiar; the feared renegades were now widely recognized names; and the group's claims to the leadership of French painting, formerly understood as vile threats, were now tolerated (though not widely accepted) notions. Impressionism had not completely lost its capacity to irritate conservative critics, but its edge had been blunted by time, exposure, and historical circumstances.[3]

What placed the whole situation in vivid perspective was the emergence in the middle of the decade of the young Georges Seurat. At the age of twenty-seven, Seurat stunned the Parisian art world when he exhibited his monumental *A Sunday on the Island of the Grande Jatte* 1884-86, at the eighth and last Impressionist exhibition held in Paris in May and June of 1886 (fig. 6). Executed by juxtaposing hundreds of small touches of paint in a broad range of complementary colors that attempted to describe the essential components of perceived color-light in a "scientific" way, Seurat's huge canvas challenged the basic premises of the Impressionists' style and orientation and was immediately recognized as a new direction for avant-garde painting.[4]

No one made this challenge clearer than contemporary reviewers, particularly Félix Fénéon, who was beginning his career as an art critic with his writings on Seurat. In his ground-breaking pamphlet, *Les Impressionnistes en 1886*, Fénéon drew the battle lines from which the Neo-Impressionists and their supporters would wage their attack on the older leaders of advanced French art, specifically Monet.[5]

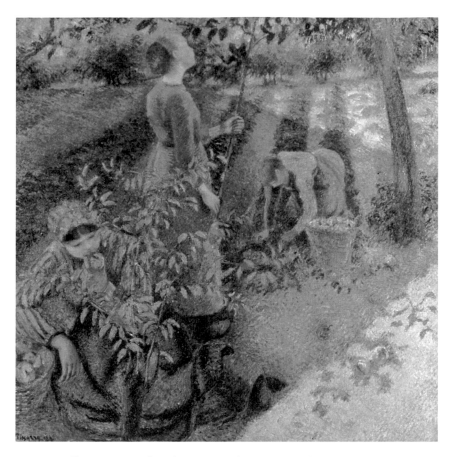

Fig. 7. Camille Pissarro, *Apple Picking*, 1886. Ohara Museum of
Art, Kuranshiki, Japan.

Fénéon declared that Seurat's divisionist art relied on structure and science, not intuition and chance;
that it resonated with references to history and past art, not the immediate and the mundane; and that it
laid claims to higher realms and principles, to museums and the eternal, not to bourgeois drawing rooms
and fleeting moments in time. It was therefore superior to Impressionism and deserved to be recognized
as the most innovative and up-to-date style of the day.

Such claims had not been lost on Pissarro. The oldest member of the Impressionist group had met
Seurat in 1885 and had enthusiastically adopted the younger artist's pointillist technique. Calling Mo-
net's brushwork "rancid" and Impressionism "romantic," Pissarro abandoned his former colleagues and
began painting pictures that clearly placed him in an opposing camp (fig. 7). However, Pissarro went
one step further. He insisted that Seurat and his principal follower, Paul Signac, be included in the
eighth Impressionist show, something that contributed to the decision by the leading Impressionist land-
scape painters – Monet, Renoir, and Sisley – to abstain.[6]

Monet's abstention was particularly understandable. Unlike Renoir, he had not left France to study
ancient and Renaissance art in Italy. Neither had he sequestered himself and become endlessly repetitive
as the forlorn Sisley had; in fact, he had been enormously productive during the decade. Although
plagued by self-doubts, he had worked at a prodigious pace, producing almost twice as many paintings
in the first six years of the 1880s, when he supposedly was "in crisis," as he had during the same period
in the '70s, when in theory he had not been hampered by such serious personal and aesthetic questions.[7]

Aloof and self-absorbed, he never gave up on Impressionism. In 1880, he had become disillusioned

with the exhibition practices of the group and had returned to the Salon. Motivated in part by a desire to broaden his market, particularly through private dealers, Monet took this step back into the traditional arena because he also felt "our little temple has become a dull schoolroom whose doors are open to any dauber," a barb that was directed at Degas and Pissarro, who had invited artists like Raffaelli and Gauguin to participate in the fourth Impressionist exhibition in 1879. Egotistical as usual, Monet nonetheless felt that the Impressionists should present a united front. When queried in 1880 about his defection, he asserted, "I am still an Impressionist and will always remain one."[8]

Unlike his former colleagues, Monet staunchly maintained that belief. Indeed, he put it into practice in an unprecedented way, traveling extensively during the decade to paint some of the most spectacular and varied sites in all of France, from the black, ocean-pounded coast of Belle Isle in the Atlantic south of Brittany to the lush, sun-drenched shores of Antibes on the Mediterranean (figs. 8 and 9; plates 3 and 4). The places he chose had dramatically different geological formations, weather conditions, lighting effects, and temperature ranges. They also possessed strikingly different moods, mythologies, associations, and appeals. Little wonder that Monet could write about his difficulties so frequently during the decade. "It is so difficult, so delicate, so tender [in Antibes]," he told Berthe Morisot in 1888, "particularly for some-

Plate 4. (not in exhibition) *Antibes* seen from the Salis, 1888. Toledo Museum of Art

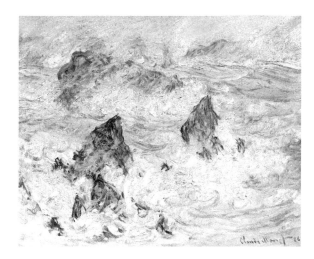

Fig. 8. Claude Monet, *Storm off the Coast of Belle Isle*, 1886. [W.1118]. Private Collection, Switzerland.

Fig. 9. Claude Monet, *Antibes seen from the Plateau Notre-Dame*, 1888. [W.1172]. Museum of Fine Arts, Boston. Juliana Cheney Edwards Collection.

one like me who is inclined toward tougher subjects."[9] He clearly had set a taxing agenda for himself.

This agenda developed for a number of reasons. Having abandoned the challenges of painting contemporary subjects in the late 1870s, Monet was attempting to find appropriate replacements, diverse locales that would similarly tax his imagination and energy. He was also trying to widen his audience; not everyone was as attracted to the ruggedness of Belle Isle as he was. In addition, he was perhaps attempting to satisfy a wanderlust that had built up over the previous ten years, during which he had done very little traveling.

There were larger motivations operating here as well. He seems, for example, to have been attempting to decentralize Impressionism. In the 1860s and '70s, the movement had gained its impetus and following from the cauldron of Paris. Its practitioners and patrons were for the most part residents of that city or the surrounding suburbs, its subjects Parisian-related, its style a means of describing modern metropolitan and suburban life.[10] When Monet abandoned the capital region and contemporary subjects, he set out to remove Impressionism's strong ties to Paris and the Île de France. He wanted to make it a style that would be responsive to the country as a whole. Thus, he chose sites that covered France from the north to the south. Furthermore, Monet participated in many more provincial exhibitions than he had joined in the 1870s, including ones held in such unlikely places as Grenoble, Limoges, and Nancy (which afforded him the opportunity to increase his income as well). Finally, he concentrated almost exclusively on French sites, suggesting his desire to assert Impressionism's continued association with the nation. By painting such varied and demanding subjects, Monet could also assert his powers as an artist and demonstrate the range and versatility of Impressionism as a style. Thus, just as one location differed from another, so each group of paintings that Monet produced at these sites contrasted in palette, touch, and composition.

To realize these imperatives – to gain prominence for himself and his decentralized style, to underscore Impressionism's ties to the French countryside, and to broaden his market while satisfying his urge to paint new sites – to do all of this in the most profound and professional manner was Monet's primary goal in the 1880s. And in the competitive art world of late 19th-century Paris, having such a goal was absolutely essential, especially if one wanted to live well, as Monet did.

The competitiveness of that world and the importance of Monet's objectives were dramatically increased, of course, when the Impressionists broke up and Seurat laid claim to the leadership of contem-

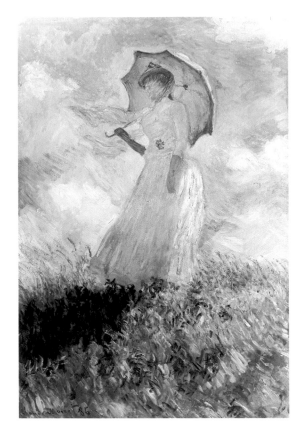 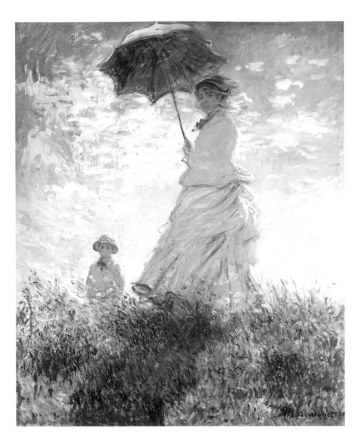

Fig. 10. Claude Monet, *Woman with a Parasol*, 1886.
[W.1077]. Musée d'Orsay, Paris.

Fig. 11. Claude Monet, *Camille and Jean on a Hill*, 1875.
[W.381]. National Gallery of Art, Washington, D.C.

porary French painting, luring Pissarro and many others into his camp. Monet responded at once. Not only did he refuse to join the eighth Impressionist exhibition; he immediately painted two very large decorative canvases of a woman with a parasol *en plein air* (fig. 10). Not having done a figure painting in more than a decade, Monet was taking up the challenge posed by Seurat's *Grande Jatte* and Pissarro's pointillist paintings, as well as Renoir's classicized figure pictures of the time. And he was doing so in strictly Impressionist terms. His two paintings are filled with the soft winds and strong light of a balmy summer's day. They are rendered with a wide range of heightened colors and remarkably discrete but energized brushstrokes. The foregrounds in both pictures are textbook demonstrations of painterly bravura. As pendants, the paintings reiterate Monet's interests and represent an Impressionist's alternative to Seurat's more hierarchical notion of repetition, which had so seduced Pissarro. Significantly, the figures in Monet's pictures strongly recall the various standing female figures in Seurat's huge canvas. They even have the anonymity that the latter all possess.

But Monet's women are far more animated than Seurat's or Pissarro's and more natural than Renoir's, thus making them seem more a part of their environment. In addition, Monet's painted surface appears more varied, implying his greater involvement with his subject and medium. Appropriately, perhaps, Monet's figures stand on much higher ground than Seurat's and tower over the viewer in an imposing, almost condescending way, enforcing their own authority and that of the artist. Not surprisingly, the pendants strongly recall Monet's own *Camille and Jean on a Hill* of 1875 (fig. 11). With its equally striking juxtapositions and loose brushwork, *Camille and Jean on a Hill* was not only one of Monet's most dramatic outdoor figure paintings of the 1870's; it was also his largest and most imposing such work of the decade. This battle would be waged on issues of size as well as style.

It was also a battle that would encourage Monet to take stock of himself and paint the first self-portrait of his career (plate 1, frontispiece). This haunting, deeply introspective picture, which Monet executed at the same time as his paintings of the woman with a parasol (and which he kept until his death in 1926), is a study of competing forces held together by Monet's unrelenting gaze and his expressive, non-reductive style. As in similar paintings by Cézanne, one cannot escape the artist's piercing stare. It is emphasized by the strongest contrast of light and dark in the picture, Monet's furrowed brow, and the frame created by his beret and beard. But, as with Cézanne's self-portraits, there is much to be found in other areas of this picture. The head, for example, is set precariously on a pyramidal base of extraordinary contrasts. Monet's jacket on the left is rendered with long, thin strokes of purple and blue. It rises assuredly and, in the case of the shoulder, almost lyrically to the generally defined lapel and the harsh angles of the white collar and blue sweater. Forms become clearer and more competitive as they approach the head. They are even rendered with greater amounts of paint. On the right, everything is exactly the opposite. Frenzied brushwork defines no clear elements anywhere. Even the shoulder is a Matisse-like series of painted strokes. This splay of paint not only contrasts with the more controlled handling on the left; it literally overwhelms the lapel on the right and then makes forays into the neck and beard. Similar, though opposite, events occur in the background. On the left, the paint is applied with bolder, more independent touches than on the right. This makes the left side press up against Monet's figure and occasionally invade it, as along the shoulder. The paint then sweeps up and around the beret, descends along the edge of his face like a soft cloud, and dissipates into the background on the right. All of this makes Monet's head appear to push out from the darker, more solid left side into the lighter, more ethereal right side, a transition that seems appropriate. For a primary issue here is the question of how Monet – or Seurat – understood that light. Even more important is the question of how either artist rendered the world illuminated by that light. These questions, of course, had long been fundamental to Impressionism. But when they were posed anew by Seurat and his followers, particularly Pissarro, they clearly caused Monet to test his former answers and to see how many new ones his Impressionist style might offer.

After completing these canvases, Monet traveled to Belle Isle to paint the most dramatic of all of his 1880s sites (fig. 12). Nothing could have been further from the gentility of the figures bathed in summer sunlight or the introspection of his self-portrait. And no site could have been further from Grandcamp and its tranquil *Bec du Hoc* (fig. 13), which Seurat painted the previous year and exhibited at the eighth Impressionist show. But that was precisely the point. Monet was out to prove his worth as the leading exponent of modernism and to claim for Impressionism its proper place as the leading avant-garde style. Even the fact that he had to extend his stay because of unaccomodating weather conditions (he arrived on the island in the beginning of September and did not leave until the end of November) was a way of testing his own stature and asserting the vital character of his art, something critics emphasized when the canvases were exhibited the following year.[11]

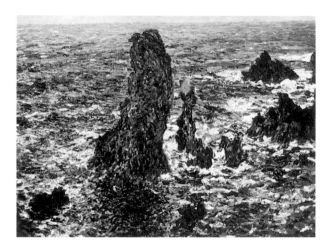

Fig. 12. Claude Monet, *The Needle Rocks at Belle Isle*, 1886.
[W.1084]. Pushkin Museum, Moscow.

Fig. 13. Georges Seurat, *The Bec du Hoc, Grandcamp*, 1885.
Tate Gallery, London.

Fig. 14. Claude Monet, *The Bend in the Epte*, 1888.
[W.1209]. Philadelphia Museum of Art, Philadelphia.

Fig. 15. Claude Monet, *Five Figures in a Field*, 1888.
[W.1204]. Private Collection, Chicago.

These were not the only paintings Monet did with the competition in mind. Another is *The Bend in the Epte,* 1888 (fig. 14). With its remarkable fracture and immensely rich surface, its daunting color combinations and startling light effects, this painting is fitting testimony to Monet's sensitivity to nature and his evident abilities as an artist. But the picture is virtually inconceivable without Seurat's dot as a reference point and Pissarro's conversion to this "mechanical" style.[12] Monet's dashes are quite different, however, from Seurat's or Pissarro's touch. Although their independence and highly regimented order smack of the divisionist dot, they have a different shape and orientation. They are larger than those dots, they are oriented along diagonal axes, and they do not appear to have been set down with the same sense of exquisite deliberation. There seems to be greater emotion behind them and greater spontaneity, as if we are seeing the results of an individual reacting to the changing scene in front of him in an immediate and heartfelt way. This is not completely true, of course, for Monet undoubtedly worked on the painting in the studio. It is, however, one of the effects that Monet wanted to achieve.[13]

In the same year, Monet painted another picture, *Five Figures in a Field* (fig. 15), which is perhaps one of the most telling of the more than fifteen figure paintings he did after Seurat so consciously set out to update that characteristic Impressionist genre. This is a curious work, but much that is odd or atypical about it – the hierarchical figures and dramatic spatial qualities, the strong color contrasts and extraordinary stillness – seems to derive not only from Renoir's turn to classicism and Pissarro's Neo-Impressionist figure paintings but also from Seurat and the *Grande Jatte.* Again, Monet has artfully rephrased these challenges in strictly Impressionist terms, employing dazzling, almost blinding light, a remarkably intense palette, and large, varied touches of rich impasto. Monet's scene is also distinctly rural, in keeping with his rejection in the late 1870s of urban and suburban settings. And it is more casual. None of the figures exhibit the kind of rigidity, for example, that paralyzes those in Seurat's picture. The two boys in the foreground have their hands in their pockets or behind their backs, while they bear their weight on opposite legs as if in contrasting contrapposto. Behind them, the older man assumes an equally unrestrained pose, while the woman to his left tilts her head to one side, slumps her shoulders, and places one hand by her hip and the other slightly behind her. There are tensions in Monet's scene created particularly by the distance between the children and the adults, and by the immediacy of the former in the foreground, but they are vastly reduced from those that permeate Seurat's, just as the number of figures have been radically diminished.

What Monet seems to be asserting in all of these paintings is his ability to outdo Seurat, Pissarro, and Renoir – to prove Impressionism's superior capacity to exploit color, describe particular climatic conditions, use paint in novel ways, and reveal fundamental truths about art and the world. For the latter, what Monet insists upon is the importance of nature. According to these pictures, nature should not be submitted to harsh, premeditated analysis, as in the *Grand Jatte* or contemporary works by Pissarro. On the contrary, it should be allowed to reign in the painting as it does in the world – resplendent in all its nuances, variants, subtleties, and surprises. The real artist, therefore, should not impose himself upon nature but attempt to be fully attuned to its rhythms and powers in order to become one with it.

These premises are central to *Five Figures in a Field*. Unlike the isolated and interchangeable mannequins in Seurat's *Grande Jatte*, for instance, who have no interaction and no real relationship with their environment, Monet's five figures are bathed in extraordinary light and are actually identifiable. The adults in the background are Monet's son Jean and Alice Hoschedé's daughter Suzanne and in the foreground are their younger siblings Michel Monet and Germaine and Jean-Pierre Hoschedé. The older children appropriately stand behind the younger ones and are paired with the larger, more substantial grove of trees in the background. The younger ones, unlike their older counterparts, stand in more vulnerable positions against more open fields, the edge of which they do not break. Jean and Suzanne are not self-absorbed, as is the case with every figure in Seurat's scene. Instead, they appear to be watching their younger siblings, who have stopped on their way out of the picture. Though youthful, the children assume adult postures, as if preparing for their exit by cleverly imitating the poses of their elders. The two groups are also united by their similar diagonal arrangements, by the long shadow that the adults cast, and by subtle details, such as Germaine's dark hair, which echoes Suzanne's jacket, the boys' V-neck openings, which are humorous variations on Michel's beard, and the fact that they all wear similar, though individualized, hats. Unlike all of Seurat's figures, the younger children have recognizable personalities; they even exhibit combinations of uneasiness and naiveté befitting their age.

Combined, these factors suggest that Monet is advancing rather traditional ideas about innocence and maturity, sentimentality and sharing, dedication and persistence, all of which seem to be the result of the fact that these figures are not in a city or suburb but are intimate parts of a more natural environment. Imagine Seurat's compendium of modern Parisians in Monet's country setting! The values Monet asserts in his picture have little place in Seurat's more critical view of contemporary life. And rightfully so, as they are not essential to the industrial society Seurat is describing, driven as that society is by profit margins and technical developments, cheap labor and mass production. Little wonder, therefore, that when Monet was working on *Five Figures in a Field* he told the critic Théodore Duret that he had begun "some new things, figures *en plein air*, as I understand them, done like landscapes," a veiled reference perhaps to his differences with his contemporaries.[14]

What Monet also seems to insist upon in all of these post-Seurat paintings is the superiority of a style that could assert these multiple values about art and life while preserving the individuality of the artist and the integrity of his personal vision – concerns that, on the surface at least, Seurat and Pissarro as well as Renoir seemed to have abandoned. These concerns, of course, had been central to Impressionism and had derived in large part from the Impressionists' battle to break with the hegemonic practices of mainstream artistic production. Like laissez-faire capitalists, the Impressionists had claimed the right to devise their own methods and to market their own results.[15] It was precisely because the results challenged accepted canons and so threatened the closed, hierarchical system in France that the Impressionists had been the target of persistent criticism. Unsympathetic critics in the 1860s and '70s had frequently claimed that Monet and his colleagues were untutored individuals who dashed off childlike splatterings without study or care. This point of view appeared to be confirmed when

the Impressionists were compared with Seurat. Trading individuality for strict methods based on the latest aesthetic and technical ideas, Seurat and his followers automatically engendered in many younger critics a reassuring sense of seriousness, intelligence, and academic training. This naturally raised their work above the seemingly more spontaneous efforts of the older Impressionists. The *Bend in the Epte* and Monet's return to large figure paintings after Seurat's emergence were clear attempts to refute that notion.

Monet had been trying to combat the prejudice against Impressionism since the beginning of the decade in other ways as well. In 1880, for example, in his first publicized interview, with Emile Taboureaux (the art critic for *La Vie moderne*), he laid out what soon would become the essential components of his personal legend.[16] It is the now familiar tale of the fiercely independent artist who was "systematically rejected by [Salon] judges" and "energetically booed by all the critics of the time." It is also the story of the natural artist. Monet admitted to attending Gleyre's atelier as a student, but only for "three months" and only "to please my family." Nature was his teacher. When Taboureaux asked to see his studio, "sparks flew from Monet's eyes. 'My studio! But I have never had one and personally I don't understand why anybody would want to shut themselves up in some room. Maybe for drawing, sure; but not for painting.'"

Sympathetic critics took up these points. By mid-decade, when the Impressionists went their separate ways and Seurat assumed his position of prominence, such writers began to emphasize these biographical "facts," underscoring not only Monet's seriousness but also his heartfelt commitment to his art and the extent to which he would go to achieve his ends. Thus, they often repeated stories of the wind and rain that Monet would brave or the ice that would form on his white beard as he stood steadfast in front of his motif, all of which increased the legitimacy of his work as well as the viewer's sense of Monet's deep, personal involvement with nature.[17] Although these stories were for the most part true, no one ever disclosed their real ending – that Monet was finishing his pictures not under the difficult conditions of the particular location but in the calm of his Giverny studio.

These critics also gradually recognized, and from mid-decade onward tended to stress, another of Monet's tactics – his increased concentration on individual sites and his efforts to capture particularly complex effects. By the end of the decade, Geffroy would even go so far as to claim that "if Monet were forced to stay in one place, in front of one motif for the rest of his life, he would not waste a moment; he would find a different aspect to paint every minute of every hour of every day."[18] By narrowing his focus but at the same time expanding the number of paintings he could make from a single place, Monet once more could assert his personal powers and those of his Impressionist style. Understandably, this aspect of his agenda likewise became increasingly important after the dissolution of his group and the rise of Neo-Impressionism. It was another way to claim supremacy.

Nowhere is this narrowing of focus more apparent than in Monet's campaign on Belle Isle where, with a limited number of motifs, he produced some thirty-eight paintings. Monet, of course, had painted various sites more than once prior to this campaign. There are dozens of canvases from the

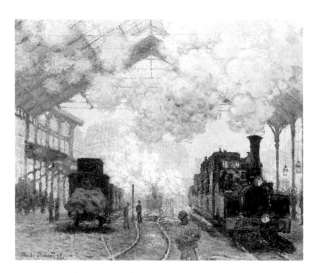

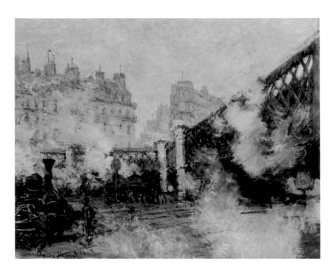

Fig. 16. Claude Monet, *The Gare Saint-Lazare*, 1877. [W.439]. Fogg Art Museum, Cambridge, Massachusetts. Bequest – Collection Maurice Wertheim.

Fig. 17. Claude Monet, *The Pont L'Europe, Gare Saint-Lazare*, 1877. [W.442]. Musée Marmottan, Paris.

1870s, for example, that show the Seine at Argenteuil from certain set locations. Monet seems to have conceived of some of these as pairs or ensembles, continuing a practice that he had begun in the previous decade with his views from the Louvre of 1867 or those of the beach at Saint-Adresse from the same year.[19] The most notable group of pictures of a single motif prior to Belle Isle, however, was Monet's twelve views of the Gare Saint-Lazare of 1877 (figs. 16 and 17). These canvases have often been cited as the first series paintings, or at least as the most significant precedent for Monet's later efforts in this format.[20] And not without reason. Monet had never focused so extensively on one motif as he had with these paintings. In addition to their shared locale, the group was produced in a concentrated period of time – between January and April of 1877 when seven of them were exhibited, together with twenty-two of Monet's other canvases, at the third Impressionist exhibition. Monet appears to have worked on nothing else during those four months.

For all of their shared concerns, however, the *Gare Saint-Lazare* paintings are only tangentially related to the *Belle Isle* or later series paintings of the 1890s. First, they do not maintain a consistent point of view. Some paintings are set inside the huge iron-and-glass shed, some outside. Even within those two areas, there are significant differences, as Monet shifted positions for almost every canvas (the Musée d'Orsay's picture and the one in the Fogg Art Museum being the closest pair). Thus, they do not possess the rigor of the Brittany canvases or those from the 1890s. Second, while they capture particular events and specific atmospheric conditions, they do not form an integrated ensemble of sequential moments charted with a keen eye for nuances and variations. Third, they vary greatly in format, some being con-

siderably larger than others. They also differ formally. Some have complicated compositions, others quite simple ones. There are no evident color relationships that would unite some of the more disparate works. And the way that paint is applied is dramatically different in many of the canvases. Thus, in the end, the *Gare Saint-Lazare* paintings are more an exploration of the bustling railroad station than a methodical examination of it, more of an ensemble than a series per se. To relate these paintings too closely to Monet's later serial efforts, therefore, is misleading.

To separate them even more, we should recall that Monet did not pursue the idea of interrelated pictures that, in hindsight, writers have asserted the station paintings suggest. He did complete dozens of canvases in the first half of the 1880s that he considered as going together; indeed, there are very few pictures from those years that are unrelated in some way to at least one other work of the time. Monet also produced two sizable groups of paintings of various motifs in Varengeville and Étretat between 1882 and 1885, his efforts in the former town resulting in nearly forty pictures. But he never attempted anything that approached the classic series works of the 1890s in focus and comprehensiveness, at least not in the first part of the decade.

His campaign in Brittany, however, begun in September 1886 shortly after the eighth Impressionist exhibition and Seurat's apparent triumph, marked a subtle change in Monet's orientation. Of the thirty-eight views of Belle Isle that he produced, for example, thirty-five include no reference to humankind. There are no people in those pictures, no houses, no boats, or other traces of civilization. There are only earth, sea, and sky (plate 3). In addition, the formats of these works are fairly regularized; most are standard-size canvases of 65 x 80 centimeters (25½ x 31½ inches). The paintings also explore a relatively limited number of motifs and do so with an equally restricted number of compositional options. While these limitations resulted in pictures that are near replicas (Monet did six paintings of the needle rocks, for example), they also appear to have forced him to be even more exacting in his description of natural phenomena – the action of the sea, the way the light danced upon the water, or the interplay of shadows and reflections cast by the craggy black rocks – subtle differences that can be seen in (fig. 12 and plate 3). Most telling, perhaps, unlike his handling of previous groups of pictures, Monet felt no qualms about exhibiting eight of these *Belle Isle* canvases together at the Sixth International Exhibition held at Georges Petit's in the spring of Monet's return, and then showing twelve of them in his huge retrospective with Rodin two years later in 1889, also at George Petit's. He was obviously more confident about them as a group than any other suite of paintings from the 1880s, despite, if not because of, their proximity to each other.

Critics who reviewed the 1887 exhibition recognized the importance of these pictures. Joris-Karl Huysmans, for example, was ecstatic about them and called Monet "the most significant landscape painter of modern times," while Alfred de Lostalot felt they possessed "the power to silence the critics."[21] Both writers were struck by the forcefulness of Monet's efforts. De Lostalot, for example, saw Monet as being "more violent and excessive than ever before in his application of paint and his choice of color," but that such "coarseness" was countered by extraordinary control. "You have to admire these

feverish canvases, for despite their intense color and rough touch, they are so perfectly disciplined that they easily emit a feeling for nature in an impression filled with grandeur." Huysmans sensed connections between the pictures, and described the group as "a series of tumultuous landscapes, of crashing, violent seas, with wild tones – harsh blues, garish purples, acrid greens – jarring waves with stiff crests, under raging skies." That he should have called them a "series" is understandable. The term was commonly used throughout the 19th century to describe a group of paintings; Monet himself used it many times in the 1870s and early '80s.[22] It had appeared at least twice before in the critical literature on Monet, first with Emile Zola, who used it when referring to Monet's garden subjects of the 1860s, and second with the critic for *La Presse*, who employed it to characterize Monet's submissions to the second Impressionist exhibition in 1876.[23] While somewhat fortuitous, therefore, Huysmans's use of the term for these *Belle Isle* paintings nonetheless suggests that they came across as a group, something that Gustave Geffroy made even clearer in his review of the show.

Geffroy claimed that Monet's paintings revealed inherent interrelationships, that they were "views of an ensemble." "All of these forms and these glimmers of light speak to one another, collide with each other, influence one another, saturate each other with color and reflections."[24] In his opinion, these paintings were the product of "a rustic alchemist, always living out of doors, . . . [who is] active enough to be able to begin several studies of the same motif under different lighting conditions in the same afternoon [and who] had acquired a singular ability to see the disposition and influence of tones immediately." To support his contention, Geffroy provided a sketch of Monet's working method. "Quickly, he covers his canvas with the dominant values, studying their gradations, contrasting [and] harmonizing them. Then, [he works toward] the unity of these paintings, which, with the form of the coast and the movement of the sea, establishes the hour of the day by the colors of night and the disposition of the clouds. Look at these thin bands of clouds, these limpid, gloomy effects, these fading suns, these copper horizons, the violet, green, and blue seas, all these states so far from a singularly defined nature, and you will see mornings dawn before you, middays brighten and nights fall." It was this kind of interpretation, even this kind of language, that would be repeated over and over again about Monet's later work, particularly his series paintings from the 1890s. That the *Belle Isle* pictures could suggest this "critical paradigm" to Geffroy once again underscores the significance of Monet's campaign on the island while indicating the subtle shift that was taking place in his art.[25]

That shift is evident not only in the number and the focus of the *Belle Isle* paintings and the critical reaction they provoked but also in the fact that just prior to this campaign, Monet had selected ten quite different works to show in the Fifth International Exhibition at Georges Petit's. Following past practice, he had wanted to affirm his ability to cover a wide range of subjects. Thus, he chose a view of Menton, one of Cap Martin, a Giverny landscape with haystacks and children, three diverse views of Étretat, a snow scene, a springtime picture, and two different paintings of tulip fields in different parts of Holland.[26] To have opted the following year for eight *Belle Isle* pictures out of the seventeen works that he exhibited in the Sixth International emphasizes once more the emergence of a new orientation, something

collectors may have sensed, as nearly every one of his paintings in that show was sold on the spot.

The strong focus of Monet's work on Belle Isle perhaps could be explained by the constraints of the place; the island was not very large. It may also have had something to do with the fact that Monet had blocked out only a few weeks to spend there. However, neither of these reasons is satisfactory. Monet could easily have found many more motifs, if that had been part of his plan; he was too driven and imaginative to have been limited by a site as dramatic as Belle Isle's *côte sauvage*. In addition, despite his best intentions, he extended his stay no less than half a dozen times, remaining eight weeks longer than he had originally intended. The focus appears instead to have been the result of other factors — perhaps his own urge to confront new and challenging pictorial problems, or his desire to capitalize on the increased interest in his work. "This trip must be very good to me," he told Alice Hoschedé, "it is very useful after my success at Petit's."[27] It might also have been the result of Monet's desire to know a place so intimately that he could feel a certain mastery over it. After being on the island for approximately a month, Monet actually admitted that the latter was an issue . "I well realize that in order really to paint the sea, one must view it every day, at every time of day and in the same place in order to get to know its life at that particular place; so I am redoing the same motifs as many as four or even six times."[28] This important admission makes a good deal of sense in light of the pressures Monet was experiencing. For although always uneasy about his work, he now was more concerned than he had ever been in the past. That he reached such a level after the eighth Impressionist exhibition and Seurat's veritable triumph was surely no coincidence. The stakes for avant-garde painting had risen in like measure.

Even if Monet had wanted to escape those pressures by going to the wilds of Belle Isle, they would have pursued him. For within a week of his arrival, he had received letters from Renoir and the critic Octave Mirbeau, he was corresponding with Durand-Ruel and Georges Petit, and he was spending a fair amount of time with the Australian painter John Russell, who owned a house on the island and had recognized "the prince of the Impressionists," to Monet's pride and amusement.[29] More significant than these continued connections to the capital and the world of contemporary painting was the chance arrival on the island of Gustave Geffroy. Monet was both surprised and pleased upon his return to his hotel one evening to find the art critic for *La Justice* seated at the table that he generally occupied. "It's funny to be so far away and to have these meetings," Monet told Alice when describing this fortuitous encounter.[30] Geffroy had come to Belle Isle to do research for a book on the anarchist Blanqui. He had had no idea that Monet had made the long voyage there as well. Indeed, the artist and the critic had never met before, although Geffroy had written an appreciative article on him in 1883, to which Monet had responded with a letter of thanks.[31] The two got along very well right from the beginning. Like most artists of the period, Monet was happy to be able to establish good relations with empathetic people in positions to assist him. It was a mutually beneficial meeting, however, as Geffroy was able to watch Monet paint. He thus left the island with firsthand information about the artist and his practices, which he clearly tapped for his 1887 review and many others thereafter.

This chance occurrence gave rise to a friendship that would last for forty years. It also led to discussions about Monet's position and his particular inclinations, as Geffroy's review suggests. Those topics were the subject of various letters that Monet wrote from Belle Isle to Durand-Ruel, Alice, and Geffroy himself. In a letter that apparently no longer survives, for example, Durand-Ruel told Monet that he was out of his element on Belle Isle, that he should come home and spend the winter in the Midi "because," as Monet described it to Madame Hoschedé, "my business is the sun."[32] This did not sit well with Monet. "Hey," he griped to his future wife, "they will end by drowning me with the sun! One has to do everything," he declared, "and it's precisely because of that that I congratulate myself for doing what I'm doing." The desire to do it all had never been so strong, but, of course, neither had the contemporary scene been so competitive – which is undoubtedly one reason why, after admitting to Durand-Ruel that the sinister qualities of the island were forcing him out of what he was used to painting, Monet insisted that "it is not necessary to specialize in a single theme."[33]

It was this same desire to be seen as all-encompassing and yet focused that perhaps led Monet to follow his dealer's suggestion and go to Antibes, the antithesis of the "somber and terrible" Belle Isle (plate 4). The ultimate for an avowed painter of sunlight, Antibes more importantly afforded Monet the opportunity to expand his repertoire and paint the physical extremes of the nation from the North to the South, thus laying claim once again to the capacities of Impressionism to represent the country . And as in Brittany, Monet produced an astonishing number of pictures (close to forty) of a relatively limited number of motifs. Unlike his immediate enthusiasm for Belle Isle, Monet was initially concerned about the area. He expressed his admiration for it when he first arrived, but he felt that parts of it were also "not very diverse." "I should guard against repeating myself," he cautioned. "That's why before retracing my steps, I take a good look; maybe I will even go tomorrow to Beaulieu and Éze [which lay about 20 kilometers to the East]. That will cause me to lose time, but I think it would be prudent; I will work with greater confidence afterward."[34]

Monet's fears about repeating himself proved partially founded, as the paintings that he brought back from Antibes were less varied within individual groups than those from Brittany. His lapse might have had something to do with the greater consistency of the light in the South, or with Monet's assumption that people simply would have been attracted to the picturesque sites that he had chosen and that he did not have to vary his effects as much. Perhaps it was also due to the fact that he felt even more out of his element than he had been at Belle Isle, something he had admitted to Berthe Morisot (as quoted above). He repeated this fear to Alice and to Geffroy. "I definitely see that this area is not for me," he told Alice when he first arrived, "Tomorrow, I am going to see if I can find lodging elsewhere, possibly in Agay."[35] A month later he told Geffroy, "I am very worried about what I am doing. It is so beautiful here, so clear and luminous! You are bathed in blue air, it's frightening."[36] His repetitions might therefore have been the result of his need to come to grips with this less familiar area and its climate.

Whatever the reason, he felt confident enough about his efforts upon his return to Giverny to create a whole exhibition from ten of the works. The show opened at Boussod & Valadon's in June 1888, barely

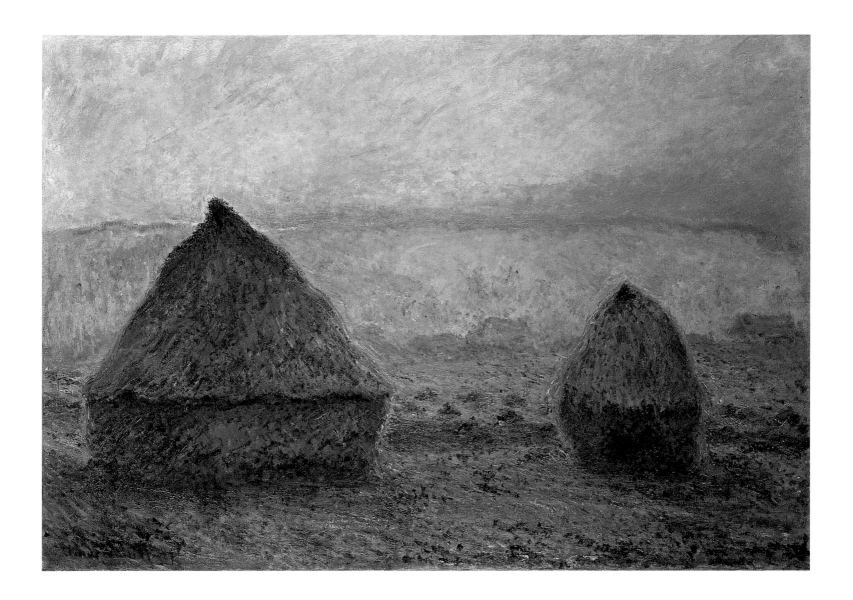

a month after he had left the South. That Monet would have staged such a show again is significant. For the second time in less than a year, he was staking his claim on a very closely related group of pictures of a single locale, a fact that did not go unnoticed in the press. Geffroy once again made it a central part of his review, feeling that Monet had been able to capture in these works "all that was characteristic about the area and all the deliciousness of the season."[37]

However, neither these Antibes paintings nor those from Belle Isle nor the many others that he did between and after these campaigns approached Monet's initiative of late 1888. At the end of the summer or early in the fall, after having completed *Five Figures in a Field* and *Bend in the Epte* – his most conscious responses to the challenges of Neo-Impressionism – Monet turned to his surroundings at Giverny and began at least three and perhaps as many as five views of grainstacks (fig. 18, plate 5). They would prove to be the most propitious group of paintings of the decade.[38] For more than Monet's *Antibes* ensembles or his six paintings of the needle rocks at Belle Isle, these *Grainstack* pictures focused on a known landscape and a familiar motif and were clearly conceived of as a suite. In three of them, Monet stood in exactly the same position and rendered two stacks under three distinct lighting

Plate 5. (cat. 16) *Grainstacks. (Sunset.)*, 1889. The Museum of Modern Art, Saitama, Japan

Fig. 18. Claude Monet, *White Frost. Sunrise*, 1888-89. [W.1215].
The Hill-Stead Museum, Farmington, Connecticut.

conditions. In the others, which show a single stack, he likewise assumed a consistent position and similarly developed quite different effects – one of late fall (which he left unfinished), the other of winter fog.

Begun long before the famous letter to Geffroy, these paintings should be seen as the apogee of Monet's agenda for the '80s. They are the culmination, for example, of Monet's efforts to decentralize Impressionism, as their generic qualities of site and subject make them, in the end, representations of the French countryside as a whole. Even more than the *Belle Isle* or *Antibes* pictures, these paintings also reveal Monet's intense scrutiny of a single subject *en plein air* and his evident desire to extract highly refined variations from that one motif. No one could say that these canvases were dashed off or that Monet lacked discipline, seriousness, or skill. Indeed, his palette appears expansive in these works, his brushwork a brilliant combination of description and independence, his composition both classical and novel, his sensitivity to light astonishingly artful yet strikingly believable. Reaffirming de Lostalot's contention that Monet had the ability to silence the critics once and for all, these paintings and the series that they prompted in 1890 would earn Monet his long-sought place in the hierarchy of contemporary art.

With these paintings, as with *Five Figures in a Field* and *Bend in the Epte*, Monet was going to advance his reputation on the basis of his craftsmanship, persistence, imagination, and eye. But even more important, he was going to attain the stature he desired because he invested in these canvases values that

were dear to himself and his native culture, values that had always been a part of his work but now were stated with eloquent simplicity. They were values that were not readily apparent in Neo-Impressionism. First among these was a love of the French countryside, something sympathetic critics had always pointed to in Monet's work but which in these canvases was now evident for all to see. Second was a deep admiration for nature, again a point that had been made often in the past but which had gained greater credence from the *Belle Isle* pictures onward. With the sublime pictorial effects that Monet was able to achieve in these *Grainstack* paintings, he reaffirmed that admiration in a way that was now both uncompromising and all-inclusive. Nature in these pictures becomes magisterial, a source of wonder and fulfillment, a power that is at once elusive and omnipresent, chilling and restorative. Although essential to any landscape painter, such feelings about the natural world did not seem central to Seurat and his followers, as various negative critics at the time were quick to point out. Third among these values was the element of individualism. Critics of all persuasions had recognized this distinct characteristic in Monet's work. Indeed, it had been the primary cause of the negative criticism that he and his Impressionist colleagues had received in the 1870s. In the 1880s, Monet and supportive writers emphasized this quality, beginning with Taboureaux's interview at the outset of the decade. By 1889, the outspoken novelist, anarchist, and cultural critic Octave Mirbeau, who was also one of Monet's most ardent supporters, would go so far as to assert that Monet had purged himself of all past influences and had developed revolutionary work "due to [his] moral isolation, self-focus, [and] immersion in nature."[39] Mirbeau asserted that Monet did not go about this in a haphazard fashion. He did it "according to a methodical, rational plan, of inflexible rigor, in some ways, mathematical," a not-so-veiled attempt to claim some of the science from Seurat.

Monet's independence was evident not only in how he conducted his life and practiced his craft; it was also apparent in his choice of subjects. Monet himself attested to the importance of his selection process when he expressed his concern about repeating himself in Antibes. He even blasted all of the painters there, labeling them "idiots" because they had indicated to him, "from their stupid point of view, the less interesting spots to paint." The next day, "listening only to my instincts, I discovered superb things."[40] No one made the significance of selecting appropriate subjects more apparent than Geffroy. "To believe that these thoughtful, liberated artists [the Impressionists] did not choose their subjects is one of the numerous fantasies born by accident from the practice of Impressionism. On the contrary, their choice was always their profound and important preoccupation. But legends are made of this kind of stuff. We have grown used to characterizing these artists as indifferent cameras focusing on all spectacles and the error is going to be repeated, even by those who are capable of knowing better."[41] Mirbeau took the whole issue one step further. In remarks directed precisely at the Neo-Impressionists and their supporters, he asserted that Monet's entire art was the product "of reflective thought, of comparison, analysis, [and] a knowing will."[42]

These assertions should cause us to consider Monet's choice of subjects in the 1880s more carefully. For example, during all of his travels in the decade Monet painted non-French sites only twice, once in

1884 when he spent two months in Bordighera on the Italian Riviera, and again in 1886 when he went to Holland for a fortnight during tulip season. Speaking no foreign languages and being particular about what he ate (Monet even found the food in Antibes "vile"), Monet undoubtedly wanted the security of the French tongue and his native cuisine. Returning to France from Bordighera in 1884 gave him "the greatest pleasure."[43] The fact that he concentrated so heavily on sites in his own country, and was truly excited by each one, bespeaks his deep-rooted feelings for his homeland.

However, Monet was not an ardent patriot, as is evident from his many disparaging remarks about the government when negotiating the donation of Manet's *Olympia* in 1889. When the Franco-Prussian War broke out, it was Monet who fled the country to avoid military duty (unlike Manet, for example, who volunteered for the National Guard.) But Monet had a deep affection for the land and for the beauties of *la France*, as he revealed to Pissarro in 1871 during his self-imposed exile from his war-torn country. Monet told Pissarro to cheer up because when he got back home he would find "beautiful things to paint in France; the country's not lacking in that regard."[44] In the 1880s, he confirmed that over and over again.

Although always influenced by economic concerns, his affection for his country came to the fore when he learned that Durand-Ruel was planning to sell his paintings outside of France. Initially, he seemed to support the idea. "Your son told me about your hopes for (future) [sic] business in America and Belgium," he informed the dealer in June of 1885. "I hope to hear good reports."[45] However, barely a month later, he wrote Durand-Ruel again to express his misgivings. "I recognize that certain canvases regretfully are leaving the country for the land of the Yankees and I would like to reserve a selection of them for Paris, for [Paris] is above all and [maybe] the only place where there is still a little taste."[46] Six months later he was quite upset about the whole situation. "After all that you have sent to America, what remains in France? I would very much like to believe in your hopes for America, but I would chiefly want my paintings to be made known and sold here. All of that is difficult, I understand, but [the other] is worrisome."[47] Two years later while in Antibes, he raised this complaint to Durand-Ruel again.[48] Ironically, soon after he returned from the South, the government offered him the Cross of the Legion of Honor, one of the most prestigious awards a Frenchman could earn. Monet refused it – an example of his disdain for authority and its accolades – but the government's gesture underscores the recognition he was receiving and the fact that he was touching responsive chords.[49] He undoubtedly understood this, for shortly afterward he began his *Grainstack* paintings.

These paintings are as replete with associations as they are rich in visual incident. In fig. 18, the early morning light glistens on the frozen earth, filling the scene with the aura of potential. The grainstacks stand in the cold, waiting to be warmed by the rays of the rising sun. Though isolated and erect like weighty monuments, the stacks are literal extensions of the town.[50] They are the farmer's source of income and the town's most substantial product. They are also the tangible evidence of the prosperity of the place and of the countryside's fertile soil and benevolent climate. As they rise from the earth, their conical tops receive the largest amount of morning light. Those tops also imitate the houses

Fig. 19. Jules Breton, *End of the Day*, 1867. Location unknown. From Marius Vachon, *Jules Breton*, Paris, 1899, 25.

Fig. 20. Limbourg Brothers. "June" from *Les très riches heures du duc de Berry*, 1411-1416. Musée Condé, Chantilly.

that Monet includes deep in the distance. Like the roofs of those structures, the stacks are built out of sheaves of individually bound stalks that were then thatched, the result of the farmers' long hours in the fields. Labor is totally absent from these views, unlike so many late 19th-century depictions of the fields of France (fig. 19). There are no sweating peasants here, and no indication of the difficulties entailed in producing those stacks.[51] There is also no sense of the poverty that existed in rural areas or the routine of rural life that artists such as Breton tended to stress. Instead, Monet's pictures breathe the air of contentment. For this is the countryside that fulfills all promises, the rural France that is wholesome and fecund, reassuring and continuous.

It is also the rural France that had been represented by French artists for centuries – in the labors of the months from Romanesque churches and medieval manuscripts (fig. 20); in the paintings of Claude Lorraine or Nicolas Poussin; in the fêtes of Watteau, Monet's favorite painter, and the canvases of his followers. It is also the rural France that had so preoccupied dozens and dozens of 19th-century French artists particularly Barbizon painters such as Millet (fig. 21), in addition to the hundreds of anonymous French artists who produced innumerable images over the centuries that serve as popular precedents for Monet's later efforts. Even Pissarro had done several paintings of stacks in the 1870s and '80s as well as a series of prints of the subject.[52] Anyone who took up the motif, therefore, automatically took his place in this heralded lineage.

Monet would not have wanted it any other way, for his pictures affirm not only the essential values of the French countryside but also the fecundity of the nation's artistic past, something once again that Seurat and his followers seemed to criticize or ignore. In addition, they lay claim to certain principles, such as order and permanence, seriousness and harmony, that Fénéon felt belonged to the Neo-Impres-

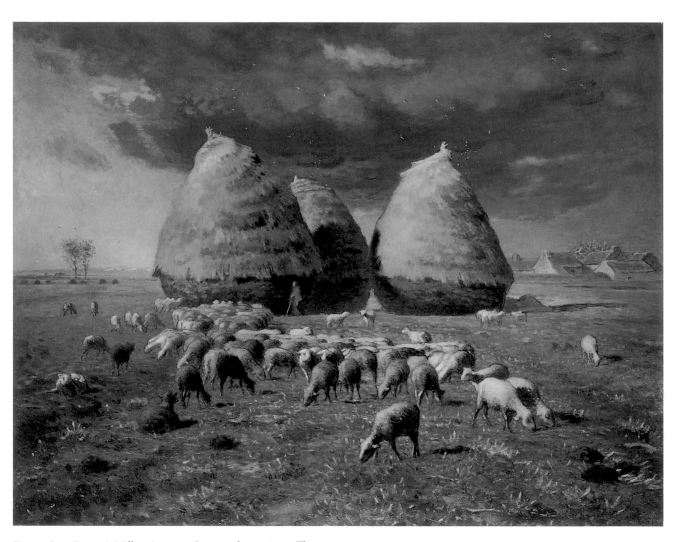

Fig. 21. Jean-François Millet, *Autumn, Grainstacks*, 1868-75. The Metropolitan Museum of Art, New York, bequest of Lillian S. Timken, 1959.

sionists. Monet seems to have arrived at a new understanding of these principles, not only from his knowledge of past art, but also from his involvement with nature. For it was the partnership between humanity and the natural world, artist and visual phenomena, that produced the best art, according to Monet, not pre-ordained notions of artistic practice scientifically applied to a canvas in the isolation of the studio. It was precisely on this partnership that Monet had been staking his claim for the hegemony of Impressionism. It was why he could stand out in the rain to paint the stormy sea at Belle Isle, bemoan the passing of an effect at Antibes, or fulfill his "wish to prove that I can do something else" and paint a picture such as *Five Figures in a Field* (fig. 15).[53]

In fact, the grainstacks themselves in many ways are analogous to the figures in that earlier picture. Like the figures, they too are products of nature and are clearly understood as part of the landscape. They also are similarly shaped by man and the environment. In addition, they are at once vulnerable and hardy, potential victims in their splendid isolation and stalwart constructions made to endure. Like the family members, the stacks too are sources of pride and concern and stand as the tangible evidence of natural continuities. Formally, they assert themselves as individual entities, although at the same time they are one with the enveloping atmosphere, just like the figures. They even have a kind of aura around them, like their human counterparts. And just as the children in the foreground of *Five Figures in a Field* recall their older siblings behind them in pose and overall shape, so the larger stacks echo the smaller ones while recalling the shapes of the houses in the distance.

These *Grainstack* pictures, therefore, are not only about light and color, instantaneity, and agrarian phenomena. They are also about nurturing and growth, commitment and community, concerns that Monet believes can be found in the countryside and that, rightfully or wrongly, once again seem alien to Seurat's enterprise on his overcrowded suburban island. They were concerns, as we shall see, that had particular relevance to France in the later 1880s and the decade of the '90s, and that contributed substantially to Monet's success during those years. They were also concerns that the artist did not abandon. In 1896, Monet offered the American painter Lilla Cabot Perry an unqualified opinion. "Nature does not have 'points,'" he told her when painting his *Mornings on the Seine*. Seurat and his followers had clearly challenged that belief, but they had been unable to overcome it. Even Pissarro soon began professing it again. After four years of Neo-Impressionism and many verbal jabs at Monet, he abandoned the dot and returned in 1890 to what he described as "the fullness, suppleness, liberty, spontaneity, and freshness of sensation postulated by our Impressionist art."[54]

Fig. 22. Claude Monet, *The Valley of the Creuse*, 1889, [W.1218]. Private Collection.

Fig. 23. The Confluence of the Creuse, Postcard, ca. 1900. Courtesy Robert L. Herbert.

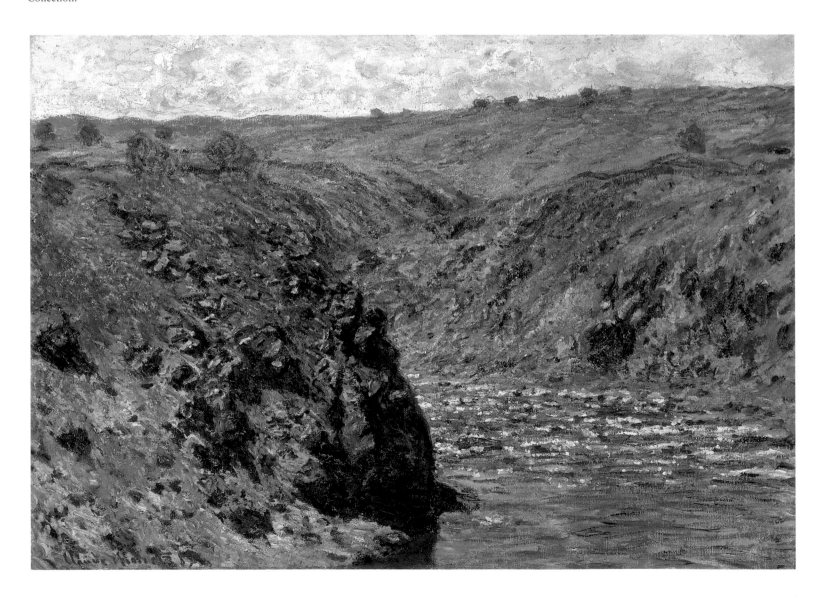

Plate 6. (cat. 1) *Valley of the Creuse. (Sunlight effect.)*, 1889. Museum of Fine Arts, Boston

3 *From the Massif Central to the Musée Luxembourg: Monet in 1889*

WHEN Pissarro saw the ten paintings from Antibes that Monet exhibited at Boussod & Valadon's in 1888, he questioned whether they were right for their moment. "I saw the Monets," he told his son Lucien. "They are beautiful, but Fénéon is correct; while good, they do not represent a highly developed art."[1] Pissarro was apparently not alone in his opinion, as he informed his son two days later. "I told you that Monet's recent paintings did not impress me as more advanced than his other works; almost all the painters take this view. Degas is even more severe; he considers these paintings to have been made to sell. . . . But the recent works are, as Fénéon says, more vulgar than ever. Renoir also finds them retrograde."[2]

Although Monet never expressed an opinion about the relevance of the work he had done in the South, his desire to remain a leader of French painting surely engendered strong feelings about the merits of his efforts, a conclusion amply supported by his letters of the period. Thus, just as Pissarro could berate his former friend and claim that it would be useless to discuss painting with him any longer ("What would be the point? – he cannot understand me?"), so too could Monet apparently tell Theo van Gogh, who had purchased the ten pictures and had initiated the show, that Fénéon's critical review "could have been anticipated." Such were the divisions in French painting of the late 1880s.[3]

That Monet permitted Boussod & Valadon to exhibit the paintings, however, indicates that he thought he was producing appropriately contemporary work. Geffroy had no doubts about that. At the beginning of his review of the show, the critic told his audience that Monet's paintings were a perfect tonic for the troubles that Kaiser Wilhelm of Germany was making following the Schnaebelé Affair and a welcome reprieve from the strains of the current French election, caused primarily by General Boulanger.[4] Although somewhat backhanded, Geffroy's tribute to the seductive powers of Monet's paintings of the South was the kind of praise that he often rendered in subsequent reviews of other shows, although with fewer references to contemporary problems.

Geffroy's allusion to the Kaiser and French politics, although brief, raises intriguing questions. Did he simply want to fill space or did he want his audience to be informed accurately about Monet's efforts? If the latter was the case, had Geffroy talked to Monet about the validity of these remarks or were they the product of his own thinking about the pictures? The former would not have been impossible, given the close relationship that the critic and artist enjoyed. In addition, in a rare admission, Monet himself had expressed his concern about the political situation while in Antibes. Writing Alice Hoschedé in late

April 1888, he said that despite never having read a newspaper there, "I heard that the political situation is deteriorating; that's all we need."[5] If war had broken out, of course, the art market would have suffered, which must have accounted for most of Monet's concern. However, his tone suggests a flippancy and disgust that characterized his attitude toward politics in the late 1880s. Monet, therefore, may well have appreciated Geffroy's remarks. After all, one of his primary objectives in these *Antibes* pictures had been to capture the fairylike light of the Mediterranean, which by its very enchantment would carry viewers far from the political follies of the moment, a point that Theo van Gogh himself would make. "Although Monet is not so radical as Degas and other geniuses," the dealer told his fiancée, "he has in any case the gift of being able to cast a ray of light in these pessimistic times, one that will bring clarity and encouragement to many."[6]

Monet fretted about these *Antibes* paintings. "Tell me what you know of the effects my paintings produced," he asked Geffroy during the course of the show. "When I am not working, these things worry me."[7] His concern might not have been the product of his inactivity alone, but might also have stemmed from the negative reactions the exhibition had already prompted. It could have derived as well from his feeling that these picturesque canvases were not sufficiently rigorous or different enough to meet the challenge of staying on top, a fact that history has borne out, as they have not been held in the same esteem as many other paintings in his oeuvre. Monet himself was less than fully satisfied with what he had done. "I would like so much to prove that I can do something else," he admitted to Geffroy before the show closed.[8]

The immediate results of his uneasiness, as we have seen, were canvases such as his *Five Figures in a Field*, and his first *Grainstack* pictures, paintings that preoccupied Monet from shortly after writing Geffroy in June 1889 to some time in January or February of the following year, at which time he wrote Berthe Morisot: "I think that it will be a beautiful winter. I would be delighted to do some snow and hoarfrost effects." But, he continued, "the atrocious and extremely variable weather has not stopped, so I have not done anything of value."[9] Although he complained that it was too late to go anywhere else to work, Monet decided shortly after writing this letter to join Geffroy and two of his friends, Louis Mullen and the poet Frantz Jourdain, on what was supposed to be a brief trip to the Creuse Valley in the *Massif Central*, in the central part of France. This trip would be Monet's last major excursion for more than five years; it would also be one of his most important, for it solidified the tendencies that he had manifested since Belle Isle and set him firmly on a course that the *Grainstack* pictures had suggested.

BY THE TIME Geffroy invited Monet to join him for this excursion to the Creuse, the two had been corresponding regularly since their chance encounter on Belle Isle and had met frequently for dinners in Paris. They clearly enjoyed each other a great deal and had many similar interests and opinions, as Geffroy's two complimentary reviews of Monets shows in 1886 and 1887 amply affirm. Their appreciation for the power and beauty of the Creuse would also be mutual.

Geffroy's connection to this area was through Maurice Rollinat, a melancholic poet whom the critic

had befriended in 1883 after Rollinat had published a celebrated collection of poems, *Les Nevroses*. Rollinat lived in the small town of Fresselines, which in 1889 consisted of a church, an inn, a post office, and a few houses, much as it does today. The town sits high above the Creuse River on one of the many hills that overlooks the valley.[10] The Creuse is actually two rivers: the Petite Creuse, which originates in the northeastern part of the *département* near Boussac and the Grande Creuse, which begins further south near La Courtine. Twisting and turning as they run through the heart of France, the two rivers meet at Fresselines to form an even larger body of water that winds its way northward to empty into the Vienne. Well known for its rugged terrain and rock quarries (the name Creuse even derives from the Celtic "caro," meaning river of rocks), the valley of the Creuse was sparsely populated, although rich in lore and visual beauty. It had been the setting for many stories by the novelist Georges Sand, who found "the supple and subtle folds in the landscape . . . infinitely satisfying." It had also been the summer home to many painters, including Théodore Rousseau, who had been attracted to the region by the untarnished character of its villages and the raw evidence of nature's handiwork.

Pleased at having visitors to his untrammeled spot, Rollinat gave the Parisians a tour of the area. Monet was so impressed with the river and the untamed splendor of the valley that after a week he returned to Giverny to retrieve his paints and canvases. In another week, he was back and reinstalled in the town's humble inn. By the end of the month, he had more than twenty paintings under way, a clear indication of his enthusiasm for what he described as the "awesome wildness of the place."[11]

Of the twenty-four canvases that he completed during this campaign, twelve concentrate on the hills that sweep down to the convergence of the Creuses. Of these, no less than ten have almost exactly the same vantage point and essentially the same composition (plates 6-9). In their number, appearance, and subtlety, and in the way that Monet subsequently chose to exhibit them, these pictures could be considered Monet's first series. To paint them, Monet stood on the other side of the small hill that appears in the lower-left corner of fig. 22. In this picture, the Petite Creuse enters the scene from the lower right and it moves diagonally across the canvas to meet the Grande Creuse, which flows into the picture from center left. The conjoined river then cuts right and left and then right again as it negotiates its way around the primitive mounds of the landscape. The large mound in the left foreground of the ten similar pictures is the first large hill in the upper left of fig. 22. It is this same hill that Monet isolated in the majestic painting entitled *Study of Rocks; Creuse* but which is known as *The Rock* (plate 13). The river that we see in these ten pictures, therefore, is the united Creuse, the Petite Creuse being outside the scene to the right, the Grande Creuse behind us to the left. Thus, the site that Monet chose for these paintings was the most dramatic of the area, the very place where the rivers joined and where the now larger body of water created the most dynamic relationship with the hills that it had formed over the centuries.

Monet was relatively faithful to the site, as is evident when a detailed canvas, such as plate 6, is compared to a photograph of the area that was taken at the turn of the century (fig. 23). In this painting, as in the photograph, boulders sit precariously on the face of the huge mound in the foreground; skeins of rock stretch across the hills beyond, like fingers of some immense prehistoric hand emerging

from the waters below; ground cover of various hues vies for space among these harder forms, while only a scattering of trees breaks the rigor of the distant hills' rough contours. The sunlight in the painting makes the area appear relatively inviting, but the lack of any evidence of the civilized world suggests the obdurate qualities of the place. It was these qualities that made Monet think of Belle Isle. "Here I am again in a remote land," he told Berthe Morisot. "It's superb, with a real savagery that reminds me of Belle Isle."[12] Predictably, Monet dwelt on precisely those Belle Isle-like characteristics in the majority of these pictures. This painting, in fact, is the only one that is so brilliantly lighted. The other nine are far more ominous, something that startled Monet himself. "In looking at my series, I was terrified to find them so somber," he confessed to Alice. "It is going to be a lugubrious series."[13]

Monet's description was indeed accurate, as many of these ten pictures are some of the darkest and most forlorn that he had ever done. Filled with the fading light of late afternoon, charged with the last gasps of the sky at sunset, or muffled with the somber illumination of overcast skies and early evening, they make an eerie ensemble, especially those such as plates 7, 8, and 9. Moody and direct, they push beyond the reserved through scintilating plate 6. One of these, plate 7, stands out as the least worked up of any of the group, probably the product of no more than three or four painting sessions. Plate 9 is more developed than this, although Monet clearly spent less time on it than on others. Like many of the nine, these three evocatively capture the haunting power of the place that Monet described so often in his letters during his stay.

Monet achieves these effects by manipulating various formal elements in the pictures. He alters the size of the foreground mound, for example, which makes the hills beyond appear more aggressive. He suppresses specifics of the site for a more general impression of the area particularly in plates 7 and 9, and he allows the paint to take on a life of its own by applying it in larger, bolder strokes, again most evident in plates 7 and 9. He employs many of the same colors in these three as he had in plate 6, but he uses a more limited palette of lower valued hues, which makes the scenes simpler and more brooding.

Plates 6, 7 and 8 and the other pictures like it not only capture the primitive qualities of the valley; they also attest to the range of effects that Monet was able to extract from this site, with its limited forms and simplified shapes. This range exceeds that found in the *Belle Isle* views of the needle rock and what Monet was able to capture in the canvases he brought back from Antibes. It is this kind of range that his *Grainstacks* had suggested and that Monet would reinstate when he returned to that series in 1890, which is one reason why this trip to the Creuse was so important. The closely knit group of pictures that he produced on this trip also attests to the kind of rigor that Monet exercised during his stay in Fresselines, a rigor that had likewise played a primary role in the production of the *Grainstack* pictures from that winter and that would become essential to his later serial efforts. Finally, the *Creuse* pictures speak about certain fundamentals of art and nature in even stronger language than any previous group of paintings, fundamentals that once again would be critical to Monet's series paintings of the next decade.

Given their importance, these fundamentals are worth examining in some detail. One senses them

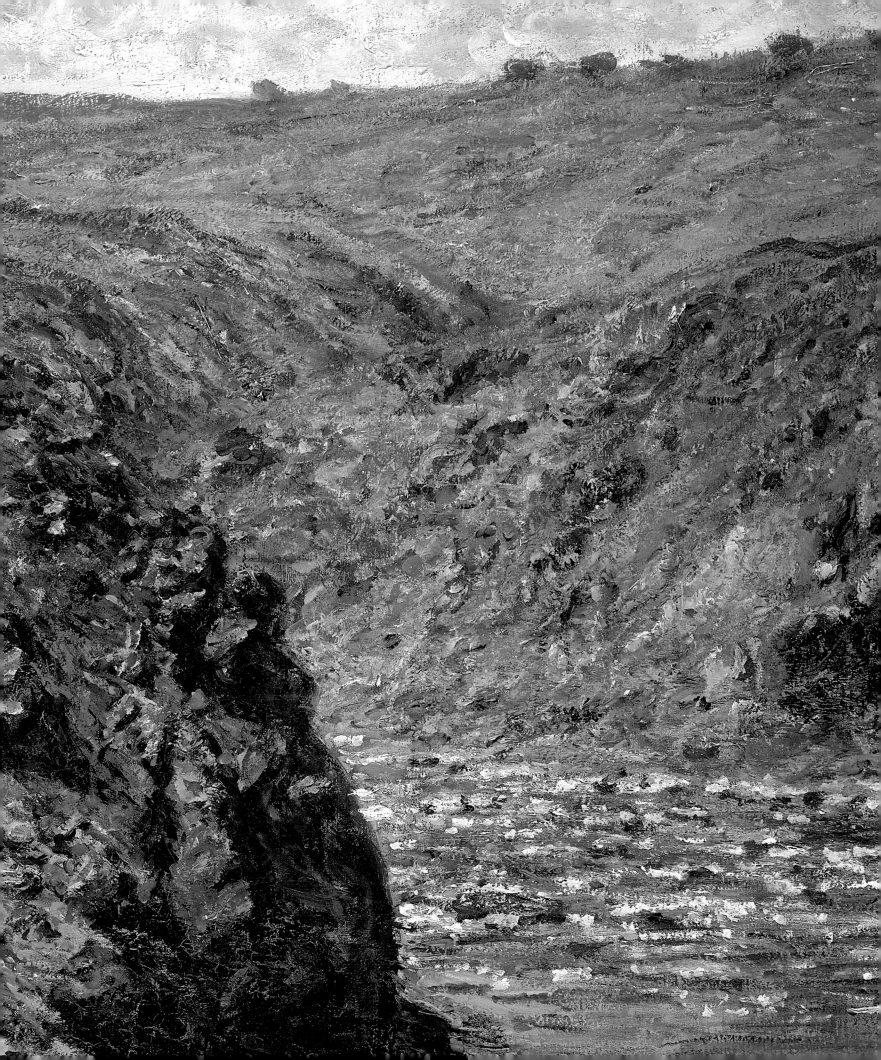

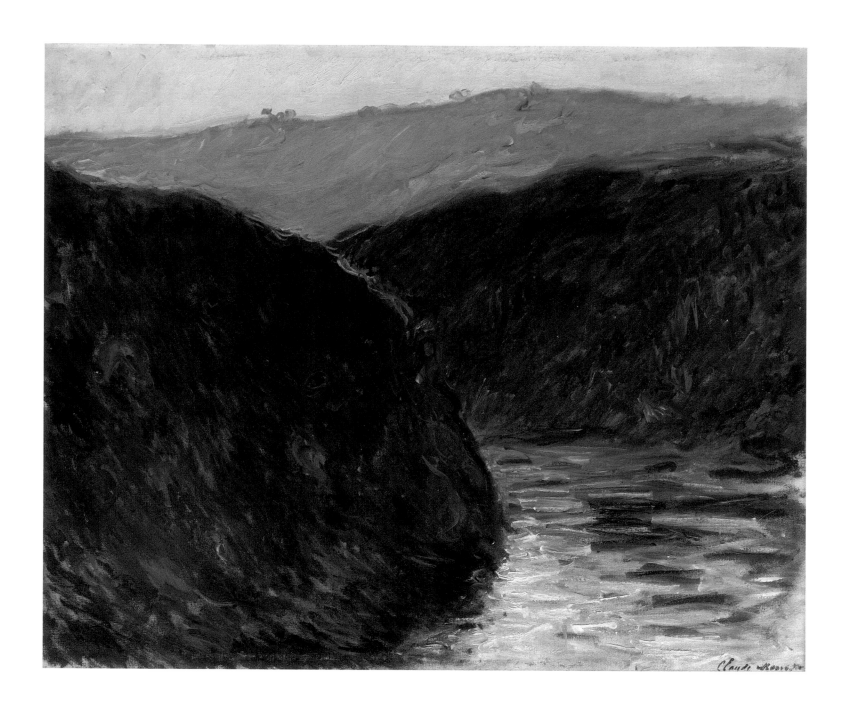

in many aspects of the series, particularly in the conjuncture of the natural elements in the sites – the two rivers flowing into each other, the conjoined river pushing into the hills and plowing still deeper into the earth, the hills themselves reaching toward each other as if trying to be reunited. They can also be felt in the contrasting shapes of those natural forms – the bulbous hills, the triangular river, the elongated rectangle of sky – and how they interact. In plate 6, for example, the river rises on the canvas as it bends to the left, disappearing behind the foreground rock just as it touches the central vertical axis of the picture. The force of the river is emphasized not only by its triangular shape but also by the bolder touches of brighter color so prominent in its upper reaches; it was the river that molded these hills to begin with, of course, and that clearly continued to wield its power. Indeed, from where Monet chose to

Plate 7. (cat. 4) *Valley of the Creuse. (Evening effect.)*, 1889. Musée Marmottan, Paris

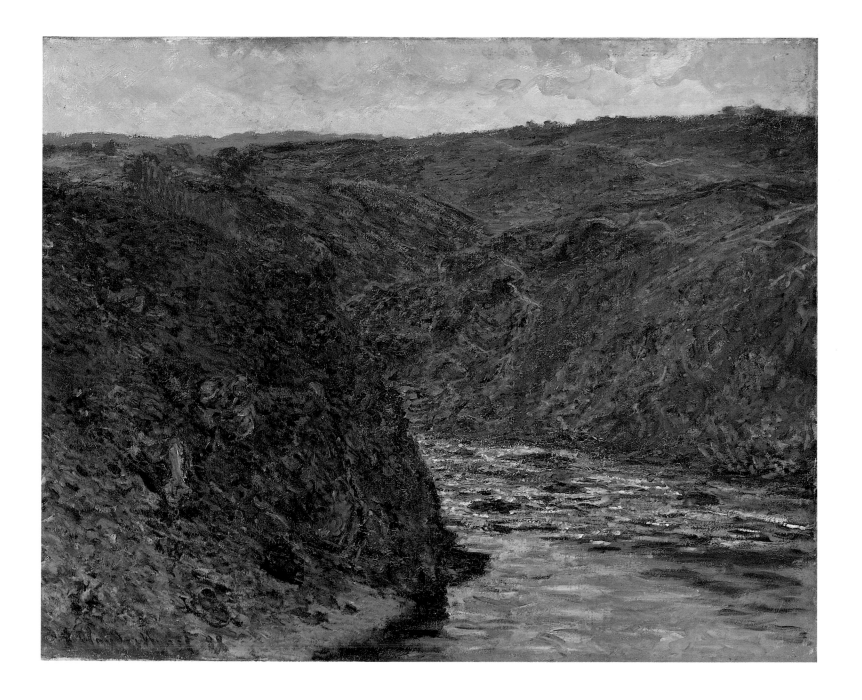

paint these pictures of the confluence, the water becomes a wedge that drives into the hills, forcing them apart, and effectively causing them to rise. Their rise is actually implied in the successive heights of the hills, particularly the two on the right. As they expand in these scenes, the hills occupy greater amounts of the canvas, appropriating that allocated to the sky. It is not by accident, therefore, that the rectangle of sky in these pictures begins to narrow where the hill in the background on the left disappears behind the hill on the right. Nor is it coincidental that this occurs just above the point where the river reaches its apex, which most often is also the point where the series of paired trees along the horizon begins or ends. All of these elements are deliberately interrelated. That furthest hill in plates 6 and 8, for example, is as blue as the water in the foreground, while the trees that initially appear to be randomly

Plate 8. (cat. 2) *Valley of the Creuse. (Gray day.)*, 1889. Museum of Fine Arts, Boston

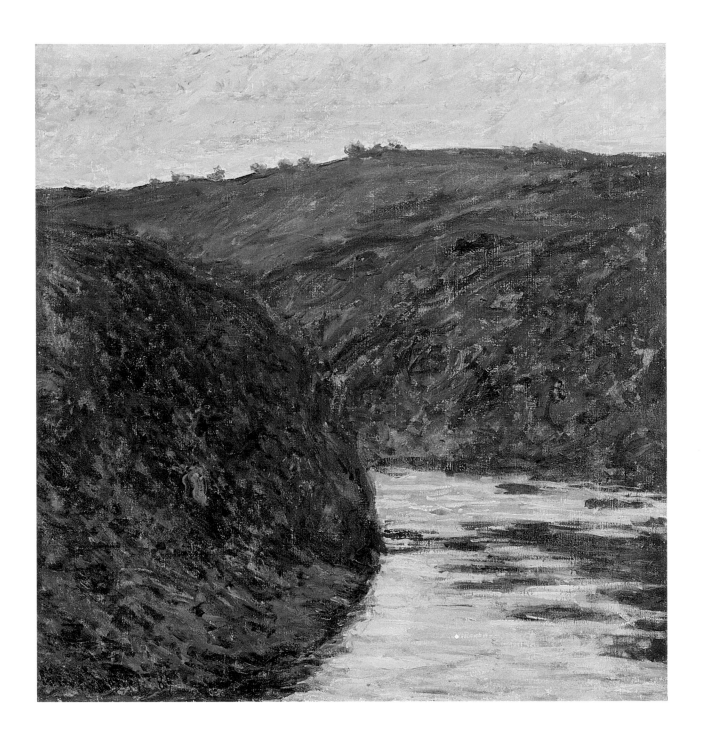

scattered across the landscape in plate 6 actually act like syncopated notes in some rhythmic pattern. The trees in plate 6 also echo the clouds above them and draw attention to differences between the hills in the scene.

These subtleties contribute to the sense of the elemental in these paintings, a quality that Monet felt deeply, as is evident not only in the relationships he establishes in them, but also in the extraordinary palette, the vigorous brushwork, and the grandeur that he captures in the other views of the site. This place spoke to Monet in terms that he obviously understood. And he reacted accordingly, as Geffroy knew he would.

Although most apparent in this particular group of paintings, the sense of the elemental is also force-

46 Plate 9. (cat. 5) *The Creuse. (Sunset.)*, 1889. Musée d'Unterlinden, Colmar

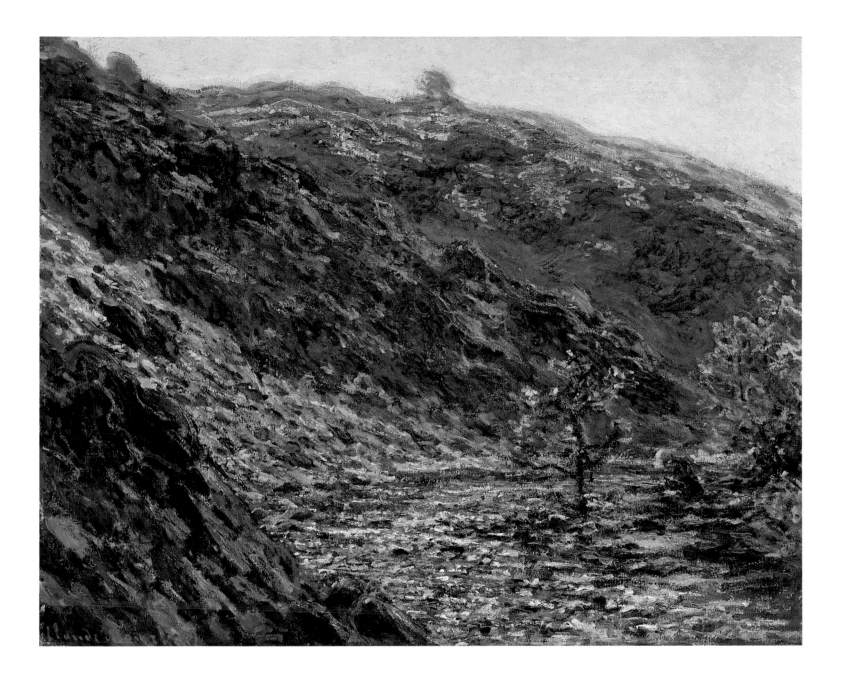

fully stated in many of the other canvases that Monet produced during this important Creuse campaign. When Monet moved slightly up the Petite Creuse to paint plates 10-12, he transformed the site into a highly unified drama of competing geometric shapes.[14] Hills that in reality are similar to the huge mounds in the other ten pictures are now cast as a series of monumental triangles that rush down to the water in rivulets of contrasting color. The river itself and the sandbar on the right form one more triangle each.

These pictures, like all the others of the campaign, are not only about competing shapes; they are also about the struggle of natural elements. For example, the prow-like sandbar on the right pushes its way out into the river to force the water to the left. As the river turns and rushes out of the scene in the lower right, one feels the power it possesses, particularly its ability to wear down the hill on the left, whose

Plate 10. (cat. 7) *Valley of the Petite Creuse*, 1889. Museum of Fine Arts, Boston

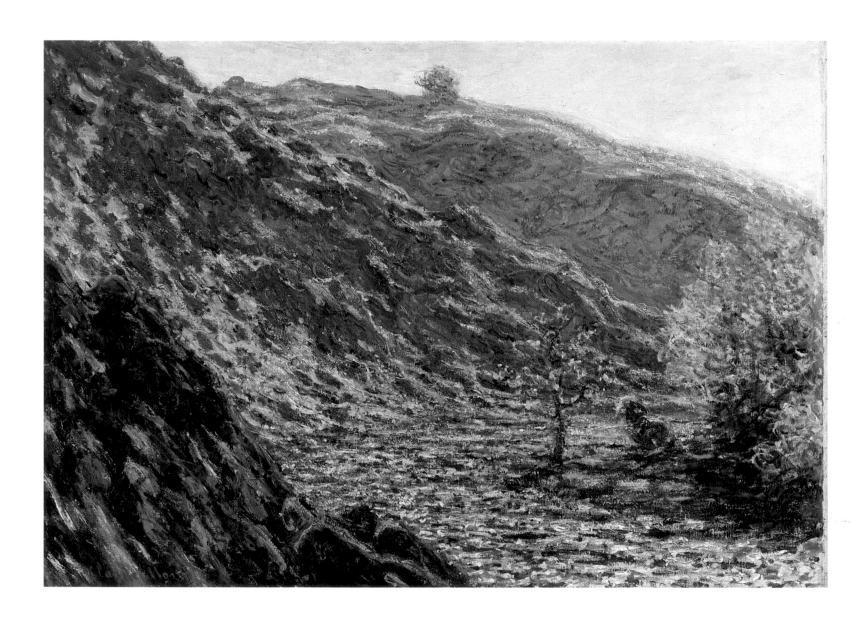

cavity becomes noticeably deeper than it had appeared at first. The trees play a special role in these pictures as well. The old gnarled one, for example, marks the very point where the river changes direction. It also stands in evident contrast to the larger, fuller tree on the right and to the equally substantial though more distant tree on the horizon in the center. In addition, it raises its arms in a complicated gesture, as if it were a lone human actor on this stage of natural splendor. Is it celebrating the beauties of the place like an old, appreciative bard or frantically defying its own apparent age?

In either case, this tree was important to Monet. "I am going to do a big sketch of my poor oak with the yellow Creuse," he declared to Alice very near the end of his stay.[15] "Through it, you will realize the rages and difficulties I have had [here]." The picture he produced was fig. 24. The old oak stretches across

Plate 11. (cat. 8) *The Petite Creuse*, 1889. The Art Institute of Chicago

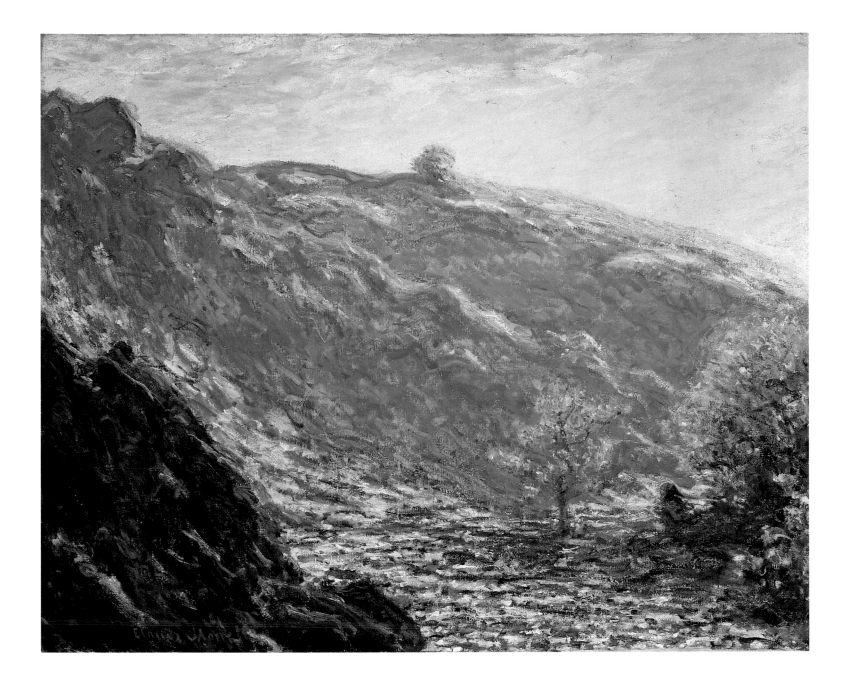

more than three-quarters of this canvas, its branches twisting and turning as if orchestrating the flow of the water beneath it as well as the descent of the hill beyond. This is a truly elemental picture composed of nothing more than the most basic occupants of the site – water, tree, and land.

Such a reduction to absolutes was also at the heart of *The Rock* (plate 13), where the canvas is dominated by the massive, almost volcanic form of the hill. So large is that hill and so actively does it appear to rise and swell that the canvas, despite its rectilinear strength, seems barely able to contain it. The mound actually appears to be pushing the cluster of trees that breaks the horizon on the left up and out of the picture, an action it takes with the tallest tree to the right. Monet clearly fulfilled the prediction he had made to Morisot in his letter of February 1889 that he "was going to do some astonishing things here."[16]

Plate 12. (cat. 9) *The Petite Creuse. (Sunlight.)*, 1889. Private Collection

49

Nevertheless, in typical fashion for Monet, he was unsure of himself. "Alas," he continued to Morisot, "the further I go, the more difficult it is to render what I want; and on top of that, miserable weather – rain everyday and brutally cold." To make matters worse, he was soon hampered by meteorological difficulties of another sort – the advent of spring. To Monet's great regret, the trees in early May started sprouting leaves. He was particularly concerned about the five paintings that featured his old tree and the three of those (probably plates 10-12) in which it played "the lead role."

Monet reacted with typical expediency. After speaking with the person who owned the land on which the old tree stood, he paid the "wealthy goat" fifty francs and then hired two local residents to carry a ladder down the treacherous path to the confluence and literally pick the leaves off the tree.[17] The ironies of this affair exceed all those that we know about Monet. Here is a painter devoted to nature who is now actually impeding the natural cycle so that his motif would conform to the way that he had begun painting it. Although perhaps excusable on the grounds that he was at least being true to his first impression of the place, Monet's radical action underscores how desperately he wanted to salvage pictures that he had begun earlier in this campaign, a desire that was clearly heightened by the pressures of his upcoming exhibition with Rodin and by the competitiveness of the contemporary scene in Paris. "The more I think of it, the more I had better do some things," he confessed to Alice.[18]

His action also suggests how much he had invested in these pictures, something he had admitted to Alice and repeated to Rodin. "I continue to work a great deal, despite the horrendous weather," he told the sculptor, "and I am beginning to see myself a bit in what I do."[19] This statement is particularly significant as Monet rarely admitted to an autobiographical reading of his art. And what he appears to have recognized of himself in these moody and difficult paintings are the paradoxes of

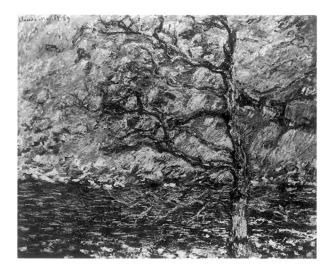

Fig. 24. Claude Monet, *Old Oak at Fresselines*, 1889. [W.1231]. Destroyed during World War II. Photo courtesy Gallery Durand-Ruel.

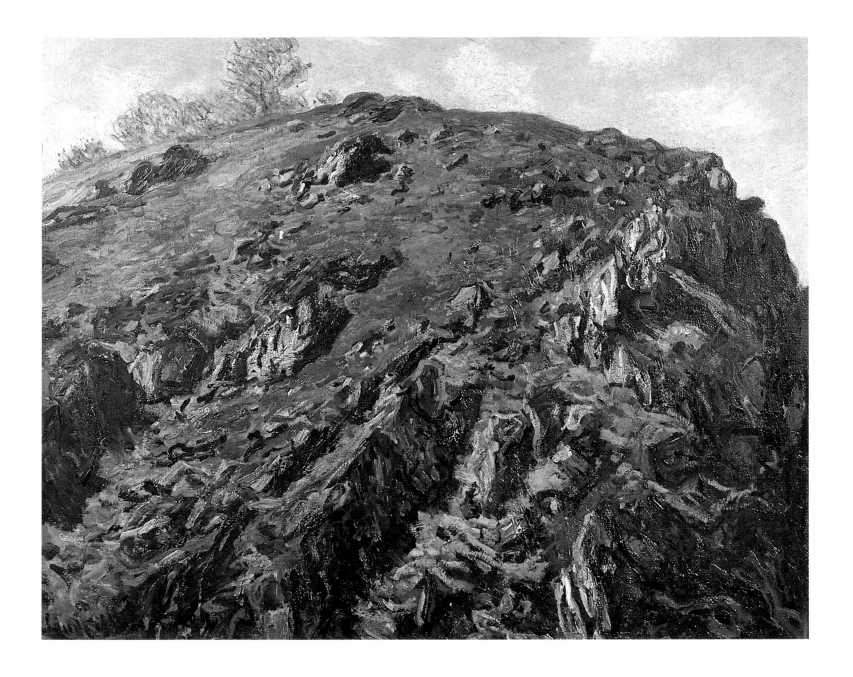

his own personality and those of his enterprise – the aging, cantankerous man engaged in an old and fitful practice now pushed by the pressures of the Parisian art world and the natural environment to new limits, ones that required youthful vigor and unbridled enthusiasm, as well as vaseline and gloves on his rain-chilled hands. He was probably being remarkably truthful when he told Alice three days before he left Fresselines, "You will never know what I have suffered during this campaign . . . I am at the end of my tether."[20] Although eminently profitable, it had been a trying three months – emotionally, physically, and artistically.

Monet was not back in Giverny more than a few days, however, before he turned to business once again – this time, his joint exhibition with Rodin at the Galerie Georges Petit. Monet invested a great

Plate 13. (cat. 6) *Study of Rocks; Creuse*, 1889. H.M. Queen Elizabeth, The Queen Mother

deal in this exhibition, for good reason. It would be the largest gathering of his work to date in a highly visible, prestigious space, and at a particularly propitious moment. When Petit first wrote him about staging the show, Monet sat down and wrote Rodin at once. "I received a note from Petit suggesting a meeting for Saturday morning at ten o'clock to talk about staging an exhibition – *just of you and me* [Monet's emphasis] – in his gallery during the Universal Exposition. Are you still interested?" he asked the sculptor, thus revealing that they had discussed this venture earlier. "Before doing anything, I need to know if I can count on you."[21] Monet clearly understood what such a show meant, and he pressed Rodin for an answer. "Tell me yes or no by telegram right away and give me a date for when we can get together." They met several times, and after protracted negotiations with Petit, details of the exhibition were finally agreed upon. It would open on June 21 and would run for an unprecedented three months. Entrance fees would be split between Petit and the two exhibitors, while Petit would receive fifteen percent of all sales. For the use of the gallery, Petit would also get 10,000 francs worth of paintings from Monet and the same in sculpture from Rodin.[22] These were quite reasonable terms, particularly for Monet, who, at the time was selling his paintings wholesale to Boussod & Valadon for between 2,000 and 2,500 francs apiece, which meant he only had to give Petit four or five works to meet his rental fee. Thus, as the Eiffel Tower rose on the Champ-de-Mars, Monet's expectations rightfully soared. "We could do very well for ourselves," he told Rodin two months before the show was scheduled to open.[23]

When Monet made this assessment, he was hard at work in the Creuse Valley. Although he was far from Paris, his finances and his career were never far from his mind. In this case, his concern was quite understandable. The economic and political possibilities of this joint exhibition were enormous, as thousands of people from all around the world would be in the capital for the exposition. And the French government was doing everything possible to ensure that they would be shown the best that the country offered. France was on display again. To be a part of that from Petit's gallery on the fashionable rue de Sèze was a formidable opportunity.

Monet spent a great deal of time in Fresselines worrying about the show. "What problems I have caused myself," he lamented to Alice. But he also understood the stakes involved. "What vanity, what necessity," he told her.[24] It was his awareness of just how important it was that spurred him into action, writing dealers and collectors, cajoling them to lend their paintings, a task he pursued feverishly in the weeks after his return to Giverny. When he sent the material for the catalogue to the printer in early June, he had amassed nearly 150 works. This was going to be the definitive Monet show. Not surprisingly, perhaps, Monet included at least fourteen *Creuse* canvases. Obviously, the concerns he had so often expressed about finishing this series once again proved to be unfounded. In fact, the *Creuse Valley* pictures as a group were the second largest ensemble in the show, exceeded only by his seventeen paintings from the Antibes trip.[25] More important, unlike any other views of a single locale, Monet chose to exhibit at least five of his ten paintings of the confluence and three of the bend in the Petite Creuse, a concentration that he did not repeat with any of the other groups. Most important, he hung all of the *Creuse* pictures together, something once again that he did not appear to do with paintings of any

other site.[26] In fact, with the exception of the ten *Antibes* pictures that Theo Van Gogh had gathered for Monet's exhibition the previous year – an exhibition that was the dealer's responsibility more than Monet's and that actually covered nine different places in Antibes – this was the first time that he had taken such a daring step. That he did so with *Creuse Valley* pictures further underscores his belief in their significance, an opinion shared by the critics.

In addition to the *Creuse Valley* paintings and those from Antibes, Monet included twelve *Belle Isle* pictures. He also showed at least six of the fifteen figure paintings he had done since Seurat's debut, including *Five Figures in a Field*. Although the exhibition was billed as a retrospective, more than half the paintings had been done in the previous three years. Monet clearly saw the exhibition as a way to prove his worth and reinforce his claim to the leadership of French painting. If anyone doubted his ability to accomplish this, they had only to look at the catalogue. Of the 145 works listed, only a third were still for sale by the time the show opened. And of those completed prior to 1886, only six were available. All of the others were already owned by dealers or private collectors, whose names were prominently included under the titles of their respective canvases.

Monet was equally as tactical when it came to selecting the author for the catalogue essay on his work. Instead of asking Geffroy, who would have been a logical choice (and who was already writing the essay on Rodin for the catalogue), he turned to Octave Mirbeau, who as a critical observer of the contemporary scene was a much more prominent figure in French cultural circles. Like Geffroy, Mirbeau had written three reviews of Monet's previous exhibitions, one of which he had recently published in conjunction with the small show that Monet had had in February and March 1889 at Boussod & Valadon's. That essay, which had appeared on the front page of the conservative newspaper *Le Figaro*, formed the basis of Mirbeau's catalogue contribution.[27]

Undoubtedly drawing on conversations with Monet, Mirbeau greatly expanded his earlier panegyric to "the greatest living artist," as the writer called his painter friend. And with both precision and poetic license, he set down what would be a kind of model for understanding Monet's efforts. Above all else, according to Mirbeau, Monet's art was discriminating and truthful, the product of a deep engagement with the natural world and of a discerning, scientific eye. Every brushstroke was both premeditated and heartfelt, a unique combination of consciousness and imagination that captured the precise effects of light at particular moments of the day. Monet's paintings, in Mirbeau's opinion, made visible not only "the life of air, the life of water, of scents and light," but also "the ungraspable, invisible life of meteors synthesized with admirable boldness and eloquent audacity." In effect, Monet was able to capture "living nature . . . with its cosmic mechanisms and . . . laws of planetary movements," in which one could find both ultimate harmony and "the dream, with its warm breadth of love, its spasm of joy [which] takes to the air, sings, and enchants."

The consciousness that Mirbeau insisted was such a critical part of Monet's art unfortunately would slip from the critical discourse about the Impressionist's later efforts, as would Mirbeau's emphasis on the artist's rigor. What would be repeated with greater frequency was the false idea that Monet himself had

created at the beginning of the decade – namely, that he was concerned only with light and that "the outdoors is his only studio." In addition, nearly every later writer who was sympathetic to Monet's efforts would take up Mirbeau's notion that Monet's work was internally consistent; that the artist had begun his career in pursuit of ever-changing effects of light; that this all-consuming challenge led him to finer and finer gradations of those effects; and that this finally culminated in more and more canvases devoted to the same motif under different lighting conditions – i.e., the series paintings.

There are problems with these notions. Besides maintaining a studio nearly his entire career, Monet was not guided by the same binding principles from the moment he decided to be an artist until the retrospective with Rodin. His life and art were more complicated than that, as was the evolution of his series paintings.

There is a logical explanation for Mirbeau's deceptions. As Monet himself admitted to Durand-Ruel, the essay was "written just for the foreign public."[28] Although it is difficult to know exactly what Monet meant by this statement, it is clear that he and Mirbeau saw the essay as a sophisticated sales pitch. Whether geared primarily to prospective collectors who may or may not have been familiar with Monet's work, it had to emphasize certain "facts" that would make the paintings and their creator as appealing as possible. Mirbeau therefore trotted out all of the generalities that Monet wanted people to believe, particularly the ones that upheld the idea of the independent, self-taught painter beholden only to nature and to his art, forever following the fleeting effects of light.

Aware of the opportunity that the show presented, Mirbeau took care to make this essay more than a mere come-on to the uninitiated by including a number of counters to Fénéon's attacks and by casting aspersions on the rest of Monet's competition. Asserting that Monet did not suffer from "worry – the contemporary sickness so fatal to productivity" (a backhanded critique of the other Impressionists), Mirbeau distanced himself and his artist hero from effete contemporaries by declaring Monet to be "male and healthy." He also inferred that Monet shared his definition of art, which he offered near the beginning of his essay: "Art that does not concern itself – even in dream conceptions – with natural phenomena, and that closes its eyes to what science has taught us about the functioning of an organism, is not art." Truth, Mirbeau claimed, is "the unique source of the dream," and it was this truth that Monet relentlessly pursued. Monet tracked it in "moral isolation," forgetting all "theory and aesthetics . . . all that was not the motif of the present hour." But he did not do so blindly. In a clear swipe at the Neo-Impressionists, Mirbeau asserted that Monet's work was "the product of thoughtful reflection, comparison, analysis, and a willed consciousness," an appropriation of Neo-Impressionist premises that other critics stated even more bluntly. "Monet has been able to employ pure tones and a simplified procedure without resorting to pointillism," wrote Jules Antoine for *Art et Critique*.[29]

The catalogue for the exhibition must have met Monet's expectations. Running ninety pages long, it was the largest publication that had ever accompanied a show of his work (and, in terms of length, would not be surpassed in his lifetime). His hopes for the exhibition were amply fulfilled, though not

immediately, as he complained for weeks about the installation, the lighting, and the timing of the opening.[30]

Despite the amount of newspaper coverage that the Universal Exposition commanded, Monet's show received a considerable amount of attention. It also brought many raves. "In this superb exhibition," wrote Octave Maus in *L'Art moderne*, "there is not a lapse nor a hesitation. . . . Nature has never been rendered with more intensity and truth." Charles Frémine of *Le Rappel* went even further, declaring it was "an exaltation of colors which range bravely above the natural scale."[31]

A critical success, the exhibition naturally attracted many interested buyers, a large number of whom were Americans. In fact, from this time onward, Americans would be among Monet's most ardent admirers. That very September, for example, Pissarro could report to his son that Theo Van Gogh had sold one of Monet's paintings to an American for the astonishing sum of 9,000 francs. Over the next few years, Mrs. Potter Palmer, the great Chicago collector, and James Sutton, the New York dealer, would purchase dozens of Monet's paintings, earning him huge sums of money. Monet's prior objections to Durand-Ruel's commercial interest in the "land of the Yankees" were not voiced again.[32]

One of the paintings that Mrs. Palmer bought was a view of the Creuse (plate 11). The painting that Theo Van Gogh sold for such a staggering sum was also apparently one from this campaign. In fact, of the fifteen Creuse pictures that can be traced between 1889 and Monet's death, nine were bought by dealers or private collectors by 1892.[33] The success of the group is somewhat surprising, given their challenging qualities and the very modest esteem in which 20th-century critics and collectors have held them. However, Monet clearly valued them and undoubtedly communicated his regard for them to prospective clients. In addition, critics who visited the Monet-Rodin show singled them out for praise. Paul Focher, for example, writing in *Gil Blas*, found them to possess "an incomparable majesty," while Octave Maus felt that "of Monet's entire oeuvre, it is perhaps these that reveal the most extraordinary mastery."[34] Like Maus, nearly every critic who mentioned these "tragic landscapes" was struck by the range of natural effects that Monet had been able to capture and was impressed with the ruggedness of the motifs that he had chosen to paint – "the narrow valleys filled with shadows, the ravines cut by a torrent, blocks of rock in tormented forms."

Monet contemplated returning to the Creuse after the show closed, but the trip never materialized, nor did he make any other major excursion for quite some time.[35] His abstention was due to several factors. First, the Creuse campaign had been the most frustrating and physically taxing of his entire career, an experience he most likely did not want to repeat right away. He was simply getting too old for the toll that it had exacted, especially on his health.[36] Second, as we shall see, he became completely absorbed in his series paintings in the first half of the 1890s and did not want to leave Giverny. Third, and more immediate, was the subscription that Monet initiated to purchase Manet's *Olympia* from the artist's widow and donate it to the State (fig. 25). So engrossed in this task did Monet become that he not only abandoned his travels, but also stopped painting for almost a year.

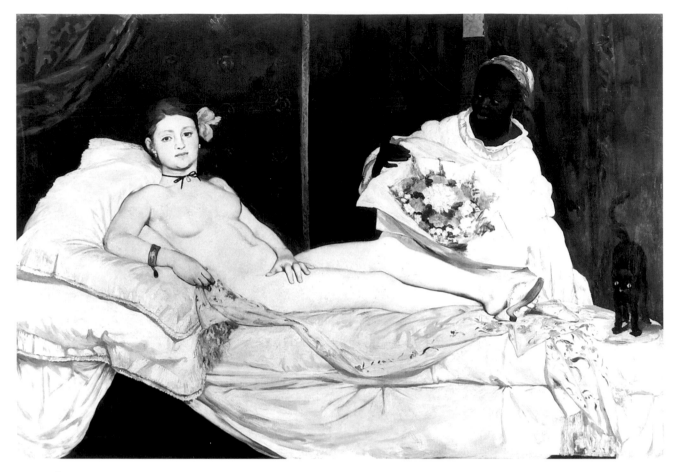

Fig. 25. Édouard Manet, *Olympia*, 1863. Musée d'Orsay, Paris.

Monet had gone through similar periods of inactivity prior to this, but none of them had lasted nearly as long. He was able to take this unprecedented break because he had earned a lot of money in previous years (25,000 francs in 1886; 44,000 in 1887; and 28,000 in 1888) and thus could afford not to work for a while. But instead of remaining idle, he applied himself to raising this subscription with the same kind of singleminded commitment that he demonstrated when painting.

Monet's obsession derived in part from his honest feelings for Manet's widow, who apparently needed money.[37] This project represented something much larger and more important than empathy, however. First, it meant saving a major work from going to a foreign country, as it had been rumored that an American was going to buy the picture. This was a topical matter, as James Sutton, representing the American Art Association at the Secrétan sale in June 1889, had just purchased Millet's *Angelus*, to the immense regret of the French public. Ironically, the sale had been held in Petit's gallery just prior to Monet's show there with Rodin. Although he never mentioned this "national loss" – as the newspapers described the departure of Millet's icon of French rural life – Monet clearly was not going to let the same fate befall Manet's *Olympia*.

Monet was not simply being patriotic. He saw the political advantages of the occasion as well. By offering this once-controversial canvas to the State free of charge, he was, in effect, forcing the State to endorse an avant-garde tradition that it had fervently opposed and obliging it to enthrone a particular brand of modernism to which Monet was the heir. It was a brilliant strategy with even bigger stakes

than his retrospective with Rodin or his campaign in the Creuse. It is not surprising, therefore, that Monet substituted his pen for his palette and did not return to Fresselines.

Monet must have begun writing letters to prospective contributors some time in late June or early July, for by July 16, 1889, he had already received word back from at least one faithful participant, his old patron Dr. de Bellio, who pledged 1,000 francs to the cause. By early October, Monet's efforts had resulted in commitments of over 15,000 francs; by November the sum had climbed to 18,000.[38] Monet wrote to anyone who he thought might support the subscription, even individuals that he did not know very well, although he admitted to Berthe Morisot that the task was not easy given the government's apparent opposition.[39] It took until February of the following year, however, to reach 19,415 francs, at which time Monet decided to write the Minister of Public Instruction, Armand Fallières, and officially offer the State the painting:

Paris, 7 February 1890

Monsieur the Minister

In the name of the group of subscribers below, I have the honor of offering to the State the *Olympia* by Édouard Manet.

We come to you as representatives of and spokespersons for a large number of artists, writers, and art lovers who have recognized for a long time now how considerable a place the painter, prematurely taken from his art and his country, should occupy in the history of this century. The discussions that swirled around Manet's paintings, the hostilities that they provoked, have now subsided. The struggle will still go on against those people who are less convinced than we of the importance of Manet's oeuvre and his definitive triumph. However, we only need recall once-decried and repressed figures, such as Delacroix, Corot, Courbet, Millet, to cite only a few names, who suffered anonymity at the beginning of their careers only to enjoy incontestable posthumous glory, figures who today are celebrities.

But the vast majority of those people who concern themselves with French painting believe that Édouard Manet's role was effective and decisive. Not only did he play a large part individually; he was the representative of a great and rich evolution as well.

It therefore seems to us impossible that such a work [as the *Olympia*] should not have its place in our national collections, that the master is not represented where his disciples already reside. In addition, we have been concerned about the incessant movement of the market, the extraordinary purchases of works from us by Americans, the easily predicted departure for another continent of so many works of art that are the joy and the glory of *la France*. We have wanted to retain one of Édouard Manet's most characteristic canvases, one in which he appeared victorious in the fight, master of his vision and of his craft.

It is the *Olympia* that we put back in your hands, Monsieur Minister. Our desire is to see it take its place in the Louvre, in its time, among the productions of the French school. If regulations bar its immediate entry, if it is objected, despite the precedent of Courbet, that a period of ten years has not elapsed since Manet's death, we believe that the Musée Luxembourg is perfectly appropriate to receive the *Olympia* and to have it until the appointed hour. We hope that you would like to give your approval to the work with which we are associated, with the satisfaction of having accomplished simply an act of justice.[40]

This was an astute appeal. Note, for example, how Monet claims that the subscribers were simply representing a much larger segment of the informed public (a segment that suddenly becomes the majority several lines later), how they have known about Manet's importance for a long time, and how tragic Manet's premature death was, a loss to his country as well as to his art (thus prevailing on national pride). Some people might still disagree with the subscribers' opinion, but the squabbling of the past was well behind them. In addition, that opinion was based on the group's involvement with contemporary art, its knowledge of history, and what happened to so many once-neglected though now-famous artists. That Monet ends his list of such heroes with Millet is also significant, for the loss of the *Angelus* was still keenly felt. He plays upon that loss, by implication, when he refers to the market and the insatiable appetite Americans had for French art, and invokes nationalistic fears about the inevitable erosion of France's patrimony to underscore his point. Having claimed earlier that Manet's disciples were already represented in the nation's collection, though careful not to cite anyone in particular, Monet tells the minister he knows that the State could make an exception to the ten-year regulation since it had already done so for Courbet (another indication of his knowledge of the rules of the game). Finally, Monet uses the verb *remettre* when he says he is placing the painting in Fallières's hands, implying that it had been there before. Supporting their offer was therefore not just a simple act of justice, as Monet says. It was really a vindication of the past, a confirmation of the subscribers' position, and a contribution to the country's legacy to the future.

Although it was a sophisticated letter, Monet knew that it did not mean the end of his nearly nine-month-old project. "They have their little regulations all ready which allow them to refuse the offer without even discussing the work," he told his friend Félix Bracquemond. But, he added, "the important thing is that this be accomplished, that this magnificent painting remain here in France."[41] To Monet's great dismay, however, it took five more months to reach a final agreement and nearly twelve weeks on top of that for documents to be sent from Monet's lawyer to the Minister's Director of Fine Arts, an event that occurred on August 27, 1889. Monet was responsible for the last delay; he had finally returned to his work and had put everything else aside. Prior to that, however, he had applied the political acumen that his letter to Fallières revealed he possessed in abundance.

The most pressing issue in the negotiations was Monet's continuing demand that the State accept the painting *sans engagement*. That meant that it would promise to keep the painting in Paris even if it took it for the Musée Luxembourg and not for the Louvre. Monet was tenacious on this point. Although Fallières acceded to Monet's demands in a personal letter to the artist, Monet insisted to the Director of Fine Arts that he make it a provision in the contract. When the first letter of agreement arrived without this stipulation, Monet sent it back, and when he received no reply to subsequent letters to the director on the point, he wrote again.[42] Monet persevered because he knew what was involved. The government could easily accept the picture on behalf of the State, claiming it would go to the Luxembourg, and then send it out to the provinces where it would inevitably be forgotten. Monet wanted to make sure that it

stayed in Paris so that it would attract attention and eventually join the masterpieces of France's patrimony in the Louvre.

While Monet's maneuverings attest to his political skills and to his willingness to play the game, his concern for Manet's position in the history of French art reveals his sense of how that history should be written. Manet was not merely part of a tradition but the representative of "a great and rich evolution" which, for the 19th century at least, would appear to mean the path first cut by Delacroix and followed by the other artists that Monet listed. That lineage was obviously more important to Monet than any other, not only because it represented the best artists of the century and the most innovative work, but also because he was clearly a part of it. Less definitive but perhaps even more intriguing is the assertion that Manet's "considerable place" was going to be in the "history of this century." Monet does not say the "history of the art" of this century. Surely this was not an oversight; the letter was written with too much care. Instead, Monet was implying that Manet and his work were a part of the larger realm of people and events that comprised the tale of 19th-century France.

The press at the time understood this all too well. For after Monet's letter was published in *Le Figaro* the day after he sent it to Fallières (an indication again of Monet's forceful tactics), what erupted in the Paris papers was nothing less than verbal and visual warfare. Of the many articles, editorials, and caricatures that were published on the topic – and there were many – two perhaps best characterize the reaction of those who opposed the donation. The first appeared in *La Liberté*, a voice of the Right.:

> Can one think that the memory of Manet will remain unscathed by the criticisms that such a canvas suggests? Such modesty would require an extremely limited understanding of the French character. Moreover, it is not only the French who visit our great national museum, now the repository of universal art. . . . every day, crowds of visitors stream through the galleries of this palace where the annals of our past are on display and where everyone can still sense the most radiant figures of the monarchy. . . . What will foreigners, who are no less refined than us, think when among the masterpieces, amidst these magnificent treasures, they find this bizarre Olympia and her horrible escort screaming such discordant notes? What will these people say, these refined visitors from all countries, these Latins . . . and Athenians . . . when looking at this creature advertising vice and [representing] the most incomplete art in the Louvre of François I and Henri II?[43]

The revulsion that this critic clearly felt was matched by the acerbic wit wielded by a caricaturist in his full-page illustration for *La Vie Parisienne* (fig. 26). With her arm around Antonin Proust, followed by her maidservant carrying sheets and a bed slat, the forlorn, berouged (though now discreetly draped) Olympia steps from the Apollo courtyard of the Louvre into a boudoir of robust Venuses and bathers who fill the arcade leading to the museum's main entrance on the right. Concern strikes many of these ladies of painting and sculpture – Gérard's, Correggio's, and Ingres's on the left; Milo's, Frago's, and Santerre's next; Houdon's and Rembrandt's, Goujon's and Rubens's, with another one of Ingres's rounding out the scene on the right together with an Egyptian Sun goddess of the XVIII dynasty. Over them stand the celebrated Swiss guard who, the caption tells us, have been brought back for the first and last

Fig. 26. Anon., "La Belle Olympia au Louvre." *La Vie Parisienne*,
22 February 1890.

Fig. 27. Ferdinand Dutert, Gallery of Machines, Paris, 1889.
From *Revue de l'Exposition universelle* de 1889, vol.1, Paris,
1889, 221.

Fig. 28. Sir Joseph Paxton, The Crystal Palace, Sydenham,
England, 1851. From *The Industry of all Nations*, London,
1851, xvii.

time since the battle of Brunoy. It is unclear whether they are there to preside over the induction of the cat-carrying Olympia or to prevent her from entering. There is some question also whether they would permit her beau with the bouquet or the pipe-puffing beer drinker behind them to enter as well, both of whom mock two other paintings by Manet, the *Portrait of Antonin Proust*, 1879 (now in the Toledo Museum of Art) and the *Bon-Bock*, 1873 (in the Philadelphia Museum of Art).[44] Regardless of the guards' mandate, the not-so-fair and not-so-ladylike Olympia (as the sketch of the painting in the upper left makes even more evident) was not a welcome addition to this world of ideal beauty, a world for which the Louvre and *la France* ultimately stood.

Although the donation of the painting undoubtedly would have provoked controversy at any time after Manet painted it in 1863, it touched particularly sensitive nerves when Monet made the bequest a fact in early 1890. The critic for *Le Monde* suggested why this was the case when he expressed his disbelief at who had joined the subscription. "I regret to find among the contributors," he lamented, "the names of such artists as Flameng, Gervex, Lhermitte, Lerolle, Ribot, and Puvis de Chavannes. Some parallel manifestations prove that it is not only literature but also art that is sick."[45] He did not specify what manifestations he had in mind, but the conclusion he drew was not his alone; it was widely shared at the time. In part, it grew out of France's longstanding concern about the health of her artists. Critics in the 1860s had anxiously asked, who would replace Delacroix and Ingres. For years after that they wondered, who would help them maintain their position. And what kind of art were they going to produce? From the Franco-Prussian war onward, writers could sing the praises of dozens of French painters, such as Meissonier, de Neuville, and Gérôme, but beneath their rhetoric and their claims of greatness were these haunting questions that simply could not be answered with any kind of certainty. There were only two things on which people appeared to agree – that France had had a glorious past and that she would have a similarly distinguished future. Getting from one to the other was a frustrating challenge but one that the country could certainly meet.

That confidence had been amply expressed – and the glory equally evident – at the Universal Exposition of 1889, which opened at the same time that Monet began his subscription. There were hundreds of scientific, military, and industrial exhibits, attesting to France's ingenuity in every field of human endeavor. All of these exhibits were housed in a huge glass-and-steel structure, appropriately called the Gallery of Machines (fig. 27).[46] Rising 145 feet above the Champ-de-Mars extending 1,387 feet in length, and spanning 375 unimpeded feet in width, the building was almost twice the size of Saint Pancras Station in London, which had been the largest building until that time. In its size, function, and materials, the Gallery of Machines was the country's answer to another English achievement – the Crystal Palace, which had displayed similar products for the first Universal Exposition held in London in 1851 (fig. 28).

The Gallery of Machines was connected to the Palace of Fine Arts, indicating France's alliance of these two traditionally opposing fields. A huge building itself, 690 feet long by 240 feet wide, the Palace was filled floor to ceiling with paintings, sculpture, drawings, prints, architectural designs, and photo-

Fig. 29. Gustave Eiffel, The Eiffel Tower, Paris, 1889.

graphs. France's section consisted of two distinct shows, one covering French art of the previous 100 years, the other of work done between 1878 and 1889. The former, known as the Centennale, contained 652 paintings and 140 pieces of sculpture, including David's *Le Sacré*, Delacroix's *Death of Sardanapalus,* and Courbet's *Burial at Ornans*, and was clearly intended to reaffirm the grandeur that was France's heritage since the Revolution. The second exhibition was even bigger – 1,448 paintings and 561 pieces of sculpture – and was an obvious effort to celebrate the vitality of the arts in Republican-ruled France.[47]

The crowning glory of the exposition, however, was the Eiffel Tower (fig. 29). Although despised by many outspoken figures – Maupassant called it "an unavoidable and tormenting nightmare" – the tower was intended to stand as the symbol of France's triumph over time, space, and materials, and to represent the Republicans' steadfast commitment to liberty and progress. Sweeping 984 feet up into the Paris air from its reddish-brown base, this unprecedented, non-functional structure was so dazzling an engineering feat that peasants and heads of state alike crammed into its elevators for a view of the capital from the spire's golden-yellow top.

Despite the wizardry of the tower, the wealth of art and machines, and the impressive attestations to the country's aspirations and achievements, keen observers realized that the exposition was just a façade, as dazzling as the multiple colors of Eiffel's brilliantly painted structure but just as perforated as that monument's intricate, lacy ironwork. For the country was in the process of being surpassed in almost every field of production by England, Germany, and – shockingly to many – the United States. In a few years it would officially fall from being the second-largest industrial power in the world, which it claimed in 1885, to being the fourth.[48] Signs of this dramatic shift in status were evident even in 1889, as exports continued to decline following the ever-falling price of France's staple wheat crop. By the end of the decade, the nation was still unable to produce enough fossil fuel to meet her needs, forcing her to be the only developed country actually to import necessary items such as coal. By 1889, France had also fallen far behind her European rivals in terms of population. And while rightfully claiming an extraord-

inary cultural heritage, she could no longer assert her former strength in the arts without substantially stretching the truth. In this case, even casual observers knew it just wasn't so, as Gustave de Violaine confirmed in an article that appeared in the *Moniteur Universelle* three months before the exposition opened:

> After the exhibitions of the previous month, we can already envision what the Salon will give us this year; we can tell that our painting will not be any more advanced. And the foreigners who will come to admire our works of art at the Universal Exposition will also say that since Ingres and Delacroix, our painting has been in decline. Certainly, they will recognize the superiority of our sculpture; they will see that certain of our landscape painters are dignified heirs to the traditions of Corot and Théodore Rousseau. But for the rest, with only a few exceptions, they will find that our painters can be divided into two categories. The ones who, under the pretext of possessing a marvelous savoir-faire, don't attempt to prove to us that they have ideas or sentiments and the others who try and don't succeed.[49]

Ironically, the centennial exhibition of French painting contained three works by Monet. While a tribute to his efforts and another mark of his increased stature, Monet's presence was primarily the result of Roger Marx, the principal organizer of the show, who had taken a liking to Monet's work several years earlier and had written favorably about it. His inclusion was also undoubtedly aided by the presence of Georges Petit on the selection committee. Not unexpectedly, however, that committee chose three rather staid canvases: *Vétheuil* (W.539) the *Tuileries* (W.401) and the *Church at Vernon* (W.843). Even more ironic than Monet's presence was that of the *Olympia*. It too figured in the centennial show, to the surprise of many visitors. Having it in that exhibition, however, was one thing; accepting it as a permanent part of the Louvre's collection forever was another entirely. In François I's former palace, it would only reaffirm de Violaine's commonly held opinion about the decline of French painting – and that was to be prevented at all cost.

Despite the barrage of negative criticism, the government's hesitancy, and even Monet's doubts about the possible outcome of the donation, the *Olympia* did enter the Musée Luxembourg, where it hung *sans engagement* until 1907 when it was finally transferred to the Louvre. For Monet, it had been a war worth waging. He had provided for Manet's widow in a fitting and honorable fashion, while establishing a stronger market for her late husband's work. He had vindicated Manet himself and the tradition of avant-garde painting in France and had gained one of its protean figures his rightful place in the annals of 19th-century French art and history. He had also gained a toehold in those hierarchies for himself. And when he returned to his own work, to his *Grainstack* paintings in particular, he knew that his art could also become part of the nation's patrimony, and that like Manet he could be recognized as one of France's great artists. His successful defense of Impressionism against Neo-Impressionism and the State had been ample proof of that, as had his recent exhibitions in the capital. Unlike Manet, however, he would gain his due primarily by painting the French countryside, a subject that resonated with meaning for his countrymen in the 1890s.

64 Plate 14. (cat. 14) *Oat Fields. (Giverny.)*, 1890. Private Collection

4 Of Hay and Oats and Stacks of Grain: Monet's Paintings of Agrarian France in 1890-91

IN 1891, the year in which Monet exhibited his *Grainstack* series, good French parents could have purchased two cutouts for their children that the country's most renowned publisher of popular imagery had just introduced (figs. 30 and 31). The first one showed a carbine-carrying Prussian soldier who had been mockingly transformed into a beer-drinking jumping-jack complete with corkscrew and bottle. The second depicted Jeanne d'Arc and her house in rural Domrémy surrounded by farm animals, country folk, and a celestial pair of flag-bearing guardians.

As innocent as these two prints might have been, they reveal a great deal about France in the early 1890s, for though aimed at the juvenile market, both spoke with considerable clarity about adult issues. The Prussian, for example, is a poignant reminder of the extent to which Germany was a presence in French culture; "the enemy" had actually penetrated the playrooms of the nation. The little fellow, of course, was supposed to be funny with his head too big, his helmet too large, and his mustache seemingly as long as his gun. Everyone, however, knew that this was pure caricature, and that Prussian militarism was no laughing matter, for in their last confrontation, France had been unable to withstand Prussia's disciplined corps of goose-stepping soldiers. That she could now transform one of them into a little child's plaything was merely a way for the country to assert her superiority over her conqueror, and to inspire confidence in even her youngest citizens that she could withstand all challenges from her aggressive eastern neighbor. Such confidence was necessary, as those challenges arose constantly.

The print of Jeanne d'Arc and her farmhouse underscores the importance of national heroes to France at the end of the 19th century, particularly a hero who came from humble rural beginnings and who set an example for posterity by her patriotism and self-sacrifice during a time of war. The maid of Orléans was actually as much a part of the era's consciousness as the omnipresent threat of Germany, a fact borne out by the numerous statues of her commissioned or inaugurated in France throughout the 1890s. Indeed, so passionate was her cult that a former member of the Chamber of Deputies in 1894 began a movement to consecrate Mont Saint-Michel to her, while the diocese of Orléans that same year submitted papers to the Vatican to have her beatified (sainthood was conferred on her after World War I).[1] To such believers, she was the embodiment of the nation – hero, patriot, liberator, protector, martyr, a woman who could also perhaps awaken the spirit of the country in the 1890s, just as she had done four centuries earlier.

Most of the monuments to Jeanne d'Arc were erected in provincial locations where battles had been

Fig. 30. Anon., *A Great Captain*, 1891. Cabinet des estampes, Bibliothèque Nationale, Paris.

Fig. 31. Anon., *Jeanne d'Arc's House at Domremy*, ca. 1891. Cabinet des estampes, Bibliothèque Nationale, Paris.

Fig. 32. Anon., *The Triumph of the Third Estate*, ca. 1790s. Collection Flinck. Cabinet des estampes, Bibliothèque Nationale, Paris.

Fig. 33. Anon., *The National Budget*, 1882. Cabinet des estampes, Bibliothèque Nationale, Paris.

Fig. 34. World War I poster. Center for European Studies, Harvard University.

fought in the Hundred Years' War or in 1870. She was the perfect choice for such memorials. For in addition to her valor, she came from the countryside, as the cutout made clear. She therefore stood for all of the goodness and character credited to rural areas. As a symbol, she complemented an equally important contemporaneous belief – that the fields and farmlands of rural France represented the strength of the nation.[2]

This belief was by no means exclusive to the late 19th century; it was virtually as old as France itself. It had been most ardently proclaimed, however, in the late 18th century, first by the *philosophes*, particularly Jean-Jacques Rousseau, and then by innumerable anonymous artists who produced hundreds of prints such as (fig. 32), which hailed the value of country life and the contributions of the common man. In the 19th century, Balzac could find little in that life to recommend in his popular novel *Countryfolk* (1846), a perception that Zola took to an extreme forty years later when he portrayed the occupants of the land in his novel *The Earth* as ignorant, flatulating, fornicating boors who lived in the worst conditions imaginable. However, despite these negative views, there was a widely shared credo in 19th-century France, promoted primarily by the writings of Hippolyte Taine, that the true source of the country's strength and appeal lay in its location on the continent, its rich land, and its benevolent climate. Thus, in the early 1880s popular image-makers could produce a print such as (fig. 33), which, though a lesson about the national budget, began with a harvest scene. The countryside in France came first. Poster-makers during World War I expressed the same sentiments, as they often depicted the bounty of the nation's agrarian fields (fig. 34); that was where France's confidence lay. As one 20th-century French geographer asserted, "The history of France is the history of its soil."[3]

Unfortunately, these notions of the preeminence of the French landscape have to a large extent been lost to later histories of the art of the period, just as issues of nationalism and cultural competition have generally been overlooked. It is only through their recovery, however, that we can fully understand Monet's *Grainstack* series.

WHEN Monet wrote to the Director of Fine Arts in August 1890 to finalize the donation of Manet's *Olympia*, he told the official that he had let progress on the gift lapse for two reasons: He had not been feeling well, and then he had become completely absorbed in his own work.[4] From other letters that he wrote that summer, we can reconstruct what preoccupied him during those months before he concluded that important subscription and returned to painting.

His suffering, for example, can be linked to several developments, above all to rheumatic attacks that he experienced in July – "the cost," he told Geffroy, of "my time in the rain and snow."[5] The pain was apparently so severe that it made him concerned about having to "give up braving all weather and working outdoors. How stupid life is," he cried. He was also having difficulties with his art. "I am really depressed and profoundly disgusted with painting," he confessed in that same letter to Geffroy. "It is truly a continual torture! Don't hold your breath for anything new; the little I have been able to do is destroyed, scraped, or slashed."

As we have seen, such complaints were standard fare for Monet, although they were surely heightened in this case by the extended hiatus he had taken, as well as by his rheumatic condition. Not having painted a single canvas for almost a year prior to this letter, Monet was undoubtedly concerned about measuring up to his remarkable achievements of 1889 – to the prescient *Grainstack* and *Creuse Valley* pictures, the unparalleled success of his joint exhibition with Rodin, and the triumph of the *Olympia* subscription. They represented formidable accomplishments that had received recognition well beyond the borders of France. He was also distressed by the weather, as it rained constantly during the months of June and July, making it hardly conducive to *plein-air* painting, particularly for someone suffering from rheumatism. In addition, Monet's reactions had something to do with the kind of pictures he decided to paint when he finally took up his brushes again in mid-1890. Although some of the first canvases that he completed were rather delicate, unprovocative views of blossoming trees in the Giverny countryside (fig. 35), Monet could not resist challenging himself and attempting what he described as "things that are impossible to do: water with grasses undulating at the bottom."[6] He was most likely referring to *The Empty Boat* (fig. 36), an extraordinary painting in its size, composition, handling, and conception. However, its unresolved areas and undeveloped boat mark it as unfinished, the remnant of a vision that would not be fulfilled until the *Water Lily* pictures featuring the Japanese bridge that he would begin at the end of the decade, or more appropriately, the *Water Lily* paintings of five years after that.

Monet may have abandoned this painting either because his favorite models – his stepdaughters Blanche and Suzanne Hoschedé – became ill that summer and could not pose or because the underwater grass was raked away sometime later that summer.[7] Why he even attempted such a picture is as problematic as knowing why he let it go. When he wrote Geffroy about the project and referred to those impossible things he was painting, he used the verb *reprendre* (to take up again) ["j'ai reprisé encore"], implying that he may have begun *The Empty Boat* earlier, perhaps in 1887, at the same time that he was doing other boating scenes, and was returning to finish it in 1890. The way he rendered the underwater grass in long, independent strands of paint is quite similar to his handling of the same undergrowth in those previous pictures. If that were the case, Monet may have wanted to bring this huge canvas to a conclusion simply to salvage what had been an ambitious effort, a desire that the bad weather could have enhanced, as this painting surely would have to have been completed indoors. He also may have been interested in realizing even more emphatically the combination of dream and reality that Mirbeau had claimed in his essay for the 1889 show was one of the great characteristics of Monet's art. For more than *Five Figures in a Field* or his other boating pictures from 1887, *The Empty Boat* hovers between the world of the tangible and that of the imaginary, an effect achieved most of all by the precariously placed skiff and overhanging foliage and by the enormous amount of canvas devoted to nothing but those independent strands of paint. In any case, the picture remained in his studio unfinished until his death and Monet never attempted another such figure painting again. Instead, for most of the decade, with

Fig. 35. Claude Monet, *Giverny Spring*, 1890. [W.1243]. The Sterling and Francine Clark Art Institute, Williamstown, MA.

Fig. 36. Claude Monet, *The Empty Boat*, 1890. [W.1154.]. Musée Marmottan, Paris.

the exception of his views of Rouen Cathedral, Mount Kolsaas in Norway, and the Thames, Monet found everything he needed for his art and legacy in the offerings of rural France.

There is a certain logic to this: in addition to becoming more involved with rural subjects than ever before with his *Grainstacks* and *Creuse Valley* pictures of 1888 and '89, Monet was growing older (he would turn fifty in 1890) and probably felt the urge to stay closer to home. He also had amassed enough money to be able to live well and had generated a large enough following to ensure his future comfort. Moreover, his recent efforts, particularly the *Grainstacks*, might have heightened his interest in more refined effects and a more complicated painting style. But it certainly was no coincidence that his concentration on rural France, beginning with his views in 1890 of hay and oats and poppy fields, occurred at the same time that the country began to realize that it was no longer a true leader in the Western world. This realization took hold with some force after the Universal Exposition of 1889, for neither the 200 million francs the government invested in the show nor the more than 15,000 bottles of wine the mayors of France drained at a celebration dinner in the Palais de l'Industrie could make the exposition anything more than an expensive and dizzying last hurrah. Although the country earned short-term benefits from the increased number of visitors to Paris and the favorable opinions that the

Fig. 37. Bertall, *The Socialist Menace*, 1850. From Asa Briggs,
The Nineteenth Century, New York, 1970, 94-95.

Fig. 38. Pépin, "Socialism." *Le Grelot*, 23 October 1898.

show engendered in Frenchmen and foreigners alike, such temporal gains could not offset the fact that she was slipping from her former position of world power. Even the staged events of its imported colonial natives were for many "an indication of [France's] social depravity."[8] Thus, despite the rhetoric and the crowds and the panoply of past achievements that lay at the feet of Eiffel's amazing tower, the exposition was more of a denouement than a beginning, one that forced France to take stock of herself and determine what she could and should be as a nation. Not surprisingly, given the evident need to regroup, she redefined her goals along conservative lines.

Politically, this meant a readjustment of positions. Liberal Republicans who had waged the fight for radical reforms in labor, education, and Church-State relations, reforms initiated by Gambetta in the

1870s and carried into the following decade by Jules Ferry, began in 1889 talking in more tempered terms. Royalists who had lost their opportunity to oust the government with General Boulanger, and who therefore had become more skeptical about seeing the crown return to France, started to make conciliatory gestures to their long-time opponents. These and other efforts by politicians to repair the divisions that, since the war of 1870, had so plagued the nation, together with the efforts of the Church to rally Catholics to the state, developed in 1890 into the unique alignment between the Left and the Right known as the *ralliement*. This alignment was a loose association of strange political bedfellows – leftist anti-clerics, Opportunists, and the royalist Right. They were united for one reason: the regeneration of the Republic – the result, as one historian has observed, of "the new conditions."[9]

Those new conditions involved questions not only about the nation's status and goals but also about the increasing number of workers and their growing disenchantment with the existing order of things. The latter had been a pressing issue throughout Western Europe, as a cartoon of mid-century reveals (fig. 37). It shows the leaders of various European countries attempting to sweep the socialist beast that had incited the wave of revolutions in 1848 back into its French cave. By the last decades of the century, that predator had changed like an evil caterpillar into an even more menacing figure, clones of which were popping up all over the land (fig. 38). Although France had not experienced the same industrial growth as her neighbors, and thus had not suffered social problems of the magnitude of countries such as England and Germany, she had seen the establishment of anarchist groups within her borders in 1881 and the founding of the Socialist Workers Party there in 1882. After building a constituency, these radical factions and their offshoots made their presence felt in the country over the course of the next twenty years but never more so than from 1889 to 1894. During that brief period, nearly every major city or industrial area in France experienced some form of labor unrest. In 1893 alone there were at least 600 strikes involving more than 120,000 workers. Sabotage raids and bombings were carried out during those five years, engendering widespread fear, which culminated in the assassination of President Carnot in 1894, an event that shocked and outraged the country.[10] Unaccustomed to such violence and unsure of where or how it would occur next, the government, following its *ralliement* leaders, swung to the right and supported a wide variety of repressive laws. Even Liberal Republicans proposed many of the harshest measures, indicating the hold that conservative thinking had upon the culture. It was in the initial phase of this uneasy, reactionary climate that Monet's reputation as one of the leading painters in the country became more widely established.

MONET was to earn that reputation, initially at least, on the basis of his *Grainstack* pictures, which were likely begun in late August or early September 1890, when agrarian manuals of the time indicate local farmers would have begun cutting their fields and constructing their stacks. Just prior to this undertaking, probably sometime in late July, he started a series of pictures that depict the fields of hay, oats, and poppies around his Giverny house (plates 14-19). While reduced in visual incident and rather simplistic compositionally, they are rigorously painted, suggesting that Monet had become more con-

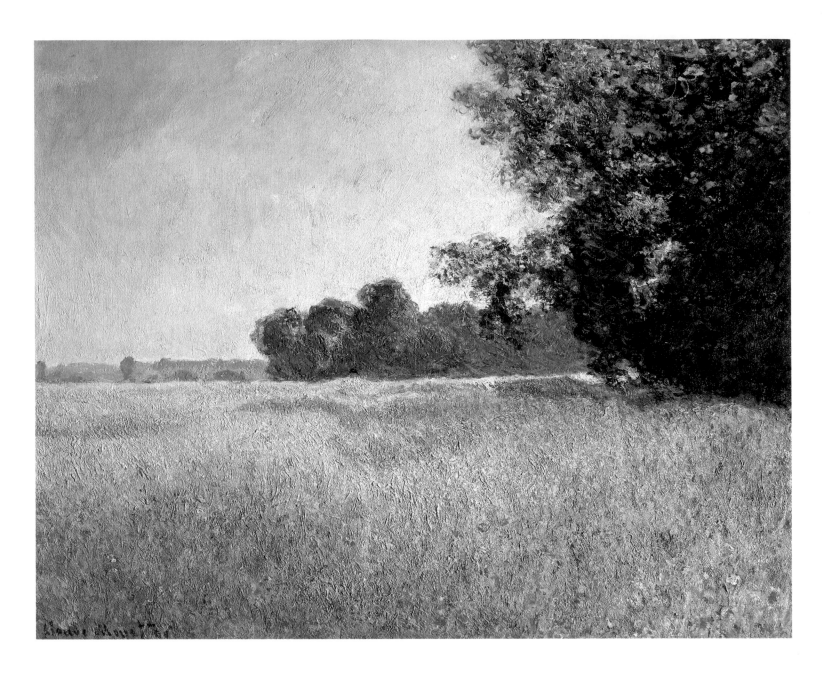

cerned not only with overall atmospheric effects, as he told Geffroy that summer, but also with emphasizing the decorative, tapestrylike qualities that painting can achieve. For above all, these canvases rely on their striking combination of artifice and observation, pattern and materiality, which harks back to the *Creuse Valley* canvases and most particularly to the *Grainstack* pictures of 1888-89.

Although Monet only did a few paintings in each group, he was pleased enough with his efforts to include four of them in his exhibition of *Grainstacks* the following May, a decision he did not take with any of the views of the Seine at Port-Villez also painted that summer.[11] Given the importance of the exhibition – it was the first he had had in two years – Monet clearly felt that these pictures could complement the *Grainstacks* and sustain the reputation he had established for himself.

The fact that these paintings depict rich and fertile fields is unusual. The fields surrounding Monet's property had frequently been the focus of his attention when he had worked in Giverny, but most often he had painted them either before any plantings had begun to grow or after any growth had been cut. And he usually had included members of his family, as if he needed to personalize the sites during his

Plate 15. (cat. 15) *Oat Fields. (Giverny.)*, 1890. Private Collection

early years in the farming community. That Monet would focus on much narrower agrarian subjects in 1890 is significant, for he painted those fields far less frequently during the 1880s – in fact, no more than a dozen times. When he did, he used compositional strategies that he would employ in 1890 as well. He also tended to paint views of haystacks at the same time, just as he would focus on grainstacks in the next decade. Thus, when Monet returned to these subjects in 1890, he was consciously reacquainting himself not only with Giverny's sheer beauty but also with its fundamental agrarian character.[12]

This is underscored by the fact that as soon as the grainstacks rose upon the landscape that summer, Monet put his field pictures aside, and did not return to them until late October when he completed some of those that Durand-Ruel had purchased early that month. (He did not finish four of the eleven that he had started until the following year and took until 1892 to terminate two more.[13]) In addition to being the culmination of the agrarian cycle that those field paintings represent, the raising of the stacks marked the end of a nearly two-year hiatus from his *Grainstack* pictures of 1888-89 and the occasion for him to return to where he had left off.

Plate 16. (cat. 13) *Oat Fields. (Giverny.)*, 1889. Musée d'Art Moderne de Strasbourg

ALTHOUGH the first specific reference to Monet's work on the new *Grainstack* series occurs in the letter that he wrote to Geffroy dated October 7, 1890, he clearly had begun the paintings at least a month or two earlier. In four letters written in the last week of August, Monet spoke about how preoccupied he was with his work.[14] September proved less productive. The maids quit, causing "a real derailment in the house." Then, Monet's eldest son Jean was hospitalized, forcing the artist to go to Le Havre several times. However between September 22, when Monet recounted these difficulties to Berthe Morisot, and the first week of October, when he wrote to Geffroy, things settled down, so much so that Monet began stalling on his commitment to finish some of Durand-Ruel's recently purchased oats and poppy paintings. "I am taking advantage of the beautiful weather," he told the dealer, two days after writing Geffroy.[15]

The weather remained beautiful for weeks, causing even greater delays in the delivery of the dealer's paintings. Durand-Ruel did not press the artist. He simply withheld final payment until December, when Monet claimed he needed the money. Even by then, however, not all of the field paintings had

Plate 17. (cat. 10) *Poppy Field. (Giverny.)*, 1890. Smith College Museum of Art, Northampton, Massachusetts

been finished. Nor had Monet begun the drawings that Durand-Ruel had requested for an upcoming issue of the dealer's new art journal, *L'Art dans les deux Mondes*. "I ask you to wait a little bit because of all that I am doing outdoors," he pleaded. "The weather is so beautiful that I want to take advantage of it as much as possible." December passed and the new year dawned and still neither the field pictures nor the drawings were forthcoming. On January 21, 1891, Monet asked the dealer to apologize for him to the magazine's editor, as he still had not produced the drawings. His excuse was the same: "I am in the thick of work [on the *Grainstacks*]. I have a huge number of things going and cannot be distracted for a minute, wanting above all to profit from these splendid winter effects."[16]

Never had Monet been so immersed in his work at Giverny and never had he seemed so pleased with what he was doing. Indeed, from the time that he wrote to Geffroy in October 1890 to early February 1891 when he invited Durand-Ruel to come and see the results of his labors (an indication that he had brought the *Grainstacks* to some kind of conclusion by that time), Monet did not utter one complaint about the challenges he had set for himself. This uncharacteristic attitude and unprecedented flurry of

Plate 18. (cat. 11) *Poppy Field. (Giverny.)*, 1890. The White Fund, Lawrence, Massachusetts

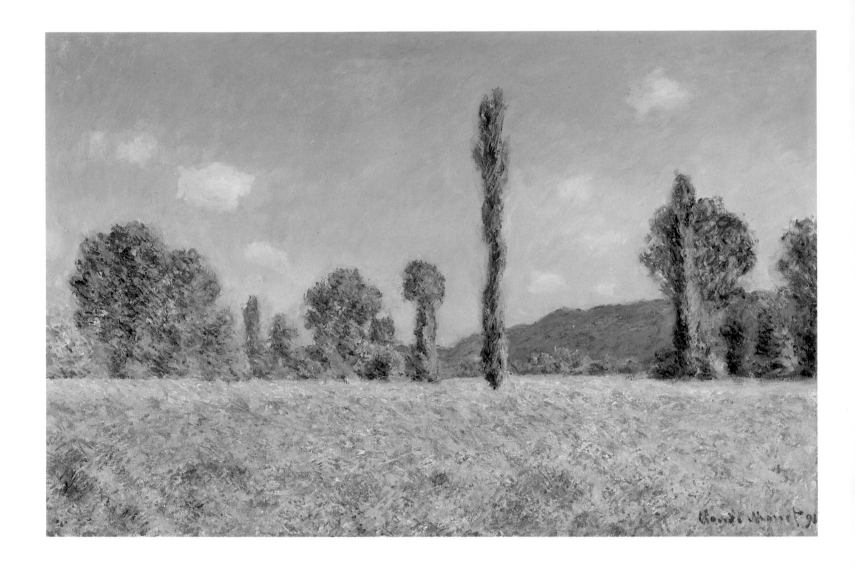

activity were due in part to the ideal painting conditions that Monet enjoyed that winter. Temperatures rarely went below 20° F., even in December and January, and never below 15°; and snow fell only enough to keep the ground covered with a crusty blanket of white.[17] He was therefore able to spend much longer periods of time outside and be assured that the light and air would remain relatively consistent. Of the twenty-five paintings that we know today are from this campaign of 1890-91, he set twelve in winter, a season in which he did not generally paint so much outdoors.

Monet's enthusiasm and productivity were also due to the fact that he had become a landowner for the first time in his life. His house had come up for sale in October and he had decided to purchase it. Having rented the property ever since he had come to the town in 1883, Monet was delighted to settle there permanently. "Leaving Giverny," he told Durand-Ruel at the time, "would worry me a great deal." He, therefore, met the asking price of 22,000 francs and signed the contract on November 17, 1890. "[I] would never find a parallel situation," he told his dealer when he was about to put his money

Plate 19. (cat. 12) *Poppy Field. (Giverny.)*, 1891. The Art Institute of Chicago

down, "nor so beautiful an area," sentiments that should be kept in mind when considering the *Grain-stacks* on which he was working at that very moment.[18]

When Durand-Ruel visited Monet's studio in February 1891, four or five months after the artist had begun that series, he would have seen the twenty-five canvases that we know of (and possibly more), plus two or three of the stack pictures from 1888-89 (plates 2, 5, 20-32, and fig. 17). They are not all the same dimensions – Monet clearly did not feel obliged to choose a particular-size canvas for a particular effect, season, or stack configuration. But all twenty-five, like those from 1888-89, have extremely simple compositions consisting of one or two stacks set on a field beyond which stretches an irregular line of trees and houses that are silhouetted against distant hills, with a strip of sky closing off the scenes at the top. The compositions are all strongly geometric – the fields, hills, and sky being reduced to parallel bands that in most cases extend across the entire canvas, with the fields occupying approximately half of the surface, and the hills and sky, a quarter each. When fifteen of these canvases were exhibited at Durand-Ruel's in Paris between May 4 and May 18, 1891, their impact was as forceful as their elemental motifs, and the show was an enormous success.

Accompanied by a catalogue in which Geffroy wrote a laudatory essay about Monet's latest efforts, that historic gathering of *Grainstacks* generated several misconceptions about the series that are worth examining in some detail, particularly as they have persisted almost unquestioned down to our own day. The first is the notion that these paintings chart the passage of the sun across the stacks with such specificity that they collectively form a kind of chronometer. Monet contributed to this idea himself when he told later biographers a story about a particular day when certain transitory effects were so striking that they compelled him to abandon one canvas after another in order to capture the passing of the light. The story generally involved his stepdaughter running back to the house to fetch the next canvas, a commute that the poor woman was obliged to make many times in the course of the day, because shortly after she had returned with the fresh one the effect was different. "Another!" Monet would cry, "another again!" In the account he gave the duc de Trévise, he deceptively told him "I worked on each only when I had my effect, that's all. It's not very difficult to understand."[19]

There is a more complicated version of the tale that Monet apparently told to François Thiébault-Sisson, the critic for *Le Temps*. Instead of starting with a particular day and a specific experience of natural conditions, the idea for the series was implanted in Monet's mind several years earlier, when Monet was painting a picture of the church at Vernon with the sun breaking through the mist. "I felt that it would not be trivial to study a single motif at different hours of the day and to note the effects of light that from one hour to the next modified so noticeably the appearance and the coloring of the building. At the time, I did not pursue the idea, but it germinated in my mind."[20] And when he saw the light changing so radically that day in 1890, he acted upon this long-held notion and produced the *Grain-stack* series.

All of these accounts are problematic, as they were published long afterward, some even after Monet's death. In addition, they all contain inaccuracies. For example, it was the church at Vétheuil that

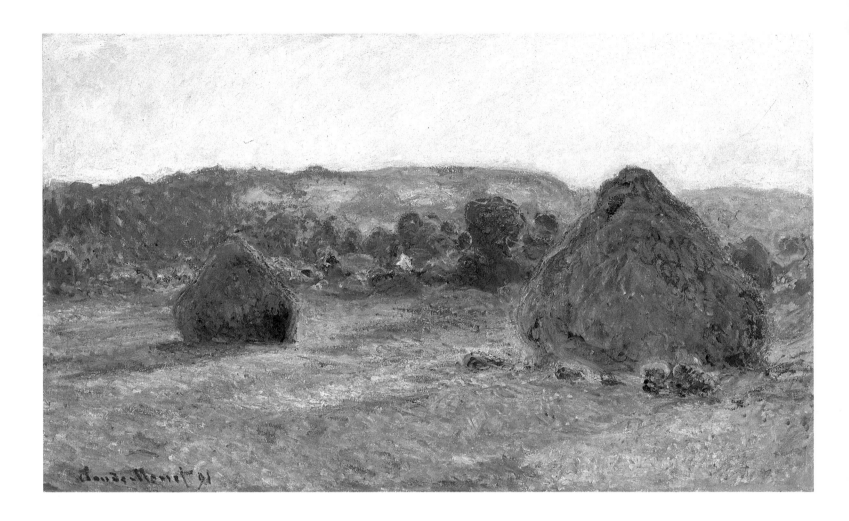

Monet painted with the sun coming through the mist, not the one at Vernon; and he painted the former far earlier than the latter. Moreover, none of the accounts can be accepted at face value, since they all came from Monet, and he so often manipulated the historical record. In this case, he clearly wanted to establish the fact that he was not a programmatic artist, that he operated on instinct rather than intellect, and that he simply applied those instincts to the dictates of nature. That he never referred in any of these accounts to his efforts at Belle Isle, Antibes, or the Creuse, and never mentioned the *Grainstack* pictures of 1888-89, does not mean that they should be discounted in favor of the Vétheuil view and the effects of a particular day. For the *Grainstacks* were not simply further attempts to paint sun coming through the mist; nor were they the result of a stillborn idea revived by the conditions of a single moment in time or of a desire to create a group of pictures that would function like a timepiece.[21] Monet was a more sophisticated artist than that.

Another misconception concerns the idea that Monet was absolutely faithful to what lay before him when he was painting this series. Believing in that fidelity can help to explain certain aspects of the

Plate 20. (cat. 17) *Grainstacks. (End of summer.),* 1890-91. The Art Institute of Chicago

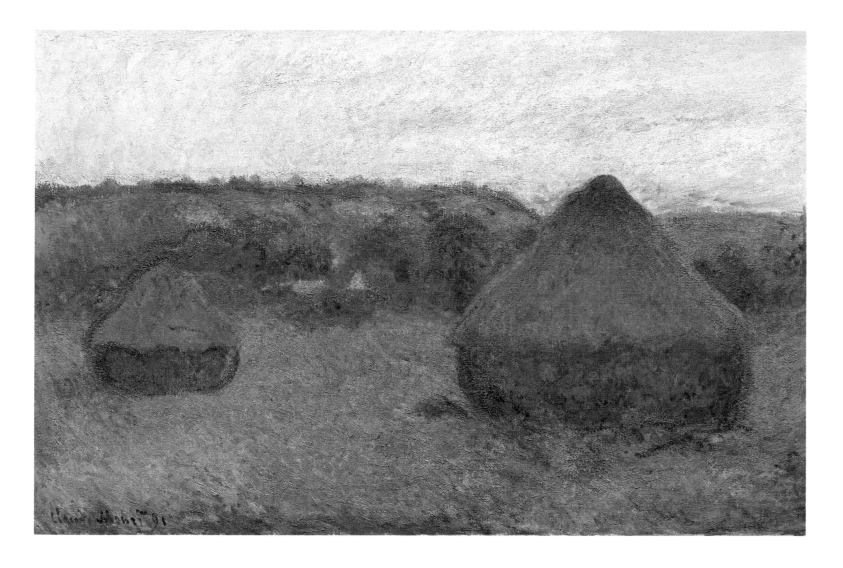

series — the shift in the light between various paintings, for example, or the different locations of the stacks, both of which are often due not only to the different times of day that Monet was capturing, but also to the vantage point that he assumed in each work. In order to paint plate 20, for example, Monet moved just slightly to the left and farther back from the stacks from where he had stood to paint plate 21. As a result, the peak of the larger stack in plate 20 is a bit further to the right of the notch in the background hills than the top of the larger stack in plate 21. The shift also creates the appearance of more space between the two stacks in plate 20, while causing the less defined conical section of the larger stack in that picture to sit well below the edge of the fields. In plate 21, the cone of the larger stack almost touches that edge.

There is a danger in placing too much trust in this kind of analysis, however. It is doubtful, for example, that Monet finished any of these paintings on the site. They all would have been "harmonized" in the calm of his studio.[22] In addition, he clearly made certain decisions in some pictures that contradict nature's laws. For example, the smaller stack in plate 21 should be higher in the field, espe-

Plate 21. (cat. 18) *Grainstacks. (End of day; autumn.),* 1890-91. The Art Institute of Chicago

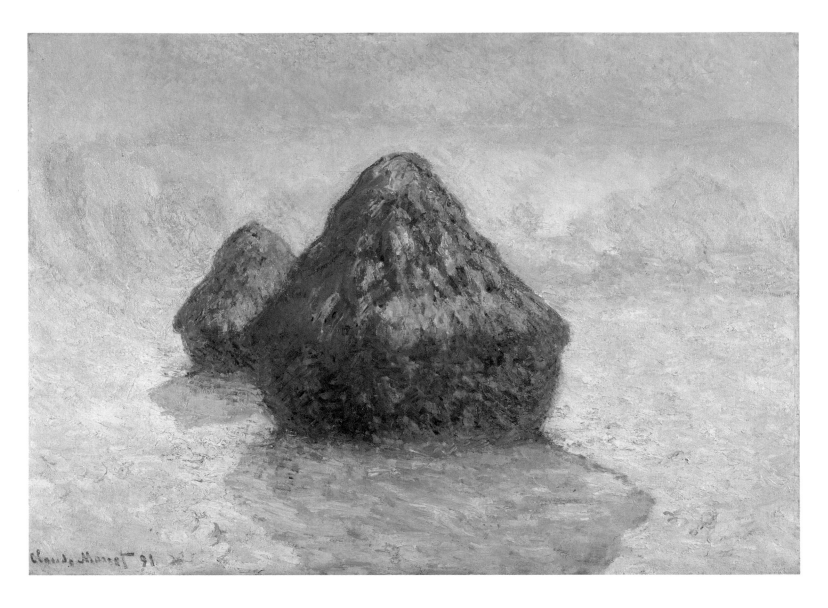

cially in comparison to its complement in plate 20. The shadows in plates 22 and 23 should run parallel rather than diverge, as they appear to do in these two scenes. In plate 23, both shadows should also have conical tops.

The pictures in this series provoke other questions as well. Could the light have ever made the stacks appear as pink as Monet painted them in plate 20? What do the oranges and reds describe in the stacks in plates 23 and 24 or the reds and greens in plate 30? Was there really as much green under the blanket of snow as Monet includes in plate 24? If so, why does it appear only around the stack? Finally, what kind of haze would so conveniently occupy the upper-left section of the sky in plate 26, assume the same diagonal orientation on its right as that of the larger stack, and end just above the apex of that form?

For the most part, the answers to these questions lie in the realm of aesthetics, for they have more to do with how Monet wanted his paintings to look than with the landscape in front of him, a fact that should remind us of his artfulness and his desire to have these pictures operate on levels beyond mere

Plate 22. (cat. 21) *Grainstacks. (Snow effect; sunlight.)*, 1890-91. National Galleries of Scotland, Edinburgh

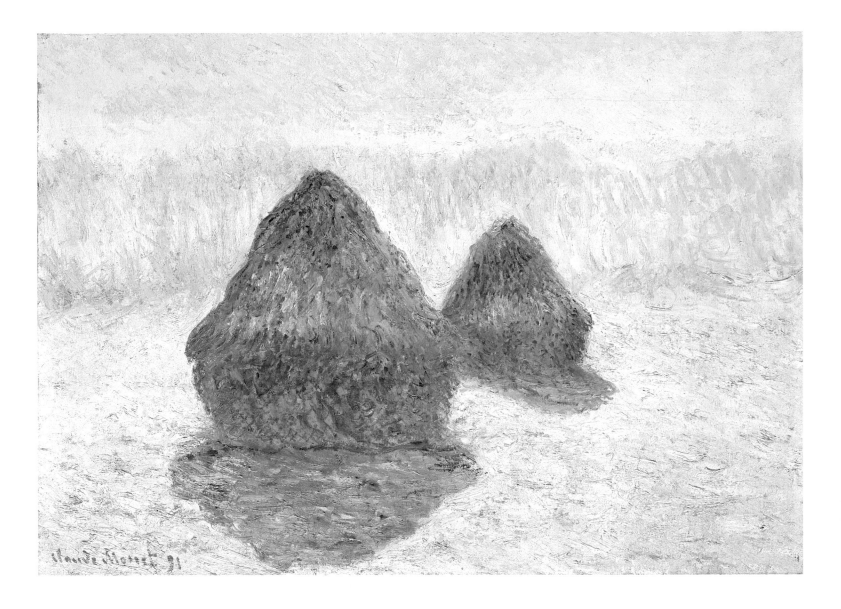

description. The series is replete with these aesthetic decisions. In the background of plate 25, for example, Monet positioned the larger stack so that it almost touched both of the larger buildings in the background. He also had the poplars in the distance march into the picture on the left, rise slightly, and then descend as they reach the apex of the smaller stack. Only occasionally in the series does Monet have the stacks nudge the horizon. When that occurs in plate 27, a single stroke of yellow light separates itself from the sky to rest on the apex of the cone. When it happens in plate 28, a similar although less pronounced poetic tryst takes place. In nearly all of the late summer and autumn views, the conical tops of those stacks break the horizon and push into the sky. In most of the winter scenes, they sit wrapped by the bands of hill and field as if bedded down for the season.

Certain decisions Monet made in this series are less evident to the eye, most notably *pentimenti*, of which there are many, for Monet often moved or altered stacks, as in plate 2, where he pushed the smaller stack to the left and enlarged the bigger one by nearly one-third its original size. He even changed effects that he had initially set down in certain pictures, as in plate 28, where he added a layer of

Plate 23. (cat. 23) *Grainstacks. (Winter.)*, 1890-91. The Metropolitan Museum of Art, New York

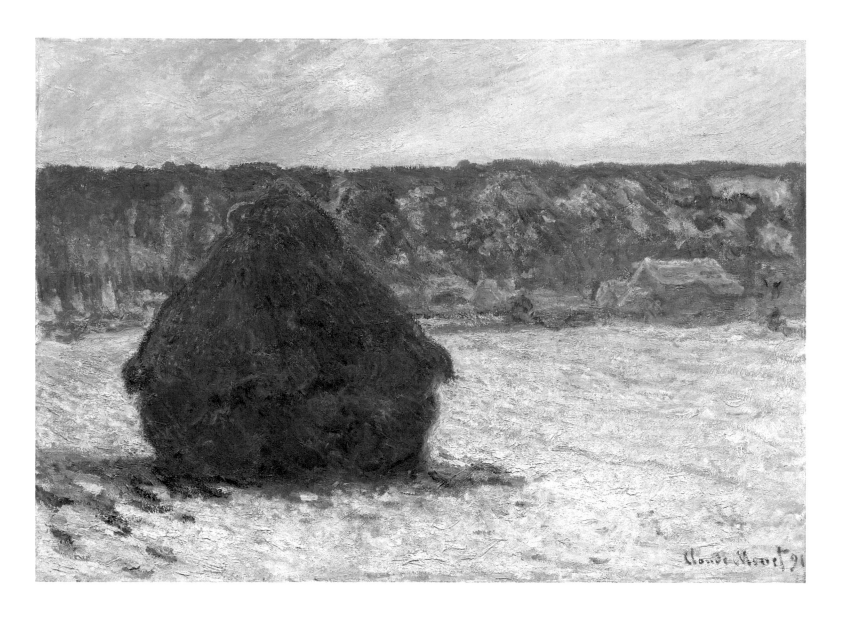

paint in the field to suggest hoarfrost over what originally appears to have been a lighter snow scene.

In moving from one canvas to another, one senses not only the many artful choices Monet made but also his deep engagement with the stacks themselves. They are never overwhelmed by the light or obscured by the atmosphere, and thus they never lose their identity as forms. Monet even goes so far as to outline them, often in bold colors, and to define their conical tops by rivulets of light that run down their undulating edges. Although inert, the stacks seem to be invested with great feeling, for when the morning sun appears, they turn their faces to greet it (plate 29; fig. 18); when it goes down in a brilliant display of warmth and power, they quiver at the sight (plates 5, 20, 31, and 32). They swelter in the midday heat of summer (plate 2), huddle together in the fading light of winter (plates 22, 23, and 26), and stand mournfully alone in the evenings, like solitary actors on a dimly lit, deserted stage (plates 24 and 30).

Rarely are they truly alone, however; in nearly all of the paintings, houses and barns appear in the background. And in every case, Monet is careful to establish relationships between them. For example,

Plate 24. (cat. 25) *Grainstack. (Snow effect; overcast day.)*, 1890-91. The Art Institute of Chicago

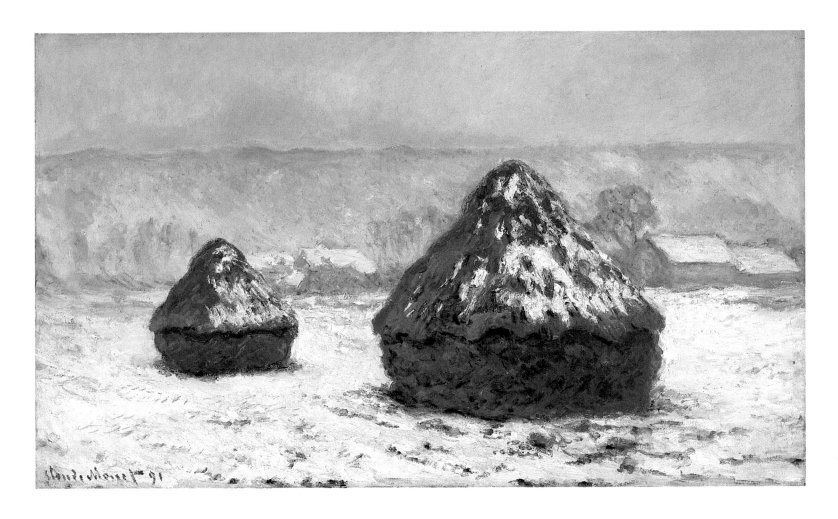

the slopes of the conical tops of the stacks and the ridges of distant roofs are always parallel. Usually the stacks touch the buildings; on occasion, they are linked to them by bands of trees. These structures also appear in the various drawings that Monet did in preparation for these paintings (figs. 39 and 40). There, the ties are even more apparent, as no atmospheric conditions disguise the fact that the line defining the stacks is the same that describes the houses, barns, trees, and hills.

If Monet did not intend us to find some significance in these connections, he would have eliminated them or only painted views like the two in which the structures do not appear. In reality, of course, there were a host of meaningful connections that existed between the stacks and the structures – the fact, as noted in Chapter 2, that the stacks were built by the people who inhabited the houses and were their most important product; that they represented the wealth of the town and its hope for the future; that they too were quite carefully raised structures and were even thatched like the roofs of the distant houses and barns. As the products of the fields that the occupants of those houses owned, the stacks were also the tangible evidence of the land's fertility and the care that its owners had taken over the

Plate 25. (cat. 20) *Grainstacks. (Snow effect; gray day.)*, 1890-91. Shelburne Museum, Shelburne, Vermont

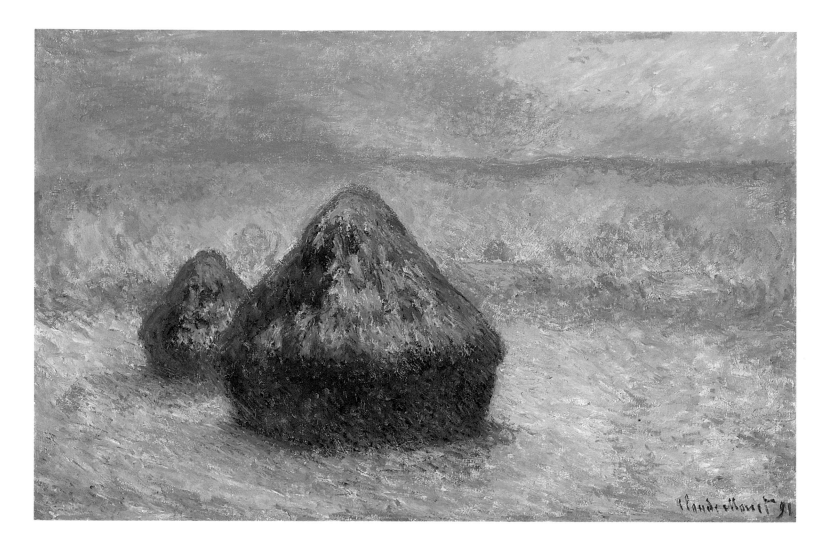

years to keep it productive. There is a kind of parity, therefore, between the stacks and the structures, something that Monet implies even in the way that he locates them on the canvas. In almost every picture in which the houses and barns appear, Monet places them in the same horizontal zone as the cones of the stacks, thus providing them with enough leverage visually to hold their own against the larger forms. When the stacks become enormous, as in plate 32, the structures meet them at the exact center of the canvas.[23] Monet was not as specific about the construction of the stacks in his paintings as, for instance, Auguste Herlin was about how farmers near Lille cut, bound, and moved their wheat to build their stacks which he described in painstaking detail in his *Threshing at Colza*, 1861 (fig. 41). But this does not mean that the stacks lacked significance for Monet or that he was concerned only with the light that surrounded them. He had never been interested in the kind of painting that Herlin represented, and had never chosen his motifs without weighing their import and investing in them personally.

Monet suggested his empathy with the stacks when he told the duc de Trévise that he had begun the paintings because he had been struck by the grainstacks as motifs and that they had "formed a magnifi-

Plate 26. (cat. 22) *Grainstacks. (Sunset; snow effect.)*, 1890-91. The Art Institute of Chicago Detail, plate 26 >

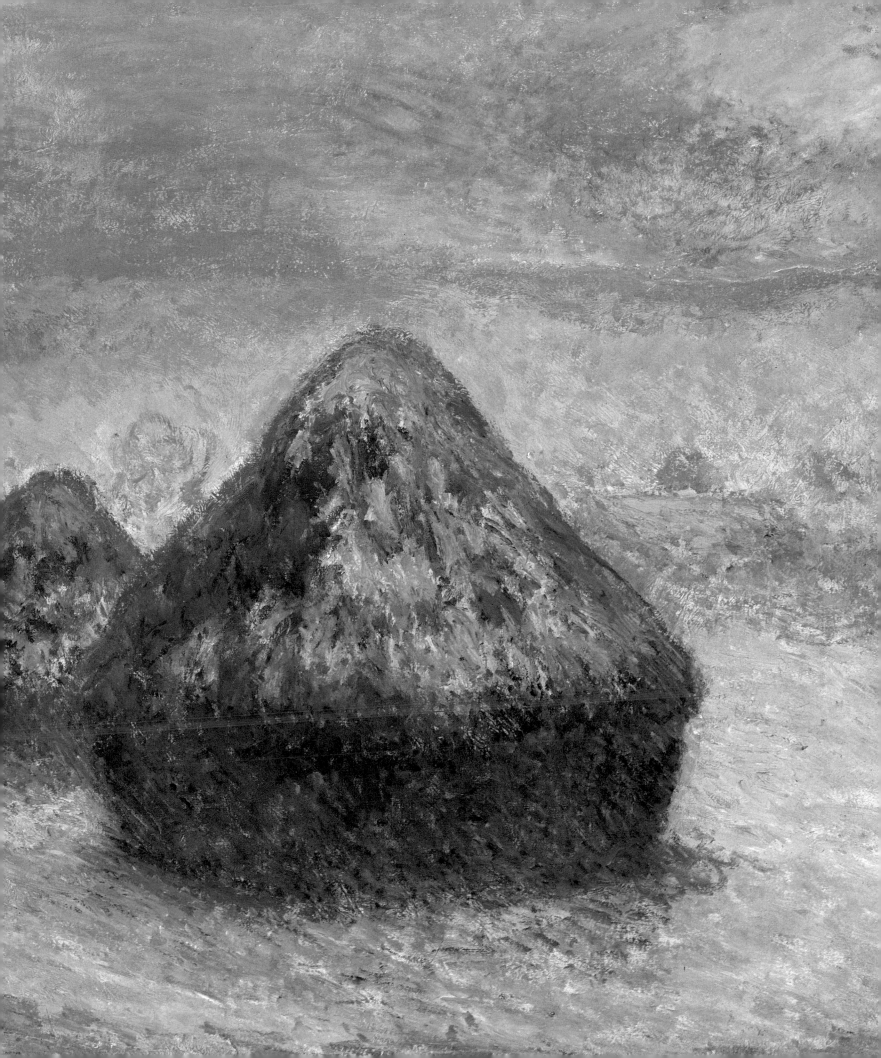

Fig. 39. Claude Monet, *Preparatory Sketch for Grainstacks*, [1890]. Musée Marmottan, Paris.

Fig. 40. Claude Monet, *Preparatory Sketch for Grainstacks*, [1890]. Musée Marmottan, Paris.

Fig. 41. Auguste Herlin, *Threshing at Colza on the Plains near Lille*, 1861. Musée des Beaux-Arts, Lille.

Fig. 42. Photograph of grainstacks behind Monet's house at Giverny, 1905. From Louis Vauxcelles, "An Afternoon with Claude Monet," *L'Art et les Artistes*, December 1905, 90.

cent group."[24] It is also worth remembering that the stacks were literally at his doorstep, as photographs of the area make clear (fig. 42). (Monet's house appears in the trees to the right of center.) In addition, when Monet was painting these monumental forms (which stood fifteen to twenty feet tall), he told Geffroy in that often-quoted letter that he was trying above all to render "ce que j'éprouve." The verb *éprouver* has no real equivalent in English; "to experience" or "to feel" is about as close as we can come. However, neither of these conveys the many implications of the French, for *éprouver* suggests experience of a complex kind. It refers not only to participation in or perception of an event and the feelings directly associated with it, but also to a broad range of sensations, with things revealing themselves slowly so that they become known in their fullest dimension. Thus, it refers to a heightened awareness of knowledge and emotion that is stored in the depths of one's unconscious as well as to what one sees and feels in the present. Only once before, in 1868, had Monet used this word when describing his efforts, which suggests that the *Grainstacks* are as complex as the verb itself, that they too are about such things as time and change, innocence and age, grand themes that were critical to someone as demanding and driven as Monet.[25]

Of Hay and Oats and Stacks of Grain

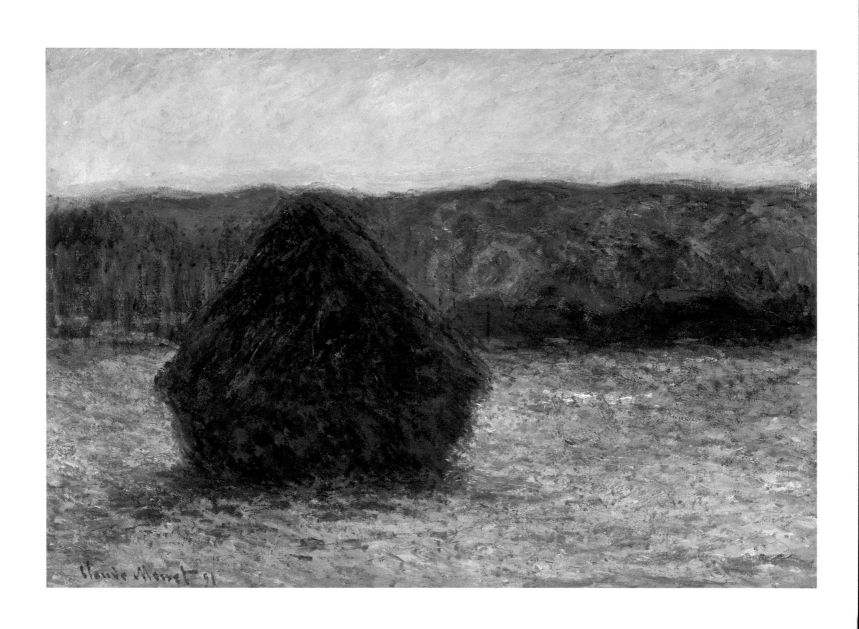

88 Plate 27. (cat. 28) *Grainstack. (Thaw; sunset.),* 1890-91. The Art Institute of Chicago

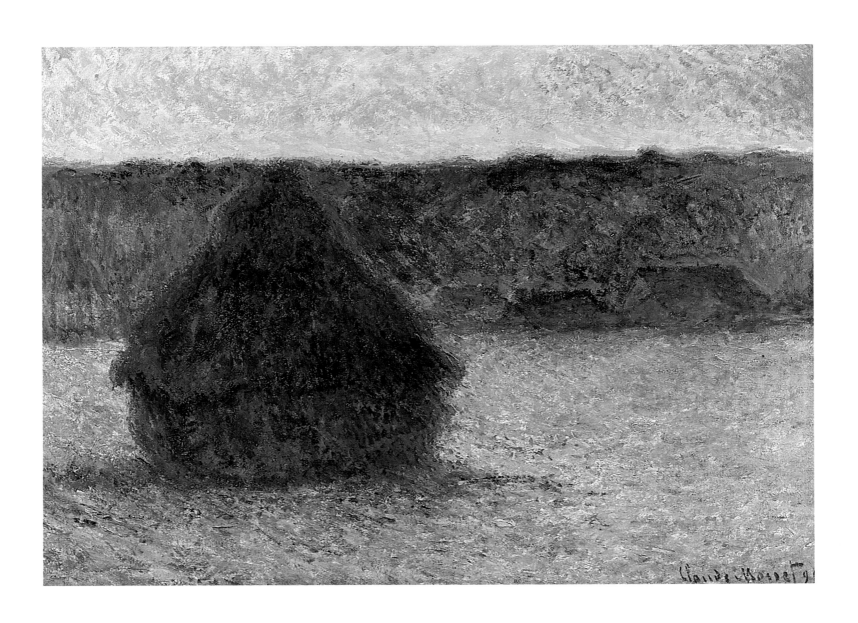

Plate 28. (cat. 26) *Grainstack. (Sunset; winter.)*, 1890-91. Private Collection, England

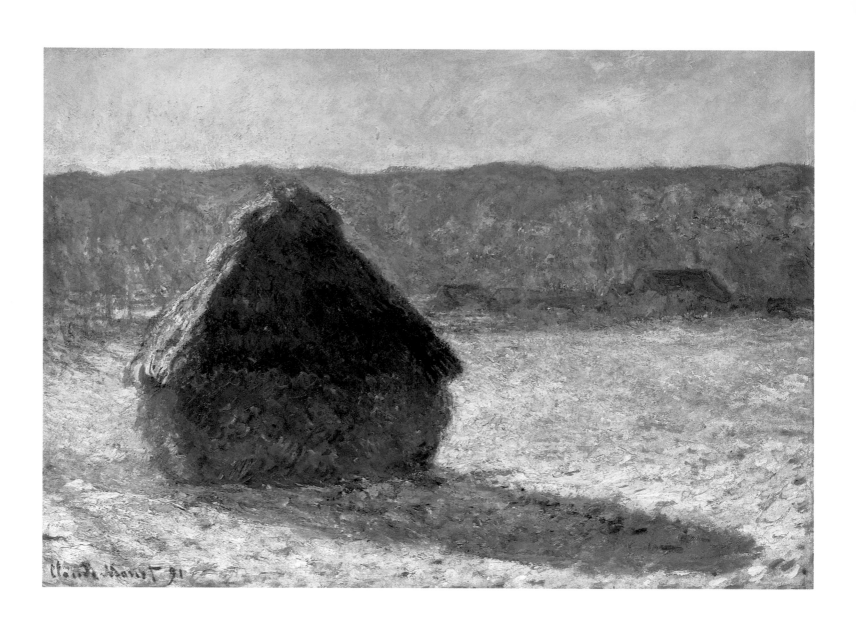

90 Plate 29. (cat. 24) *Grainstack. (Snow effect.)*, 1890-91. Museum of Fine Arts, Boston

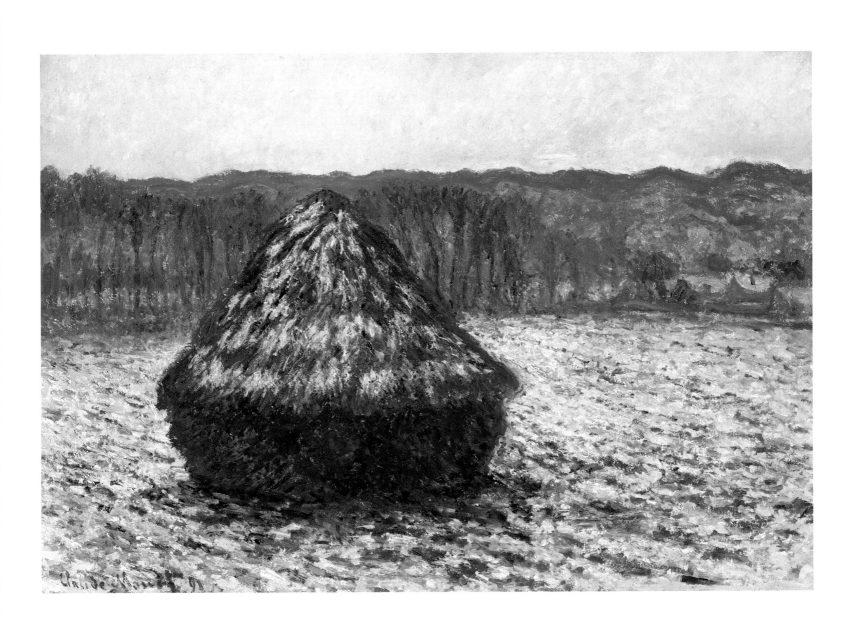

Plate 30. (cat. 27) *Grainstack*, 1890-91. The Art Institute of Chicago

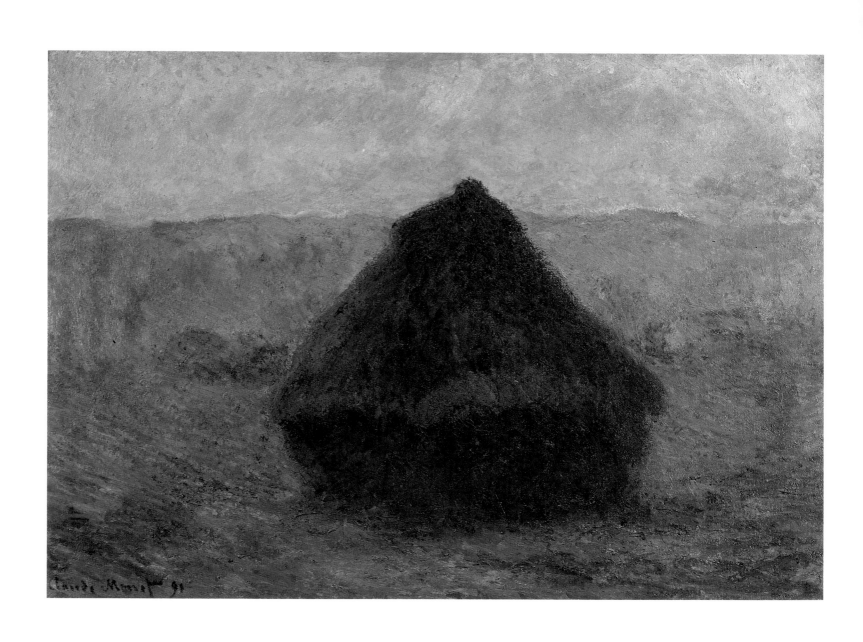

92 Plate 31. (cat. 29) *Grainstack*, 1890-91. Collection Pierre Larock-Granoff, Paris

THAT Monet really set out to paint what he "experienced" in front of those stacks, and not so much what he saw, goes a long way to explain the apparent slips in his fidelity to nature's laws. It also confirms the fact that he was not following some formula or theory. This latter point might seem obvious, but it tends to be obscured by the sheer number of *Grainstacks* he painted. Also, it has often been overshadowed by the modernist appeal of the concept of painting a series devoted to a single subject and by parallels that 20th-century writers have noted between these paintings and ideas about time and space that were circulating in the late 1880s and early '90s, particularly those formulated by Henri Bergson.[26] These notions have an obvious affinity with the continuum that the *Grainstack* series suggests, and with what could be perceived as Monet's apparent attempt to fuse time and space in these pictures. The nearly simultaneous appearance, for example, of Monet's paintings and Bergson's writings (which were first published in 1889) lends support to this reasoning, as does the kind of language that critics used to describe Monet's work. Geffroy, for example, began his catalogue essay for the *Grainstacks* by claiming that Monet was interested in the way that "immutable objects constantly took on new forms, [in] the unceasing flow of changing sensations in front of an invariable spectacle, one interwoven with the other, [and in] the possibility of summarizing the poetry of the universe in the restricted space [of a canvas]."[27]

All of this is undoubtedly more than mere coincidence or the product of zeitgeist. However, it is unlikely that Monet had read any of Bergson's writings or had even been interested in them. Like his approach to painting, his taste in literature ran counter to the theoretical. But he did read Symbolist writers like Mallarmé and Huysmans, and had ample opportunity to talk with these and other Symbolists at Berthe Morisot's Thursday dinners and at the Impressionist gatherings that took place monthly in the second half of the 1880s at the Café Riche in Paris, both of which he attended on a regular basis. Thus, Monet would have been familiar with their interest in the continuity of experience and its subjectivity as well as their attempts to meld imagination and reality, dream and consciousness to arrive at a higher level of awareness. It is therefore to the arts and not to philosophy that we might look for more appropriate parallels to Monet's seriality.

The strongest ties are with Mallarmé, whom Monet met sometime in the mid-1880s. According to Berthe Morisot, the two quickly became good friends. They corresponded regularly throughout the latter half of the decade, exchanged expressions of mutual admiration, and broadened each other's aesthetic circles. Monet introduced the poet to Whistler; the poet brought certain writings of Edgar Allen Poe to Monet's attention. Their relationship had grown so strong by the end of the decade that Monet actually gave Mallarmé a painting in the summer of 1890, which caused him to go into rapture.[28] Mallarmé's enthusiasm for Monet's work stemmed from his own insistence on the importance of mystery and allusion. He felt that one should never fully describe things in an empirical fashion but rely instead on the powers of suggestion. "To evoke an object little by little in order to reveal a state of mind," he told an interviewer in 1891, "or, inversely, to choose an object and to derive from it a state of mind by a series of decipherments – that is the perfect use of mystery."[29] Like other Symbolist critics, therefore, Mallarmé tended to write about the poetry of Monet's vision and the ethereal quality of his art, stressing

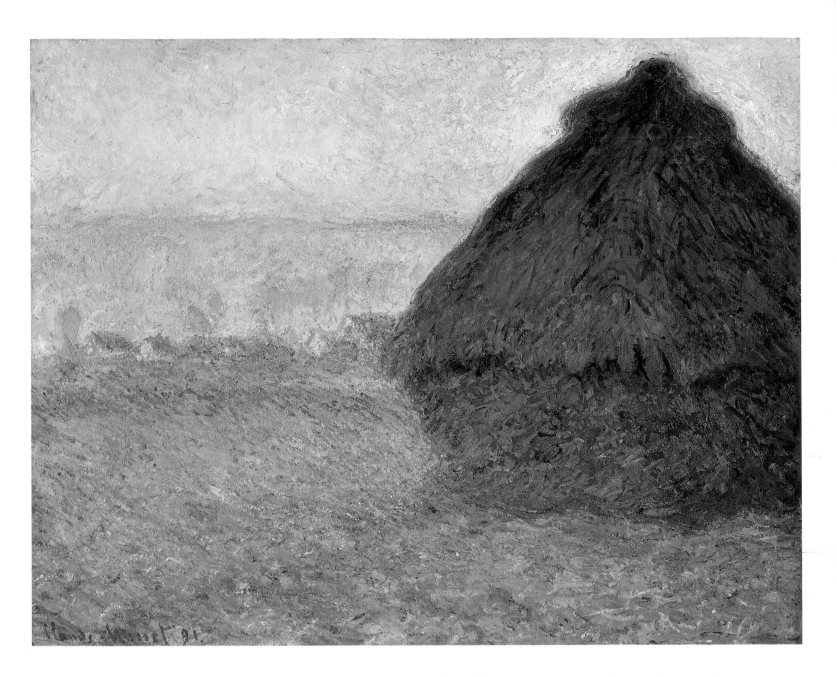

in particular his fascination with the dematerializing effects of light, observations that Mirbeau took to their logical extreme when emphasizing the dreamlike quality of Monet's pictures and his apparent interest in the "intangible" and inexpressible.

In comparison to the views of harvested fields by Breton, Herlin, or other 19th-century Realists, Monet's series appears to be the perfect visualization of the Symbolists' concerns. Devoid of workers, animals, and topographical specificity, the paintings reveal their secrets slowly, encouraging deep contemplation if not spiritual reverie. The stacks, though solid, are eerily silent, forcing the viewer to compare one with another in order to understand them fully. Occasionally, Monet gives such prominence to air and light – the most elusive and intangible elements in the known world – that the atmosphere and rays of the sun are actually suggested with greater amounts of paint than the stacks, structures, fields, or hills, as is evident, for example, in plate 32. Monet himself encouraged the connections to Symbolist thinking by telling a visitor to the exhibition of the series in 1891 that "a landscape hardly exists at all as a landscape, because its appearance is constantly changing; it lives by virtue of its surroundings – the air

Plate 32. (cat. 30) *Grainstack. (Sunset.),* 1890-91. Museum of Fine Arts, Boston Detail, plate 32 >

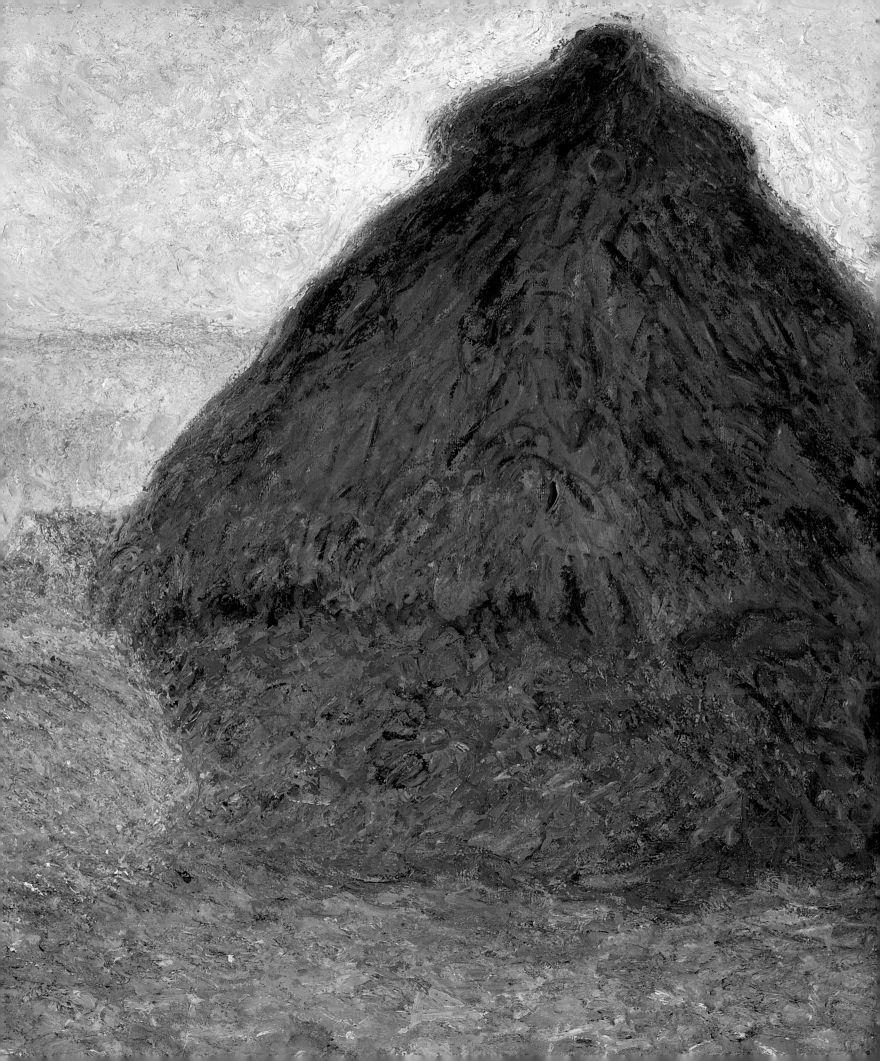

Fig. 43. Claude Monet, *Portrait of Su-*
zanne Hoschedé with Sunflowers, 1890.
[W.1261]. Private Collection.

Fig. 44. Paul Ranson, *Nabis Landscape*, 1890. Josephowitz
Collection, Lausanne.

and light – which vary continually."[30] He also spoke more frequently about his interest in the ambiance
and the envelope of light than he did about the stacks or the setting and actually painted a portrait of his
stepdaughter, Suzanne Hoschedé, in late 1890 that could easily be mistaken for a work by a Symbolist
artist (fig. 43).

Despite these connections, Monet's art and Symbolist theory and practice should not be linked too
closely. First, the portrait of Suzanne Hoschedé is unique in Monet's oeuvre, an experiment that was not
to be repeated and a very private picture. (Monet eventually gave it to Suzanne's widower, Theodore
Butler.) Second, there is a rich tradition of evocative 19th-century landscape painting, beginning with
Turner and moving through Corot and Whistler, that Monet was aware of and was equally indebted to
[which will be discussed at greater length in Chapters 8 and 9]. Monet also had his own practice to rely
upon. His work had always been fundamentally subjective, as it had been predicated on his personal
judgment and sensations. It was simply because that subjectivity had become more pronounced by the
end of the 1880s that people such as Mallarmé and Mirbeau could suggest that distinctions between
Symbolism and Impressionism had actually collapsed.[31]

Those distinctions collapsed only to a certain degree, however, as Monet did not want to be consid-
ered a Symbolist. He always insisted that his art was grounded in nature and was the product of his

sensations in front of his motifs. Although obsessed with light, he was not interested in the dematerialization of objective reality nor in the altered states of consciousness that so fascinated the Symbolists, a point that can be readily affirmed when his *Grainstacks* are compared with Symbolist paintings, such as Paul Ranson's *Nabi Landscape* (fig. 44), which was completed in 1890, the same year that Monet began his series. If there was mystery in Monet's work, it was because there was mystery in nature; if he seemed to emphasize the suggestive, it was because he sought to render his feelings in front of nature's offerings; if poetry overwhelmed prose, it was because nature and painting were essentially poetic, as Turner, Corot, and so many other landscape painters of the 19th century had amply demonstrated before him.

Of course, Monet was happy to have the leading proponents of this novel approach to art and life support his work, even if they wrote about it as invoking "the dream" and "the intangible." When Mirbeau prepared an article for a Paris journal, the newspaper announced it beforehand and then increased circulation for the issue in which it appeared, in one instance even reprinting 20,000 copies.[32] Beyond the sheer number of people that such articles might reach, being championed by these writers meant the possibility of appealing to a whole new market and of confirming Monet's stature as one of the leading painters in France. Most important perhaps, from Monet's point of view at least, his leadership would be confirmed not because he abandoned Impressionism for something entirely different, as Pissarro had done when he took up Neo-Impressionism, but because he had stayed with his style and subject matter and had been able to extend them by appropriating compatible aspects of this latest avant-garde movement.

MONET tried to ensure his supremacy with the *Grainstacks* by applying his marketing skills as soon as the series was sufficiently advanced. On December 5, 1890, he wrote to Durand-Ruel advising him to come to Giverny as soon as he could. "I am reserving canvases for you," he assured his original backer, "but I have not been able to keep them all."[33] That was because "Mr. Valadon [of Boussod & Valadon] came to see me recently and bought several." The reference to Durand-Ruel's competition may have been innocently offered, but it smacks of Monet's inclination to play dealers and collectors against one another. "It is only with great difficulty," he cautioned the dealer, "that I have been able to keep the *Grainstacks*." Durand-Ruel did not heed this warning, concerned as he probably was about receiving the paintings Monet still owed him. Monet pressed his case, however, telling the dealer in January that he regretted he had not yet come. "I know the weather is a little difficult for traveling, but I don't want you to have to choose among canvases that others have rejected."[34] Durand-Ruel again declined, asking the artist to select several paintings for him and to set them aside. Monet found that both "very embarrassing" and "quite delicate." "I prefer to wait," he told the dealer, "until you can come to Giverny and choose the works that you like yourself." He even offered not to show everything to others who might visit in the interim, a gesture that could be seen as preferential treatment for an old friend or as a subtle way to apply pressure.[35]

Monet's tactics eventually paid off, and handsomely; before the show even opened, Durand-Ruel purchased eight of the fifteen *Grainstacks* that the artist would exhibit. In the meantime, Monet had been able to sell two others that he would include in the exhibition, to the publishing magnate Paul Gallimard, and to James Sutton, who had purchased Millet's *Angelus* two years earlier. That meant that of the fifteen stacks that went on view in May 1891, ten were already spoken for, leaving only five for anyone who might have been interested.[36] It was an ingenious way of controlling the market.

Monet not only pressed all who may have been keen on his work before the show began; he also made sure that word got out about it. He made several trips to Paris during the winter; invited the collector-dealer M. Montaignac to Giverny to see things just after he had made a major trip to America; had Mirbeau out to talk about an article he could write; and negotiated space for Mirbeau's piece in Durand-Ruel's journal *L'Art dans les deux Mondes*, doing several drawings to accompany it.[37] The article appeared on March 7, 1891. After a long and evocative description of Monet's garden and the fields surrounding his house, Mirbeau broached the issue of the artist's newest work, albeit obliquely. He asserted that Monet "has no need to vary his themes and change his settings in order to inspire a panoply of impressions. A single theme – as in his stunning series of *Grainstacks* in winter – is enough to allow him to express the manifold and varied emotions that the drama of the earth undergoes from dawn to nighttime." It is not until the last paragraph of the article that Mirbeau comes back to those paintings, but he uses them brilliantly at that point to entice his reader. "How far he has come from *The Port at Honfleur* and *The Church of Saint-Germain-l'Auxerrois* – both so beautiful in the classical sense, and so reminiscent of Canaletto's finest works – to the extraordinary *Grainstacks* of this past winter! What conquests from one year to the next! Not an instant of weakness, not a moment of hesitation or of regression in Claude Monet's upward, direct, unswerving, and swift course toward what lies beyond progress itself. It is something rare, deserving of the highest praise, this ceaseless outpouring of masterpieces."

Shortly after the article appeared, rumors about Monet's activities began to circulate in Paris. Pissarro, who visited the capital later in the month, relayed them to his son. "This is a bad moment for me, Durand doesn't take my paintings. . . . For the moment, people want nothing but Monets. Apparently he can't paint enough pictures to meet the demand. Worst of all," he lamented, "they all want *Grainstacks in the Setting Sun*! Always the same story, everything he does goes to America at prices of four, five, and six thousand francs. . . . Life is hard."[38] Less than a week later, he wrote his son again. "I saw de Bellio, who sends you his best. He mentioned that Monet was going to have a one-man show at Durand-Ruel's and exhibit nothing but *Grainstacks*. The clerk at Boussod & Valadon told me that the collectors only want *Grainstacks*." What Pissarro really found regrettable was the fact that "Monet [could] submit to this demand that he repeat himself – such is the terrible consequence of success!" he concluded.[39]

If Pissarro had known how Monet's show had come about, he might have been even more upset. For it had been urged on Durand-Ruel by Monet himself as an alternative to a group exhibition that the

dealer had proposed of all the Impressionists. "We should talk about your proposed exhibition at the first possible occasion," Monet told Durand-Ruel in December 1890. "But I personally am dead set against anything to do with reestablishing shows of the old group. You have enough paintings by all of us to constitute a kind of permanent exhibition already," he claimed. "It would be much more interesting to do small shows from time to time of select, recent work by each one of us. To redo our old exhibitions seems to me to be unproductive and maybe harmful."[40] Monet's arguments held sway, and his *Grainstack* series initiated this new marketing strategy.

IN ADDITION to the fifteen *Grainstacks*, Monet's exhibition contained four field pictures from the previous summer, a *Creuse Valley* canvas, and two figure paintings, bringing the total number of works in the show to twenty-two. Appropriately, the Creuse picture was *The Rock* (plate 13), which had clear visual and metaphorical ties to the equally elemental *Grainstacks*. The figure paintings that Monet chose were the two views of a woman with a parasol that he had done in 1886 (fig. 10). It was the first time that Monet had ever exhibited these latter canvases, although they had always been in his possession. Most likely, Monet wanted to lay claim again to territory outside his specialty and prove his prowess as a figure painter, just as he had in his retrospective with Rodin in 1889 when he had exhibited four other figure pictures. There was more to the inclusion of these two paintings, however, as he hung them in the exhibition above a row of *Grainstacks*.[41] Although perhaps motivated by practical concerns, such as limited space or lighting, this arrangement clearly gave these very personal canvases special prominence and suggests that Monet saw them as contributing to the larger design of the show. Perhaps they were supposed to stress the feminine in nature or the human qualities of the stacks. They might even have been intended to evoke earlier diptychs that depicted religious figures or muses hovering over earth-bound scenes below them. As such, they would have been a satirical comment on the vogue for religious and mystical painting at the time. At the very least, they would have indicated the continuity of Monet's concerns over the past five years with light and air and the integration of the human or its surrogate with the landscape.

It is certainly more than mere coincidence, however, that Monet selected these two works, for they were the ones that he had been prompted to paint after Seurat's triumph in the eighth and last Impressionist exhibition. In fact, these pictures were the very ones with which Monet had begun his five-year quest to claim his leadership of French painting, a challenge that had led him to Belle Isle and ultimately to the notion of seriality that was so richly represented by the *Grainstack* pictures in the exhibition. Even before the show opened, Monet had subtly suggested the connections between these important moments in his career. For when he finally took the time to do the illustrations for Mirbeau's preview article in *L'Art dans les deux Mondes*, he decided to do drawings not only after a *Grainstack* picture but also after one of these pendants and a painting from Belle Isle.

WHEN the show opened on May 4, "everyone" was there, according to Pissarro. Although the older Impressionist found the series "marvelous," "very luminous and very masterful," his enthusiasm was by no means unreserved, as he tried to explain to his son. "What do they lack? Something very difficult to define clearly. Certainly in rightness and harmony, they leave nothing to be desired; it would rather be in the unity of execution that I would find something to be improved, or rather I should prefer a calmer, less fleeting mode of vision in certain parts. The colors are pretty rather than strong, the drawing is good but wavering – particularly in the backgrounds. Just the same," Pissarro admitted, "this is the work of a very great artist."[42]

Critics overwhelmingly agreed with Pissarro's final assessment. Roger Marx, for example, felt that the series revealed the "acuity of [Monet's] vision, his absolute sincerity [and] his compositional powers," which Marx considered to be equaled only by Corot. Even Camille Mauclair, who had frequently criticized Monet in the past for a host of apparent lapses, now found him to be a "great painter [who] unites incredibly rich color with minute drawing, [producing] a surety of execution that is almost mathematical." Fénéon was nearly alone in his tempered disdain for what he saw as Monet's eagerness "to serve [nature's] caprices." "Nature is not quite so mobile," he asserted, "she does not reel." In his opinion, Monet should have "coordinate[d] her disparate appearance, recreate[d] her in a stable form, and endow[ed] her with permanence." However, he had to admit that Monet had captured unique effects and had empowered his stacks "with his shrewd sight and polychrome intentions. When have colors fused in a more sparkling harmony of clamorous tones?" he asked, an observation that Monet undoubtedly appreciated.[43] While every reviewer marveled at the qualities of light that Monet was able to evoke, they always anchored their comments about these effects in the stacks themselves, something that should remind us of their importance. Ironically, Fénéon was one of the more sensitive observers in this regard. "In the evening sun especially, the *Grainstacks* are exalted; in summer, they are given a halo of dark, red, flickering sparks; in winter, their phosphorescent shadows stream over the soil and, against the sky, first rose, then gold, they shimmer, enameled blue by a sudden frost." While responding to what they saw in the pictures and to what they felt, Fénéon and the others who gave such prominence to the stacks had been preempted by Geffroy.

Geffroy called the "gathering of these fifteen paintings of grainstacks . . . [an] extraordinarily victorious artistic demonstration," a reference perhaps to Monet's triumph not only over nature but also over his competition. Geffroy went on to describe the site that had so inspired Monet, "a field with grainstacks, a humble piece of land adjoining some low cottages, surrounded by nearby hills, decked out with the unbroken procession of clouds." He then focused on the stacks themselves. They were "transitory objects on which are reflected, as in a mirror, the influences of the environment, atmospheric conditions, random breezes, sudden bursts of light. They are a fulcrum for light and shadow," he claimed, "sun and shade circle about them at a steady pace; they reflect the final warmth, the last rays; they become enveloped in mist, sprinkled with rain, frozen in snow; they are in harmony with the distance, the earth, and the sun."[44]

Geffroy's sensitivity to the stacks themselves increased when he led his reader through the seasons in which they were set. "They first appear during the calm of beautiful afternoon. Their edges are fringed with rosy indentations of sunlight; they look like gay little cottages set against a background of green foliage and low hills covered with rounded trees. They stand erect beneath the bright sun in a limpid atmosphere. . . . At the close of the warm days . . . the stacks glow like heaps of gems. Their sides split and light up. . . . These red-glowing grainstacks throw lengthening shadows that are strewn with emeralds. Later still, under an orange and red sky, darkness envelops the grainstacks which have begun to glow like hearth fires. Veils of tragedy – the red of blood, the violet of mourning – trail around them on the ground and above them in the atmosphere. . . . Monet unmasks changing portraits, the faces of the landscape, the manifestations of joy and despair, of mystery and fate."

There is no way to know whether Monet would have concurred with everything Geffroy asserted in his essay, particularly his cosmic claims that Monet "constantly evokes in each of his canvases the roundness of the terrestrial globe [and] the course of the earth through space." However, in all likelihood, they had discussed issues pertaining to the series at great length prior to the show. And even if he did not agree with the specifics of Geffroy's interpretations, Monet would have appreciated the critic's poetic empathy.

In addition to responding to the stacks, Geffroy and other writers who reviewed the show found more in these paintings than atmospheric conditions and instantaneity. Like the stacks themselves, the series functioned for them in complex ways, "beyond their apparent subjects," as Desiré Louis described, while they obviously touched responsive chords. "Need I add that the show is a great success?" Pissarro asked his son the day after the exhibition opened. "This is not surprising, considering how attractive the works are. These canvases breathe contentment."[45]

On the surface, Pissarro's explanation seems quite reasonable. Everyone could find something to like in pictures that were painted with such "pretty colors," as Pissarro described them. In addition, who could disparage scenes of such beauty and calm? With nothing disturbing or unrecognizable in them, the paintings encouraged the eye to roam and the mind to expand.

But Pissarro's explanations suggest a host of other concerns that these paintings and their reception appear to raise. What kinds of criteria for painting were operating here? What role was Monet assuming? And what really were viewers seeing in these works? How, therefore, in the end, were these series paintings actually functioning?

These were important questions that were often asked in late 19th-century France. Pissarro, for example, was so interested in the role of the artist that after offering his explanations for Monet's success, he asked his son if he "would collaborate with [him] in outlining the anarchist conception of the role artists could play and the manner in which they could organize in an anarchist society, indicating how artists could work with absolute freedom once rid of the terrible constraints of Messrs. capitalist collector – speculators and dealers. How the idea would be further developed, the love of beauty and purity of sensations, etc., etc."[46]

Fig. 45. J. Veyrassat, *August in the Brie*, 1889. Location unknown. From Louis Ernault, *Paris-Salon 1889*, plate 48.

Fig. 46. Marguerita Pellini, *The Three Ages of Life*, 1889. Location unknown. From Louis Ernault, *Paris-Salon 1889*, plate 80.

Monet had no interest in Pissarro's socialist beliefs. Although a staunch individualist, like his older friend, and a deep believer in the purity of sensation, he was perfectly happy to work within those "terrible constraints," having developed marketing strategies that had rewarded him well. But Monet's ego was much larger than Pissarro's, as were his aspirations. Having laid the groundwork for achieving his ambitious goals through his extensive travels in the 1880s and his triumphant exhibition with Rodin, Monet now was going to try to secure them with this series of paintings of the bounteous French landscape. In doing so, Monet was appealing directly to the nation's deep-rooted interest in images of her countryside. Indeed, so popular were paintings of rural France by the mid-1860s that Zola could claim that the classical version of the genre had been killed by the twin swords of "life and truth."[47] By the 1890s, landscape had become the most practiced subject in French art and the dominant subject in the annual Salons.

France's interest in *la terre*, of course, was tinged with pride, patriotism, and nostalgia. No incident demonstrated this better than the sale of Millet's *Angelus* in 1889. For as soon as its loss to the American, James Sutton, was imminent, the painting became part of the country's patrimony that had to be preserved. However, despite angry letters in leading Paris newspapers demanding that the government appropriate the money required to keep the painting in France, despite heated debate in the Chamber, and even a national subscription, this modest-size canvas left its homeland for the new world of the Yankees. The nation's outrage over the loss was due to the fact that a parvenue country was making off with a painting that stood for everything French citizens wanted to believe about rural France — that life

was simple beyond the walls of the city, that the peasant was pious, the soil fertile, and the landscape beautiful. Gambetta even saw the picture as "a moral, social, and political lesson."[48]

The nation's grief over the loss of this icon was partially assuaged two months later when a Rheims widow, moved by the public's outcry, purchased Millet's *Gleaners* for 300,000 francs, claiming that she would donate it to the State in compensation for the *Angelus*. Like Monet and the widow, Sutton understood the hold that these images of the countryside had on the French public, and being an entrepreneur, he exploited the situation. Barely twelve months after he had purchased the picture, Sutton sold it to M. Alfred Chauchard, the Director of the *Magasins du Louvre*. Chauchard paid the American 800,000 francs, which was 200,000 francs more than it had cost the dealer. The return of the painting was an event of such importance that when Sutton's courier arrived in Paris he was greeted by a host of French officials, including President and Mme Carnot, the President of the Chamber of Deputies, M. Freycinet, and a section of the French army. Sounds of cannons from the Invalides filled the air while carillons throughout the city rang to announce the happy hour.[49]

The furor over Millet's masterpieces suggests the country's specific interest in views of agrarian France, something that is borne out by the innumerable farm scenes that cluttered the Salons of the 1880s and '90s, such as Veyrassat's *Autumn in the Brie*, 1889 (fig. 45). All of these paintings stressed the fecundity of the countryside and the heartiness of rural folk. They also assured their viewers that rural traditions continued despite the growth of cities and the changes wrought by progress. Although more subtle, Monet's *Grainstack* pictures operated on the same level.[50]

Monet's paintings also implied that the countryside was a place where one could find reassurances about the world, where contemporary problems seemed to vanish, and a deeper union with nature appeared possible. Geffroy and other critics emphasized these points. Such notions, of course, had always been the primary appeal of landscape painting. But by avoiding the specifics that his contemporaries stressed, Monet allowed these essential attractions to emerge even more forcefully.

Monet's *Grainstack* paintings also appealed to contemporary associations between the human and the natural – to poetic metaphors, for example, that could be drawn between the stages of life and seasonal changes. Once again, these too were as old as the discourse on landscape. They had been eloquently treated by Tacitus and Lucretius (whose writings Monet had read), by medieval sculptors and printmakers, and by innumerable artists and writers for centuries thereafter. In the 1880s and '90s, however, the pairing of the human and the natural had become quite popular. It was the leitmotif in Maupassant's *La Vie* (1884), for example, which Monet had also read, where the progress of Jeanne's life is consistently set against seasonal descriptions. It was the standard reference in innumerable decorative schemes done during those years for public buildings in Paris and its environs. In addition, dozens of artists, both academic and avant-garde, did allegorical paintings on the subject, though none perhaps quite as unassumingly as the little-known Marguerita Pellini, whose triptych entitled *The Three Ages of Life* (fig. 46) was featured in the same Salon of 1889 as Veyrassat's harvest scene. Louis Ernault found the painting "a little melancholic," but he felt he would ask Mme Pellini if he might "stop en route and

without going all the way to winter. . . stay with the young harvester in the walls of her summer wheat." That was where it was most wholesome, particularly with the grainstack rising in the background appropriately recalling the way the harvester emerges from in between her fellow workers.[51]

The moment for Monet's *Grainstack* series, therefore, was extraordinarily propitious, a fact that was made all the more apparent by the Centennial Exhibition of French Art at the Universal Exposition of 1889. For while the show featured many celebrated works such as Delacroix's *Death of Sardanapolus* and Ingres's *Portrait of Napoleon on his Imperial Throne*, it contained an inordinate number of landscape paintings. Indeed, of the 650 canvases in the show, more than 200 were scenes of rural France, the overwhelming majority of which were by Barbizon artists. Little wonder that Roger Marx in his review of Monet's show could state that the *Grainstack* paintings "will be judged topical," for he felt that like those older Barbizon scenes, they "symbolize and sum up the labor, the sowing, and the harvesting, all of the harsh fight with the elements to fertilize the land, all the arduous and superb work of the earth."[52] And, as with the recent flight of the *Angelus*, Marx regretted that "impatient America, who is always stealing our masterpieces, has already made off with more than one work in the series," as if to say these distinctly French paintings should remain in France because they proclaimed the national belief in *la belle France*.

That belief, of course, had always been central to the life and spirit of the nation, but in the early 1890s, it was professed with heightened conviction. For as France attempted to redefine her goals, she needed reassurances about national fundamentals. She could take pride in various advances she had made during the period, such as her widely expanded colonial empire or the enormous extension of her railroad lines, but if she looked across her eastern borders to Germany or across the seas to England and America, she found that her competitors were outdistancing her in all areas of production, even in the realm of the arts. Thus, images that propagated the wealth and beauty of the countryside, such as Monet's *Grainstacks*, did much, however naively, to allay nascent fears about her undesired change in status. Such images also helped to soothe the pain that most French citizens continued to feel about the loss of Alsace and Lorraine. There was still much to be proud of within the redrawn boundaries of the nation and much for others to covet. That was the primary point of the broadside about the national budget discussed earlier in this chapter (fig. 33). "France is a rich country," the last caption claims, "which is why she was the envy of the Prussians, our hereditary enemy. If we want to conserve our riches, always be armed and ready to defend them."

Thus, Desiré Louis could be struck by how these paintings sparked "memories or dreams of the countryside," by how their skies, whether "clear or vaporous, gay or melancholic, express[ed] the mysterious sounds of the universe," and by how "these ebullient canvases [could engender] the impression of a generous and benevolent life," for Louis had actually gone to fight the Prussians in 1870, had been captured in the battle of Metz, and been held prisoner in Germany until the end of the war. However, Monet's pictures spoke with equal poignancy to people such as Marcel Fouquier of *Le Journal des artistes*, who had not had similar experiences. "Claude Monet is the naive, sincere, moving, lyrical painter

of nature and all things," Fouquier declared on May 10, 1891, and, "he will take his place among the greatest artists who painted the landscape of France."[53] The *Grainstacks* were able to operate on these various levels because Monet's vision of the French countryside and of what French art could be was intimately bound up not only with the particular moments in time that the paintings recorded but also with Monet's awareness of history.

Ironically, Seurat, who had recently turned thirty-one, never saw the *Grainstack* series; he died in April 1891, three weeks before the paintings went on view. His challenge to Monet, thus, came to a tragic and untimely end, but it had contributed substantially to the vision that Monet would fiercely and successfully propagate throughout the 1890s.

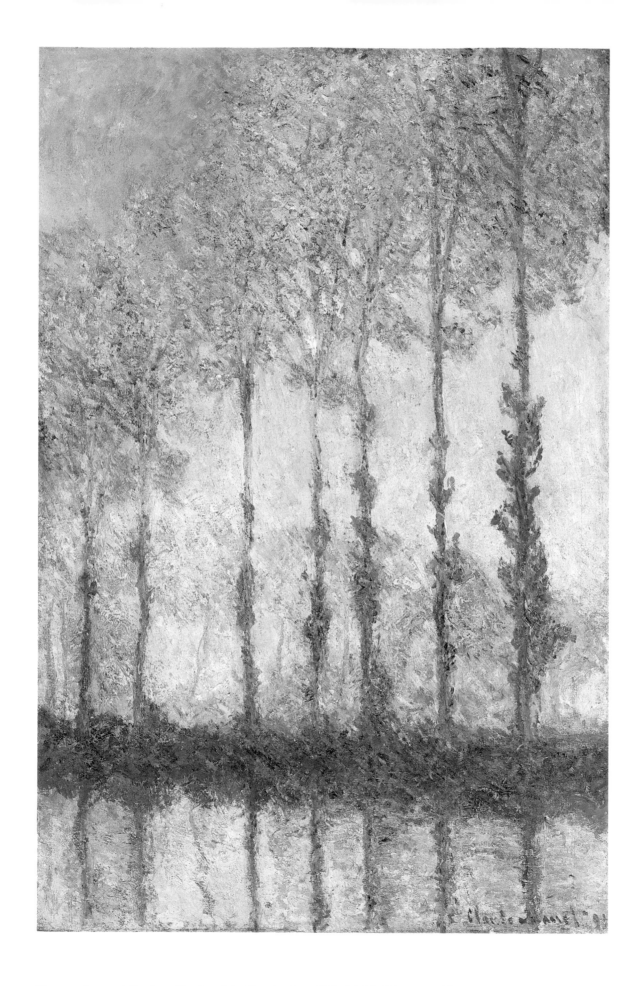

Plate 33. (cat. 33) *Poplars. (Banks of the Epte.)*, 1891. Philadelphia Museum of Art

ON June 18, 1891, the village of Limetz, located just two kilometers south of Giverny, decided to auction off a group of poplars that lined the banks of the Epte along the northern edge of the community. The poplars, which had been planted by the village on communally owned property, had grown to their ideal height of approximately thirty feet and were ready to be harvested. Unbeknownst to the village fathers, however, Monet had begun a new series of paintings of those very same trees, (plates 33-45); and when he learned that his motif was destined to be cut down, he decided to take action.

He first went to see the Mayor and requested a stay in the sale, which had been scheduled for August 2. His request was denied. He then decided to go to the auction to purchase the trees himself. At some point before the bidding began, the idea came to him to collaborate with a wood merchant who was also interested in buying them. "I asked him how high a price he expected to pay," Monet later told a biographer, "promising to make up the difference if the bid went over his amount, on the condition that he would buy the trees for me and leave them standing for a few more months." When the gavel came down, Monet and the lumber man were the co-owners of the poplars.[1]

Although it is amusing to think of Monet attending a country auction and emerging with a wood dealer as a business partner, the story raises several important issues. It attests to how deeply involved the artist could become with his motifs, his financial investment in this case implying the personal, aesthetic and, perhaps, metaphorical significance that he attached to his subjects. In addition, the story should remind us that, like the grain that formed the stacks, the poplars in these pictures too were a crop that was cultivated for the market. The trees are spaced at regular intervals in Monet's paintings because they were planted approximately eight feet apart to maximize their growth. They run along the banks of a river because of their capacity to absorb a great deal of water and thus diminish the possibility of flooding in the area, while the river would provide the trees with appropriate nutrients. Even their nearly branchless trunks are the result of practical concerns: the trees have been trimmed for firewood and to make them grow straighter and taller, thereby encouraging their use in the construction trade as scaffolding or lumber and to make smaller items for domestic use, such as matches and boxes.

Although everyone in the 19th century would have readily recognized the monetary potential of these trees even as firewood (coal and wood being the only sources of fuel for heat at the time), they would also have appreciated what Monet stresses most about them: their slender trunks, bushy heads, litheness, and rhythmic arrangement – in short, their decorative beauty. Rural people had recognized

Fig. 47. Claude Monet, *View near Rouelles*, 1858. [W.1]. Private Collection, Japan.

Fig. 48. Claude Monet, *Poplars at Giverny*, 1887. [W.1155]. Private Collection, Boston.

these qualities of poplars long before Monet painted them. As the minuet of trees, poplars were often used to line rural roads and entrances to estates. Their spry elegance added to the charm of a place. They also acted as an effective wind barrier. Monet stresses their height and their sweeping command of the landscape, a characteristic that had led people to use the trees to demarcate property lines or the boundaries of a district, as had been the case with Limetz's poplars. Thus, like grainstacks, poplars were another well-known element of rural France that contributed to its economy, stability, and beauty.

Monet, of course, had painted poplars prior to this series. One of the first paintings he ever did, in fact, includes a row of such trees in the background (fig. 47). Poplars appear often in his views of fields around Argenteuil in the 1870s and they abound in similar scenes of more rural Giverny from the 1880s, often becoming the primary focus of attention. They were even the subject of two startling canvases from 1887 (fig. 48), which must have served as touchstones for the series four years later. But as with the grainstacks, Monet never concentrated so extensively on the trees and never presented them in so orderly a manner until 1891. His *Poplar* series thus marks a significant change in his approach to this career-long motif.

It is reasonable to see this change as stemming from the greater effort that Monet's more refined effects required. It is also possible to understand it in light of the *Grainstack* paintings, which are equally disciplined and elemental. But it is surely no coincidence that this change occurred in the early 1890s, at a time when France was attempting to find its center and reestablish its once-firm hold on cultural production in the world. For, as with the *Grainstack* paintings, in which poplars figure so often in the back-

ground, the twenty-four canvases that comprise the *Poplar* series can be understood as Monet's further attempt to assert the French qualities of his art and to appeal to deep-rooted beliefs about his nation and its character. The interest in the decorative, for example, was more than just aesthetic; it touched particularly sensitive chords in the nation's consciousness in the last decade of the century. In addition, the poplar was not merely a charming tree that everyone would have recognized as a typical rural element; it resonated with meaning for patriotic Frenchmen, as it had been chosen as the "tree of liberty" during the French Revolution and had been closely associated with the nation from that moment onward.[2]

THE DATE when Monet began his *Poplar* series cannot be determined precisely. More than likely, it was some time in the spring of 1891, as he subtitled one of the paintings in the group (*Spring*), (plate 41). They were therefore painted soon after the *Grainstacks*, perhaps some of them even at the same time. While this timetable is an indication of Monet's obsessiveness, his immediate turn to the trees also suggests the kind of confidence that he had in the *Grainstack* series and in the direction in which he had taken his art. He had sold many of the stack paintings prior to their exhibition and thus knew that dealers and collectors were interested in such work. However, he also must have understood that he had devised an extremely effective way of achieving a variety of desired ends beyond mere economic success.

Monet must have realized the potential of the poplars to accomplish these ends even while he was immersed in his *Grainstack* paintings, as he included them in nearly half of those canvases, always marshaling their rhythms to enhance the impact of the stacks. He was thus sensitive to what they could achieve formally before he began the new series. Moreover, when painting these *Poplar* pictures, he was as uncharacteristically happy with them as he had been with the stacks; he complained only three times about the progress he was making on them during the whole ten-month campaign, and then only mildly.[3]

Monet retained the compositional simplicity of the *Grainstacks* for his *Poplars* but fashioned a different scheme for them. Although he included a few horizontal canvases for variety (plates 44-45), he restricted the *Poplars* primarily to a vertical format and stretched the trees and their reflections from the bottom of the canvas to the top. Instead of placing special emphasis on the surface of the picture as he did with the stacks, Monet took the two-dimensional grid created by the trees and punctured it with the deep space that their wiglike foliage hollows out as the trees sweep into the distance. Finally, where Monet isolated the grainstacks, endowed them with great weight, and made them immutable, he presented the poplars as elastic, elegant forms whose effectiveness is enhanced by their numbers and whose graceful movement through the scene makes them seem like courtiers at an 18th-century ball.

Monet was able to achieve these effects by choosing his vantage point carefully. For all of the *Poplar* pictures, he selected a spot near where the river bent back on itself twice before disappearing from view; this allowed him to establish the S-curve that so characterizes the series. He did not look directly across the river at the screen of trees, but instead turned slightly to the left so that the trees would rise and

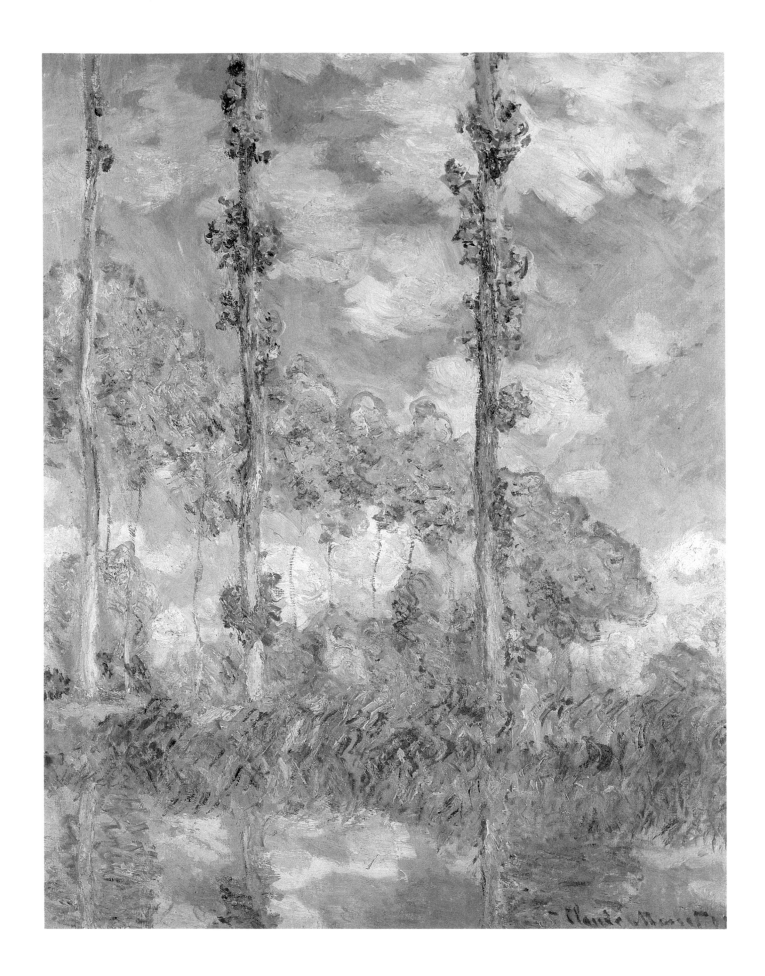

Plate 34. (cat. 38) *Poplars. (Summer.),* 1891. The National Museum of Western Art, Tokyo

fall as they moved in front of him. By working from this angle, he could also contrast the increasing height of the trees with the decreasing amount of water in the foreground. To enhance that contrast and energize the movement of the trees, Monet stationed himself in nearly a dozen paintings so that the poplars' dramatic sweep would be contained by the shape of the canvas. In these pictures (plates 33, 36-39), the sweep begins behind the bulbous tree in the background on the left, moves right and left to touch each side of the scene, and then culminates in the upper-right corner. In many of the other works in the series, the S-curve is more subtly stated. To paint canvases such as plates 34, 40-43, Monet moved closer to the trees, which reduces their number, cuts off their tops, and eliminates the upper part of the S-curve. However, by placing two of the three foreground trees on the left side of those canvases, Monet suggests that this section of the curve exists outside of the scene on the left. There is one unique canvas in the series, the Mondrian-like painting in the Metropolitan Museum of Art in New York (plate 35). In this view, the trees are closer to us than in any other. They also march across the whole canvas laterally, although Monet maintains his angled view while carefully locating two of the trees to the left of center and two to the right. He also has the lower section of the S-curve push its way into the scene in the background and turn just as it reaches the center of the picture.

In almost every canvas, Monet's vantage point appears to be just slightly above the level of the water, which suggests that he painted the series from the boat that he had often used in the past as a studio, particularly at Argenteuil in the 1870s. His boat also would have made his commute to the site much easier, as the poplars were about two kilometers overland from Monet's house, a substantial distance to consider when carrying canvases, painting supplies, and an easel. Instead of walking, Monet could have rowed to that section of the Epte without much difficulty, as a tributary to the river ran through his property. Whatever the circumstances, his low vantage point in these paintings is critical, for it allows the trees to rise above us and be silhouetted against the sky. By not including any distracting elements, Monet is also able to maximize the height of the poplars and focus our attention on their internal rhythms. This in turn allows us to sense their rootedness, interrelationships, and youthful vigor.

Monet was surprisingly truthful in this series to what apparently lay in front of him, so much so that the trees can be tracked from one canvas to another. For example, plates 33, 36-39 all show the same poplars. Even the branches at the top of these trees are similar. He was equally consistent in the paintings that have three poplars in the foreground (plates 34, 40-43). These trees are the first three in the views with the screen of seven, as is evident by the way the first two bend, by the space between the second and third, and by the greater proximity of the full one in the background and the curve of the others on the right. Monet's verisimilitude applies to the four trees in the Metropolitan painting as well (plate 35); they are the third through the sixth in the screen of seven.

As with the *Grainstacks*, however, Monet did not feel bound to absolute veracity. Artfulness plays an important part in these paintings as well. Some trees, for example, have untrimmed branches in certain canvases and not in others. Branches also shift positions as does foliage. In addition, trees in the

background bend one way in some pictures and another in others. On the one hand, these deviations from exactitude are not really significant, for the paintings are not exercises in documentation. On the other, they are important, as they underscore that, while tied to the particularities of a site, Monet did not feel overly bound to duplicate their specifics.

This freedom is even more evident when considering the effects Monet captured in these pictures. Once again he did not set out to reproduce precisely identifiable hours of the day, indicating a time in only four of the twenty-four paintings in the group, and then just sunset or dusk. But he depicted the spectrum of daylight conditions and treated three of the four seasons – spring, summer, and fall – choices that he emphasized by subtitling most of the *Poplar* paintings he exhibited with an indication of what season they represented. Even more significant is the fact that the series contains works such as plate 34. While filled with the brilliant light of a balmy summer's day, this painting goes far beyond meteorological accuracy. The brushwork is so vigorous throughout the scene that description is often overwhelmed by pure bravura, most prominently in the foreground bank and distant foliage. The colors are also so bold that they border on the garish. Similar effects are evident in other canvases in the series, such as plates 41-43.

Such contrasts and formal tensions energize these paintings and provide a relief from the insistent geometry that Monet employs. But they also make us aware that, while rooted in the visual world and in Monet's sensations in front of his motif, these seemingly descriptive views are attempts to do more than just capture particular aspects of nature.[4] They clearly display the artifice of Monet's craft as much as his ability to reproduce reality. By allowing the abstract elements of painting to carry visual weight, Monet gives his viewers the opportunity to indulge themselves in the aesthetic delights that painting offers. He wants them, in sum, to enjoy this series for its decorative appeal.

The decorative quality of painting, of course, had been a factor in Monet's work from the beginning, primarily because, like all of the Impressionists, he had been concerned with enfranchising his medium and allowing it to be the bearer of meaning. He also had always been interested in the power of color, the importance of surface pattern, and the significance of compositional structure, decorative dimensions of his craft which could be used to enhance the impact of a painted image. This was pointed out by critics even in the 1870s.[5] In the 1880s, however, as Monet narrowed his focus in terms of subject and reduced the number of elements in his pictures, he dwelt even more on decorative considerations (particularly the emphasis on color as opposed to light and dark modeling). This caused quite different reactions. Geffroy, for example, praised Monet's views of Antibes from 1888 precisely for their "bouquet of colors" and their "perfumelike quality." Pissarro, on the other hand, criticized those same paintings because he felt that they were too "vulgar," by which he meant too removed from analysis and from naturalistic description, and therefore too pretty and salable. Lacking rigor and complexity, for Pissarro they were closer to objects that one would hang on a wall simply because they looked nice rather than because they had staying power, and thus more like the work of a suave colorist than the product of a

Fig. 49. Paul Serusier, *The Talisman*; *The Grove of Love*, 1888.
Musée d'Orsay, Paris.

serious artist. Apparently, other painters shared Pissarro's opinion. Degas even went so far as to call
Monet "a skillful but not a profound decorator."[6]

The negative overtone of these criticisms was probably not lost on Monet. Shortly after his *Antibes*
pictures went on view, he painted the surprising *Five Figures in a Field* and the *Bend in the Epte*. Also
that autumn, he began his first *Grainstacks*, which extended the extraordinary color schemes of those
earlier paintings and the tapestrylike effect of their impastoed surfaces. With their more simplified com-
positions, the *Grainstack* pictures drew attention to structural concerns and to the relative flatness of the
scenes. And by showing them as a group, Monet underscored the significance of their collective impact
and of seeing the paintings in relationship to each other, just as decorative programs of the past had
been conceived and experienced. Indeed, Monet told one visitor to the *Grainstacks* exhibition that the
paintings had their greatest impact when shown together.[7] It is therefore not surprising that the *Poplars*
are so "decorative." The issue was central to Monet's enterprise.

Monet was not alone in his interest in the decorative. When Renoir went to Italy, he was most
struck by Pompeian frescoes and Raphael's decorations of the Vatican. Even Pissarro placed it at the
forefront of his efforts, as is evident from a letter he wrote his son after seeing Monet's *Belle Isle* paintings
in 1887. "The effect [of Monet's paintings] evidently is decorative," he affirmed, "but the pictures lack
finesse. I do not know if they conform to our vision which is for harmony and which demands less of a
decorator's art and more of the decorative."[8] It was in large part due to his desire for decorative har-
mony that Pissarro turned to Neo-Impressionism. Seurat had equated art with harmony. In addition,
his characteristic dot was a way of achieving not only a more precise transcription of perceived color
and light but also a more refined, harmonious surface.

Younger contemporaries like Bernard, Anquetin, Gauguin, and Sérusier took the issue of the decora-
tive to its logical extreme. Wanting, as Gauguin put it, "to get as far away as possible from that which
gives the illusion of a thing," these artists rejected the descriptive power of painting and emphasized its
evocative appeal, arranging forms and colored areas intuitively to prompt deep emotional effects.[9] Draw-
ing upon "primitive," anti-naturalistic prototypes such as stained glass and non-Western art and arti-
facts, they created such remarkable works as Sérusier's *The Talisman; The Grove of Love*, 1888 (fig.
49), which stresses the essential components of painting – flatness, color, shape, and touch – by radically
denying Renaissance perspective and any sense of traditional modeling. It is in fact difficult to recognize

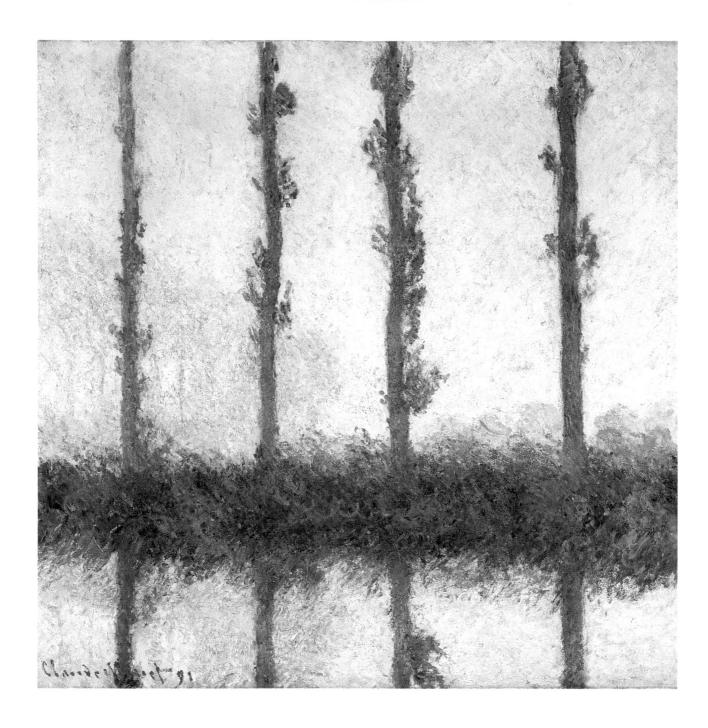

that this work depicts a scene similar to Monet's – poplars lining a riverbank on the left and water extending from the foreground into the distance.

It was not only these "avant-garde" artists who were interested in the decorative. The issue was equally central to mainstream painters at the time. The once-heralded Albert Besnard, for example, was able to gain a considerable following in the 1880s and '90s and an important commission to decorate the Pharmaceutical College in Paris with his toned-down version of Impressionism. Jules-Paul Laurens was hailed in the last decade of the century as one of the most promising artists of his time because of his allegiance to history painting and his ability to adapt that traditional genre to mural decorations.

Plate 35. (cat. 41) *Poplars,* 1891. The Metropolitan Museum of Art, New York Detail, plate 35 >

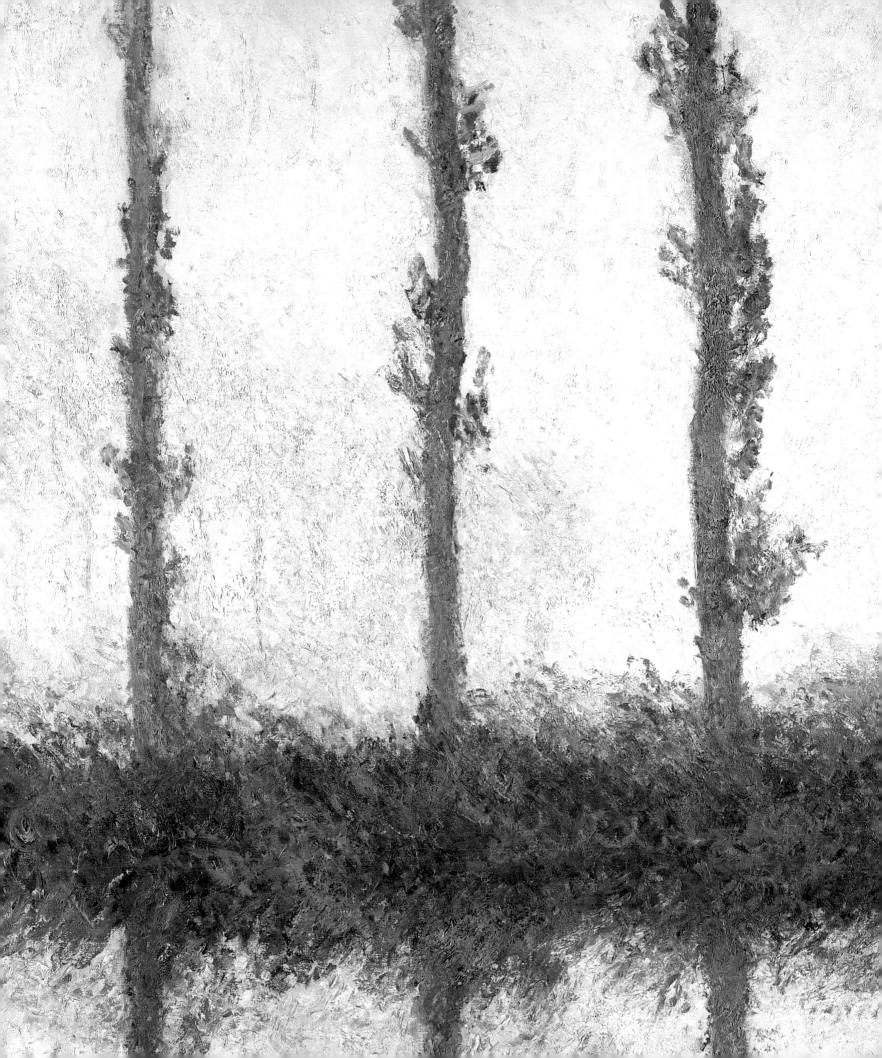

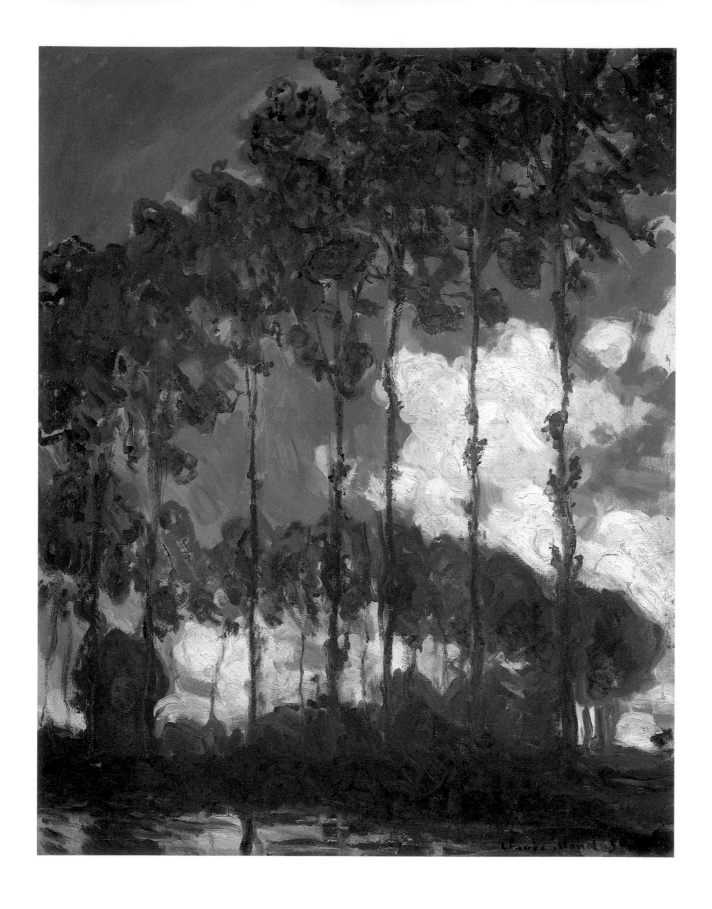

116 Plate 36. (cat. 35) *Poplars. (Banks of the Epte.)*, 1891. The Trustees of the Tate Gallery, London

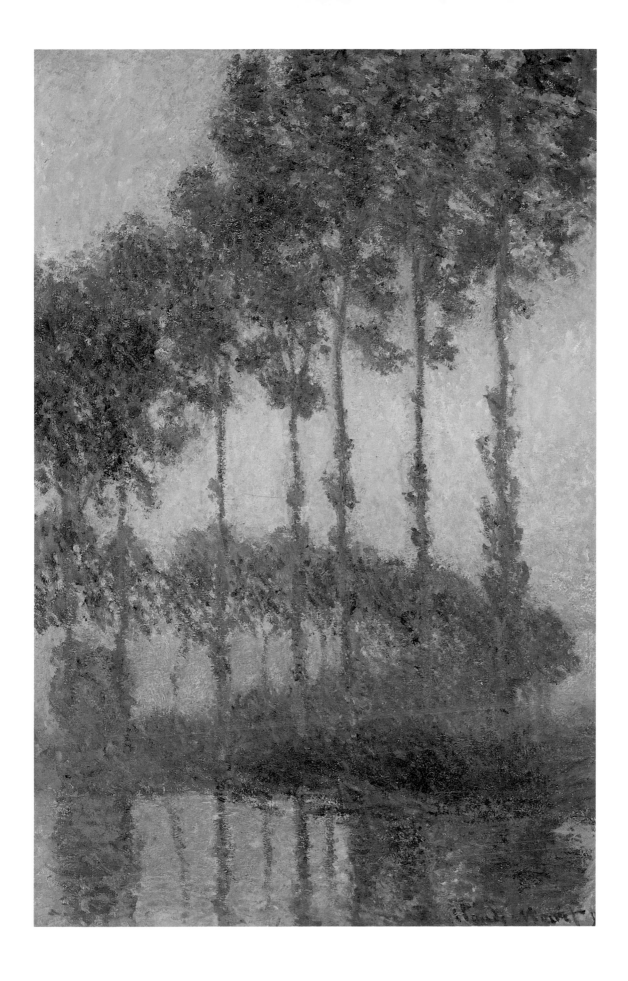

Plate 37. (cat. 32) *Poplars. (Banks of the Epte. Twilight.)*, 1891. Private Collection, New York

117

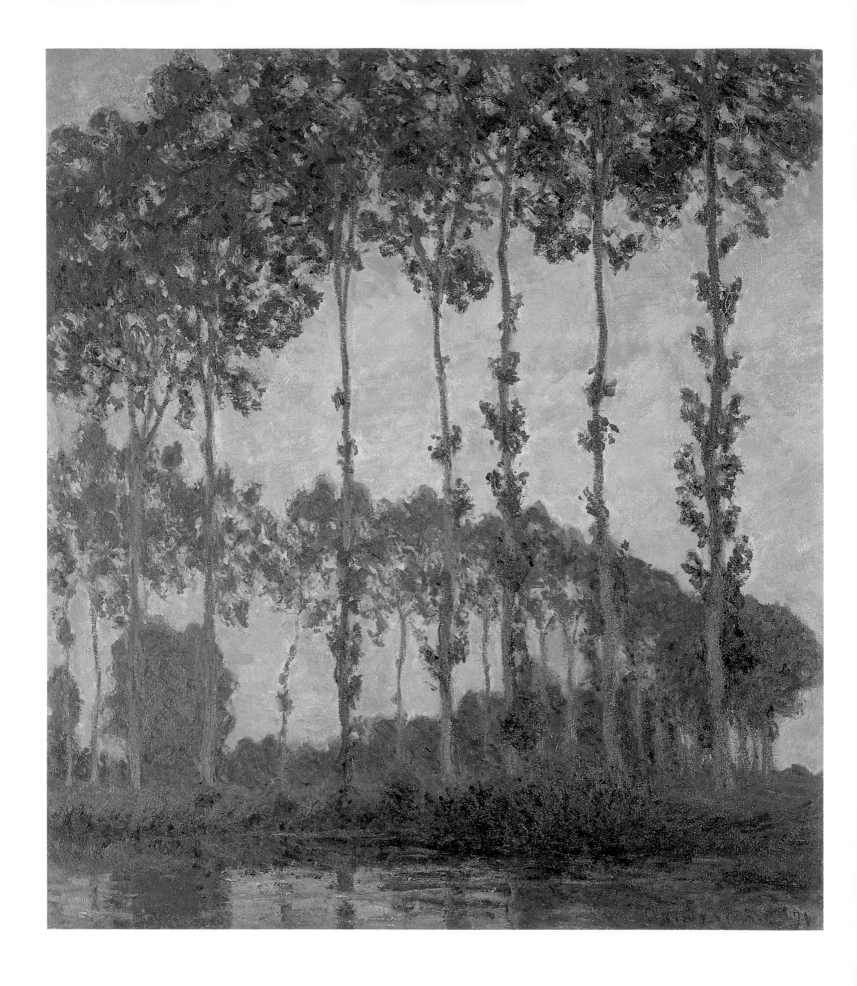

118 Plate 38. (cat. 34) *Poplars. (Banks of the Epte. Cloudy day.)*, 1891. Ise Cultural Foundation, Tokyo

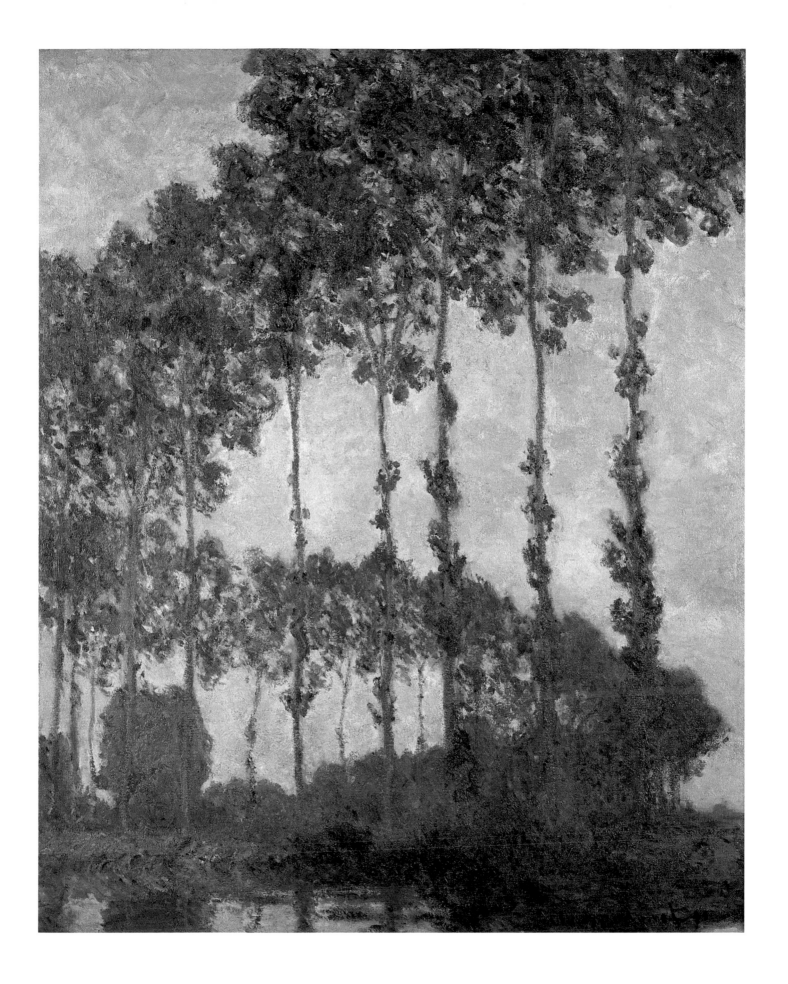

Plate 39. (cat. 31) *Poplars. (Giverny. Cloudy day.)*, 1891. MOA Museum of Art, Atami

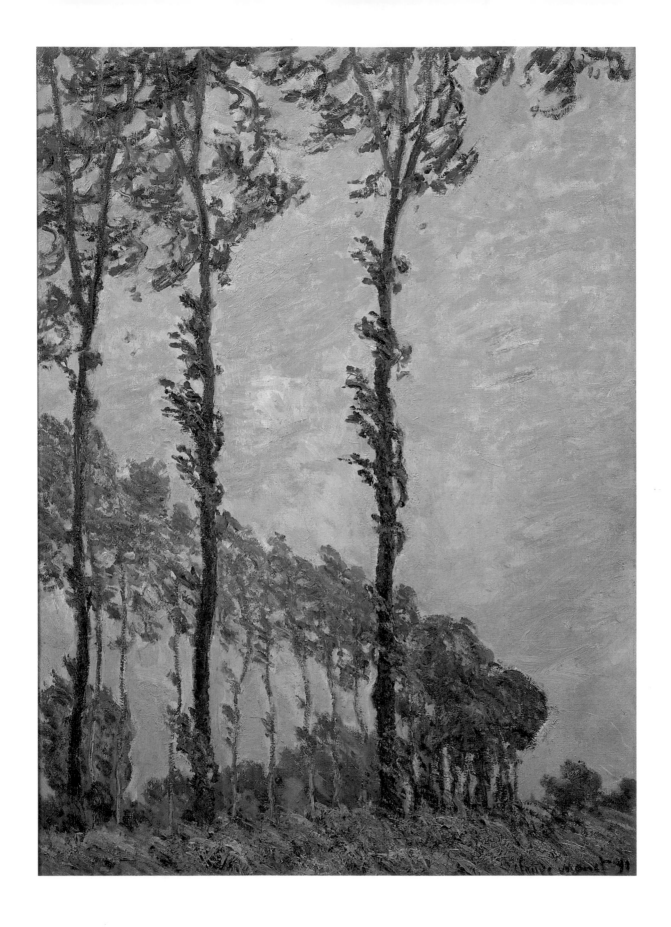

Plate 40. (cat. 36) *Poplars. (Wind effect.)*, 1891. Collection Durand-Ruel, Paris

The most prominent figure in the field, however, was unquestionably Pierre Puvis de Chavannes, an artist whom even Monet admired. Puvis was invited to participate in nearly every major civic project that the government sponsored in the 1880s and '90s; by the early part of that last decade, he had gained such an international reputation that Boston commissioned him to decorate the main staircase of its new Public Library.

Why was there such a concern about the decorative in *fin-de-siècle* France? On the one hand, it could be understood not as a sudden development but as the natural evolution of 19th-century ideas about the nature of painting. From Delacroix to Manet, artists and critics had been attempting to liberate the discipline from being merely a way of describing the world to becoming more of a vehicle for personal expression. As it evolved toward greater subjectivity, artists took greater liberties with its vocabulary, permitting line and color, for example, to have a life independent of form, and treating its essential artifice as an asset to be emphasized, not a liability to be disguised. In the 1860s, Zola defended Manet's art as being merely nature seen through a temperament, but by 1890 Maurice Denis was claiming "that a picture – before being a battle horse, a nude woman, or some anecdote – is essentially a plane surface covered with colors assembled in a certain order."[10] The differences between these opinions are critical. In Zola's formulation, great art involved an individual's deep engagement with the world. For Denis and his circle, such art meant decorative art, because for them it was the highest form of expression, the manifestation, as Albert Aurier put it in 1891 in his celebrated article on Gauguin, "of an art at once subjective, synthetic, symbolic, and ideistic."[11]

In addition to formal and theoretical developments, the concern for the decorative in the late 19th century can also be seen as the natural evolution of France's involvement with decorative projects, in the most general sense of the term, since the Middle Ages. The 19th century itself witnessed an enormous amount of time and money devoted to such undertakings, beginning with Napoleon I's many building programs and continuing through Napoleon III's transformation of Paris, all of which required legions of painters to decorate the interiors of the new structures that arose. The reconstruction efforts after the Franco-Prussian War also spawned ambitious beautification projects, right up to the end of the century. In addition to the Palace of the Legion of Honor and the Pantheon, there were dozens of civic buildings in the capital and its suburbs, as well as in other major locations in France, which high-minded officials wanted to endow with decorative painting.

This continuing interest in the decorative extended to all aspects of interior decoration, from textiles and *boiserie* to designs for fireplaces and furniture, resulting in the development during the Second Empire and Third Republic of an increased demand for luxury goods. Enthusiasm for the decorative arts also led to the founding of the Union Centrale des Arts Décoratifs in 1864, a privately funded organization that became the mouthpiece for industrial manufactures in France in the latter half of the century. This surge culminated in the establishment of a Department of Art Objects in the Louvre in 1894 and a separate Museum of French Furniture in 1901.[12]

Partly because of the continued pressure of the Union Centrale, partly due to the expanded market

for luxury items, leaders of the State-sponsored Salon decided in 1890 (the same year as Maurice Denis's pronouncement about the nature of painting) that they would amend their by-laws which had been in place for centuries and include a section devoted to the decorative arts. Gaining admission to the Salon meant that the decorative arts had achieved a measure of parity with what had traditionally been considered superior artistic practices. As with the interest in decorative painting, this development can be understood as the logical culmination of the pressure that had been placed on the accepted hierarchy of aesthetic endeavors during the 19th century. It can also be seen as a natural outgrowth of the fact that the decorative arts had always been featured alongside the other so-called higher arts in the Universal Expositions from 1851 onward.

These seemingly predictable developments, however, were by no means inevitable. They were actually the result of a complicated process that was spurred on by a host of interrelated factors. Chief among these was France's concern about its cultural status. In the realm of the decorative arts, that concern had been expressed as early as mid-century, when visitors to the First Universal Exposition in London had seen the advances made by English craftspeople who had been trained at special English schools and who had been nurtured by the Victoria and Albert Museum, which had been established primarily for the decorative arts. Similar cries went out after each subsequent international exposition. Those that were uttered in 1889, however, were even more urgent than those that had come before, as they were sparked by the widely recognized fact at the time that France was indeed losing her position as the preeminent producer of decorative art objects. That change in status was particularly clear in the realm of furniture-making, for between 1873 and 1889 France's export of furniture declined by one-third, while her imports grew fivefold. When combined with the increased industrial strength of her rivals and the tenseness of the international scene, made evident by political flare-ups like the Schnaebelé Affair of 1887 when Germany was almost ready to cross the Rhine again, many observers in 1889 felt that France was approaching a crisis situation, a suspicion that the Universal Exposition unfortunately confirmed. Thus, despite sweeping pronouncements that French officials made about the country's superiority in the world, people such as Mirbeau saw the exposition as "the last flash of a moribund society, the supreme cry of an agonized civilization," a view that he proclaimed on the front page of *Le Figaro* in July 1889.[13]

The government would never have agreed with him, of course, but it was astute enough to initiate stopgap measures in areas where it could. Its most active intervention came in the realm of the decorative arts, where the exposition more than anything else had brought to light the fearful strengths of France's rivals. To discover the reasons for this intimidating situation, official delegations were sent out to research artistic institutions in England, Germany, Austria, Russia, Italy, Belgium, and Portugal. The government also initiated in-house studies of its own manufactures and debates on what the country should do.[14] All of the information that was gathered affirmed that there was indeed considerable talent beyond France's borders, and that foreign governments encouraged such talent by devoting substantial amounts of money to this area. In addition to England's Victoria and Albert Museum, France had to

contend with the fact that Germany had founded a museum of industrial arts in 1881. France's competitors also motivated their crafts people to excel by rousing them with the moral incentive to usurp France's position. Prince Wilhelm of Germany had announced his agenda in his remarks at the inauguration of his new museum: "We defeated France on the battlefields in 1870. . . . Now we want to defeat her in commerce and industry."[15]

Germany was not the only country to use nationalism as a rallying cry for the arts. According to Maurice Vachon, a member of one of those French delegations, it was a pervasive motivation. "Every country in Europe wants to return to its traditions," he observed in 1891. "To do so, they each hunt for their oldest and most hidden treasures." Those treasures and traditions yielded traits particular to each country. Thus, Vachon asserted, instead of "the fusion that economists and philosophers predicted, the fusion toward which our trains and steamships would have pushed us, . . . particularism triumphs. . . . Each country can now only fight via the special character of its productions, its indigenous art," which meant that the art of each country now expressed "the most inveterate nationalism."[16]

To a greater or lesser degree, of course, nationalism had always been a factor in each country's cultural production, but in the years following the Universal Exposition, the years of Monet's triumph, it became both more blatant and more urgent. Given the keenness of the competition and the stakes of preeminence, it was almost a programmed response. Little wonder, then, that the French government underwrote the revitalization of the decorative arts in the 1890s and supported so many arts programs during the decade, from new murals for its municipal buildings to the restoration of architectural monuments, particularly those from the 18th century. Such measures reaffirmed France's values and traditions and collectively contributed to the nation's quest to reclaim her cultural supremacy. There were even calls for an exhibition of French art from the Middle Ages and the Renaissance simply to prove that the country's output during those times rivaled that of the Italians and the Flemish. That the decorative arts were admitted to the annual Salons in Paris at that time was thus not merely the result of evolutionary factors or narrow market concerns but intimately bound up with the larger issues of cultural competition. As Roger Marx put it in his Salon review of 1892, "It is nothing less than a question of harvesting a heritage . . . of glory that the decorative arts had assured France during the course of [the last] eight centuries."[17]

The same was true of the increased interest in decorative painting. There were obvious benefits that city and state governments could derive from having civic buildings adorned with new works, especially if they promulgated French values. But there were other advantages that an emphasis on decoration could yield. For example, it appeared to many people, Roger Marx included, that by exploring the possibilities of the decorative, artists might be able to devise new forms of expression and thereby lead French painting out of the doldrums in which it had languished for too long. Such an exploration would also lead French artists back to the nation's patrimony, as some of her greatest artists in the past had been some of her greatest decorators – Le Brun, for example, and Watteau. Even Poussin was considered a decorative painter in the early 1890s.[18] By combining their achievements with the advances

that had been made in the 19th century, France's painters could emerge once again as world leaders.

As with her concern about her decorative arts, France's worry about her status as a country of decorative painters was heightened just after the Universal Exposition by an explosion of interest in another foreign culture – Japan. So infatuated with things Japanese did France become in the early 1890s that Oriental influence was evident in all areas of French cultural production from poster-making to dress designs, prompting Marx to assert in 1891 that "it would be foolhardy to try to enumerate the ways in which it manifests itself."[19] This surge in interest was stimulated by several developments. One of the most important was a huge exhibition of Japanese prints, illustrated books, and painted scrolls that Siegfried Bing, one of the great promulgators of Japanese culture, had been invited to organize for the venerable École des Beaux-Arts in April and May of 1890. Containing an unprecedented number of works – 725 prints, for example, and 421 illustrated books – drawn from the best private collections in France, the show was the largest gathering of this material that had ever been mounted. It was also the first time that France officially embraced the art of this foreign culture. Coming a year after the opening of the private Musée Guimet, which contained an extensive collection of Oriental art, and the Universal Exposition, which had featured a sizable Japanese section, the exhibition at France's premier art school attracted thousands of people, including Monet, Mirbeau, and Pissarro. It was also a huge critical success, sparking the interest of collectors and dealers ready to capitalize on the expanding market. Even Durand-Ruel staged a major exhibition of prints by Utamaro and Hiroshige in 1893. The French government contributed to the frenzy as well, acquiring a substantial number of Japanese works of art during the decade. The Louvre purchased its first pieces in 1892.[20]

An enthusiasm for things Japanese was not new to France. It paralleled what had occurred in the late 1860s and early '70s when the nation had first become enthralled with the East. Marx's observations, in fact, sound remarkably similar to those made in 1873 by Ernest Chesneau, who described how, after the Universal Exposition of 1867, Japanese artifacts "invaded the European market. Their bronzes, ceramics, boxes, colored paper, even toys, were in thousands of shop windows in Paris. The vogue was such that even the decorations on everyday pastries were borrowed from Japan."[21] According to Chesneau, France's luxury goods, fashion, and art quickly fell victim to this invasion, with mixed results. Certain painters, for example, were reproducing scenes of contemporary life in Japan from what they could glean from the prints available in Paris, while decorative artists were merely imitating Japanese motifs. Chesneau's concerns were strictly nationalistic. He did not want to see French art become so compromised that it would lose its particular character. Happily, he noted, some painters and decorative artists were able, "more intelligently, to adapt aspects of Japanese art to our own flora and fauna, and to natural forms that belong to our climate." Chesneau was referring primarily to the Impressionists, who were often associated with Japanese art, although not always favorably. As early as 1880, for example, one writer claimed that they had gone too far and had "exploited [Japanese art] without conviction, as if it were a commodity for the senses."[22]

Whether viewed positively or not, the conjuncture of Impressionism and Japanese art is critical to

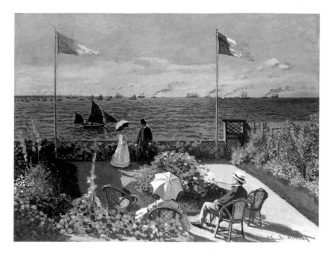

Fig. 50. Claude Monet, *The Terrace at Sainte-Adresse*, 1867. [W.95]. The Metropolitan Museum of Art, New York.

Fig. 51. Claude Monet, *Meditation*, 1870-71. [W.163]. Musée d'Orsay, Paris.

Fig. 52. Utagawa Hiroshige, *Numazu, Yellow Dusk*. From *Fifty-three Stations on the Tokaido*. Museum of Fine Arts, Boston.

understanding Monet's *Poplars*. For as strongly as these pictures speak about the decorative in painting, they also represent the culmination of Monet's interest in the Orient, which had begun in the first decade of his career. Like his former Impressionist colleagues in the 1860s, he had admired the bold, unmodulated color of 18th- and 19th-century Japanese woodblock prints when they first appeared in Paris curio shops. He was also intrigued by their inventive compositions, relative flatness, and lack of chiaroscuro modeling, and appreciated the fact that their subject matter was drawn from everyday life in Japan. So enthused was Monet with these prints that he collected them avidly. By 1890, his house in Giverny was a testimony to his passion. His collection of Japanese prints filled every room that did not contain his own paintings or works by his friends. His dining room was painted two bold shades of yellow, imitating colors that Hokusai often used, and his everyday service was dark-blue imitation Japanese. Japan left its mark on the grounds as well. During June 1891, when he was in the middle of painting his *Poplars*, he invited a Japanese horticulturist to Giverny. Four days after the visit, according to Theodore Butler, "the master was completely occupied planting flowers . . . from all over the world."[23]

From the 1860s onward, Monet often incorporated formal elements of Japanese art or actual Japanese artifacts in his own painting, from the flattened shapes and bold colors of his *Terrace at Sainte-Adresse*, 1867 (which he called "my Chinese [sic] painting"), to the Japanese fan and oriental vase he placed in the background of *Meditation*, 1870-71 (figs. 50 and 51). The *Poplars* continue this dialogue, as they recall prints, such as Hiroshige's *Numazu, Yellow Dusk* (fig. 52), which Théodore Duret even claimed was the inspiration for the series.[24]

Plate 41. (cat. 37) *Poplars. (Spring.)*, 1891. Private Collection

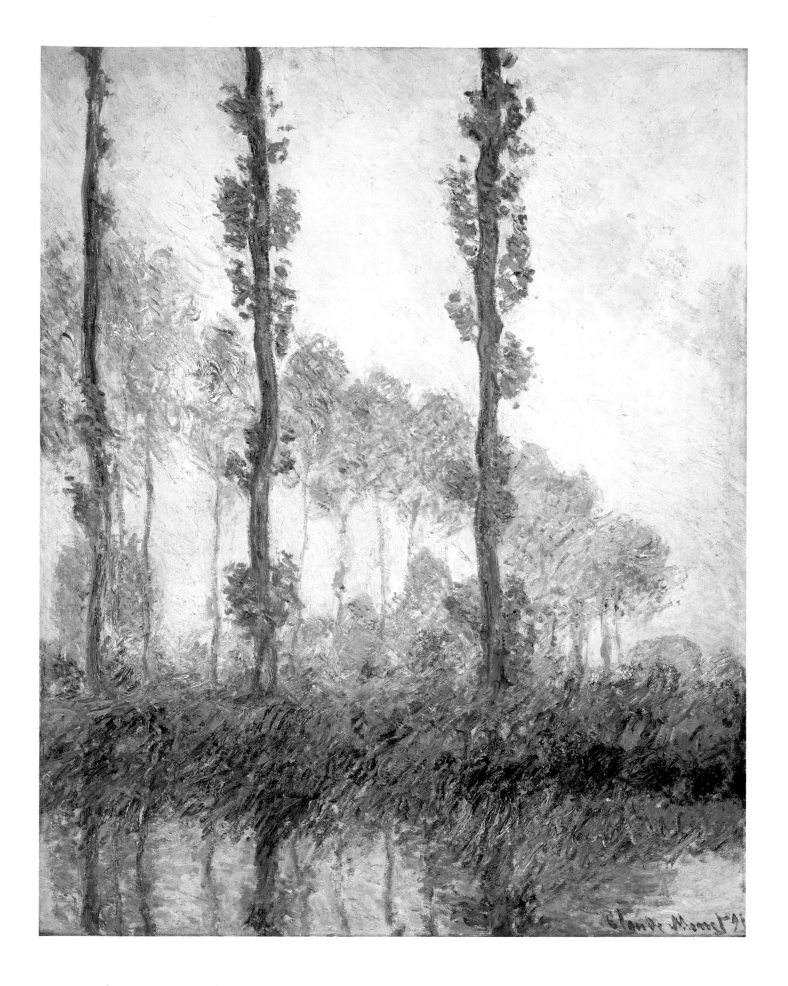

Plate 42. (cat. 40) *Poplars. (Autumn.),* 1891. Private Collection

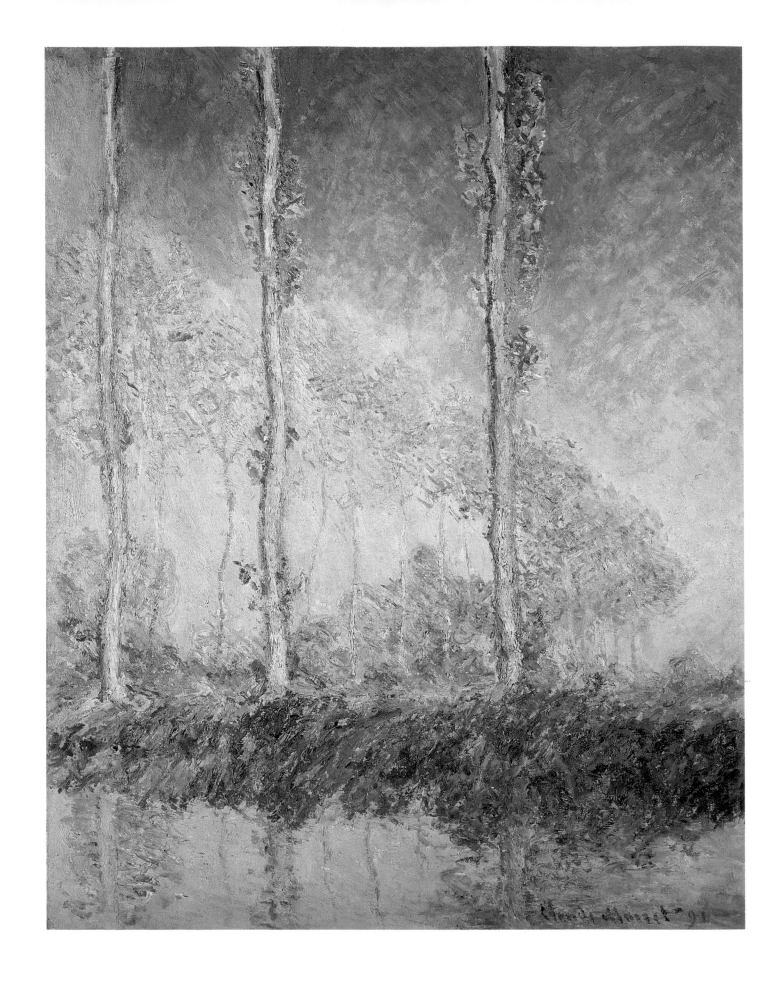

128 Plate 43. (cat. 39) *Poplars. (Autumn.)*, 1891. Philadelphia Museum of Art

Like his contemporaries, Monet undoubtedly understood Japanese woodblock prints as the product of "primitive" artists whose talents derived from their deep feeling for nature. Nature was their "constant guide . . . sole, revered teacher . . . and inexhaustible source of inspiration," asserted Siegfried Bing. In an article on Japanese landscape that appeared in 1891, Geffroy actually claimed that "all Japanese artists, regardless of their specialty, were once landscape painters" because "life in the open air [in Japan] mingles man and nature together in the Far East and sets humanity against a background of earth, sky, and water."[25]

This widely professed belief stemmed from romantic notions about Japan. Most people in France, for example, thought of Japan as an Eastern Eden, a place of such peace and beauty that it permitted the Japanese to be at one with their world. Geffroy never visited Japan, but he still could claim that "everywhere [in Japan] there are tender images, harmonious, delicately suggested colors, deep perspectives into the landscape which disappear under rosy skies; curly and foamy waves, moonrises . . . blue waterfalls, fall foliage [with] red maples, and disheveled and sumptuous chrysanthemums."[26] Promoted by travel literature and repeated in novels by Pierre Loti (one of the most popular French writers of the 1880s and '90s), this vision of Japan made the country extremely attractive. It also led people to believe that Japanese artists were more Rousseau-like and innocent than their Western counterparts. "The Japanese artist is like a sweet infant, . . . naive, and joyful," wrote Ary Renan, a longtime observer of the Far East. "He has a facility to love, observe, and laugh that the older civilizations lost in the preoccupations of the centuries. Nothing tarnishes the purity of his gaity and his expansiveness. The world is a great garden in which he plays without worry."[27]

This childlike innocence was one reason why people who thought highly of the East could claim that Japanese artists had superior powers. They were unaffected by the "progressive" developments that had so altered the West, and thus were able to penetrate the very essence of nature and render things around them in a simple, forthright manner. Freer than their Western counterparts, the Japanese artists had also been able to move beyond mere imitation because they had learned to rely on memory as well as observation. This allowed them to have more profound sensations about the world and to make artistic decisions based on aesthetic criteria, as opposed to the West's continued desire for verisimilitude. It was for this reason as well that they were seen as such gifted decorative artists, and why they would have been appropriate reference points for Monet, particularly with his *Poplars*. For as Roger Marx asserted in the same year as Monet began those pictures, "We love Japanese art because it is the expression of a supremely sensitive people, . . . because in it, all is intuitive, spontaneous, full of unerring tact and innate delicacy, and because . . . this delicacy unites the freshness of impression, the searching naiveté of the early masters, with all the subtleties and abstractions of societies that have grown old and polished by the lapse of centuries."[28]

Given French culture's vulnerability to outside influence in the early 1890s, however, not everyone looked on Japanese art so favorably. The conservative critic Alphonse Germain, for example, made this quite clear in an article that appeared in November 1891, just as Monet was harmonizing his *Poplars*.

Fig. 53. Pierre Puvis de Chavannes, *Inter Artes et Naturam*, 1890.
Musée des Beaux-Arts, Rouen.

Like many contemporaries, Germain believed that the future of French painting lay in landscape, but of a particularly refined kind, one that would "synthesize the varied effects of season, months, hours of the day, the atmosphere as well as the multiple aspects of nature."[29] He asserted that the Japanese had intuitively understood the value of this decorative landscape painting, as he described it, but that "their native inferiority left it in an embryonic state." It was therefore up to "us to . . . develop it according to our racial originality. . . . What better way," he concluded, "of transforming our sullen rooms into oases free of common care." The two artists whom Germain believed were the models to imitate were Alexandre Séon and Puvis de Chavannes, the aesthetic inheritors of Corot – "that so national a master." Although Séon had few champions beyond Germain, Puvis commanded broad-based support. Even Georges Lecomte, one of Monet's staunchest allies in the 1890s, raved about Puvis's *Inter Artes et Naturam* (fig. 53) a year prior to Germain's article.[30]

Lecomte could also express similar nationalistic sentiments when comparing Puvis's work to that of the Japanese. "How narrow and small-minded Japanese art appears in the face of [Puvis's] emotive canvas."[31] In Lecomte's opinion, "no painter in Japan has ever attained this level of artistic expression," because the Japanese, though wonderfully talented, were "incapable of representing the immateriality of an idea or the eloquence of a symbol with the materiality of color. Their schools have not produced great decorative painting, despite their instinct for color and harmony." Even their architectural monuments, Lecomte felt, "are far from the elevated eloquence of a Gothic nave or tower!"

For both Germain and Lecomte, the problem with the Japanese (and conversely the advantage for the French) was the fact that the Japanese did not endow their work with intellectual weight. "The ideal for them," Lecomte stated, "did not exist," which Lecomte found "truly pitiful." Moreover, "the Japanese did not invent any of their artistic practices." Their architecture, calligraphy, woodblock printing, metal casting, even their religion, according to Lecomte, all came from China. The *coup de grâce* for Lecomte, however, was that their frock coat came via "artistic and civilized Europe." Germain could be just as racist: "Enchanting colorists, they remain insensitive to the effects of light; master calligraphers, they are deprived of a feeling for proportions. These sculptors of delicate notes, these precious makers of exquisite trifles, lack the ability to make deep universal statements, the sign of the chosen people."[32]

Repulsive in hindsight, these remarks suggest how blinding France's ethnocentrism could be when the country was faced with stiff international competition. France, in the end, had to be better, a chauvin-

Fig. 54. Claude Monet, *La Japonnerie*, 1876. [W.387]. Museum of Fine Arts, Boston.

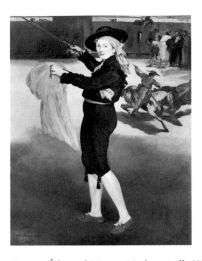

Fig. 55. Édouard Manet, *Mademoiselle Victorine in the Costume of an Espada*, 1862. The Metropolitan Museum of Art, New York.

istic attitude that was not reserved for rightist conservatives. Lecomte, in fact, was a leftist Republican. Even the socialist Pissarro could be equally pro-Western when it came to Japanese art. Although he found an exhibition of prints by Utamaro and Hiroshige held at Durand-Ruel's in the early 1890s to be "marvelous," he based his opinion primarily on the fact that the Japanese artists confirmed the rightness of his own efforts. "Damn it if this show doesn't justify us!" he told his son. "There are gray sunsets that are the most striking instances of Impressionism." He even appropriated Hiroshige, calling him "a marvelous Impressionist." And when Pissarro learned that the Japanese dealer Hayashi did not like his recent work, he derided him in disbelief. "Incomprehensible! A Japanese! They all are poured from the same mold! decidedly . . . or I am indeed blind!"[33]

Monet never made any derogatory remarks about the Japanese that we know of, although he too surely felt that their art was a way of legitimizing his own. However, he had a clear understanding of their conventions and of the differences between his work and theirs, as he made eminently apparent fifteen years earlier in *La Japonnerie*, 1876, his most blatant and most outrageous appropriation of things Japanese (fig. 54). Depicting his first wife, Camille Doncieux, in a samurai-studded kimono, standing on a tatami mat in front of a wall bedecked with fans, this life-size portrait is a contemporary costume piece, in the manner of Manet's *Mademoiselle Victorine in the Costume of an Espada* from the previous decade (fig. 55). Japan has simply replaced Spain as the country in vogue.[34] *La Japonnerie*, however, is riddled with irony. This is evident in the absurd contrast Monet establishes between the grimacing samurai Shok and the innocent Camille, who seems to be completely unaware of the soldier's sword-wielding presence. It is also apparent in Monet's treatment of Shok. Although part of Japan's warrior aristocracy, he is depicted as a midget whose left arm is curiously deformed and whose sword has either broken or fallen. The object of his ferocity is not a devil but the cat in the fan to the left; the handle of that fan points to the sheath of Shok's sword, while the cat looks directly at him. Moreover, in the fiction of the picture, the cat is as big as the little fellow, which would be sufficient cause for his concern. The fans contain other ironic notes. Just behind Camille, for example, appears a fish whose eye seems trained on either the small urchin in front of him or Camille herself. At the end of Camille's sleeve on the right another fish appears, as if the first one had just swum through the red sea of the kimono and was about to leap into the bay in the fan to the far right. Most telling are the two fans on either side of Camille that depict Japanese women. Both ladies look skeptically at Monet's wife, surprised to find a

Frenchwoman posing as one of their own, an anomaly that Monet emphasizes by having her wear a blonde wig (her hair was actually dark brown.) In addition, Camille holds in her hand a fan that is decorated differently from all the others. Tricolor in red, white, and blue, it recalls the French flag. Camille could therefore be seen as the personification of *la belle France*, a modern Marianne who has become completely enamoured of Japanese things but who, alas, appears to be unaware of what is occurring around her. The implication is that she is unattuned to what this Japanese culture really means, appropriating it merely as another article of consumption. Monet's title also suggests this criticism, for "*Japonnerie*" translated literally means "Japanese curio," although with a slightly derogatory edge. In addition, the fans he depicts are cheap, throwaway types.

Monet, therefore, was not out to blur the boundaries between East and West or to imitate Oriental art. Unlike many of his contemporaries who so avidly borrowed aspects of Eastern culture, he wanted to bend Japanese idioms to distinctly personal ends, which is why, despite all of the formal and aesthetic associations between his work and Japanese graphics, none of his paintings ever actually look like a Japanese print. Monet's forms are always far more three-dimensional, his medium more manipulated, his colors more varied, and his surfaces more integral to the effect desired. By distinguishing his work from his Eastern counterparts, Monet wanted to reaffirm his own abilities as a modern landscape painter. To have accomplished that in the face of such enthusiasm for Japanese art in the 1860s and '70s was a mark of his achievement during those decades. The *Poplars* were his way of meeting that challenge again in the 1890s.

WHEN Monet exhibited his *Grainstacks* in 1891, he had included canvases that did not belong to that series. With the *Poplars*, he decided to limit his show to the new paintings alone. Nothing would distract from their power as a group. This tactic guaranteed Monet some notoriety, as no modern landscape painter had ever so restricted a major exhibition. His decision also ensured that he would have a totally harmonious environment for his work. While emphasizing the decorative character of the series – the homogeneity of the ensemble and the uniqueness of the individual canvases – such an environment was designed to confirm Monet's versatility, inventiveness, and sensitivity to natural effects. As with the *Grainstacks*, Monet actively solicited dealers before the scheduled opening in March at Durand-Ruel's, with positive results once again. By the end of January 1892, he had sold twelve of the paintings, four to Boussod & Valadon, who promptly put them on view, a competitive move that bespeaks the rivalry among dealers for Monet's work.[35]

Although it was only on the walls for ten days, between March 1 and March 10, the exhibition of fifteen *Poplars* at Durand-Ruel's was a resounding success and attracted considerable critical attention. Mirbeau anticipated the positive response when he saw the paintings prior to the show. He found them to be "absolutely admirable, a series in which you [Monet] renew yourself . . . and . . . attain the absolute beauty of great decoration."[36] Mirbeau experienced "complete joy" in front of the series, "an emotion that I cannot express, so profound [was it] that I wanted to hug you . . . Never did any artist ever

render anything equal to it." Mirbeau felt that Maurice Rollinat "should have seen this series," because the melancholic poet had just caused Mirbeau to suffer through an evening of atrocious music and poetry that culminated in a song about poplars. "We had anticipated music that would sound like the rustling of leaves, svelte and light to express the yearning, the grace, the delicious, airy melody that is the poplar. And what did we get, my dear Monet, but verses that had a terrifying and absurd roar. It was as if the Himalayas were crumbling or trains crashing . . . I was thrown into a daze and didn't know where I was . . . The truth is that M. Rollinat has no feeling for nature." Mirbeau had no doubt about Monet's capacity in that regard, given "the beauty, novelty, and grandeur of the lines [in the *Poplar* paintings], and the immensity of the sky," all of which attested to Monet's mastery of his craft. "It is again the revelation of a new Monet. I was bowled over."

The novelty of these decorative pictures was evident even to conservative critics like Raymond Bouyer. Writing for *L'Artiste*, Bouyer admitted that Monet was able to carry the idea of variety in unity further in the *Poplar* pictures than he had in the *Grainstack* series. In his opinion, Monet was also able to develop the ornamental aspect of painting to a greater degree in these canvases, so much so that it led Bouyer to speculate about the future of French landscape art, which he saw as tending toward the decorative, toward paintings "full of allurement and nobility." He was not certain whether Monet or his Impressionist colleagues would actually be able to develop this new art, but there was little doubt in his mind that Monet in particular had greatly contributed to the groundwork that was then in place.[37]

After seeing the new exhibition, Georges Lecomte was certain that "decorative beauty ought to be the distinctive sign of our era in the general history of art" and that Monet was one of the leading proponents of its development. "Finally, the vigorous talent of M. Claude Monet, who for a long time limited himself, but with what power of evocation! to the rendering of the fugitive intensities of ephemeral natural effects, seems more and more to abstract the durable character of things from complex appearances and, by a more synthetic and premeditated rendering, to accentuate meaning and decorative beauty." Like Mirbeau, Lecomte affirmed Monet's deep attachment to nature, insisting that the artist's desire to describe the world "is never sacrificed to decorative preoccupations."[38] This was an essential point, one that distinguished Monet's pursuit of the decorative from the multitude of possibilities, and which set his efforts apart from the more prosaic achievements of some of his contemporaries. For Lecomte, as for Mirbeau and other Monet supporters, the only valid use of the decorative was "as the logical development of the true," by which he meant a way for artists to translate the decorative qualities of nature into art. Any other use was to be condemned. Thus, he railed against those artists such as Maurice Denis who "cover canvases with flat tones that do not at all restore the luminious limpidities of the atmosphere, that do not at all give the envelope of things, the depth, the aerial perspective . . . [Such artists] concern themselves with expressing faith by plastic means and, on behalf of religion, they sacrifice the essential plastic qualities [of painting]."[39]

Monet's other supporters were quick to make this same point. That was one of the reasons why so many like Geffroy described the fifteen *Poplar* pictures as if they were arranged in a temporal sequence

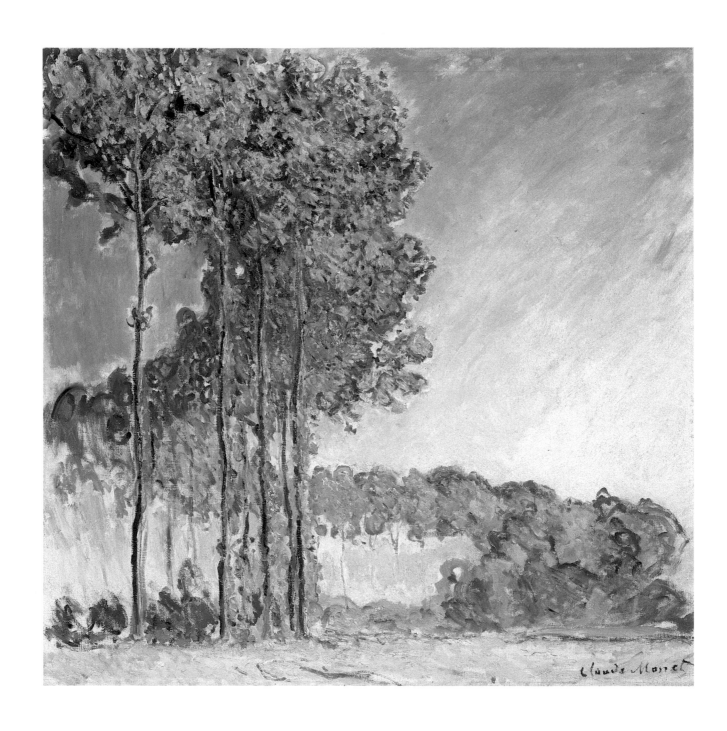

134 Plate 44. (cat. 43) *Poplars. (View from the marsh.)*, 1891. The Fitzwilliam Museum, Cambridge, England

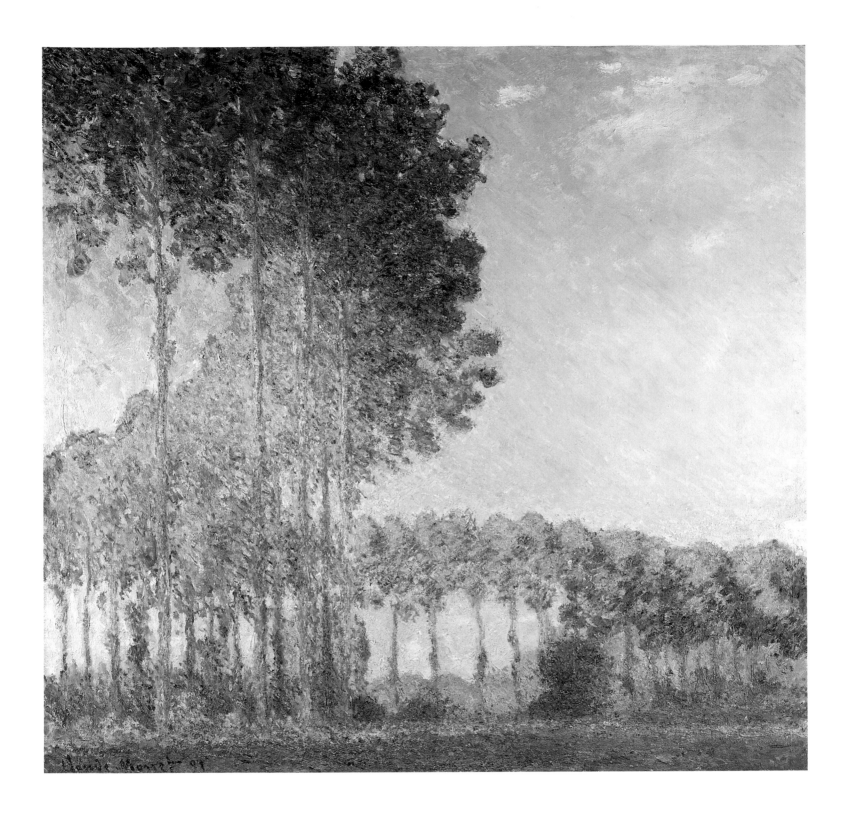

Plate 45. (cat. 42) *Poplars. (Banks of the Epte. View from the marsh.)*, 1891. Private Collection

Fig. 56. Germain Boffard, Hotel de Soubise, Salon Ovale, 1735, Paris.

Fig. 57. Charles Girault, Petit Palais, 1900, Paris.

from dawn until dusk. By leading readers to believe that they could see the sun rise in the first painting in the series, climb to its height by the seventh or eighth, and then descend to set in the fifteenth, they could emphasize Monet's allegiance to nature and thus separate him from those who were interested in the decorative for other reasons.

Nature was not the only element that would differentiate Monet's series from the work of his competitors; his use of past art would do so as well. While Denis, Sérusier, and Gauguin drew upon pre-Renaissance prototypes, and while artists such as Séon or Puvis evoked recollections of Poussin, Monet in his *Poplars* turned to the whiplash curves and decorative splendor of the rococo (fig. 56). His choice could not have been more appropriate. In addition to the formal and aesthetic parallels with his *Poplar* pictures – particularly the marriage of organic and ornamental forms – the rococo provided Monet with a distinctly national precedent, as it was a style that had first appeared in France in the early 18th century. From there it had spread to nearly every country in Europe, attesting to its appeal and to France's cultural hegemony at the time. The style also embodied quintessential French qualities – elegance, charm, lightheartedness, and grace, which were qualities that Monet invested in his work as well. Coincidently, it was a style that appropriated aspects of Oriental art, especially Chinese art, which eventually led to the development of what became known as Chinoiserie. But rococo artists turned to Chinese art only after they had established their own French idiom, much like Monet's interest in Japanese prints. They also did not allow it to overwhelm the national character of the style that they had devised. Above all, whether dealing with foreign elements or emphasizing the abstract qualities of their style, 18th-century French artists and decorators did not allow artificial forms to take precedence over natural ones, a priority that Monet clearly shared.

Monet's evocation of the rococo stems in part from his personal inclinations. His favorite painting,

Fig. 58. Anon., *The Poplar as the Tree of Liberty*, ca. 1790s.
Collection Flinck. Cabinet des estampes, Bibliothèque Nationale,
Paris.

Fig. 59. Anon., *The Light of Justice*, ca. 1790s. Collection Flinck.
Cabinet des estampes, Bibliothèque Nationale, Paris.

for example, was Watteau's *Departure from the Isle of Cythera*. His library was full of books by 18th-century authors and histories of the period. The small reading room of his house in Giverny, with its decorative moldings and blue harmonies, was a simplified version of a modest 18th-century parlor, while the house's pink stucco exterior recalled that of the Petit Trianon. Monet even wrote at a desk that was a product of the "century of style," as the 18th century was called, while his lace-trimmed shirts marked him as a man who enjoyed the elegance of that past age.

Monet's evocation of the rococo was also perfectly timed. Although it had never faded as a source for later art – the extravagance of the Second Empire is inconceivable without it – the art and architecture of 18th-century France was to become institutionalized in the 1890s in an unprecedented fashion. After a decade in which an enormous number of studies were published on all aspects of artistic production during the reigns of Louis XIV, XV, and XVI, the French government initiated a variety of measures in the 1890s that would make the 18th century an inseparable part of the country's patrimony.[40] In 1890, for example, it devoted considerable funds to the restoration of the Château de Chantilly, a key monument in the evolution of rococo architecture and interior decoration. Also in 1890, it decided to reconstitute the 18th-century rooms of the Bibliothèque Nationale that Henri Labrouste had left in shambles after his "renovations" of the building thirty years earlier. In addition, it voted to make the Louvre a line item in the national budget and increase its subsidy nearly threefold (from 160,000 francs to 400,000). Much of that money would be used to establish the Department of Art Objects and the Museum of Furniture within the Louvre, both of which would emphasize France's 18th-century heritage. The government also took it upon itself to establish Versailles as a national treasure and began the process of documenting its many riches. The culmination of this institutional revival of the rococo came in the form of the Petit Palais, which was constructed for the Universal Exposition of 1900 (fig. 57).

With its scalloped-shell entrance and opulent lobby, its encrusted surfaces and elaborate gilding, the building was an 18th-century pastiche, the absolute antithesis of the Gallery of Machines of 1889 (fig. 27).[41]

This change in taste was yet another example of France's historicism and introspection at the end of the century. It also reflects her swing to the right under her *ralliement* leaders, a course correction that was caused in part by the turbulence of the moment – the hundreds of strikes that hit major businesses throughout the country in the early 1890s and the outbreak of anarchist violence. Just days after Monet's *Poplars* exhibition closed at Durand-Ruel's, for example, the anarchist Ravachol bombed the home of a French official involved with the trial of other revolutionaries. Ravachol was arrested but a few weeks later another bomb exploded in the restaurant where he had been taken into custody, blowing the legs off the owner and maiming dozens of innocent patrons.[42] Thus, like Japan and its appeal as an Eden, the 18th century offered the disquieted country a reassuring model of social order. In fact, critics such as Roger Marx actually linked Japan and rococo France, going so far as to assert in 1891 that elegance and charm characterized both of their artistic productions in the 18th century.[43] Monet's union of the two in his *Poplar* paintings, therefore, was yet another timely way to ensure his own success.

Monet could have chosen from among any number of motifs to have made his point. That he selected the poplar is significant. For unlike the oaks of Théodore Rousseau, or the olive trees and cypresses of Van Gogh, the poplar possessed a high degree of decorative elegance. It was also a tree of such strict linearity that he could marshal it to emphasize abstract qualities as well. And as a typical rural planting, it would not only draw attention to the beauties of the countryside and reaffirm the values of close contact with nature but also suggest how something so common could become special, when viewed aesthetically. In addition, his choice revealed how each tree individually could contribute to a collective effect. These latter concerns were important because they would have partially offset the aristocratic overtones of such decorative painting, just as Monet's twill suits countered his lace-trimmed shirts and his casually arranged studio balanced his more formal Giverny reading room.

The poplar had actually been associated with these ideas ever since it had been selected as the tree of liberty during the Revolution of 1789. The reasons for this choice remain obscure, but it was most likely due to the derivation of the name from the Latin *populus*, which means both "people" and "poplar."[44] Whatever the rationale, by 1793, 60,000 poplars had been planted in France and hundreds of broadsides had been issued with the tree as a symbol of the new republic (fig. 58). The tree featured in all of the fêtes and funerals of the 1790s. One image-maker even imagined a group of them illuminated by the light of social justice, standing at the door to the Jeu de Paume where the representatives of the people first declared their opposition to the aristocrats and clergy, who struggle for survival in the waters of change below (fig. 59).

The poplar's social connotations did not die with the 18th century. Although it often was used in religious prints of the first half of the 19th century to mark grave sites of the faithful and pious, as in fig. 60, it maintained its significance as a symbol of Republican values to such an extent that 1848 witnessed

Fig. 60. Anon., *Saint Julien*, 1842. Collection Flinck. Cabinet des estampes, Bibliothèque Nationale, Paris.

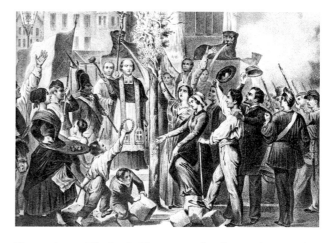

Fig. 61. Anon., *The Curé of Saint-Eustache Blessing the Tree of Liberty in the Marché des innocents in Paris, March 26, 1848*. From Roger Price, (ed.), *1848 in France*, Ithaca, 1975, 65.

Fig. 63. Anon., *The Complete and Definitive Evacuation of France by the Prussians*, 1873. Collection Flinck. Cabinet des estampes, Bibliothèque Nationale, Paris.

Fig. 62. Honoré Daumier, *The Artists*. *Le Charivari*, 19 January 1865.

Fig. 64. Anon., *The Republic confronting the elections. Le Figaro*,
30 March 1889.

innumerable poplar-planting ceremonies, one of the most celebrated of which occurred on March 26, 1848 when the curé of Saint Eustache in Paris blessed a poplar in the Marché des Innocents to symbolize the reconciliation between the Republic and the Church (fig. 61). Daumier affirmed its ties to "the people" in two lithographs, one of which, from 1865, shows a country amateur contemplating the possibility of finding a buyer for his hastily executed poplar painting (fig. 62). Novelists such as Zola and Maupassant also attest to the vitality of the tree's symbolism during the century, as they included references to its practical applications, feminine grace, and enduring capacity to fly the tricolor in various works, including *The Earth, Bouvard and Pécuchet*, and *A Woman's Life*.[45] The poplar's continued association with France, however, is made most apparent by a print that appeared in 1873, celebrating the "complete and definitive evacuation of French territory by the Prussians" (fig. 63). The print shows the Prussian soldiers marching across the landscape to their home on the distant right. The "enemy," as the caption describes the evacuating forces, were actually no longer on French land. The border to the left is demarcated by the striped column, the tomb (on which a soldier plants a French flag), and the healthy row of poplars, whose slender, symmetrical forms contrast with the more massive Bavarian oaks to the right. So ingrained was the poplar as a symbol of *la France* that tree-planting ceremonies occurred again in 1889 to mark the centennial of the Revolution, while the political media employed the poplar in advertisements for candidates running in the election that year, and in commentaries on the proceedings, as is evident from the row of trees that appears in a scene of rural France in the upper-left corner of a supplement to *Le Figaro* (whose main image is another reminder of the continuing horror of the 1870 defeat) (fig. 64). Thus, when Monet chose to paint "his trees," as he described them to Geffroy, he selected a motif that was as rich in its historical references as it was personally appealing and typical of rural France. It was yet another way to assert his position in the contemporary hierarchy and to claim his place in the annals of his country's art. Before the decade was over, he would realize those ends, not only because of his dexterity with a brush and his sensitivity to nature, but also, as the critic for *L'Ermitage* put it, "because he understood the poplar, which summarizes all the grace, all the spirit, all the youth of our land."[46]

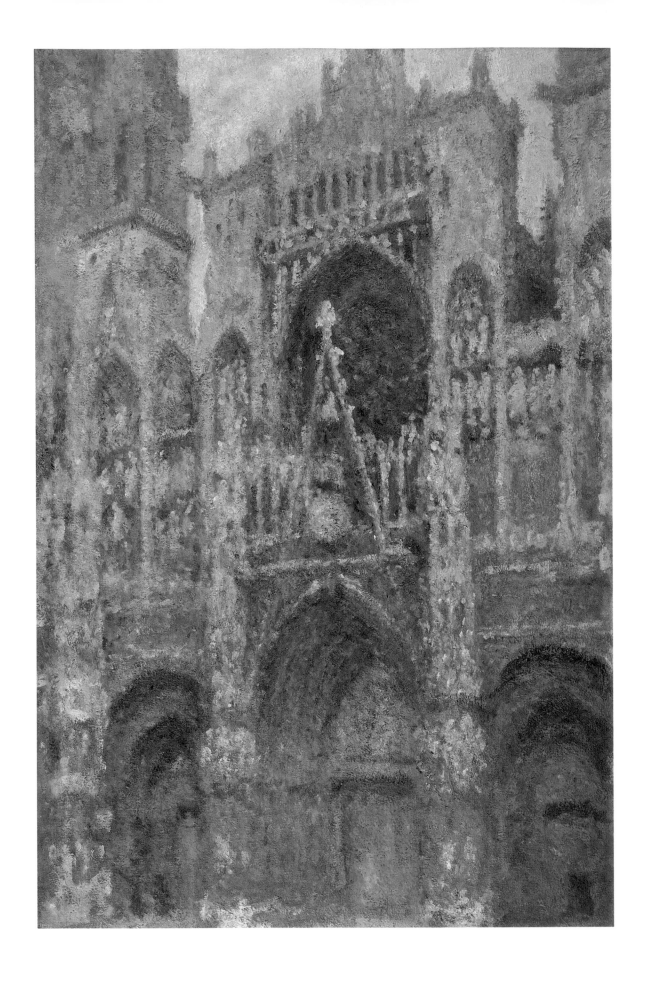

142 Plate 46 (cat. 48) *Rouen Cathedral. Façade. (Gray day.)*, 1894. Musée d'Orsay, Paris

6 *From Rouen Cathedral to Mount Kolsaas in Norway: Religious and Natural Monuments, 1892-95*

BY THE TIME the *Poplar* paintings went on view at Durand-Ruel's in March of 1892, Monet was already immersed in his next project – a series of views of Rouen Cathedral plates 46-51, 55, and 62-64. Begun some time in late January or early February of 1892, these new paintings would be unique in Monet's oeuvre. Although he had painted various buildings in the past and had even done a distant view of the same Gothic monument in the early 1870s (fig. 65), he had never focused so exclusively or so rigorously on an architectural element, whether old or new. He had also never spent so much time on a single motif. When in May 1895 he finally showed twenty of the thirty canvases that comprised the series, they caused a great sensation. The exhibition itself was something of an event, as Paris had not seen new work by Monet since the *Poplars* and they had only been on view for ten days three years earlier. Not all visitors found the series completely to their liking. Ary Renan thought Monet's handling of the medium was "strangely troubling" while Camille Mauclair felt that his colors were "exaggerated," his drawing insufficiently rigorous, and his subject inappropriate. But they were in the distinct minority, for the overwhelming number of people who saw the *Cathedrals* during the month that they were shown agreed that they were a triumph. "I am carried away by their extraordinary deftness," Pissarro told his son. "Cézanne . . . is in complete agreement . . . this is the work of a well balanced but impulsive artist who pursues the intangible nuances of effects that are realized by no other painter."[1]

After the success of the *Grainstacks* and the *Poplars*, this kind of a reaction was almost predictable, for, like his earlier efforts, the *Cathedrals* were as topical as they were accomplished. They too addressed the issue of the decorative and the health of French painting; the medium had rarely been used to achieve as much as it was made to do in these painstakingly worked canvases. The paintings were also novel in their focus on a single motif that, like the poplar, was fraught with meaning. In the early 1890s, France had witnessed a religious revival of considerable proportions, with interest renewed not only in Catholicism but also in a broad range of what Pissarro called "superstitious beliefs," including occultism and Buddhism.[2] By choosing to paint a religious structure, Monet was placing himself squarely within that discourse. A Gothic cathedral, however, was a very special subject. Once again, it was distinctly French. Like the rococo, it was born on the Île de France with the construction of Saint-Denis at a moment of national greatness and embodied significant French characteristics. Even more important perhaps, the Gothic was admired and adopted by the rest of Europe during the Middle Ages, reaffirming once more, like its 18th-century counterpart, France's cultural hegemony at the time. Unlike

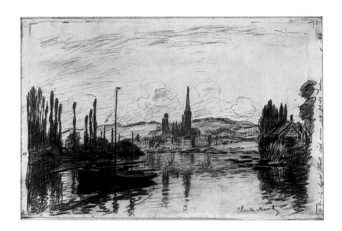

Fig. 65. Claude Monet, *View of Rouen*, 1883. The Sterling and Francine Clark Art Institute, Williamstown, MA.

Fig. 66. Claude Monet, *Sketch of Mont Saint-Michel*, early 1890s. Musée Marmottan, Paris.

the rococo, however, the Gothic was perceived in the 1890s as the product of a unique partnership involving all segments of society – enlightened rulers, generous churchmen, and the common man, who was understood to be a worthy and talented individual. Its art was also perceived to be grounded in nature. It was for these reasons that Pissarro felt such an affinity with the Gothic, although one did not have to have socialist leanings to share Pissarro's sentiments. Louis Gonse, the editor of the conservative *Gazette des Beaux-Arts*, felt this way as well. The Cathedral, therefore, was the perfect subject for *ralliement* France, a fact that was not lost on Monet. Indeed, only a month into the project, collectors who heard about the new series began putting in their orders. François Depeaux, for example, a Rouen businessman, told Monet he wanted two, one for himself and one for his city's museum.[3] When the *Cathedrals* went on exhibition, Clemenceau devoted the entire front page of his newspaper *La Justice* to an article that he wrote extolling Monet's achievement, and ended his homage by calling on President Félix Faure to go see the series and buy them all for the nation: "You are President of the Republic and the French Republic at that. . . . Why has it not occurred to you to go and look at the work of one of your countrymen on whose account France will be celebrated throughout the world long after your name will have fallen into oblivion? . . . Remembering that you represent France, perhaps you might consider endowing [her] with these twenty paintings that together represent a moment for art, a moment for mankind, a revolution without a gunshot."[4] When it came to notoriety, history proved the justness of Clemenceau's predictions, although Faure unfortunately did not heed his call. Monet's *Cathedral* paintings, therefore, were subsequently scattered throughout the world, never to be fully united again.

GEFFROY, in his essay for Monet's *Grainstacks* exhibition of 1891, implied that the idea of taking Rouen Cathedral as a subject may have occurred to Monet while he was working on those agrarian scenes. "For one year, the traveler has given up his travels, the hiker has forsaken hiking," Geffroy told his readers. "He dreamed about the places he had seen and transcribed: Holland, Normandy, the South of France, Belle Isle, the Creuse, the villages on the Seine. He dreamed as well of places he had only visited but to which he would like to return: London, Algeria, Brittany. His fancy roamed over vast expanses and zeroed in on special areas that attracted him: Switzerland, Norway, Mont Saint-Michel, the cathedrals of France, as lofty and beautiful as the rocks on promontories."[5]

It is curious to think of Monet in Switzerland, although his son Jean had lived there for a while when he was studying to be a chemist. For a landscape painter the country had obvious appeal, and for Monet there were also certain personal and historical associations, since Monet's friend and mentor Courbet had lived and worked there for the last four years of his life, dying in La Tour-de-Peilz in 1877, a renegade from his homeland. Monet eventually went to Lucerne, Davos, and Saint-Moritz, but not until 1913 and then only for pleasure, unlike Norway, where he went to visit his stepson Jacques in 1895, returning with more than twenty-five canvases. Monet also went to Mont Saint-Michel, in the early 1890s. Although this too seems a bit odd for someone dedicated to rural sites, the 12th-century abbey church hovering on its rocky perch high above the sea was a dramatic combination of the human and the natural that had attracted pilgrims and tourists for hundreds of years, as it still does today. The motif did not sustain Monet's interest, however, as he returned to Giverny with only two small pencil sketches of it (fig. 66). That Monet considered this motif at all, however, is significant, as it attests to his broad interest in historic France and to the nation's medieval heritage, making his choice of Rouen Cathedral all the more poignant.

His choice was as practical as it was informed. Rouen was only sixty kilometers from Giverny and just twice that from Paris, thus easily accessible by train from either location. It was a city that Monet knew well, for he had gone there often when he visited his brother Léon, who lived in one of its western suburbs. He had painted aspects of the town on several occasions in the 1870s and was thus familiar with its offerings. Choosing Rouen also ensured Monet a certain guaranteed recognition, as the city was well known in France. One of the largest in Normandy, it had served as the province's ancient capital and, in the Middle Ages, as the site for coronation ceremonies for the kings of France. It had also been where Jeanne d'Arc had been burned at the stake. In the 19th century, it had gained a reputation for its booming industries and active port and for its own form of Haussmannian renovation, as new streets had been rammed through its older sections in the 1870s and '80s and modern amenities had been added to its core, to many people's regret, Pissarro among them. Although transformed, the city had managed to retain many vestiges of its medieval past, for which it had gained considerable renown over the centuries. In fact, its medieval architecture was the primary source of its tourist appeal and the main preoccupation of 19th-century books on the city.[6]

In addition to many fine examples of domestic and commercial architecture of the Middle Ages,

Fig. 67. Bachelay, *View of Rouen from Mont-Sainte Catherine*, 1768. Cabinet des estampes, Bibliothèque Nationale, Paris.

Fig. 68. Claude Monet, *Rouen from Mont-Sainte Catherine*, 1892. [W.1314]. Private Collection.

there were more than a dozen Romanesque and Gothic churches in Rouen. Monet chose to paint the Gothic Cathedral of Notre Dame. Besides being centrally located in the old section of the city, Notre Dame was Rouen's largest and most impressive structure, dominating the horizon and tourists' attention (fig. 67). Although not considered a masterpiece by medieval scholars then as well as now, the Cathedral received due accolades because it was one of the oldest Gothic churches in the province, one of the most varied and picturesque, and one of the most original in its details. Moreover, it was so integrated with the older buildings of the city that it easily conjured up images of the medieval past for authorities of the period as well as for less knowledgeable visitors. Its distinction also derived from the fact that it contained nearly the entire history of the Gothic style, from its early beginnings in the 12th century to its perpendicular splendor of the late 15th and 16th centuries, as the façade was built during that 400-year span.[7] Given its appeal, the Cathedral had attracted dozens of French painters and printmakers as well as some of the greatest figures in English art, including Turner and Bonington, long before Monet decided to paint it. Thus, when he focused his attention upon it, he was placing himself in a long and distinguished tradition.

Monet followed many of the leads that his forebears had established. He explored sites in and around the city, for example, doing three paintings and several drawings from the same hills of Saint Catherine where Turner had stood for some of his engravings and where Puvis had set his *Inter Artes et Naturam* (figs. 68 and 53). He also did at least one painting and nearly half a dozen drawings of some of Rouen's medieval streets, which had attracted virtually every artist who had worked in the city (fig. 69). And when rendering the façade of the Cathedral, like his predecessors, he opted most often for a southwestern vantage point, near where the rue du Petit-Salut entered the square in front of the church

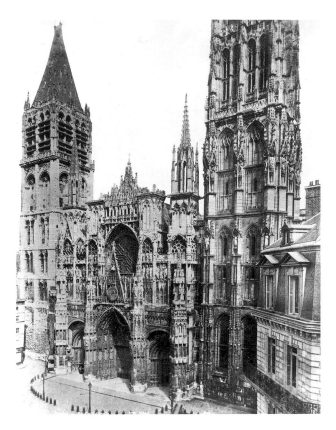

Fig. 69. Claude Monet, *Sketch of la rue de l'épicerie, Rouen.* [1892]. Musée Marmottan, Paris.

Fig. 70. Anon., Photograph of Rouen Cathedral, nd. Cabinet des estampes, Bibliothèque nationale, Paris.

(figs. 70, 71, and 74). This location had several benefits. It allowed the artist to see the largest amount of the façade and appreciate the way the structure rose as it moved from the shorter Tour d'Albane on the left to the taller Tour de Beurre on the right. (The change in scale also suggested a temporal progression, as the Tour de Beurre was the more recent of the two towers.) Most important for Monet perhaps, the site afforded the best view of the magic that the sun performed on the façade. In the early morning, for example, as in plate 47, the light rises up from behind the Tour d'Albane like a golden apparition, casting the church into a bold silhouette. After gradually enveloping the pinnacles, the light cascades down onto the façade, illuminating it in successive levels until the early afternoon, when the whole structure appears to glisten, as in plate 48. Shadows then creep up from the darkening square while the upper reaches of the Cathedral receive the last rays of the setting sun, as in plate 49.

Most artists who had rendered the building had made it appear to be an awe-inspiring structure, as evident from fig. 71. Monet took a different approach, tending to suggest its humbler, organic qualities, as Pissarro had done when he had worked in Rouen in the early 1880s. In many of Monet's drawings, for example, fig. 72, the church appears to be a vital kind of growth that rises and falls, trembles and swells. In others (fig. 69), it seems to emerge from out of the older houses of the city, as if the product of a great communal effort, just as it appears to be the place where the myriad touches of paint coagulate in the views from Saint Catherine (fig. 68).

These suggestions are made more explicit in one of the first paintings Monet did when he began the series in 1892 (plate 50). Unlike most of the *Cathedral* pictures, this impressive canvas concentrates not on the façade but on the Tour d'Albane. Although the tower dominates the scene, it is carefully related to the surrounding structures. It seems to grow out of the roof of the smallest house in the foreground

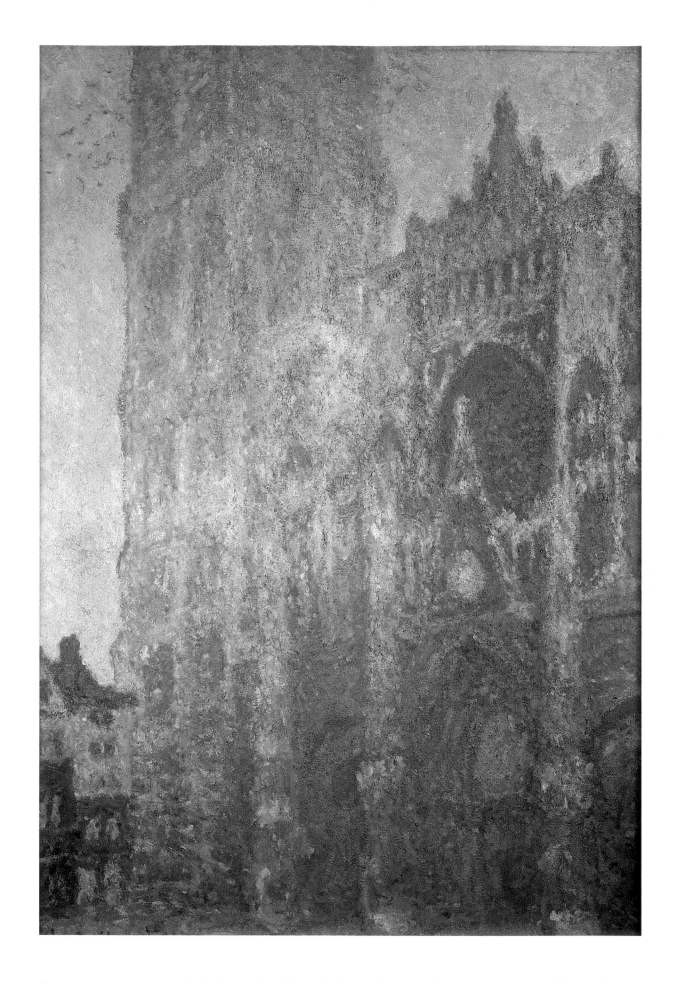

148 Plate 47. (cat. 52) *Rouen Cathedral. Façade and Tour d'Albane. (Morning effect.)*, 1892-94. Musée d'Orsay, Paris

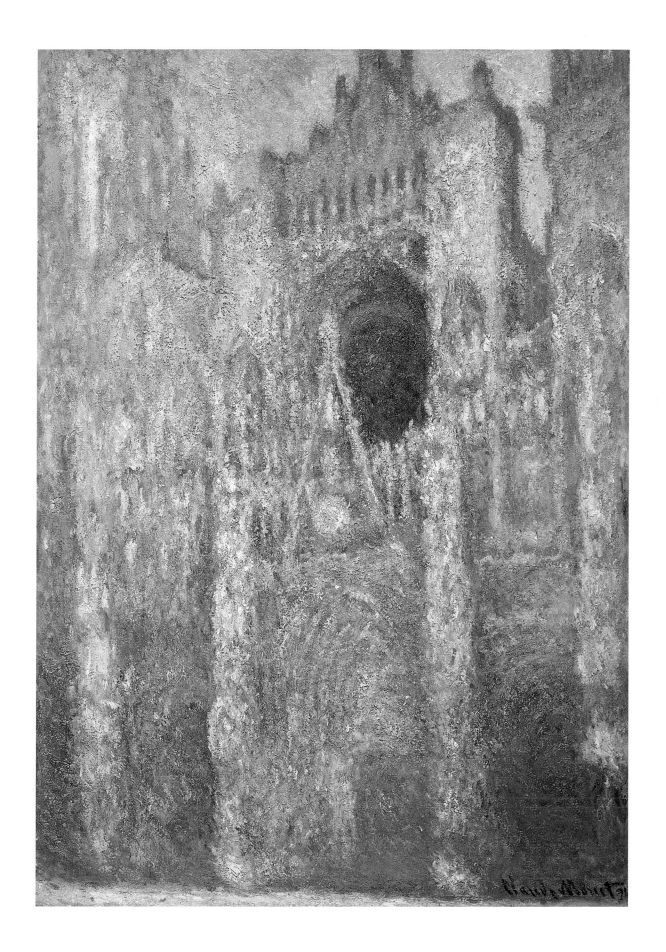

Plate 48. (cat. 56) *Rouen Cathedral. Façade.*, 1892-94. Sterling and Francine Clark Art Institute, Williamstown, Massachusetts 149

Fig. 71. J.M.W. Turner, *Rouen Cathedral*. From *Liber Fluviorum or River Scenery of France*, London, 1837, plate 38.

Fig. 72. Claude Monet, *Sketch of facade of Rouen Cathedral*. [1892?]. Musée Marmottan, Paris.

and to gain a measure of support from the other Lilliputian buildings that press up against it, their collective presence and triangular roofs acting like miniature buttresses. The tower also juts out on the right, which makes its base seem larger and more connected to the town. The houses themselves seem like appendages to the church, an impression that derives not only from their close proximity to the tower and their similar patches of lichens but also from the way that they rise up in successive stages like the tower itself. In addition, a section of the roof of the house on the right meets the tower just where the horizontal ribbing of the tower's first level appears to descend. The double gables on the right and colored glass in most of the windows also link the structures, as the former echo the tower's paired windows, while the latter recalls the stained glass that was such an important feature of the Cathedral.[8]

The significance of these carefully considered elements is enhanced when we realize that to paint this picture Monet had moved around behind the Tour d'Albane and the west façade to a small courtyard known as the Cour d'Albane (fig. 73). The nave of the Cathedral was to his left, as implied by the extension of the tower on that side, while other houses and narrow streets lay to his right. He had thus chosen to paint the one place where the town and its Gothic structure truly came together, and he did so twice, repeating this same view in another canvas in the series.[9]

The Cathedral's ties to the town and the sense of the building as an organic form are suggested throughout the series – in the houses that Monet includes in eight of the thirty canvases, for example, in the birds that appear in two of them, and in the people that he added in another.[10] It is also apparent

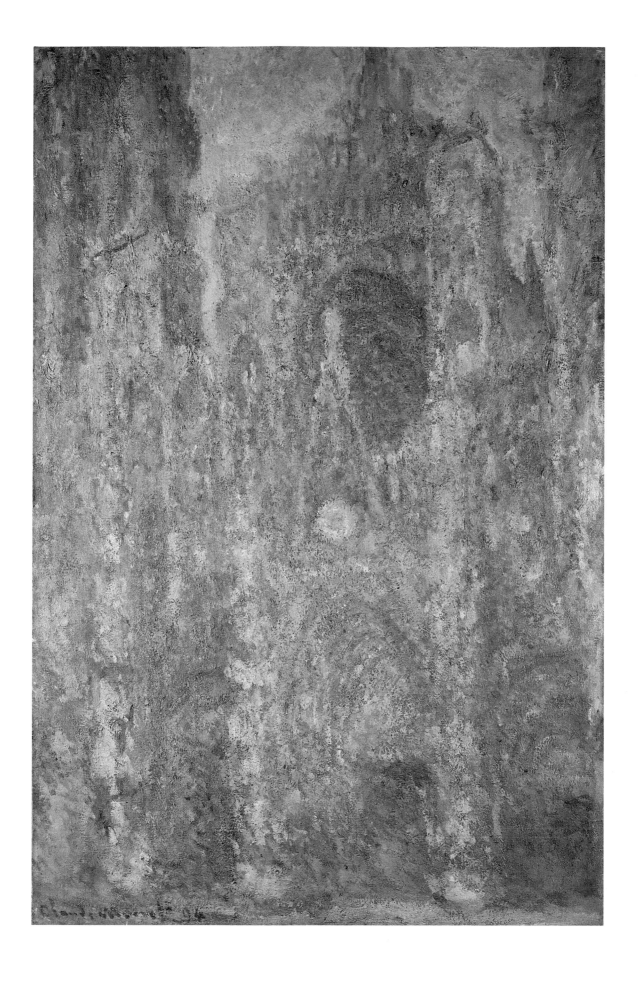

Plate 49. (cat. 51) *Rouen Cathedral. Façade*, 1892-94. Galerie Katia Granoff, Paris

Fig. 73. Anon., *View of the Cour d'Albane*, nd. Cabinet des estampes, Bibliothèque nationale, Paris.

Fig. 74. Anon., Photograph of buildings on the square in front of Rouen Cathedral, nd. Cabinet des estampes, Bibliothèque Nationale, Paris.

from his concentration on the façade itself, with its full range of Gothic styles. For as with the movement of light, one could actually read the passage of time in this façade and observe the multiple ways in which medieval craftspeople had met the challenges of their various moments in history, just as Monet was attempting to do with those that he faced when he began his *Cathedral* series.

WHEN Monet began these paintings, he was staying in the Hotel d'Angleterre and working in an apartment that he had rented on the second floor of a building opposite the Cathedral. He left Rouen on February 13, 1892, less than two weeks into his project, and went home to Giverny, apparently because he was not feeling well. When he returned on February 24, he established his studio not in the same apartment but in the front rooms of a draper's shop several doors down on the square (fig. 74). Not being directly across from the Cathedral, Monet now saw his motif on an angle (which is how it appears most often in the series). He was quite happy with the space, telling Alice the day after he had moved in that he was "very commodiously installed" and had even begun two paintings of the Cathedral in full sunlight. Although his enthusiasm never diminished, it was often countered by profound doubts about his undertaking. "Good God," he told Alice on February 25, the day after he had returned, "what work this Cathedral is! It's terrible."[11] Over the course of the nearly three months that he stayed, he would often remark that he was giving himself a lot of trouble, a condition that was caused as much by the weather as by the complexity of the motif. "I am working hard," he informed Durand-Ruel in early

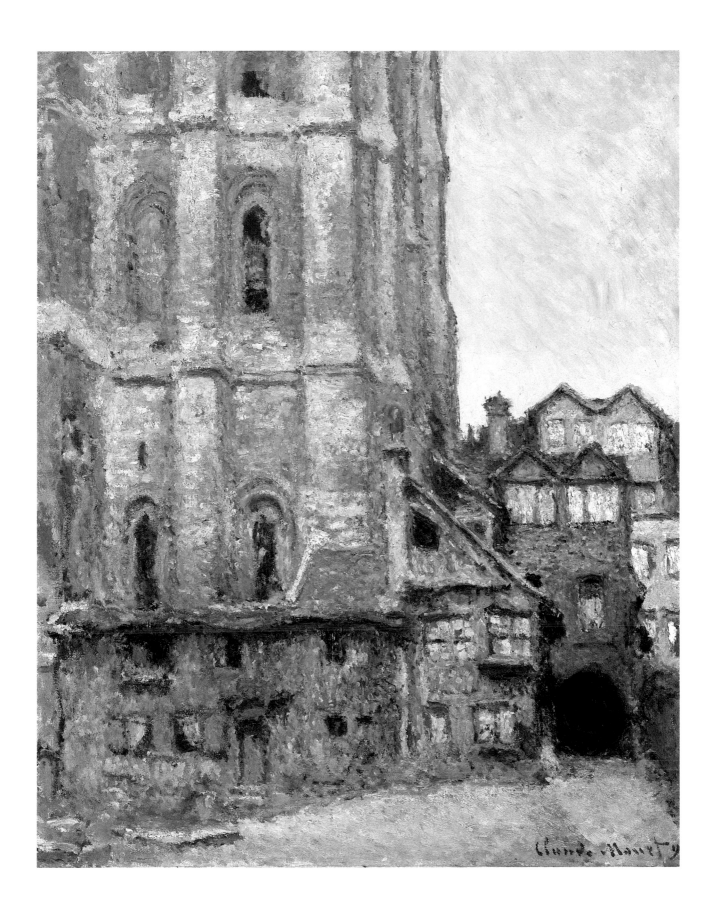

Plate 50. (cat. 47) *Rouen Cathedral. Cour d'Albane*, 1892-94. Smith College Museum of Art, Northampton, Massachusetts

153

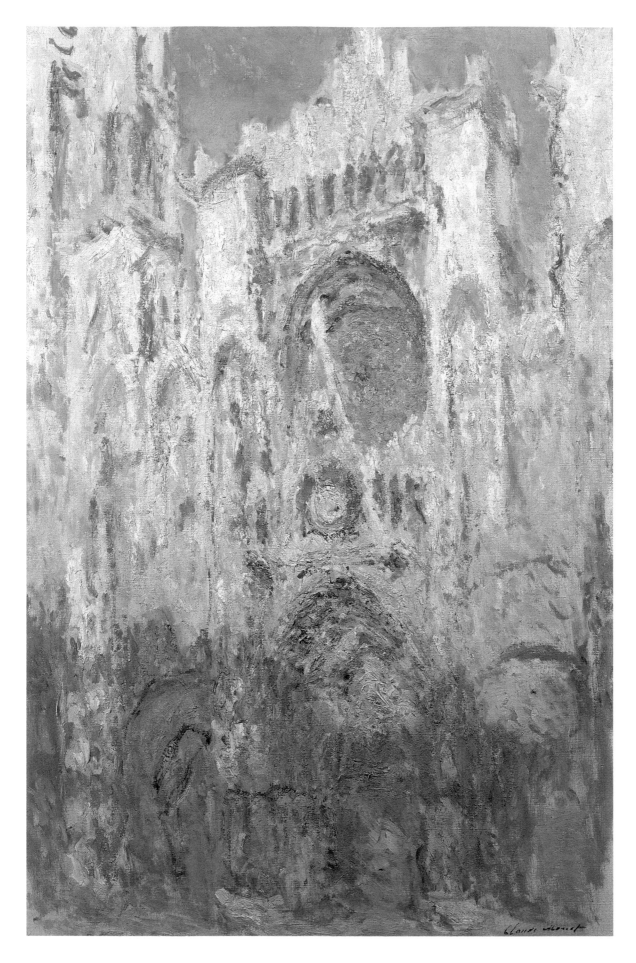

Plate 51. (cat. 50) *Rouen Cathedral. Façade. (Sunset.)*, 1892-94. Musée Marmottan, Paris

March. "What I have tackled is enormously difficult but at the same time of really great interest. Unfortunately, the weather is deteriorating, which is going to upset me." He predicted the coming of rain when he announced to Alice that he had seen the moon encircled by two large rings, "which doesn't portend anything good."[12]

Despite these concerns, and a cold that he continued to nurse, work progressed well enough for him to feel at the end of March that he had finished at least two sunlit views. But then came the first of what would be a series of almost schizophrenic reversals. The day after he announced his progress to Alice, he wrote her to say that he had "transformed all of the sunlit views; the die is cast, although it is not something that I am pleased about. If the good weather continues, I can make them into something, but if there are new interruptions, I am done for and will have to content myself with finishing my two or three gray views." Surprisingly, this setback did not discourage him. "I will do the impossible and it will work," he asserted.[13] Over the next ten days, he became more divided in his assessment of his efforts. April 3, for example, was "an excellent day again. Each day I add and subtract something that I had not even known how to see before. What a difficulty, but it's coming along. Several more days of this beautiful sun and a good number of my canvases will be saved." In the very next breath, however, he cried, "I am broken, I can't do any more and I had a night full of bad dreams, something that has never happened to me before." His nightmares were about the Cathedral: "It fell on me [and] seemed to be pink or blue or yellow." Six days later, he felt he had established a routine that would combat any variance in the weather. "I have such a singular way of working now," he told Alice, "that I do as I may." While that gave him a measure of confidence, it did not always produce the best results. "Things don't advance sensibly," he continued, "primarily because each day I discover something that I hadn't seen the day before. . . . In the end, I am trying to do the impossible." In mid-April, he returned to Giverny, "absolutely discouraged and unhappy with what I have done. I do not even want to unpack my canvases, or see them for a long time," he complained to Durand-Ruel.[14]

Although such comments may have been intended to keep his dealer at bay, they clearly were prompted by the difficulties the series posed, difficulties that are evident when the unique, unfinished version now in the Musée Marmottan (plate 51) is compared to any of the completed canvases. This wonderfully fresh painting reveals Monet's dexterous handling of the medium and his inventive use of color, even though it is the product of only several painting sessions. It attests as well to his ability to make the brush act as both a stylus to describe the Cathedral and as a wand to create the illusion of light and atmosphere across its façade. Despite its freedom and sophistication, however, the painting is crude in comparison to the finished works, whose surfaces are incredibly encrusted and whose forms are at once forcefully asserted and subtly denied. In these finished canvases, the age-old battle between line and color, draftsmanship and painterly verve is taken to a new level, while Monet's analysis of light and its effects on form is pushed well beyond all of his previous efforts. Little wonder, therefore, that even he would feel that his pictures were only "obstinate encrustation[s] of colors, and that's all." "That is not painting," he cried, and, by most traditional criteria, that was true.[15]

The canvases that Monet brought back with him from Rouen in April 1892 were not left in their cases for too long. In fact, enough people must have seen them by early May to make him feel that he had to invite Durand-Ruel to Giverny for a viewing . "Although I have decided not to sell a single one of them," he warned the dealer on May 11, "I would not want you to be the last person to see them."[16]

Monet did not work on or mention the pictures again until the following February, when he returned to Rouen to continue the series. In fact, he did very little painting between April 1892 and February 1893. Like the period in 1889 when he stopped work to organize the subscription for the *Olympia*, this second uncharacteristic lapse was partly a product of what he described to Durand-Ruel as the "deception" of the Rouen campaign. In a letter to Alice he asked, "What drives me to persist in researches that are beyond my strength?" It was also due to certain personal events in his life. His step-daughter, Suzanne Hoschedé, was married to the American painter Theodore Butler in July 1892. Initially, Monet had opposed the marriage on the grounds that Butler was not known to Alice or himself and had not properly presented himself to them. Monet was also upset that Butler was an American, and worse still, a painter! "Sacrebleu! . . . to marry a painter, if he can't do anything else, it's stupid, certainly for someone like Suzanne." So enraged did Monet become when he first learned of Suzanne's interest in Butler that he threatened to sell his Giverny estate and move his extended family elsewhere. He soon realized that Suzanne truly loved the American and he finally condoned their union.[17]

Even more momentous than this wedding was Monet's own marriage to Alice, which likewise occurred in July 1892, only four days before Suzanne's. This union was undoubtedly prompted by Mme Hoschedé's desire to "regularize" the family for Suzanne's nuptials, since she and Monet had not felt the urge to marry after Ernest Hoschedé's death a year earlier. If Monet were Suzanne's official stepfather, he would be able to escort her to the altar and give her away in proper bourgeois fashion, which he did. All of this took its toll, however, as Monet admitted to Durand-Ruel in September 1892, when he finally tried to finish several paintings that people had been demanding for some time. "Excuse me for not having written for so long, but as you may have suspected, we have had a fair number of disruptions in our life which normally is so regular and peaceful. All of this has affected work which I am only just taking up again and which is making me very melancholic. You know how I am when I stop painting. As much as I am eager to begin, I am pained to start up again."[18] So pained was he that he felt incapable of starting anything new until late December, struggling all autumn simply to finish canvases that were in his studio. This worried him, but he tried to be optimistic. "I am full of enthusiasm and truly hope that this long rest will serve me well." When he finally began again at the end of the year, the hiatus made itself apparent. "Not having worked in so long," he told Durand-Ruel in late January, "I only painted bad things that I had to destroy." It was only at the end of these labors "that I succeeded in finding myself again. The results – just four or five canvases and they are far from complete. But," he added, "I do not despair about being able to take them up again if the cold weather returns."[19]

The four or five canvases that he referred to became more than a dozen by the time he left for Rouen in February 1893. The largest number of these concentrate on the Seine, which had partially frozen that

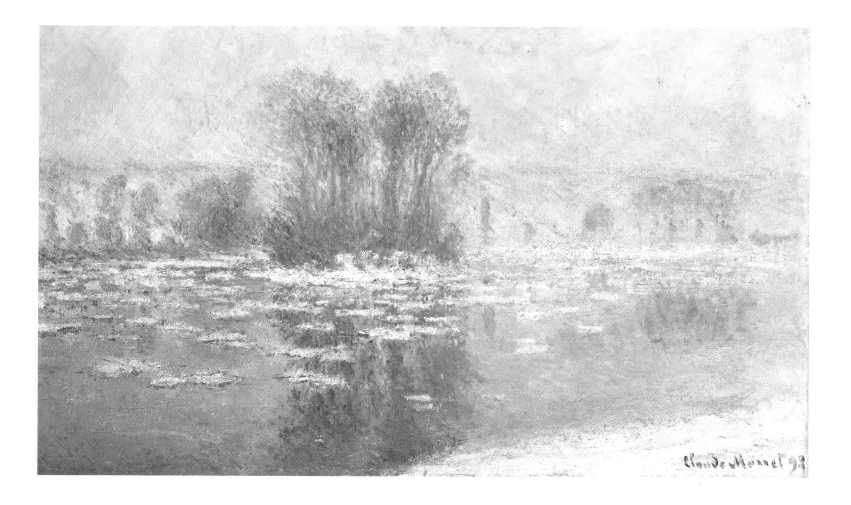

January (plates 52-54). Vaguely similar to paintings that Monet had done in the winter of 1879-80, when a similar cold had frozen the river, these *Ice Floe* pictures are what one might expect from someone who had not been challenged in quite a long time but who was determined to reinvigorate himself, even to the point of painting outdoors in temperatures that were well below freezing. They are at once elegiac and soothing, appropriately familiar in their composition and handling while striking in their coloring and their chilling atmospheric effects.

Monet put these paintings aside to return to Rouen exactly one year to the month after his first bout with the Cathedral. Obviously, he wanted to have the same light and weather conditions that he had had in 1892. He was able to gain access to the first apartment that he had rented (from which he would

Plate 52. (cat. 44) *Ice Floes. (Bennecourt.)*, 1893. Private Collection

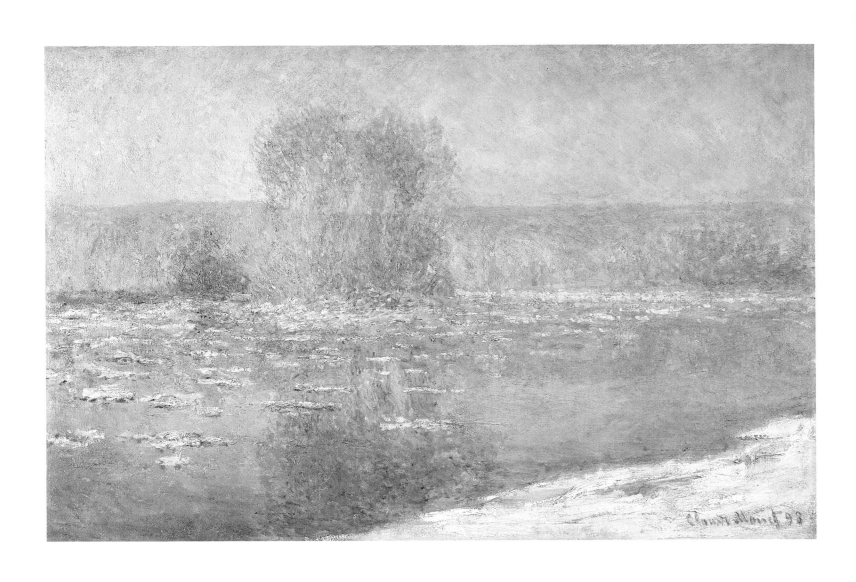

158 Plate 53. (cat. 45) *Ice Floes. (Bennecourt.)*, 1893. Private Collection

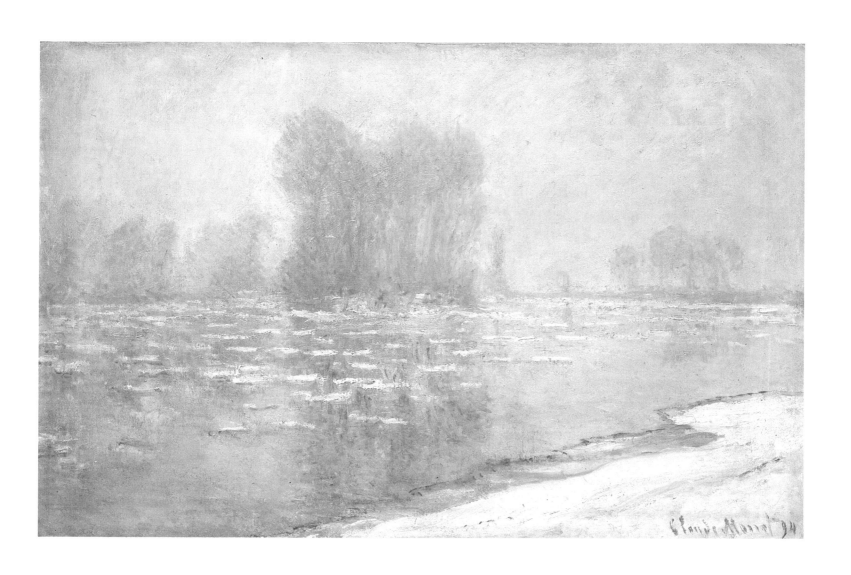

Plate 54. (cat. 46) *Ice Floes. (Morning haze.)*, 1893-94. Philadelphia Museum of Art

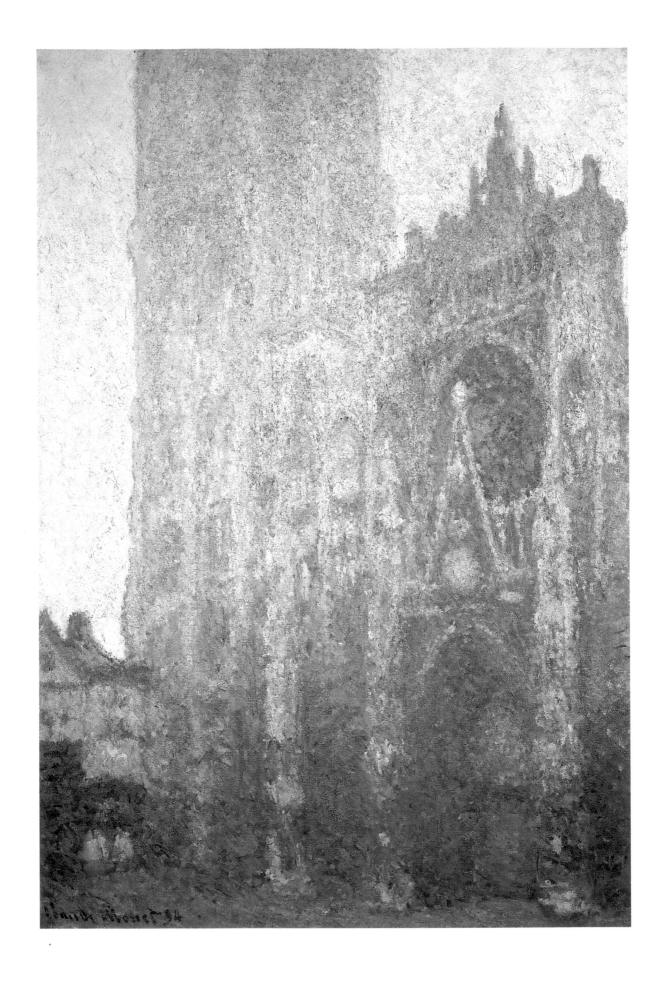

Plate 55. (cat. 53) *Rouen Cathedral. Façade and Tour d'Albane. (Morning effect.)*, 1894. Collection Ernst Beyeler, Basel

produce at least two head-on views), but the draper's shop was apparently unavailable. So too was an optician's store next door. With the Rouen collector Depeaux in tow, he managed to secure ideal space in a building that was just a few doors down from the draper's shop and that was in the process of being remodeled. It afforded Monet a similar, though slightly more angled, view of the Cathedral and the opportunity to include the houses that nudged up against the foot of the Tour d'Albane (plate 55). It was from this vantage point that Monet worked for most of the three months he spent in Rouen.

Monet was quite pleased with his new location. He immediately began two canvases and felt that he "had gotten right back into my subject." Giving his work first priority, he declined social invitations from his brother and from Depeaux. He even told Alice that it was better if she and the children did not come for a visit until his canvases were more advanced. "I had too many setbacks last year," he reminded her. After eight days, however, he was still working on the same two paintings that he had begun when he first arrived. "Good God!" he exclaimed to his new wife. "This confounded Cathedral is tough to do," although he admitted "I am very happy that I made the decision to come back, as it will be better [than last year]."[20] By the end of the month, he was not so sure. "I am furious at myself," he wrote Alice. "I am doing nothing of value: I don't know how many sessions I have spent on these paintings, and do what I may, they don't advance. . . . It's depressing." He felt the same way a month later, although by then he was sometimes working on as many as eight canvases at a time. By the end of March, he had to tell Geffroy what the critic had heard before. "Alas, I can only repeat this: the further I go, the more difficulty I have rendering what I feel; . . . anyone who claims to have finished a picture is terribly conceited."[21]

As March gave way to April, Monet had to admit that conceit was one of his own problems. "I can certainly account for my state [of mind]. I am a proud person with a devilish self-esteem; I want to do better and I want these *Cathedrals* to be very good. [But] I can't [get them to that point]." By the time he returned to Giverny, which occurred sometime between April 13 and 18, he was feeling much better. "I am less upset than last year," he told his friend Paul Helleu, "and I believe that several of my *Cathedrals* could be all right."[22] But that confidence faded as the months elapsed. Monet did not mention the paintings again until February of the following year and then with much less satisfaction. "Your son must have told you that he found me a bit discouraged," he wrote to Durand-Ruel on February 20, 1894. "I am just at the point of not wanting to exhibit the *Cathedrals*, which I have not been able to [finish] to my liking. Between now and the end of the week, I will write you to say yes or no but I think it will be no. Time is going by and I have not made any headway."[23]

Monet went back and forth about the exhibition until the beginning of May, when he finally made his decision. And as he predicted, it was negative. "I have decided not to have an exhibition this year. I am sorry to have strung you along, but it is really not in the cards at the moment. I am in the thick of work and . . . prefer not to stop." He repeated this excuse a few days later to Helleu and used it again near the end of the month. Thus he was not just trying to avoid his dealer. He had other ideas in mind, as he suggested to Durand-Ruel on May 21. He had decided that he wanted a show in October or

November that would include the work that he had begun that spring, which would make it "more varied and complete." This show too, however, would not materialize; and by January 1895, Monet was off to Norway, taking at least one of his *Cathedral* paintings with him.[24] It was not until May 1895, more than three years after he had begun the series, that the *Cathedrals* were finally exhibited.

Why was this the case? Was Monet purposefully stalling, or were there extenuating circumstances?

First of all, Monet did not actually have to exhibit his work; he had plenty of clients ready to buy whatever he produced. Second, he was truly concerned about his new series. In addition to having problems judging their state of finish, he must have been worried about their impact. For despite the success of the *Poplars* and their distinctiveness as a group, he did not want to exhibit the *Cathedrals* alone. Given the contemporaneous interest in Catholicism, he may have been concerned about how they would be interpreted if seen without other work. After such a long absence from the public arena, he also had to reassert his range and versatility and do so impressively. That meant he had to show diverse pictures and a large number of them. The problem was thus a practical one: he did not have enough time to complete the work that he had begun in the months after his return from Rouen.

His program during that period had been extremely ambitious; he may have started as many as fifteen canvases, perhaps even more. To paint the largest number of these, Monet returned to one of his favorite motifs – the Seine – rendering it at Port-Villez near Vernon, just as he had the previous year (fig. 75). He also painted the church of Vernon half a dozen times in varying conditions of atmosphere and light (fig. 76). This too was a familiar subject, as he had painted the church from the same spot nearly ten years earlier (fig. 77). The differences between the earlier and later views are enormous. Gone is the clear light of the earlier picture, the attention to specific details, and the importance of the watery reflection. These have been replaced by an evocative atmosphere that fills the entire scene of this later view, causing all the forms to become vaporous specters and the surface of the picture to assert itself as a tapestry of colored touches.

Not all the Vernon canvases from 1894 are quite as subtle as this version, nor are they all as reminiscent of the effects that Monet had been able to devise in his *Cathedrals*. But they are all undoubtedly related to his experience with Rouen's Gothic monument. For in addition to being familiar, and being dedicated to Our Lady, the Vernon church was built during the same four centuries as the Rouen Cathedral. It was, in effect, the country counterpart to that major urban structure. Monet emphasized its rural qualities in these views from 1894 by isolating the church more than he had in the earlier painting of 1883, diminishing the size of the white house on the right, and expanding the foliage on that side – to such an extent that it wraps around the church, which formerly was quite independent. He also underscored the relationship between the Vernon and Rouen series by including all six of the former in the exhibition of 1895, grouping them together in the first room of the show, and having the *Cathedral* pictures follow them in the second and third rooms. That he wanted to postpone the show thus stands to reason, as he wanted very much to be able to complete these canvases.

Fig. 75. Claude Monet, *The Seine at Port-Villez*, 1894. [W.1375].
The Trustees of the Tate Gallery, London.

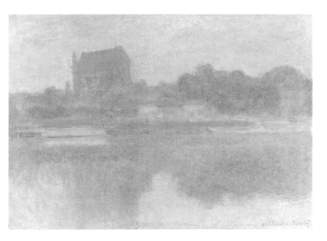

Fig. 76. Claude Monet, *Church at Vernon*, 1894. [W.1391].
Private Collection, Switzerland.

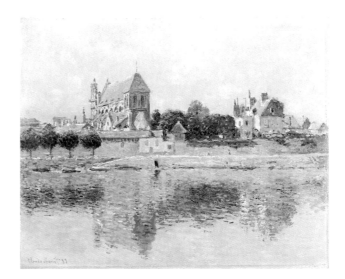

Fig. 77. Claude Monet, *Church at Vernon*, 1883. [W.843].
Private Collection, United States.

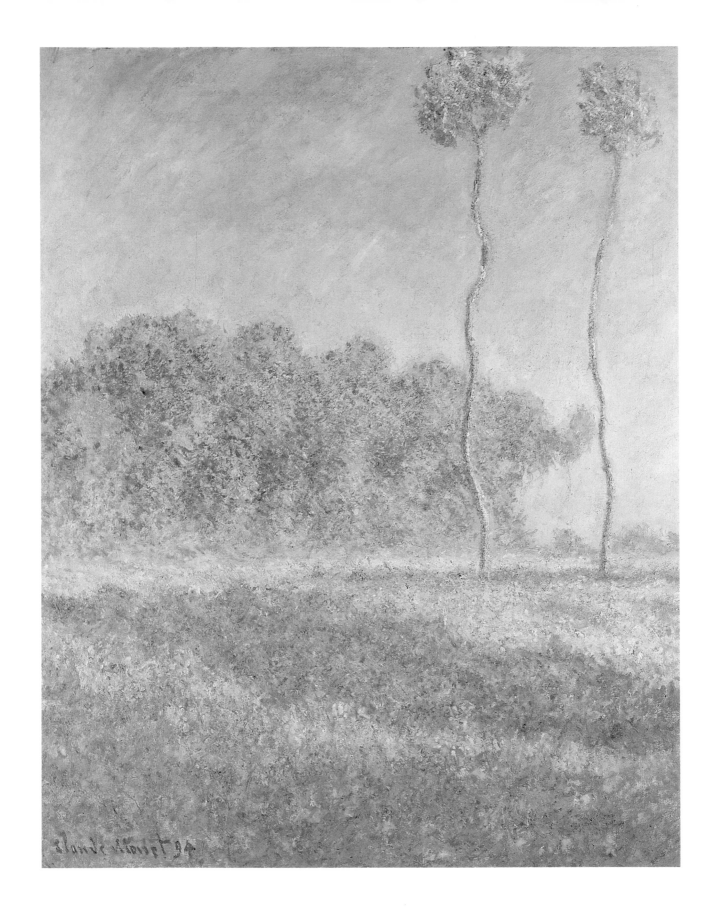

Plate 56. *Spring Meadow. (Giverny.)*, 1894. Private Collection

The most challenging group of paintings that Monet began after returning to Giverny was not the Vernon pictures but rather four views of meadows dappled with the brilliant pastel light of spring (plates 56-58). Their decorative palettes and trees recall the *Poplar* paintings of 1891. However, their encrusted surfaces and intricate color patterns attest to Monet's experience with his *Cathedrals*. So dazzling and sensuous are these pictures that they appear to be due to the amount of time that he had spent in Rouen, a notion that his letters support. When he first began his *Cathedrals*, for example, he told Alice that "it is decidedly not my business to be in cities," and that he "disliked being closed in and not being able to walk around as much as I want." He also spoke of how he missed Giverny and how he wanted to paint it in the spring. He made these same statements during his second campaign in Rouen. "This Cathedral is admirable," he admitted to Alice in March of 1893, "but it is terribly dry and hard to do; it will be a delight for me after this to paint *en plein air*." "Giverny must be so beautiful that I dare not even think about it."[25] After working all winter to bring these *Cathedral* pictures to a close, he clearly indulged himself in the beauties of his countryside that spring, the suite of meadow pictures being the almost hedonistic result. Since Monet included three of these canvases in the 1895 show, he also must have felt pressed to complete them before finalizing his exhibition plans, just as he had with the Vernon views. They were thus one more reason to postpone the show.

Monet may have been interested in delaying the exhibition for another reason as well: to develop his market and make sure that some of the paintings that he wanted to include were sold beforehand, a tactic that he had employed in the past with great success. In this case, it was particularly important, and rather daring, because Monet decided to ask 15,000 francs for each of his *Cathedrals* – more than three times what he had charged for the *Poplars* and five times what he had set for the *Grainstacks*. Although reflecting something of Monet's ego, this elevated figure was based on how long the paintings had taken him to complete, on the toll that they had exacted, and on his sense of what the market would bear. While working on the series in 1892, for example, he had learned that one of his early paintings of Rouen had sold at auction for 9,500 francs. He was startled by this sum because, in his opinion, the painting was old and of mediocre quality. However, at the Duret sale in March 1894, his *View of the Seine at Vétheuil*, 1878 (W.528), brought 7,900 and his *Turkeys*, 1876 (W.416) reached 12,000 francs. No other works did as well (a Puvis went for 9,100 and a Degas for 7,500), but such figures surely were in his mind when he set the price for canvases from his new series.[26]

The price made Durand-Ruel balk, which led Monet to believe that other dealers would probably follow suit. He did not let this appear to bother him, however. "If no dealer takes any of them," he informed Durand-Ruel on May 2, 1893, "I will no longer worry about them being scattered and will postpone my exhibition until later in order to work in peace." Nonetheless, it must have gnawed away at him, because five days later, he told Durand-Ruel that the show was off. Undoubtedly, he wanted more time either to place pictures at this price or to devise a new strategy for getting them into private hands prior to the show. Two weeks later, he hit upon a solution. He would put aside "a certain number of

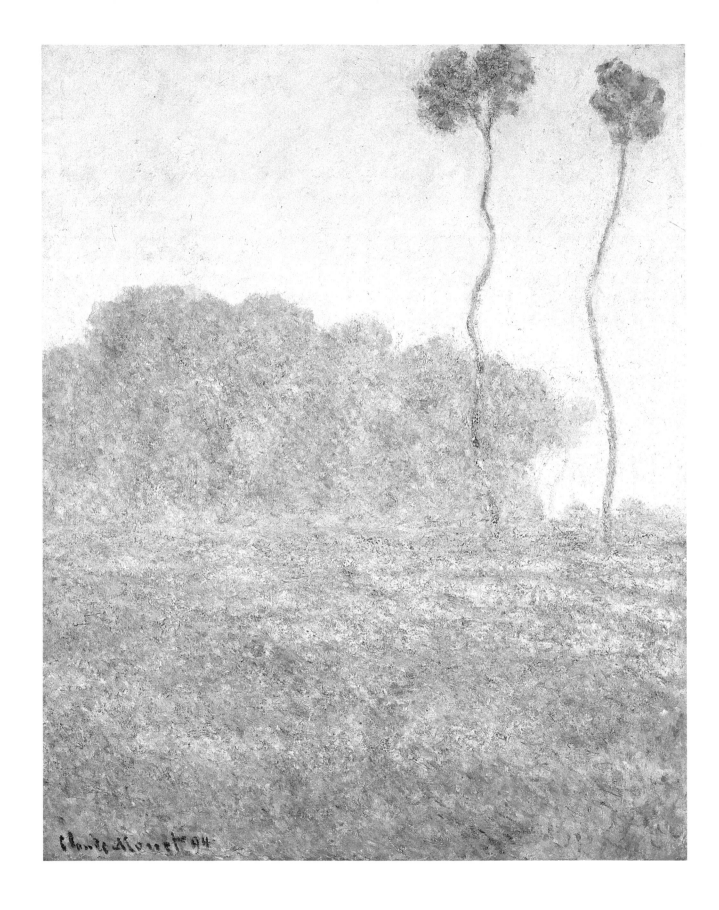

Plate 57. *Spring Meadow. (Giverny.)*, 1894. The Art Museum, Princeton University

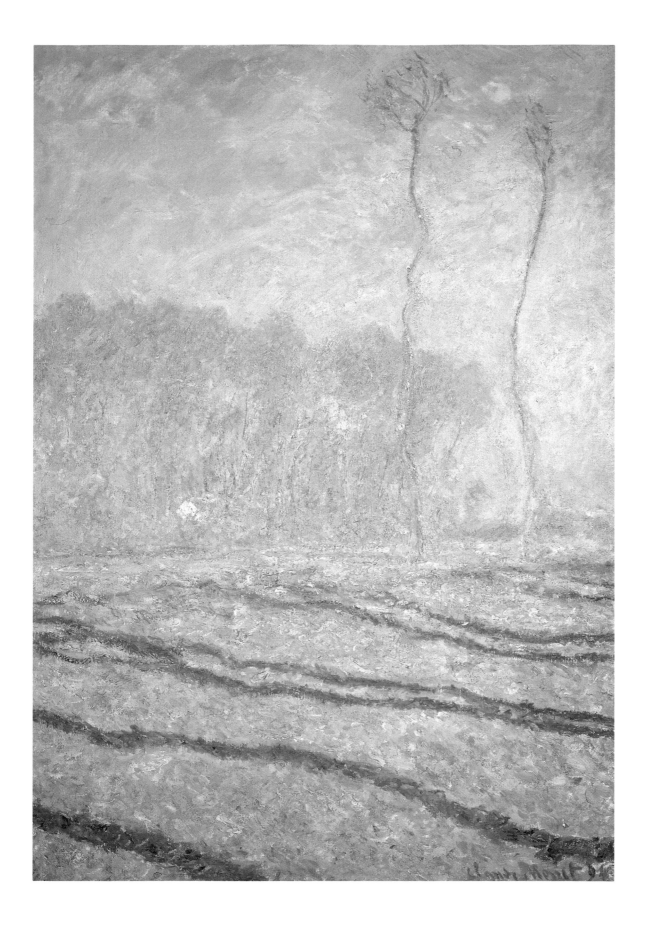

Plate 58. *Spring Meadow. (Giverny.)*, 1894. Private Collection, New England

Cathedrals to which I attach the most importance and which would only be sold for [15,000 francs]. That would permit me to sell the others for less."[27]

His strategy paid off. By September, he gloatingly informed Durand-Ruel that the *Cathedrals* had found buyers despite the dealer's predictions and that several had already left the studio.[28] Although Durand-Ruel would not purchase any for himself, Monet sold enough of them by late December to feel confident about finalizing plans for his show in the spring and about leaving to paint in Norway for nearly three months, a campaign that, like the *Cathedrals*, would focus on a motif that Monet had never painted before and would never return to again.

Monet's Trip to Norway

MONET's trip to Norway was prompted primarily by his desire to see his stepson Jacques, who had married a Norwegian widow and had decided to settle in Scandinavia where he had been practicing his trade as a shipbuilder. As the patriarch of the family and Jacques's recent stepfather, Monet wanted to spend time with Alice's oldest son and to find out whether he was ever coming back to Giverny, a question that apparently caused Alice much concern. Monet had also heard enough about the country to know that it held many attractions for landscape painters. One of his most enthusiastic sources was Fritz Thaulow, the Norwegian artist who had made a name for himself in his adopted home of France and who was an acquaintance of Monet's. Monet made up his mind to go to Norway sometime in December 1894, informing Durand-Ruel of his plans in the same letter as he set the dates for his long-postponed exhibition.

Jacques lived in Oslo, the capital of Norway, then called Christiania. The trip from Giverny took Monet nearly three days. "It's a difficult voyage when you are no longer twenty years old," he joked to Alice. Unfortunately, his first impressions were not favorable. The fjords were spectacular but frozen, and everything was covered with snow, prompting Monet to feel that "the country must be infinitely more beautiful without the snow."[29] What appealed to Monet most was the Norwegian way of life, particularly the fact that everyone traveled in sleighs, wrapping themselves up in blankets to stay warm, and that the famous Siberian huskies actually existed. Jacques apparently liked living there, although he was going through some difficulties. "You know how he is sometimes," Monet reminded Alice. "He admires everything about this country and then disparages it, finding nothing beautiful and nothing good."[30]

Monet's first impressions were soon traded for a real admiration for the wonders of the place: a 100-meter frozen waterfall, majestic mountains, huge frozen lakes. However, after almost two weeks, he had not decided what to paint and had not figured out how he would overcome the difficulties of commuting to interesting sites or working outside, which made him so upset that he regretted having made the trip altogether. "I may suddenly take the path back to France, having no taste for a country that I cannot paint. In addition, I am too old to be going off to foreign lands. In France, you can settle down and live as you please. You can [also] make the best of your time. Here, to eat at a different hour from them is

impossible. You go to bed very late and get up very late. In the end, despite the friendliness of the Norwegians, I have almost had my fill." He was also upset by the fact that "they concern themselves a bit too much with me," as he told Alice. They were even going to honor him at a big banquet, which Monet tried to discourage, telling them he "was used to living modestly *dans mon coin* and that although very flattered, I did not like those kind of things."[31]

A few days later, Jacques brought him to Sandviken, a town that was three-quarters of an hour outside of Christiania and that seemed to offer him interesting and conveniently located motifs. A week after that – three weeks after he had arrived in Norway – Monet finally reported to Alice that he had begun to work. It was not going well, however. "I have to say that for a lot of reasons that are too long to go into, it is impossible to leave Giverny for a country such as this and all of a sudden sit down and work." He found the country "very difficult to understand," claiming to Geffroy that "one needed to live here for a year to do anything good and . . . to get to know the place." He was soon complaining about the weather's variability and the challenges of rendering "the white immensity" with its "stupefying effects." By early March, he had become so irascible that people were worried about him. "It appears that I am not the same person I was several days ago," he admitted to Alice. He was so keen on what he was doing, however, that a few days earlier he admitted to Blanche Hoschedé that Norway was giving him "immense pleasure." He also wrote Durand-Ruel a few days later to ask him to postpone his exhibition yet one more time so that he would be able to finish some of the canvases that he had under way.[32]

Of the twenty-six canvases that he brought home with him when he returned to Giverny in April, at least nine were unfinished, an indication of the difficulties that he had been describing. Monet still "was not too unhappy with what I have done," as he told Durand-Ruel a day or two after he had gotten back.[33] Monet's pleasure derived in large part from the thirteen paintings that concentrate on Mount Kolsaas (plates 59-61). They were the largest group of pictures he produced and the most cogent, and it was the first time he had ever painted a mountain, an experience he seems to have found exhilarating.

Although the mountain was visible from anywhere in Sandviken, Monet painted it from just outside the town, standing in precisely the same position for almost every canvas in the series. He varied his effects tremendously, however, capturing moments at different times during the day, when the light was crystal clear as well as when it was so foggy or stormy that the mountain was nearly obscured. Some of the pictures reveal a certain tentativeness, suggesting the adjustments that Monet had to make in order to come to grips with this foreign country and its unfamiliar landscape. Most of them also do not have the complicated palettes or the intricate surfaces of the previous series of the decade; the motif and weather conditions seemingly did not require such virtuosity. Individually, therefore, the paintings do not have the same striking qualities as their counterparts in other series since the *Creuse* pictures.

They reveal their power, however, when in a group. This is partly because they all are almost exactly the same size, and because the mountain is located in almost exactly the same position in each canvas. It is also due to the fact that the mountain begins to rise against the sky on the left just below

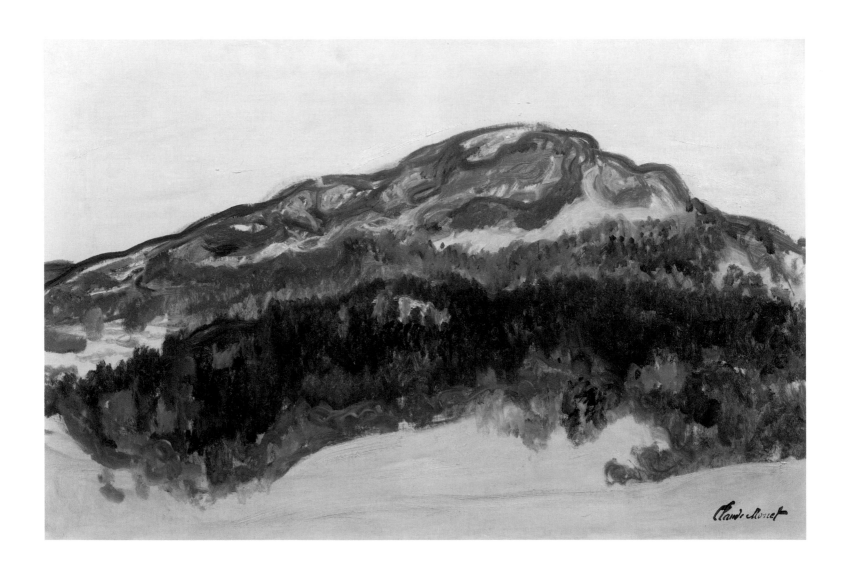

where it ends on the right. The snow on the right also rises to almost exactly the same height as it does on the left. Thus, when two or more paintings are hung together it appears as if we are looking at a mountain range instead of an individual peak. This also allows us to read the pictures as if they create a continuum or a partial diorama. Monet even placed his signature in the same location – the lower left-corner – in the six that he signed.

The *Kolsaas* pictures derive their ultimate power, however, from the undulations of the mountain and from the way it rises out of the snowbound foreground. Deep green and blue forests first, swaths of white next, followed by blue and gray ridges which push and shove their way up to create the animated silhouette of the peak. There is something primitive about this succession of planes and the starkness of

Plate 59. (cat. 57) *Mount Kolsaas. (Norway.)*, 1895. Musée Marmottan, Paris

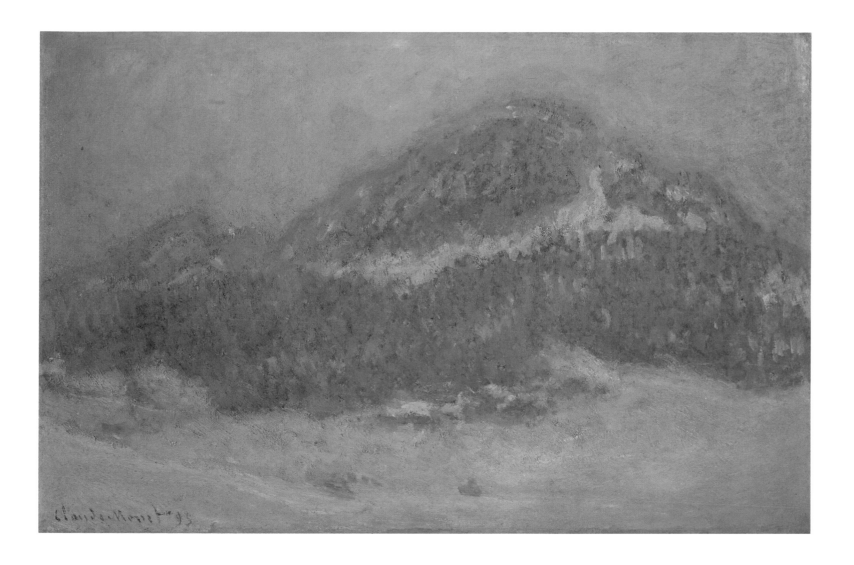

the mountain against the sky that vaguely recalls the folding hills of the Creuse Valley. And, as with that earlier group of pictures, there is a touch of the decorative in these *Kolsaas* views, due chiefly to the abstract qualities of the mountain's outline against the sky. This is particularly evident in the sketch now at the Musée Marmottan (plate 59), where that outline is merely a succession of broadly applied strokes, some of which do not even conform to the previously defined edge underneath. Like Cézanne's struggles with Mont Sainte-Victoire, Monet was clearly attempting to possess this mountain and transform it into an art object while trying at the same time to allow it to assert itself as a monumental triumph of nature that could evoke deep sensations.

This combination of nature and artifice may have derived from Monet's personal reaction to Mount

Plate 60. (cat. 59) *Mount Kolsaas. (Foggy day.)*, 1895. Private Collection

171

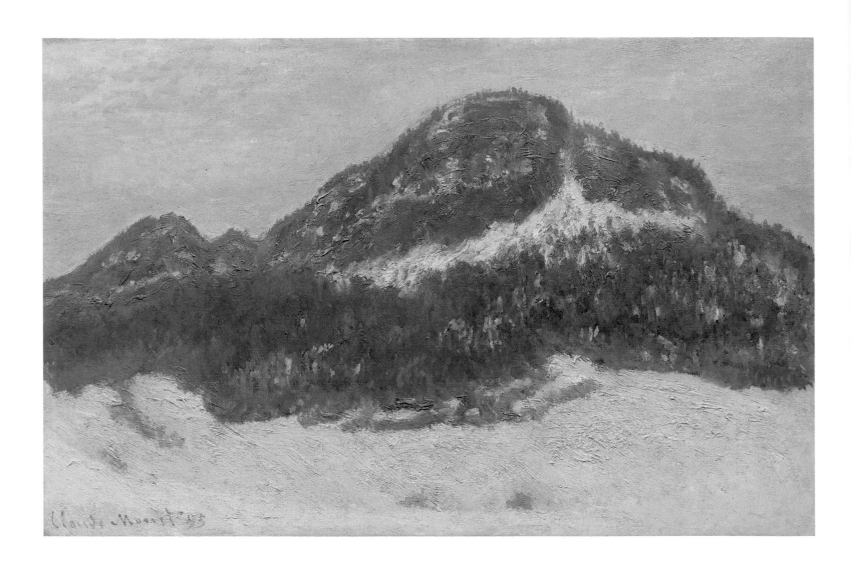

Kolsaas and its setting. But it was also the product of the way he conceived of the place. For what he found particularly enchanting about Sandviken was the way that it seemed like Japan. "I am at work on a view of Sandviken, which looks like a Japanese village," he wrote Blanche Hoschedé while still in Norway. "I am also doing a mountain that one can see from anywhere here and that makes me think of Fuji-Yama."[34] This association is a bit ironic, as Monet obviously had never been to Japan and thus had never seen a Japanese village, much less Fuji-Yama. But at the same time, it is quite telling, for while it underscores his belief that the Japanese lived close to nature like the Norwegians, it more importantly reveals how much Japanese prints were a part of his aesthetic vocabulary. Mount Kolsaas could remind him of Fuji-Yama, for example, because the latter appeared often in Japanese woodcuts, most notably in

Plate 61. (cat. 58) *Mount Kolsaas. (Norway.),* 1895. Private Collection, Chicago Detail, plate 61 >

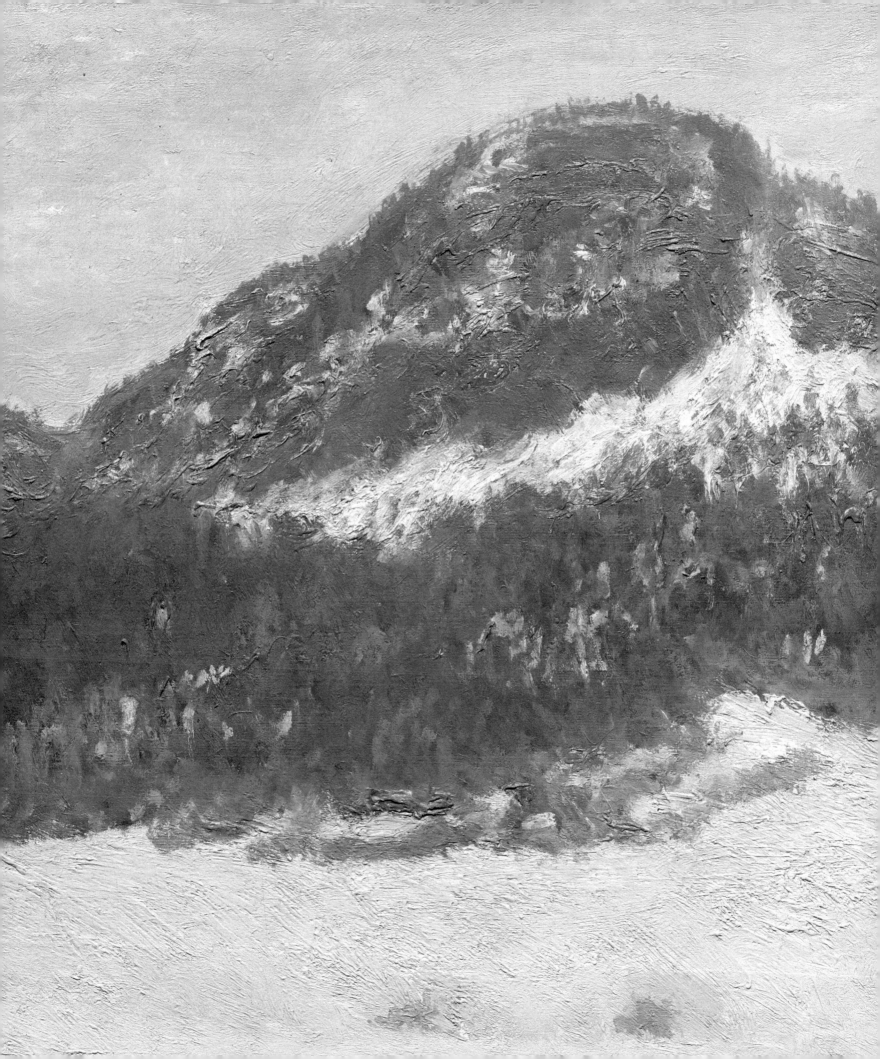

Fig. 78. Katsushika Hokusai, *Mount Fuji seen from the Umezawa manor in the Province of Sagami.* From *Thirty-six views of Mount Fuji.* Museum of Fine Arts, Boston.

Hokusai's thirty-six views of it, several of which Monet owned (fig. 78). While Monet's paintings of the Norwegian mountain have some similarities to Hokusai's prints – the bold and simple forms and the way the mountains rise from left to right – they also reveal, like all of his prior work, how much he wanted to forge an art that would be quite different, an art that would make the viewer believe that the painter was there on the spot, rendering his heartfelt sensations in front of bounteous nature, an art that, in the end, palpitated and breathed.

What he is asserting here, therefore, is not so much his debt to Japanese prints but the essential Frenchness of his vision, something that was brought home to him even during his stay in Norway. For in addition to the attention he received in the restaurants and cafés, Monet was the subject of various newspaper stories in which he was portrayed as a great French painter gracing Norway with his presence. Monet was also the celebrated guest at a dinner given in the honor of a local artist and, as he described to Alice, was toasted as one of the "glor[ies] of *la France*, after which everyone stood up, men and women, and began singing *La Marseillaise*, culminating in a hip-hip-hooray." Although far from Giverny, he was not out of contact with what he described while in Norway as his "*belle France*," a fact he ensured himself by reading *Le Figaro* every day he was there. It was quite fitting, therefore, that just prior to his departure from the country, he even received a royal visit from the Prince of Norway and his aide-de-camp, who, like dozens of Norwegian painters and writers, had nothing but praise for his achievement. "I have to confess," he told Alice, "that I was touched by their testimony, which seemed so sincere." When he left Christiania on March 31, he parted as a national French hero.[35]

The Exhibition

WHEN Monet returned to Giverny on April 3 or 4, 1895, the first person he wrote to was Durand-Ruel. He wanted to firm up plans for his long-postponed exhibition and suggested May 10 as a possible opening date. Everything was settled by the end of April. On May 5, Monet sent Durand-Ruel the material for the catalogue, instructing him to take it to the printer immediately so that he would have time to correct any mistakes in the proofs. He also told the dealer that he had only received thirty-eight announcements for the show and that he needed at least 160 more.[36] He wanted to inform as many people as possible of this event. Once again, his efforts paid off, as he received more press coverage for this show than he had for any exhibition that he had ever mounted, attesting to the kind of attention his work now commanded.

Monet was also tactical about what he chose to include in the show. First, he made it substantial by opting for nearly fifty paintings. In the catalogue, they were presented in four separate groups, three of which had titles: "Rouen Cathedral," "Vernon seen from the water's edge," and "The environs of Christiania" (which included several views of Sandviken as well as thirteen paintings of Mount Kolsaas). The fourth was a collection of fourteen works that were not united by subject matter or date. It included such paintings as a view of tulip fields in Holland that Monet had done in 1886 (W.1067), a *Creuse Valley* canvas (W.1234), a *Grainstack* (W.1272), a *Poplar* (perhaps W.1292), two *Ice Floe* pictures (W.1336 and possibly W.1333), and three *Spring Meadow* scenes (W.1366, 1367, 1369?). Listed last in the catalogue, and hung at the end of the show, this final group filled out the exhibition and made it a kind of mini-retrospective, particularly of Monet's previous series, a fact that Geffroy and others pointed out in their reviews. In addition to being a counter to the more focused groups that preceded it, this collection of diverse pictures reaffirmed Monet's range and ability. It also attested to his strength in the marketplace, for eleven of them were already owned by dealers or private collectors. The fact that he went to some lengths to obtain the Dutch picture for the show and that he included so many Norwegian paintings suggests that he also wanted to be seen as an artist who had an international dimension.[37] These foreign works placed the paintings that he had done in France in a more distinctive light; none of the Norwegian pictures found buyers, however, in contrast to the eleven *Cathedrals* and views of Vernon that were sold before or during the exhibition.

While obviously narrower in scope than this fourth group of canvases, the *Cathedrals* that Monet selected nonetheless revealed how much he had been able to extract from that Gothic monument. Among the twenty that he chose to exhibit, for example, were the two of the Tour d'Albane, a unique head-on view of the façade, four of the five that showed the medieval houses at the foot of the Albane tower, the two that showed birds, and the one in which people appear. He also selected canvases that covered the full range of lighting effects and the different vantage points from which he had painted the church.

His choices revealed as well how intent he was on rendering his motifs as accurately as possible.

With all of its intricacies, the Cathedral façade posed an infinitely greater challenge than the poplars, grainstacks, or confluence of the Creuse, making him rely even more on his abilities as a draftsman, despite the fact that he often denigrated his talents in this area. Monet's reliance on drawing is particularly evident in the preparatory sketches that he did for some of these paintings in which he rendered the façade as a remarkable, linear skein (fig. 72), and in the Marmottan canvas (plate 51), where the Cathedral's main features were laid down first and the lighting effects were added later. However, his draftsmanship is evident in all of the pictures. Their haunting visual power derives primarily from the almost magical way in which Monet, through drawing, is able to maintain control over his forms without having them disappear into a sea of paint or dissolve in the light.

Monet's control also stems from his extraordinary sense of color, which he employs in these pictures to create intricate spatial relationships and the illusion of plasticity, and from the almost sculptural way that he manipulates the paint. By applying it in nearly every manner possible – from quick, thin strokes to heavily ladened jabs – he was able to recreate the rough, weather-beaten surface of the Cathedral, with its various protrusions and hollows. His control is the result as well of his keen scrutiny of the structure. Having spent nearly six months of his life looking at it from close range, he knew the building well, a fact that the exhibition underscored.

What the exhibition also revealed was how much Monet animated the Cathedral. When seen over and over again, the stone structure seemed to various observers to rise like some natural object, growing ever more alive with the increased intensity of the light. To enhance this effect, Monet emphasized the building's irregularities far more than its symmetries, obscuring the latter by his angled vantage point and by subtle manipulations. For example, in his head-on view, unlike a print that shows the façade from the same position (figs. 79 and 80), the three portals appear to be orifices that are flexing according to their own will while the towers above seem like independent elements unrelated to the screen between them. In fact, the whole façade appears to be moving, the lower half to the left, the upper half to the right, in contrast to the solid and stable structure in the print. Even the gargoyles and statuary seem more arbitrary in Monet's work, just as the buttresses in the foreground of his scene appear more like independent growths.

The more one looks at the Cathedral across the series, the more it becomes a collection of individual parts that are related intrinsically, not according to some structural rationale; the more it also takes on anthropomorphic qualities. It appears to shiver in the cool of the early morning mist in plate 62, its tower stretching upward to greet the first rays of the sun. As the hours advance and the light begins to speckle its façade, the Cathedral seems to shake the sleep from its head and flex all of its limbs to begin the new day. By the early afternoon, it is ablaze in light whose color and warmth penetrate every crevice of its form, making it energized and alert (plate 63). Even the sky becomes more strident in these views. Then, as the afternoon progresses and the shadows begin to climb up its base, it seems to sink into the confection of color that the fading light provides, an effect that appears as natural as it does atavistic (plates 49, 51 and 64).

Fig. 80. A. Hotin, *Rouen Cathedral*, [1892]. From Louis de Four-
caud, *La France Artistique et Monumentale*, Vol. II, Paris, [1892-
1893], 53.

Fig. 79. Claude Monet, *Rouen Cathedral. Facade.* 1892-94.
[W.1319]. Musée d'Orsay, Paris.

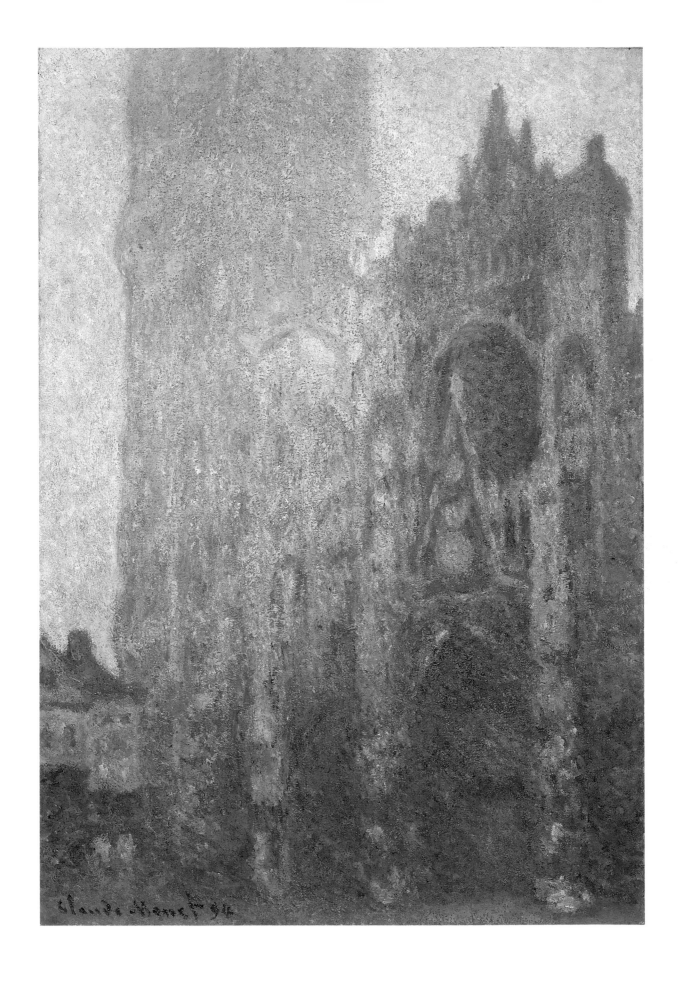

178 Plate 62. (cat. 54) *Rouen Cathedral. Façade and Tour d'Albane. (Morning effect.)*, 1892-94. Museum of Fine Arts, Boston

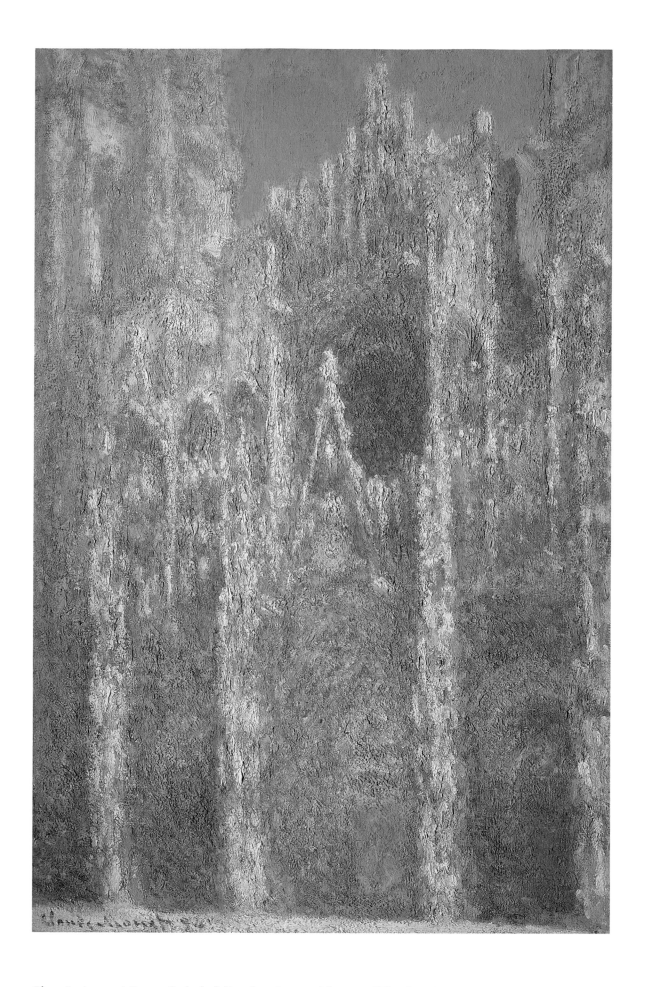

Plate 63. (cat. 55) *Rouen Cathedral. Façade.*, 1892-94. Museum of Fine Arts, Boston

These characteristics were noted by visitors to the exhibition. Clemenceau, for example, asserted that Monet had made "the stones themselves live," while the English critic Brownell felt that Monet's art had now become nature itself.[38] In addition to being impressed by the range of effects Monet had been able to capture and by the virtuosity of his brushwork, most critics recognized the importance of the *Cathedral* series as a collective entity, whether they read it according to the times of day represented, the different color schemes, or the various weather effects. Many also saw poetic elements in the pictures, particularly when it came to Monet's treatment of the light, while others made analogies to music, prompted by the color relationships and the temporal progression in the series, which seemed to possess qualities akin to musical harmonies. Although critics did not agree about the success of certain paintings, many would have concurred with Theodore Robinson's assessment even before the Rouen group was shown. "They are simply colossal. Never, I believe, has architecture been painted [like this] before, the most astonishing impression of the thing, a feeling of size, grandeur and decay . . . and not a line anywhere – yet there is a wonderful sense of construction and solidity. Isn't it curious, a man taking such material and making such magnificent use of it?"[39]

One of the most discussed aspects of the *Cathedral* series, whether it was viewed favorably or not, was Monet's choice of subject. Certain critics, such as the one for *Le Matin*, found it totally inappropriate. "One could say that a Cathedral is not a luminous synthesis, a sort of phantasmagoria of light, that its details exist at the same time and as much as its mass, and that this mass asserts itself with overwhelming power." Camille Mauclair agreed. Although he had called Monet "the most prodigious virtuoso that French painting has seen since Manet" and "the premier painter of his era," the chief critic for the Symbolist revue *Mercure de France* felt that on formal and intellectual grounds Monet's choice of a Gothic Cathedral was offensive. "Musical, Provençal colors laid onto this medieval structure with such insolence is the disturbing sign of a genius without a sense of the order of things. . . . that Gothic art, the cerebral art par excellence, is being used as a motif by this superbly sensual, pagan [artist] is a bit repugnant."[40]

In contrast, the critic for the liberal *Le Rappel* found it "a happy and surprising alliance between the somewhat morose memories of the age of faith and these ambient impressions." Georges Lecomte voiced the same sentiments, claiming that Monet's rendering "added to the beauty of the stone and the structure's architectural grandeur". The critic for the satirical *Gil Blas* went even further. [Monet] creates a song about . . . the stones of old churches . . . bathed in light. . . . It is the historical and organic cathedral that Monet wanted to beautify because . . . after centuries of embodying the mystical aspirations of the multitudes, the cathedrals have become human; they have become flesh and flowers."[41]

Critics such as Mauclair were really worried about two other problems: First, the fact that Monet had pushed painting to what they perceived to be its absolute limits. If the practice was merely going to become a forum for virtuosity, if it was no longer going to be dealing with recognizable form, it would lose its essential mandate, handed down over the centuries, to elevate and instruct, if not actually inspire. This problem was predicated on notions of decorum. Those like Mauclair who objected to

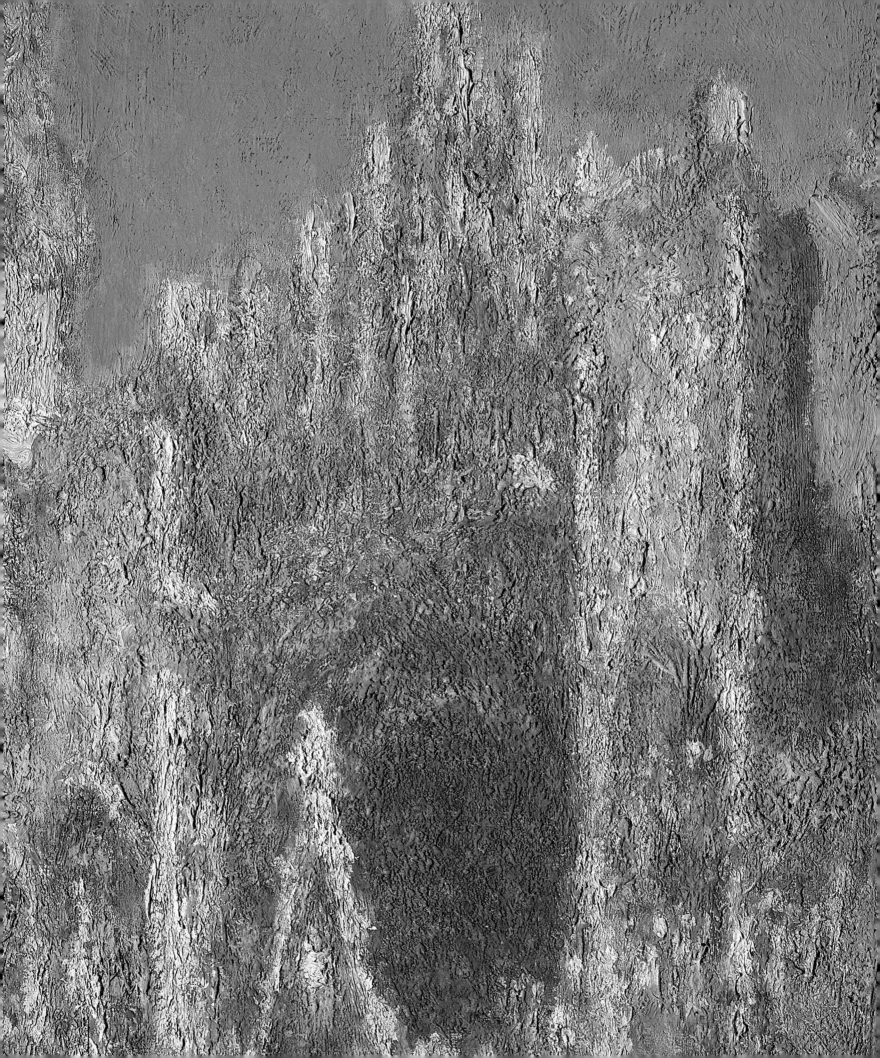

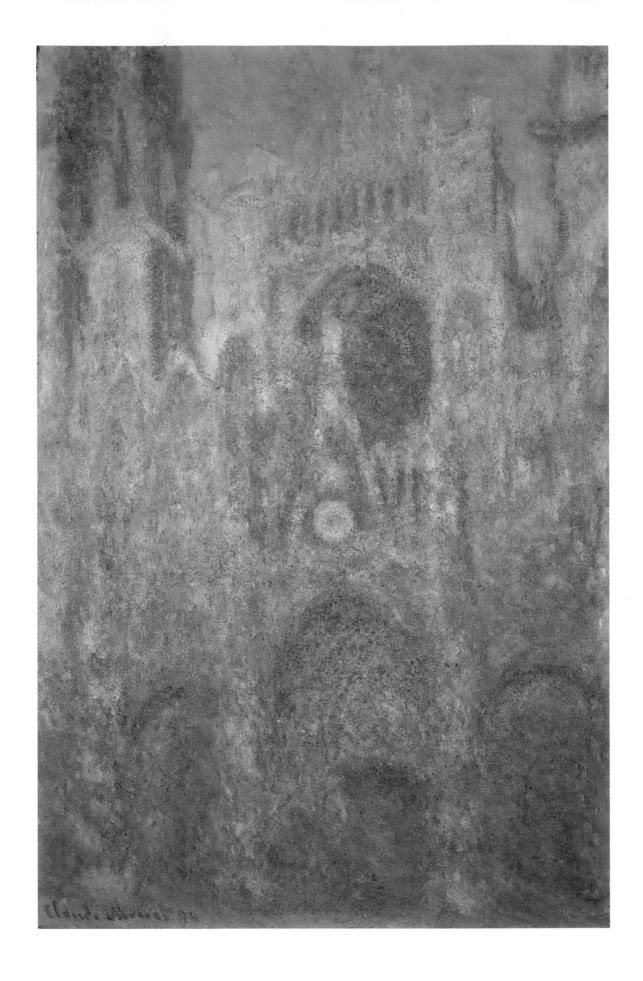

Plate 64. (cat. 49) *Rouen Cathedral. Façade*, 1894. National Gallery of Wales, Cardiff

Monet's use of the Cathedral did so because they held the subject in special reverence. It could be the focus of printmakers and illustrators, photographers and painters, so long as it was rendered accurately or with appropriate awe. If artists were going to alter it in a distinctly personal way, as Monet did, they had to face the consequences, for such alterations were an affront to aesthetic norms and suggested that the artist was abusing his privileged position in society. Monet posed a particularly vexing problem in this regard, as he was both talented and influential, as most people noted. Even Mauclair admitted to Monet's prominence, but he also felt that if Monet was to be accorded a leadership role, he had to be made aware of his responsibilities. Too much was at stake.

The stakes were made eminently clear just before Monet exhibited his *Cathedrals*. For example, in April 1895 French artists were invited to participate in an exhibition that Kaiser Wilhelm II of Germany was sponsoring in Berlin. Right-wing nationalists condemned the event and called for France to boycott it.[42] Their objections went unheeded, however, and most of the artists who were invited decided to go, with academic painters such as Detaille and Bonnat leading the way. Even Puvis consented to join them, despite his refusal to participate in a similar exhibition in the German capital in 1890. "We must not be duped," he had asserted. "We must not forget that we are dealing with a man [the Kaiser] who . . . has an insatiable envy for our country and who dreams of belittling [us] in all kinds of ways. . . . I am French. I stay in France."[43] He and his colleagues who went in 1895 did not go unscathed, however, as their claims that art did not have a country were satirized by contemporary caricaturists with images such as fig. 81. Monet does not appear in this motley group. He may not even have been invited. But what the print underscores, in its crude and mocking way, is the fact that the disasters of 1870 were still very much alive in the minds of patriotic Frenchmen, that French artists had certain responsibilities which they were expected to meet, and that the nation invested a great deal in their words, work, and actions.

Artists were not the only people who were burdened with such obligations. Musicians and singers shared them as well, and some of them were also taken to task for not meeting them "properly" in 1895. Such was the case in May of that year when, for the first time since 1863, Wagner's *Tannhäuser* was performed in Paris. No sooner had the opera opened at the National Academy of Music than it prompted vehement protests. Even the celebrated composer Ambroise Thomas called for the curtain to fall on the event. "I am very sad," he told a reporter for the nationalistic *L'Intransigeant*. "The opera was not made for the French theater. It is essentially German and anti-French." "The influence of exotic schools is pernicious for French music," he claimed ten days later. "The music of Wagner makes us lose the qualities of precision and clarity that distinguish our race. We should remain *Gaulois* above all."[44]

Such chauvinistic rhetoric was common in *fin-de-siècle* France, particularly when it came to the country's relationship with Germany. And it was not confined to excessively vocal patriots or narrow-minded rightists, although there were plenty of them. The eminent scientist Louis Pasteur, for example, could express equally "patriotic" sentiments when, in June 1895, at the age of seventy-seven, he was offered the Prussian version of France's Cross of the Legion of Honor. Pasteur refused the award. "Science may not have a country," he said echoing the artists' statement, "but savants do."[45] Camille

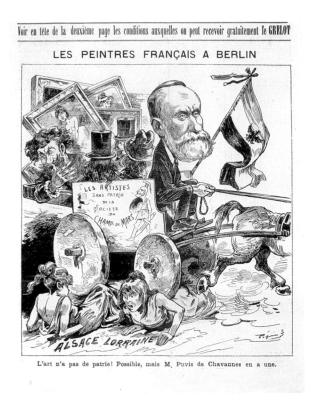

Fig. 81. Pépin, "The French Painters going to Berlin." *Le Grelot*,
10 March 1895.

Fig. 82. Pierre Auguste Renoir, *Two Women at the Piano*, 1892.
Musée d'Orsay, Paris.

Mauclair was more subtle, but his objections to Monet's treatment of Rouen Cathedral were based at least in part on nationalistic sentiments, though of a rather different order. For Mauclair was actually of German extraction. His real name was Camille Faust. His rightist tendencies, which became more blatant as the century turned, can be attributed to his duplicitous identity; espousing conservative ideology was an easy way to compensate for, if not disguise, his true origins. (It would eventually catch up with him, however, as during World War II, Mauclair was caught collaborating with the Nazis. He was stripped of his French citizenship, and deported to Germany, where he died in 1945.)[46]

Ultimate responsibility for ensuring France's strength and self-confidence in the face of international challenges lay with the government, of course, but it too would be the focus of severe criticism in 1895, at the same time once again that Monet was preparing the catalogue for his *Cathedrals* exhibition. This criticism was prompted by what some people saw as the government's inappropriate behavior with regard to Germany. It too began with an invitation from the Kaiser, this time for French officials to parti-

cipate in the inaugural ceremonies for the monumental canal that Germany had built from Kiel to the Baltic. The fact that France accepted the Kaiser's invitation infuriated many Frenchmen. "Alsace and Lorraine have not forgotten the treachery of the Germans," cried one paper, a week before Monet's show was to open.[47] The English could be regarded with equal rage. When Orléans hosted a day of celebration for its native daughter Jeanne d'Arc, two days before Monet's *Cathedrals* went on view, observers called the ceremonies "outrageous" because the Bishop of Winchester had been permitted to participate. "He ought to have been on his knees in sackcloth and ashes asking pardon for his predecessors," insisted the anti-clerical *L'Idée Nationale*.[48]

Although Monet did not address any of these issues directly in his *Cathedrals*, it was hardly coincidental that he had chosen to paint a monument of such significance to France at a time of widespread concern about the nation among her citizens. Indeed, in the very months that he began the series, the former Minister of Public Instruction Édouard Lockroy, reminded his old constituency of their "duty to recover [France's] lost strength and its former power," exhorting everyone to keep "your eyes fixed on the imperishable image of *la Patrie*." "*La France*," he said, should be "central to any debates . . . [for she] cannot live and continue to be *la France* if she remains the great, disinterested nation that she once was."[49]

Even before Lockroy's patriotic appeals to his fellow citizens' sense of national pride and obligation, one artist had been making his own contribution – Pissarro. The oldest Impressionist began setting aside one print from every edition he made in the early 1890s as his legacy to his adopted country, despite his frequent dissatisfaction with the government and the way it was handling the nation's affairs.[50] This represented a substantial commitment, since his editions were generally very limited, consisting sometimes of no more than three or four impressions. Moreover, when he began this practice in 1891, the government had purchased nothing from him. It had not even shown the slightest interest in his work. But Pissarro, like Monet, was thinking in more historical terms. So too was Renoir, who actually received a commission from the Musée Luxembourg in the winter of 1891-92, resulting in *Two Women at the Piano* (fig. 82), a work that left no doubt about his roots in the French tradition. Everything in this picture speaks about values that France held dear, from the girls' youthfulness, warmth, and grace to their interest in music, their evident social rank, and their haute-bourgeois environment (note the paintings on the wall in the background). When exhibited at Durand-Ruel's in May 1892 in a huge retrospective of Renoir's work, these modern Mariannes prompted one critic to assert that "the recent [Renoir] exhibition is among the most significant and the most beautiful that we have seen in a long time. It shows the career of a highly personal painter who is profoundly French."[51]

By choosing to paint one of France's great treasures, a work of art itself, Monet too was suggesting his ties to the country's past. His choice of a Gothic monument was especially significant, as, like the poplar, the Gothic style had been linked to the nation ever since the Revolution of 1789. Championed during the 19th century by people such as the first Inspector-General of Monuments, Ludovic Vitet (who had changed his name from "Louis" to its more medieval version), Victor Hugo, and, most nota-

bly, Viollet-le-Duc, the Gothic was widely seen by the 1890s as having been "fashioned from our materials and in our climate, to suit our character," as Viollet had asserted.[52] All proselytizers for the style, such as Louis de Fourcaud, professor at the École des Beaux-Arts in the 1880s and '90s, felt it was impossible to conceive of a moment more French than the Middle Ages, which is why Louis Courajod, the curator of medieval art at the Louvre, could end an impassioned lecture in 1893 with a heartfelt enjoinder for his students to resist the contemporary infatuation with classicism by turning to the Gothic. "Let us loosen the stranglehold that pagan Rome has on us for a second time," he pleaded, "so that the 19th century will not end without our finding ourselves again completely, openly, and absolutely French."[53] Courajod could have been encouraged by two developments that year. Taine's Chair of Aesthetics and Art History at the École des Beaux-Arts (which had been occupied since 1885 by Eugène Muntz, a noted Renaissance scholar) was given to Fourcaud, while the venerable *Revue des Deux Mondes*, which had long criticized the Gothic, finally reversed its position and warmly endorsed it.[54]

While all admirers of the Middle Age saw the Gothic style as being distinctly French, some, such as Alphonse Germain and J. Karl Huysmans, were impressed primarily by its religious dimensions, as Germain made evident in his book of 1893 appropriately titled *Our Art of France*.[55] It was precisely this perception, however, that Fourcaud and Courajod, among many others in the 1890s, strongly opposed. Like Viollet-le-Duc before them (and John Ruskin prior to them all), these men viewed the Middle Ages as a moment in which people were much closer to nature and to each other and much freer to act on their own. Hierarchical but humane, the era, in their opinion, encouraged craftsmanship, sharing, and an art that was based on the tangible experience of sensitive individuals. "Artists only rendered what was before their eyes or in their heart," asserted Fourcaud.[56] Even the Gothic cathedral, in Fourcaud's view, was not a spiritual building, as Huysmans would poetically claim in his novel *The Cathedral* (1898), but a sublime, natural structure, impressive for its harmony, stability, and irregularity of its parts, and for the fact that it was built communally over time by individual masons who were able to express their own personality in decorative motifs or statuary details. It therefore teemed with life, much the way that Clemenceau and others had seen Monet's paintings of Rouen Cathedral. Grounded in the tangible realities of nature and paint, Monet's *Cathedrals* professed a faith that could not be gleaned from dogmas or priests. (Monet did not even go inside the church until his project was well advanced, and then only because a statue was being dedicated at a high mass that was being sung by a 300-member Parisian choir.)[57] By affirming the value of tangible experience over the mysteries of traditional religion, Monet was expressing the progressive beliefs of his moment. "Religion is being replaced by intellectual activities," observed Eugène Olivie in 1892, just as Monet began his *Cathedrals*. "Beautiful music, for example, inspires devotion, certain paintings, awe; poetry, ecstasy." The same was true of philosophy, mathematics, chemistry, opera, museums, and the laboratory, he declared. They all in his view were "like Cathedrals"; they all provoked "the same silence, extended joy [and] thrilling intimacy."[58]

According to the historian and cultural critic Léon Bazalgette, Monet was thus making some of the most advanced art of his day. Unlike the vision of a Gothic cathedral as religious symbol that Huysmans propagated in his novel, Monet's *Cathedrals* were "healthy, frank, vital, realist, alive. With him, it is no longer a question of dogma nor of resurrection. . . . he considered the edifice only as a fragment of nature, according to reality, not according to religion. Occult symbols cannot trouble him. Nor can Christian symbolism. . . . From his canvases, life spills out, stripped of every symbol, of every kind of artifice or lie. It is there in front of us trembling and naked. If there really is a modern art," Bazalgette concluded, "an art linked to today's thought, the painter of the *Cathedrals*, from every point of view, is one of its representatives."[59]

188 Plate 65. (cat. 61) *Cliffs at Pourville. (Morning.)*, 1896-97.

7 Normandy and the North: Monet's Cliff Paintings of 1896 and 1897

ALTHOUGH a Parisian by birth, Monet was a Norman by preference, upbringing, and temperament. He lived in the province nearly all of his life, wrote about it with great affection, and painted it more often than any other region in France. Of necessity, his social and economic ties were always with the capital, but his heart lay in this history-laden area and his art bore eloquent testimony to its power and beauty.

Normandy had much to offer him. Bordered on the west by Brittany, on the east by Picardy, on the south by the Île-de-France, and on the north by the English Channel, it had some of the most varied topography in all of France, including mountains, high cliffs, beaches, farmland, and the Seine and its river valley. It was also one of the great food-producing regions – an important consideration for Monet the gourmet. It was particularly celebrated as the source of some of the best dairy products (more than 100 kinds of Camembert, for example), some of the best cider and alcoholic beverages (including Benedictine and Calvados), and some of the most prized meats that one could find in France. Normandy was also blessed with an invigorating though benevolent climate and a rich cultural heritage, including a long line of landscape painters, Jean-François Millet and Monet's teacher Eugène Boudin among them. It could even claim one of the oldest and largest oak trees in the country.[1]

For Monet and many others, one of Normandy's most attractive features was its northern coast, where land meets sea in a breathtaking display of elemental grandeur. The confrontation is made spectacular by the huge chalk cliffs that plunge hundreds of feet down to the waters of the Channel. More dramatic, varied, and extensive than their famous counterparts in Dover, these white cliffs are sheered in many places to such rectilinear rigidity and hollowed out in others with such sculptural deftness that they engender as much admiration for nature's aesthetics as they do fear of its brute force.

The coast and its cliffs had appealed to landscape painters throughout the century. As early as the 1820s, artists' colonies had been established from Le Havre to Dieppe, attracting droves of *plein-air* amateurs, long before the Impressionists. The area also lured professionals. Every major landscape painter of the century worked there at some point during his career, including Huet, Delacroix, Corot, Daubigny, and Courbet. Even Degas gathered material for some of his landscape essays in Étretat and Villers-sur-mer in the late 1860s. Thus, like the Forest of Fontainebleau, the Norman coast was inextricably linked to advanced art of the century.

Monet had painted this northern perimeter of France many times during his life, though never as often as in the 1880s. Working in various Channel towns between 1881 and 1886, he produced more

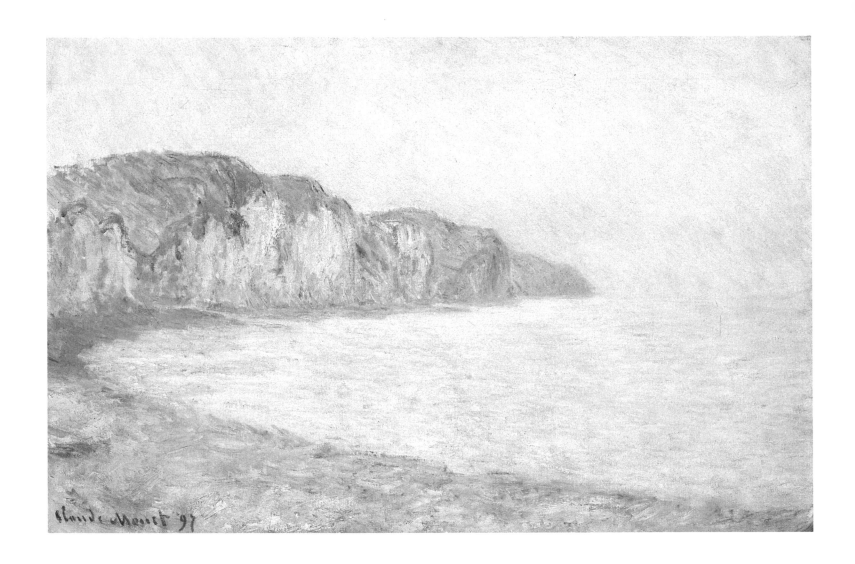

than 150 views of its raw, eloquent beauty, concentrating most often on its monumental cliffs. It was a decade before he painted those natural wonders again. In the interim, they lost none of their appeal. Between February 1896 and April 1897, he completed more than fifty pictures of them in Pourville, Dieppe, and Varengeville, thus in a single year producing a third as many as he had in the five years of the previous decade that he had worked in those towns. As he rightfully told Geffroy only a month into his project, "I am a bit fearful and am groping, but I feel that I am in my element."[2]

 These views of the beach and cliffs at Pourville (plates 65-67), the Val Saint-Nicholas at Dieppe (plates 68-71), and the gorge and headlands of the Petit Ailly at Varengeville (plates 72-80) constitute three series that Monet combined under the title *Falaises* [cliffs] when he exhibited twenty-four of them

 Plate 66. (cat. 62) *Cliffs at Pourville. (Morning.)*, 1896-97. The Montreal Museum of Fine Arts

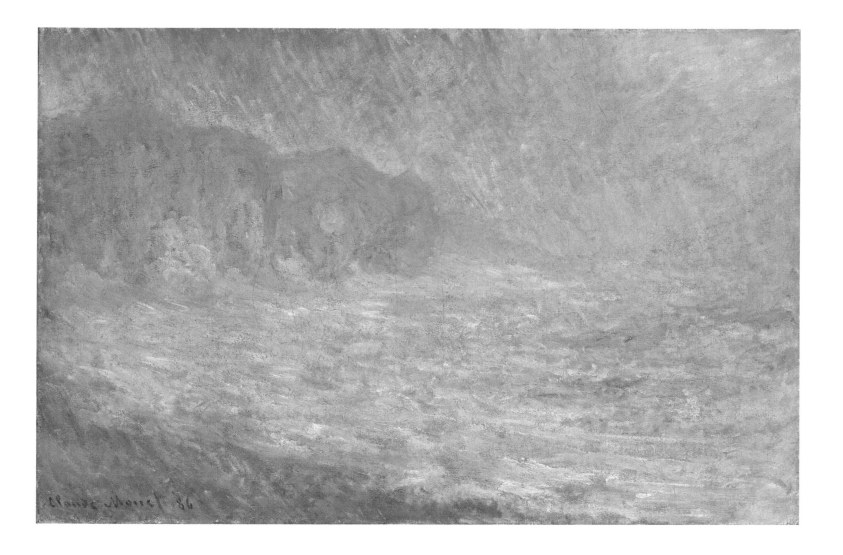

in 1898. They are some of the least-known paintings that he completed during the 1890s. They are also some of the most unusual and the most personal. At once hedonistic and introspective, they assert fundamental values that Monet held dear while they challenge notions that contemporary critics had claimed were central to his enterprise and to landscape painting at the end of the century.

AFTER the exhibition of his *Cathedrals* in May 1895, Monet did not take up his paints for nearly ten months. Although such breaks were now becoming common, this one was precipitated by two unexpected developments. First, Alice, Germaine, and Suzanne all became seriously ill that summer and required special attention.[3] The second matter involved Giverny's town council. It wanted to sell a piece

Plate 67. (cat. 60) *Cliffs at Pourville. (Rain.)*, 1896. Private Collection

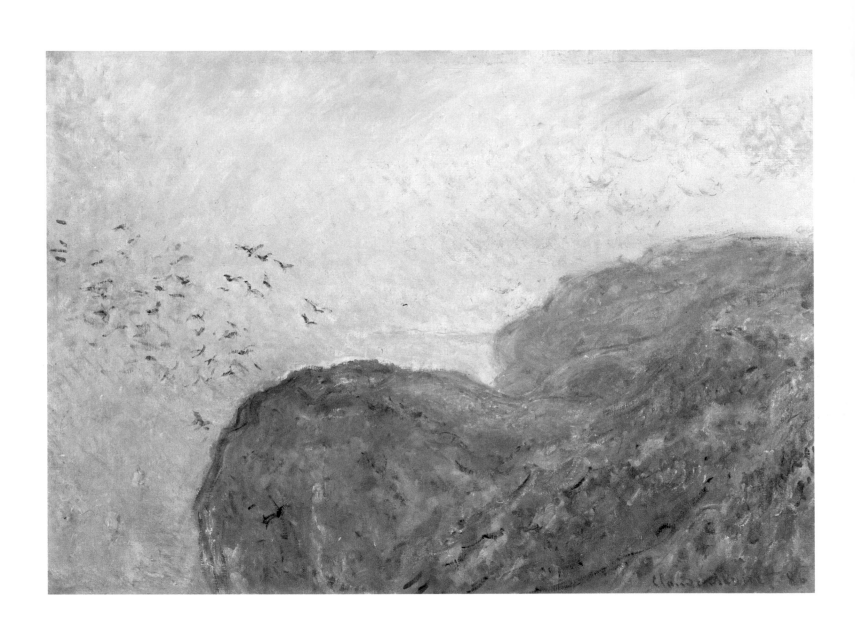

Plate 68. (cat. 72) *Val-Saint-Nicolas, near Dieppe. (Morning.)*, 1896-97. Private Collection, Switzerland

of communal property to a chemical company, which intended to build a starch factory on the land. Monet was furious with the council's limited vision, believing that the sale would spoil "the charm and the beauty of the place." So strongly did Monet feel about this issue that he spent a considerable amount of time between May and August writing letters to council members, the Mayor, the local prefect, and the prefect's assistant. He also enlisted Mirbeau's help, convincing him to use his connections successfully to influence the Minister of the Interior, Georges Leygues, to write the prefect for the Giverny area a letter supporting Monet's views.[4]

Monet knew that the town fathers might be intimidated by letters from high-ranking officials, but he also knew that they were really only interested in money. He therefore offered to pay the municipality 5,000 francs if it did not sell the land for fifteen years. When his offer was refused he became enraged, but he quickly upped it to 5,500, which, after months of haggling, was finally accepted in February 1896.

Several lessons can be learned from this. First, despite Monet's disdain for politics, he knew how to operate effectively in a political bureaucracy to achieve his own ends. Second, although he had harsh words for some Giverny officials and their supporters, he cared deeply for the area and did as much as he could to preserve its untainted beauty. With the financial security he then enjoyed, he could even exercise some power, and could give a local issue that concerned him higher priority than his art, at least temporarily.

When he finally did take up his palette and brushes again, just after the council agreed to his proposal, he headed north to the Channel "to gain strength from the sea air," as he told the dealer Joyant.[5] Although undoubtedly prompted by a desire to get away by himself after the difficulties he had faced in the previous months, particularly the illnesses in his family, Monet may well have been responding to problems regarding his work and the direction it was taking. The *Cathedrals*, for example, had required an inordinately long time to complete, had forced him to work in an urban environment which he had not enjoyed, and had obliged him to spend a great deal of time in his studio. The *Kolsaas* paintings had also been taxing and, to make matters worse, had not sold.[6] In all likelihood, he wanted to avoid these troubles and decided on Normandy because he knew it well. He was also aware that Norman motifs were marketable, as the towns along the coast had become popular tourist spots, attracting Parisians by the thousands during the hot summer months. A view of Dieppe would find a buyer much more quickly than one of Rouen Cathedral or a little-known Scandinavian mountain.

The coast also offered Monet the opportunity to state his beliefs about the value of landscape painting in a direct and personal way, instead of employing symbols such as cathedrals, poplars, or grainstacks. It provided him only with the most basic materials: earth, sea, and sky. Moreover, because he was free to choose a variety of motifs, he was also able to challenge the restraining assumption that he was interested exclusively in capturing fleeting moments of time or specific effects of light. In fact, many of the pictures in these series are of an indeterminate time of day (plates 72, 74-76, 78, and 79); some, such as plate 75, are so monochromatic that they appear almost lightless. Going back to the Channel also al-

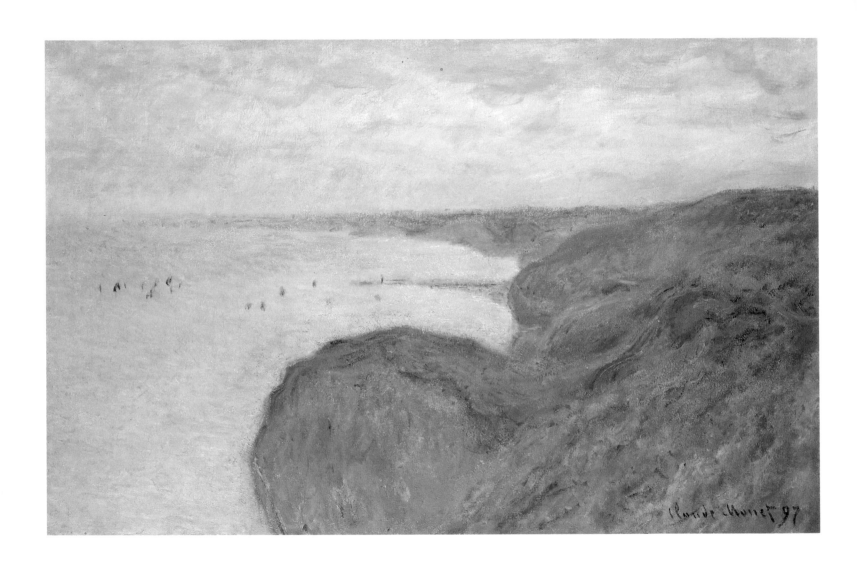

lowed Monet to return to his roots, assess his previous work, and test the Northern tradition of landscape painting on which his art had so long and firmly rested.

This tradition had been central to the evolution of modern French landscape painting as a whole. French artists from Valenciennes onward had based their *plein-air* efforts on the innovations of 17th-century Dutch painters and their 18th- and 19th-century English counterparts. As the 19th century drew to a close, however, the Northern sensitivity to light, air, land, and sea had come under intense pressure from a variety of competing groups – the Neo-Impressionists, the Symbolists, Gauguin and the Nabis, Puvis and his followers, and the Rosicrucians. So crowded had the arena of French painting become, even by 1891, that the critic for *Le Jour* "wonder[ed] whether there were any French people

Plate 69. (cat. 75) *Val-Saint-Nicolas, near Dieppe. (Overcast day.)*, 1896-97. The Hermitage Museum, Leningrad

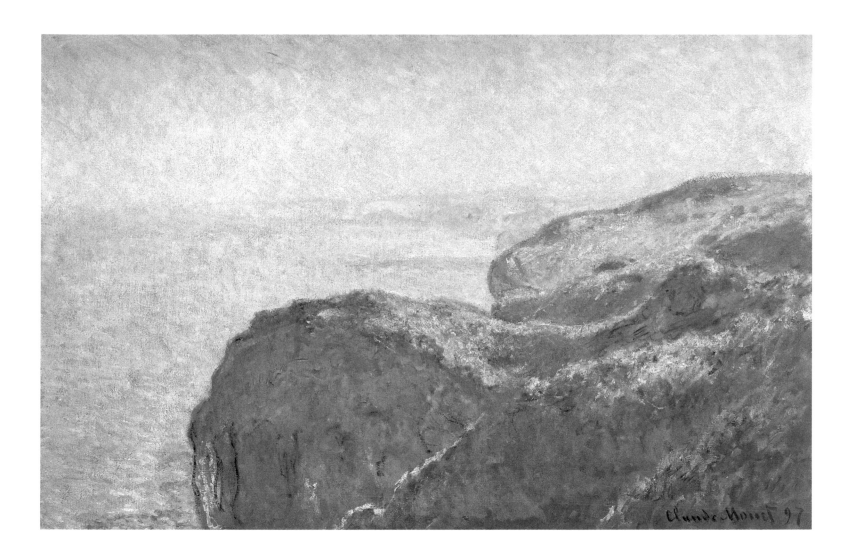

who did any thing all day but paint," a question that a caricaturist raised as well (fig. 83).[7] By 1893, the government was finally forced to look outside the Salon for works of art to purchase, a policy it had stringently resisted until then. That two historians four years later saw all of these movements as potentially confusing is thus understandable. So too was their solution – a synoptic table of the whole history of art that revealed the roots of the various directions French art appeared to be taking in the later 1890s. Consistent with the orientation of the period, the historians concluded that the most important direction was the one that led to the spiritual and the ideal, and that sensitive artists should tap this "invisible world" to raise human consciousness to a higher, more universal level.[8] Although Mauclair, Germain, and many other observers of the cultural scene felt the same way, Monet believed differently, as

Plate 70. (cat. 74) *Val-Saint-Nicolas, near Dieppe. (Morning.)*, 1896-97. The Phillips Collection, Washington D.C.

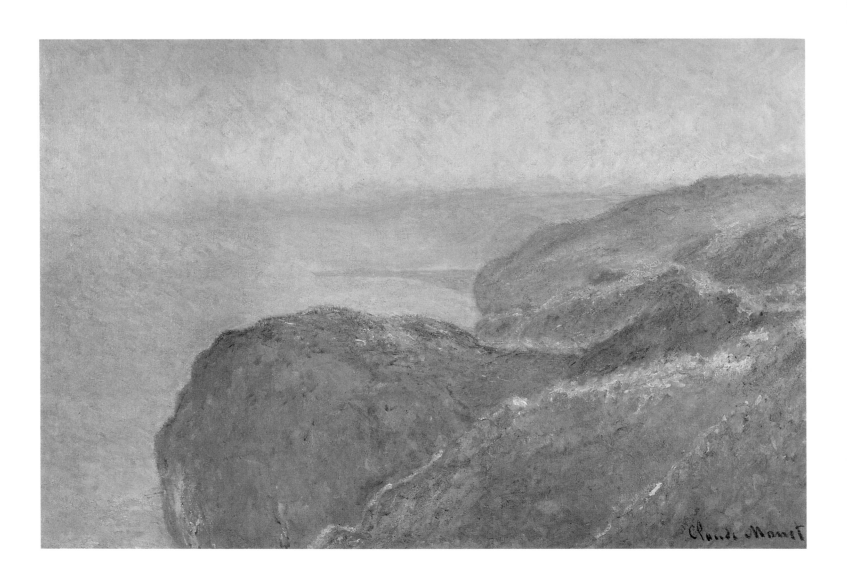

his *Cathedrals* had suggested. His Norman coast paintings would reaffirm his conviction in even clearer terms.

THE Norman campaign began in Pourville, where Monet had painted for three months in 1882. Wedged into a small area of flat land that lay between two huge chalk cliffs (fig. 84), Pourville was a modest little town, described by Paul Joanne in his guide to Normandy of 1882 as "a hamlet situated in a picturesque valley . . . with a few charming villas, a hotel-restaurant, and . . . barely twenty fishermen's cottages."⁹ A fraction of the size of the fashionable port of Dieppe, which lay four kilometers to the east (fig. 85), Pourville had far fewer amenities and tourist attractions than its neighbor and much less pre-

Plate 71. (cat. 73) *Val-Saint-Nicolas, near Dieppe. (Morning.)*, 1896-97. Private Collection

Fig. 83. Draner, "Oh these painters. . . they have become stupider than we musicians!, *Le Charivari*, 1893.

Fig. 84. Anon., Photograph of Pourville, ca. 1890. Collection Roger-Viollet, Paris.

Fig. 85. Anon., Photograph of Dieppe, ca. 1890. Collection Roger-Viollet, Paris.

tension. When Monet first visited Dieppe in 1882 he had nothing good to say about it. It was too much like a city, the cliffs were less impressive than those at Fécamp, his room was "dreadful," and the hotel, terribly expensive. (He was staying in the Hotel Victoria, which was one of the best in Dieppe, of course.) When he finally left and discovered Pourville, he was thrilled. It was "a little nothing of a village," he told Alice, but it was "three times cheaper than Dieppe" and set in "a very beautiful region." What he found particularly attractive was the fact that he "couldn't be closer to the sea. . . . I only regret not having come here sooner."[10] In 1896, he did not bother with Dieppe but went straight to its humbler neighbor.

In 1882, Monet had roamed all over the Pourville cliffs and had walked up and down the coast to paint the town from the east and west. He had also done a number of canvases from various vantage points on the beach itself. In 1896, he greatly reduced his range, concentrating primarily on views of the coastline as it swept westward from in front of the town toward Varengeville and the Petit Ailly. Monet had painted this same site in 1882 and would do so again in 1897 (plates 65-67). It was one of the least dramatic that Pourville had to offer, but it was convenient, a factor of some importance given the frigid cold that Monet had to endure during the winter months he was there. In 1896 it also allowed him to get adjusted to working again. However, as with the *Ice Floe* pictures (plates 52-54) from 1893, which likewise came after a long period of inactivity, the location resulted in rather unchallenging canvases, particularly in comparison to the *Cathedrals* of the year before.

This was due in part to the relative simplicity of the site, which led Monet to use a very straightforward composition. The site also restricted the number of forms that he could include. The unchallenging character of these pictures is due as well to the brushwork that Monet employed; the paint is applied sparingly and with far less gusto than usual, as if he was carefully mapping his way once again. Monet admitted as much when he wrote Alice after nearly two weeks in the town. "I am working, but very, very slowly and painfully. I no longer have the courage to work on five or six canvases a day. I labor on two or three and always hesitantly, unhappy with the *mise en toile* or with the site I chose, which then forces me to make changes." Two weeks later things had not improved much. "I am so clumsy, so far from seeing and understanding; I am no longer who I was, that is certain." He felt a bit better after a month, claiming he needed that long for his apprenticeship.[11]

Besides Monet's protracted labors and the dry, tempered surfaces that he devised, what is striking about these pictures is their rather extraordinary palettes of pinks, soft oranges, sea greens, pale violets, and light blues – pastel shades that he had not employed as consistently in earlier work. The same fanciful, almost unreal color is evident not only in the Pourville views but also in all of the other paintings that Monet began during this Normandy campaign in 1896. That includes several pictures done from on top of the bluffs looking east toward Dieppe and the Val Saint-Nicholas (plates 68-71), and the suite of paintings from down the coast at the Petit Ailly in Varengeville (plates 72-80).

As soon as Monet moved up onto the cliffs, as these other canvases make clear, he began to paint more animated pictures. Although perhaps related to his month-long reacquaintanceship with the

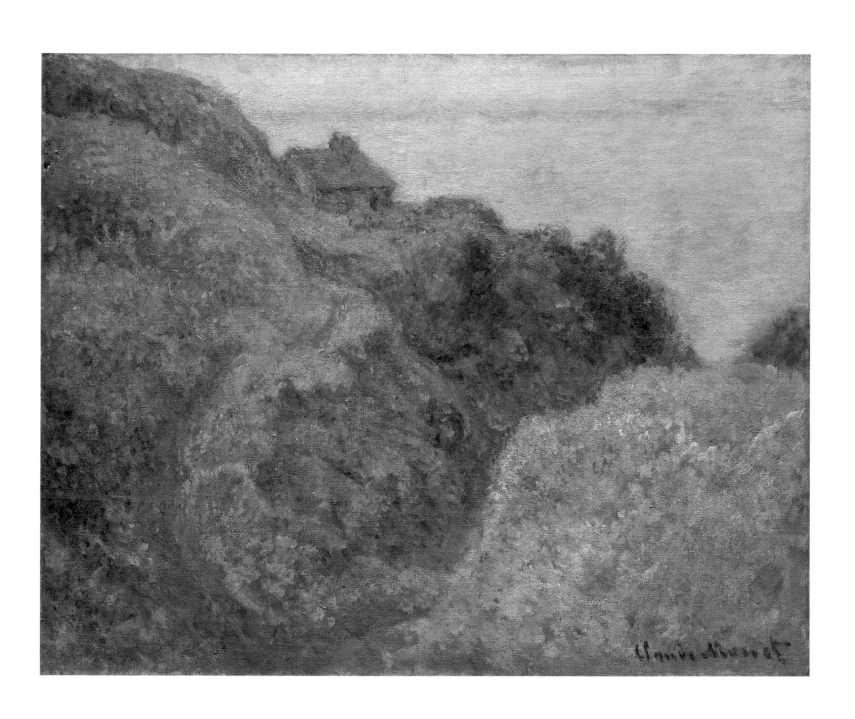

Plate 72. (cat. 67) *Gorge of the Petit Ailly. (Varengeville.),* 1896-97. The Metropolitan Museum of Art, New York

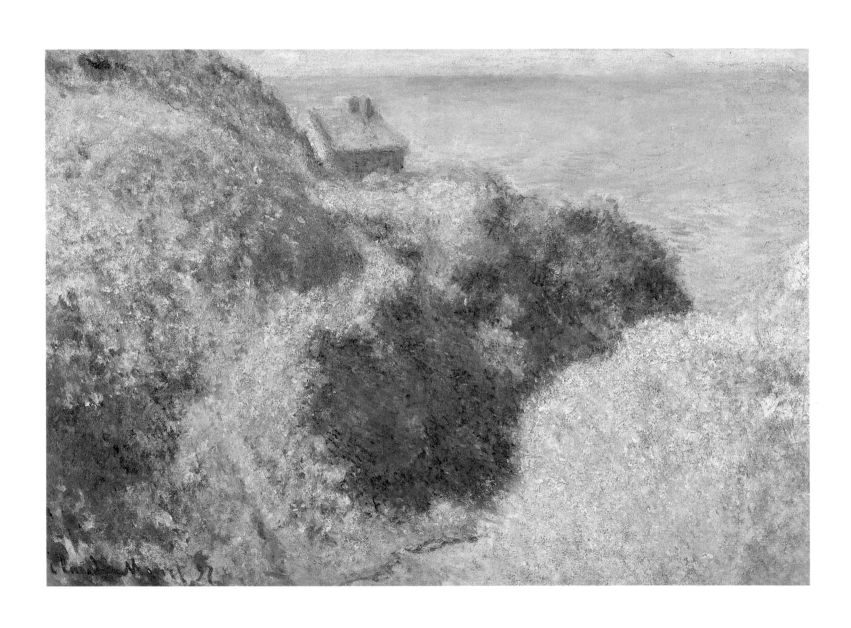

Plate 73. (cat. 68) *Gorge of the Petit Ailly. (Varengeville.),* 1896-97. Fogg Art Museum, Harvard University, Cambridge, Massachusetts

Fig. 86. Anon., Photograph of the gorge of the Petit Ailly at Varengeville, ca. 1900. Collection Roger-Viollet, Paris.

Fig. 87. Anon., Postcard of the Customs House at Varengeville, ca. 1910.

Fig. 88. Claude Monet, *Gorge of the Petit Ailly at Varengeville*, 1882. [W.732]. Museum Boymans-van-Beuningen, Rotterdam.

coast, this change was surely due to the drama that these elevated sites afforded. When looking east to Dieppe, for example, as Monet does in plates 68-71, the land rises and falls in subtle but energized motions, pushing out against the sea, sometimes quite precariously, as if to challenge the water's power before narrowing and nearly disappearing in the distance. While the elemental qualities of the site recall certain aspects of Belle Isle and the Creuse, the gulls that Monet includes in plate 68 reaffirm his Channel location, as does the moist northern atmosphere that fills the scene.[12]

In contrast to the beach, therefore, the cliffs held out greater possibilities, a fact that Monet exploited most when he went west of Pourville to paint the Petit Ailly (plates 72-80). This site had been one of his favorites in the 1880s; he had painted it almost twenty times in 1882, more than any other single motif that year. The natural formation of the gorge was one of the site's greatest attractions, the chalk cliffs having been split by glacial forces centuries earlier, with the weather thereafter gradually wearing down the hills on either side (fig. 86). Those hills were still quite steep; even climbing them today requires considerable effort.

In 1882, Monet painted the path leading through the gorge only twice. His interest lay more with the site's two other principal features – the wonderfully irregular contour of the cliffs, which he emphasized by silhouetting them against the sea and sky, and the small house that sat on a flat section of the bluff on the left side of the gorge (fig. 87). The house dated from the time of Napoleon I and had been built during the continental blockade as a lookout station for French customs officials charged with collecting duty from any ship attempting to unload cargo in the country. After the fall of Napoleon, it was appropriated by local fishermen and used for refuge and storage.

The house appears in every view of the area that Monet painted in 1882, indicating its importance to him. It is tucked into the folds of the undulating landscape, nestled against the jagged section of the cliff that rises dramatically behind it to the west, or shown perched high above the sea like a captain on the prow of his ship (fig. 88). Always isolated, the cabin appears to have been a repository for Monet's deep feelings of various and sometimes contradictory kinds. Seen under a wide range of weather conditions, it appears to be at once mournful and heroic, anxious and reserved, threatened and self-contained. It also seems to act as a surrogate for various kinds of people – wayward travelers, old Norman residents, sailors, fishermen, or those who stayed at home waiting for their seafaring loved ones to return. It can also be seen as a kind of stand-in for Monet, who like the sailor, was vulnerable to the elements but who was committed to working with them.

Such suggestions gain credence when we recall the depths of Monet's attachment to the sea and his vicarious association with those who worked it. "You know my passion for the sea," he told Alice while on Belle Isle in 1886, "I am mad about it," a fact that his fifty-nine-year-old companion and porter on the island, Poly, confirmed years later. "Only the sea made Monsieur Monet happy," he recalled. "He needed water, great quantities of water, and the more there was of it, even if it was spattering our faces with foam, the more pleased he was." Even during World War I, Monet had to visit the Norman coast

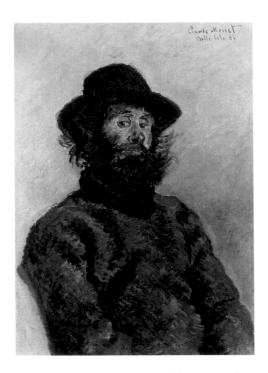

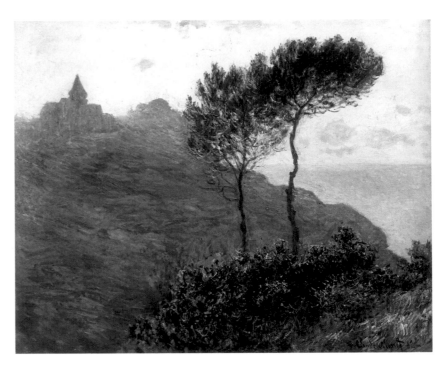

Fig. 89. Claude Monet, *Portrait of the Porter Poly*, 1886. [W.1122]. Musée Marmottan, Paris.

Fig. 90. Claude Monet, *Church at Varengeville*, 1882. [W.727]. Barber Institute of Fine Arts, University of Birmingham, England.

to be invigorated by the sea, an urge he apparently felt so often late in his life that he claimed he wanted to be buried in a buoy that presumably would have bobbed forever on the waters.[13]

Monet's enthusiasm for the sea is amply demonstrated by the hundreds of paintings he executed in which it is the primary subject. But it is expressed in more subtle ways as well. One of his favorite paintings was the portrait he did of Poly (fig. 89). Monet never parted with the latter's weatherbeaten image, hanging it prominently in his studio, like a reassuring alter ego, just above his own bust by Rodin.[14] In addition, in the 1880s Monet did more than half a dozen views of Varengeville's quaint 13th-century church (fig. 90). It lay just a bit to the west of the Petit Ailly. The church was a unique combination of the religious and the secular, as it had a roof and truss system that was based on designs for ships' hulls. It also had a sizable cemetery devoted primarily to deceased seafarers and their families. Sitting high upon the elevated headlands, the structure was as much a lighthouse or sailor's refuge as it was a building devoted to Catholicism, a fact that Monet emphasizes when he makes its silhouette a continuation of the irregular line of the coast. Monet also includes a pair of trees prominently in the foreground. Their thin, gnarled trunks twist and turn like the outline of the cliffs while their leafy tops, rising just above the horizon, reach out to the sea as if straining for some sign of returning mariners.

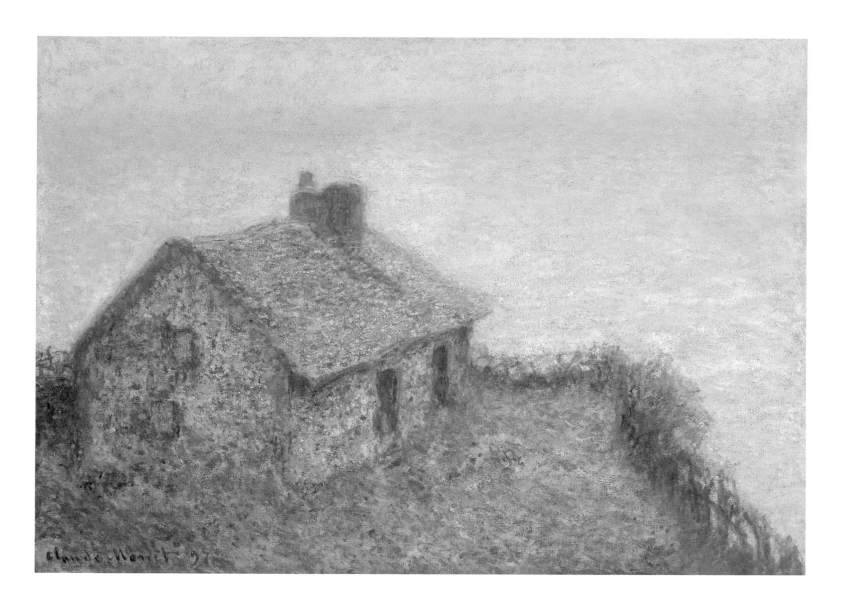

No paintings of the church or its environs survive from Monet's campaigns of the '90s, although he told Alice that he had begun two pictures in that area during March 1896.[15] As in 1882, he concentrated primarily on the customs house. He did the same in 1897, painting the house fourteen times that year, twice as many as any other motif (plates 72-80). He even mentioned it in the first letter he wrote to Alice after he had settled into his hotel in Pourville that January. "I arrived without problem and was greeted with beautiful weather," he told her. "As soon as I had lunch, I went out to see all of my motifs. Nothing has changed." This was not completely true. The land was much greener than the previous

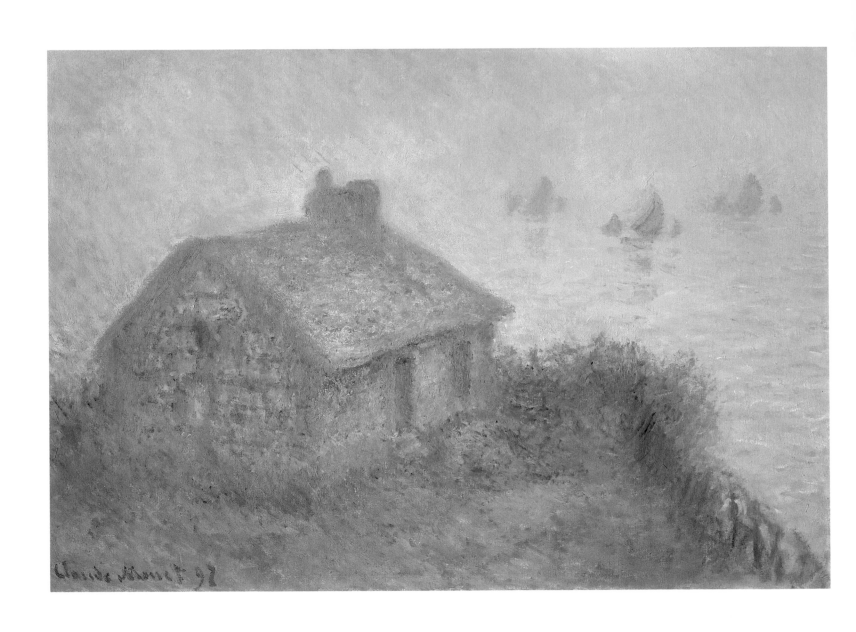

206 Plate 75. (cat. 71) *Customs House at Varengeville. (Fog.),* 1896-97. Private Collection

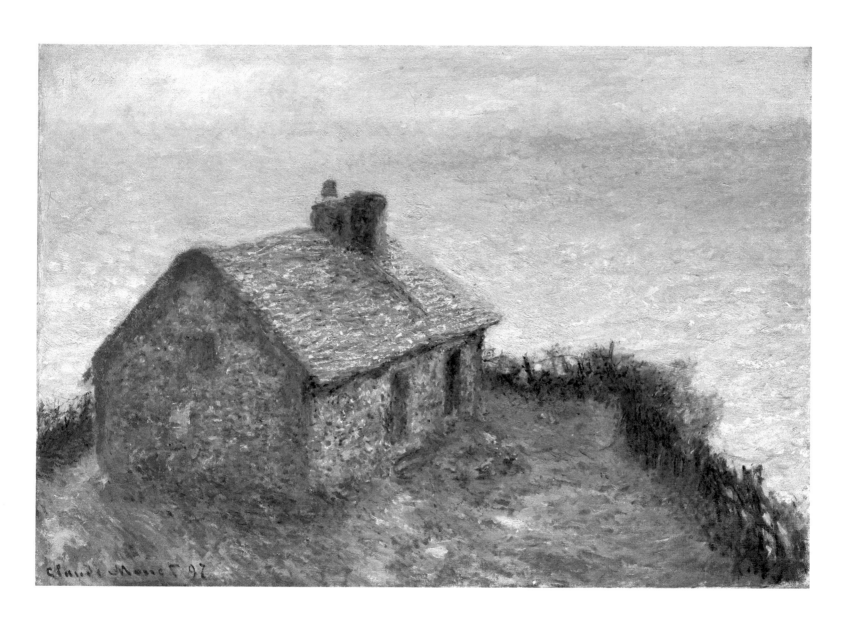

Plate 76. (cat. 69) *Customs House at Varengeville*, 1896-97. The Art Institute of Chicago

year and, as Monet soon found out, the area to the east was in the process of being leveled so that it could be converted into a shooting range. However, "the little house is intact," he noted with pleasure, and "I have a key to it."[16]

Work went very well for the next three months. Although occasionally drenched by sudden showers or forced to stop because of the "bloody winds," Monet was completely captivated by the place, with its "spring tides, furious sea, [and] beautiful movements of the earth." He complained about the variable weather conditions, the changes that the advent of warmer weather brought to certain motifs, and the toll that the campaign was taking on him physically. He even felt so ill during March that he went to his brother's house in Rouen to recover for four days. But when he packed up his belongings and returned to Giverny early in April 1897, he had more than thirty canvases to show for his efforts.

Pulsating with life, these pictures are imbued with the beauty of the coast, particularly those depicting the Petit Ailly and the Val Saint-Nicholas. Land masses turn and swell, as earth, water, and sky compete for space within the frame. Painted surfaces, often the product of many working sessions, range from the richly encrusted to the stippled to the evanescent, just as color schemes span the gamut from the pastel yellows and pinks that Monet had used in 1896 to lavenders and lime greens reminiscent of the *Creuse* paintings. In many of the scenes, forms are less precise than those from the 1880s. For example, the edges of the cliffs are softer, the contours of their forms less enunciated, the waters of the channel calmer. This is due in part to the more generalized quality of light that Monet suggests in these works. It creates fewer contrasts and thus allows forms to meld more than the brilliant illumination he had so often captured in the previous decade. Since these softer effects engender a sense of introspection, it is tempting to see these pictures as being informed as much by memory as by experience, leading us to believe that we are looking at an aging man reflecting on his past as much as observing and transcribing specific lighting conditions.

Before Monet began his Normandy campaign, he had not worked in Pourville and its environs for more than fifteen years, during which time much had happened in his art and life that was worth recalling: the challenges that he had faced in the 1880s and the ways that he had met them; the success and fortune he had gained; even the orientation toward series painting that had been the ultimate result of his struggles during the period. Varengeville in particular would have been able to evoke these memories because its elemental qualities were precisely the kind that Monet had sought during the 1880s and had found most inspiring. He had discovered them in other coastal towns of course – in Étretat, for example, and in Fécamp. However, Varengeville had been especially important to Monet in the early 1880s, as it had been the first place to prompt him to concentrate on a narrow range of subjects and to produce a sizable number of canvases in a short period of time. Although different from the series paintings that would come out of his stay on Belle Isle and the Creuse, these Varengeville pictures nonetheless had provided Monet with his first sustained alternative to the contemporary subjects that he had abandoned in the 1870s. In retrospect, therefore, he may well have seen them as instrumental to his own evolution as an artist.[17]

Fig. 91. Claude Monet, *Cabin at Trouville*, 1881. [W.686].
Private Collection.

Fig. 92. Claude Monet, *Customs House at Varengeville*, 1882.
[W.740]. The Brooklyn Museum of Art, New York.

Fig. 93. Claude Monet, *Headlands and Customs House of the
Petit Ailly at Varengeville*, 1882, [W.743]. The Philadelphia Mu-
seum of Art, Philadelphia.

Monet could have found similar motifs elsewhere in Normandy. In fact, in 1881, he had painted a
picture of a small house hugging the bluffs at Trouville (fig. 91) that vaguely recalls some of the later ones
at Varengeville. However, Monet never went back to paint this view again, a decision that most likely
was based on the fact that Trouville was fundamentally different from Varengeville and its neighbors. It
was one of the most popular spots along the entire coast of Normandy and had lost its more traditional
relationship with the sea even by the time Monet had completed this single picture. That heritage had
fallen prey to the ever-aggressive tourist industry during the 1860s and '70s. Although still retaining
picturesque parts, the town essentially had become a Parisian outpost, all boardwalks, boutiques, hotels,
and casinos. In addition, its cliffs could not compare in height or grandeur to what Monet found at
Varengeville, Pourville, or the Val Saint-Nicholas.[18]

Whenever Monet painted the customs cabin at Varengeville from close range in the 1880s, he ap-
proached it from above and included more sea than land in his view (fig. 92). He also generally raised
the promontory on which the house sat to such a degree that the land and cabin appear as if they are
riding the waves on the sea below it. In 1897, Monet came even closer to the structure, enlarged its

210 Plate 77. (cat. 63) *Headland of the Petit Ailly*, 1896. Private Collection, Switzerland

presence in the scene, and diminished the amount of area devoted to the Channel waters (plates 74-76). These tactics resulted in pictures of greater calm, an effect to which the more horizontal promontory contributes as well. In comparison to the earlier, more aggressive views of the 1880s, those from 1897 appear weightier and more monumental, as if more mature concerns were being considered.

One senses this even in the paintings in which the cabin is dwarfed by the cliff behind it (plates 77-80). In 1882, Monet did only two canvases from this vantage point (fig. 93). In 1896-97, he did five, in all of which the house appears much smaller than in the two earlier versions and at the very bottom edge of

Plate 78. (cat. 64) *Headland of the Petit Ailly*, 1896-97. Private Collection

Plate 79. (cat. 66) *Headland of the Petit Ailly. (Gray day.)*, 1896-97. Private Collection, Washington D.C.

Plate 80. (cat. 65) *Headland of the Petit Ailly*, 1896-97. Private Collection, Baltimore

the canvas. Never does he highlight it as he had in those from the previous decade. He also has the hill rise higher on the picture plane in 1896 and '97, diminishing the amount of sky in the scene, particularly on the left where the hill tends to climb to the top of the canvas. Pulling the site slightly closer to himself, Monet also tightens the right edge of the cliff, causing it to be more vertical than in the earlier views. This also makes the cliff appear more majestic and the house even humbler.

GRANDEUR and humility had always been a part of European landscape painting. They were almost the inevitable by-products of rendering nature, whether in a carefully orchestrated manner to evoke thoughts of the ideal, as in the work of Poussin or Claude Lorrain, or in a more direct fashion to prompt a sense of its presence, as in the efforts of Ruisdael or Turner. At the end of the 19th century, grandeur and humility were still important to French landscape painters, as is evident from the continuous production of realistically rendered scenes of the French countryside and from the work of artists such as Puvis de Chavannes or certain Neo-Impressionists such as Henri Cross. In keeping with the era's tendencies, in fact, these two approaches to landscape painting were taken to their logical extremes, resulting in works like Puvis's *Inter Artes et Naturam* and Veyrassat's microscopically detailed harvest view (figs. 53 and 54). The former was an extension of the classical tradition that had been set down in the 17th century; the latter, the culmination of the 19th century's infatuation with painting's power to reproduce the world with painstaking verisimilitude.[19]

According to Hippolyte Taine, who had established various categories for painting in his *Philosophy of Art* of 1875, Puvis's picture would be considered a product of the Southern European landscape tradition, while Veyrassat's would be a typical Northern picture. The formal characteristics that distinguish the two paintings and their respective traditions, according to Taine's theory, were primarily the result of the contrasting weather conditions in the two areas. The South, for Taine, was the logical birthplace of classicism because Greece and Italy enjoyed a more predictable climate and more consistent, clearer light. Such an environment naturally gave rise to notions of the ideal and to concepts of order, stability, clarity, and calm. The North, on the other hand, was dominated by shifting weather patterns, harsher climates, and gray, ever-changing light. Those who lived there developed a keen interest in the real and an enthusiasm for capturing particular effects of nature. Because this interest relied on what an individual could see and experience, Northerners also developed a parallel enthusiasm for romance and fantasy. They therefore tended to produce either absolutely mimetic art or art that was moody, personal, and obscure. In either case, they bore witness to the volatility of man and nature.

Because it stretched from the Mediterranean to the Channel, France enjoyed a dual orientation and two competing traditions. All landscape painters understood this about the country, Monet included, as is evident from his trip to Antibes in 1888. In the 1890s those differences became the focus of considerable attention as France attempted to decide which tradition was more appropriate for its national art.

There was considerable enthusiasm for realistic work, just as there had been since mid-century; there was also widespread interest in Impressionism. But what distinguished the decade in terms of landscape at least was the keen desire for paintings of arcadian environments filled with reverie, mystery, and a sense of the spiritual. These works appealed to the decade's nostalgia for simpler times, tapped its interest in the subjective and the transcendent, and provided the nation with reassurances about the vitality of its painters. "This is not a step backward," wrote Raymond Bouyer in 1898, "but a new affirmation of free will against the recent tyranny of materialism. . . . A new page in history is being written for the benefit of the beautiful."[20] This orientation toward the beautiful and the ideal was broadbased. It led the astute critic André Mellerio in 1896 to assert in his study of what he called *The Idealist Movement in Painting* that idealism was quickly relegating Impressionism to the past because ideas and the imagination were replacing observation and sensation as the basis for making art. It was even cited and praised in books on non-art topics. And it generated interest in Poussin as well as previously unknown or neglected artists, such as Sandro Botticelli, who appeared to have been addressing similar concerns with his Neo-Platonic figures and imaginary settings. So rapidly, in fact, did Botticelli rise in popularity that Mirbeau wrote a mocking article in the same year as Mellerio's study in which the Renaissance artist awakes and expresses incredulity at his new status.[21]

This turn to the South was the almost predictable aesthetic response to the call for "a new spirit" of cooperation and regeneration that reverberated throughout the country from the early 1890s onward. For *l'esprit nouveau* demanded subservience to the common good, not brash individualism; it called for an allegiance to higher principles, not an interest in the mundane; and it assumed a belief in the inherent goodness of *la France*, not a vague sense of what the nation could or should be. As its formulator, the Minister of Public Instruction Eugène Spuller, stated in 1894, "*L'Esprit nouveau* is the spirit that tends, in a society as troubled as ours, to draw all Frenchmen together around the ideas of good sense, justice, and charity."[22] In addition, Greece and Italy, which had given birth to Western civilization, were seen by Spuller and others as the fountainhead of all enlightened thought and the foundations on which France had rested for centuries. Indeed, most people believed that France had actually inherited the Greco-Roman traditions when Louis XIV revived classical architecture with unprecedented taste and splendor in the 17th century and upheld antiquity's literary achievements with the likes of Racine, La Fontaine, and Corneille. Some people even felt that with Claude and Poussin, France had surpassed her ancestors in painting, as the Greeks and Romans had left no work by any comparable artists. As Hippolyte Taine flatly asserted in 1875, "During the reign of Louis XIV, one could say that France educated Europe."[23]

This was a powerful concept, particularly in the 1890s when the country could no longer claim a similar leadership role. Once again, however, in keeping with what happened so often during the decade, the interest in France's ties to the classical past bred an exclusivity that soon became extreme. In 1891 Jean Moréas denounced the Symbolist movement that he had helped to found in 1886 and proclaimed the establishment of the French-Roman school, which he declared would "reaffirm the Greco-

Fig. 94. Pierre Puvis de Chavannes, *The Sweet Land*, 1882. Yale
University Art Gallery, New Haven.

Latin principles . . . [and] . . . restore the Gallic chain that had been broken by the romantics and their
Parnassian, Naturalist, and Symbolist descendants." His co-founder, Charles Maurras, made the new
school's allegiance to Southern traditions absolutely clear when he assured the readers of *La Plume* in
June 1891 that "one cannot conceive of an idea or a dream that was not created by the Mediterranean."
"It is proper to call anything barbarian that is alien to classical letters," he claimed a few years later,
"not only because it is outside the Helleno-Latin tradition, but also because it is foreign to higher hu-
manity."[24] By 1895, when Maurras made this claim such chauvinistic notions had become more com-
mon and more pointed. "At a time when we are suffering an all-out invasion of barbarian literature," a
writer for the *Mercure de France* observed in May of that year, "when the Scythians and the Saxons
monopolize our theaters and libraries . . . we have to defend the patrimony of the Latin muses; we must
counter the monstrous imaginations and inconceivable chaos of the foreigner with a taste for the order,
measure, and harmony of our race and fight with all of our might for the salvation of the French
spirit."[25]

Such aggressively defensive almost paranoid rhetoric might seem alien to the world of the arts, but,

by mid-decade, that world was being called upon to play an important role in the new France, just as it had after the Franco-Prussian War. That meant that its critical language would be broadened by military jargon and its ideology informed by contemporary politics. The unity and power of *la France* was that paramount an issue. Anything that could contribute to it was called upon to do so; anything that did not could be held suspect or cast out.[26]

Coming just after his views of Rouen Cathedral, Monet's paintings of Pourville, Varengeville, and Dieppe were timely counters to these conservative notions and their manifestation in classicism's resurgence. As poetic evocations of the elemental character of the Norman coast, they proclaimed the continuing relevance of the Northern tradition of landscape painting and the significance of experiencing nature's raw powers and ephemeral beauty. Thus, instead of conformity, they affirmed individuality; instead of a fictitious ideal, they proposed the palpable and the real. They did not disavow certain Mediterranean traits, such as majesty or harmony, as is evident in particular from certain Pourville views, such as (plates 65 and 66). In their simplicity, chalky surfaces, and unnatural colors, these canvases are nearly as "Southern" as Puvis's *Sweet Land*, the epitome of what the Mediterranean tradition was expected to produce (fig. 94). But unlike Puvis's picture or those by his many followers in the late 1890s, these Norman canvases, while harmonized in the studio, were the hard-earned products of Monet's engagement with the vicissitudes of those dramatic coastal sites, with a Northern nature that, in short, was more vital than the temperate South.

Normans had always valued that engagement and extolled the energy of its results. As the medieval conquerors of England under William I, and some of the heartiest people in France, they took pride in their self-sufficiency and strong-mindedness, just as they looked upon their central role in France's history with a sense of accomplishment. They were not alone, as most post-Revolutionary French Republicans treasured a deep relationship with nature and disdained imposed hierarchies. But as the 19th century came to a close, these notions appeared to be passing into history just as grandeur and humility had, compromised as they were by the many complex questions about the aging nation's character that the *fin de siècle* raised. Monet's coastal paintings were his attempt to reassert the centrality of these ideas in seductively unequivocal terms. He set out to do the same with his views of early morning light on the Seine which preoccupied him during the same two year period. But for that series he ingeniously devised a different strategy, which earned him widespread acclaim and the undisputed leadership of French landscape painting.

218 Plate 81. (cat. 81) *Morning on the Seine, near Giverny*, 1896-97. Hiroshima Museum of Art, Hiroshima

The Changing of the Light:
Monet's Mornings on the Seine of 1896-97

IF THE NORMAN COAST was a critical reference point for Monet during his long career, the Seine was his constant touchstone. He lived near its banks all his life and painted it more frequently than any other single subject. In fact, not a year went by from the early 1860s to 1889 that he did not render its flowing waters at some site between Paris and the Channel. As a result, no river is more associated with Impressionist landscape painting. Moreover, of France's many rivers, none is more central to the nation's idea of itself. Although the country's two other well-known waterways, the Loire and the Rhone, are longer and are set in more picturesque regions, the Seine has "shores that [are] starred with great cities, [and] waters that have mirrored Gallic boats, Roman galleys, Norman fleets, and English galleons," as one early 20th century guidebook proclaimed. It was famous "since before Caesar looked out upon it through the silken curtains of his litter" because it flowed from its source in the Côte d'Or to Paris, the heart of the nation, and from there to the northern extremity of the country, emptying into the Channel at the ever-bustling port of Le Havre. Winding its way past rich, cultivated land, the Seine was both a river of beauty and an artery of commerce, home to pleasure boats, fishing vessels, and cargo-carrying barges. Although many Parisians liked to believe it began at the Arc de Triomphe, the Seine in fact was France's national waterway.[1]

In the first half of the 1890s, Monet tended to paint the river in between his major series, either as a respite from those travails or as a way to gear himself up for his next undertaking. In either case, his efforts generally resulted in marketable groups of meditative works, such as his *Ice Floe* pictures of 1893 or his views of Vernon from the following year. In 1896, after his first campaign on the Norman coast, Monet decided to concentrate more intensively on the Seine. When he began these pictures late that summer, he rose at 3:30 every morning to be on the river just before dawn – a choice of working conditions that is unprecedented in his career. The result was the *Mornings on the Seine* (plates 81-89), a series of paintings that chart the progression of early morning light on the water and its leafy banks with extraordinary refinement.

As a group, these canvases complement those that Monet had begun in Pourville, Varengeville, and Dieppe. First, they depict a motif that is linked by geography to those sites, since the Seine runs through Normandy and empties into the Channel. The two series are also tied by formal considerations. The simple, arabesque compositions that Monet employs in the *Mornings on the Seine* continue the decorative arrangements that he used so often in the coastal paintings. The soft, harmonic colors and dry,

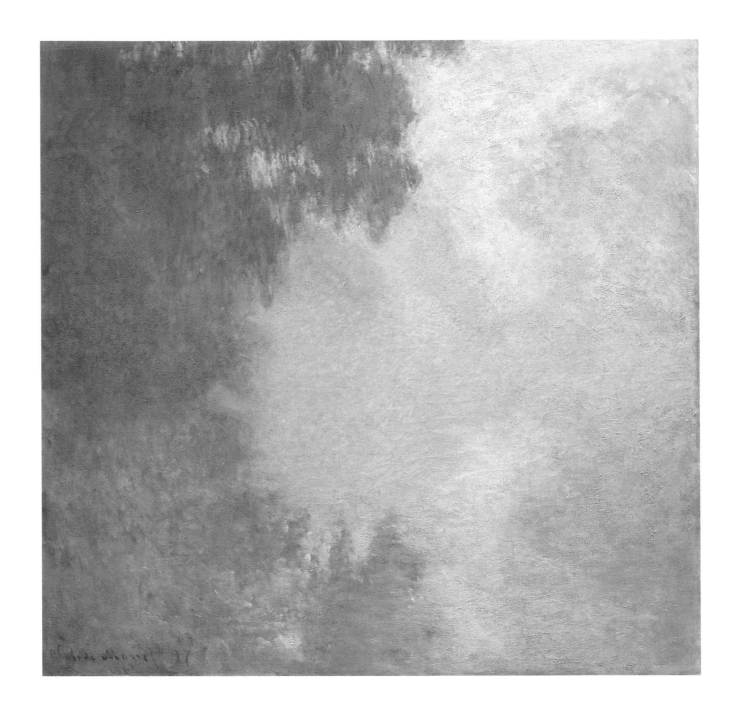

tapestry-like surfaces of the newer series extend what Monet had been exploring in the North, while both series deal with a reduced number of forms and a sense of Monet's splendid isolation in untrammeled nature. The two groups of paintings are quite different, however, just as the Seine – an internal waterway with lush valleys and soft banks – is the antithesis of the ocean-fed Channel with its severe cliffs and rocky beaches. Thus, where the Norman coast pictures are open and expansive, windswept and volatile, the *Mornings on the Seine* are contained and self-reflective, hushed and delicate, suggesting yet another dimension to the Northern tradition of landscape painting that was so essential, in Monet's mind, to the vitality of French art.

Plate 82. (cat. 78) *Morning on the Seine, near Giverny. (Mist.),* 1896-97. The Art Institute of Chicago

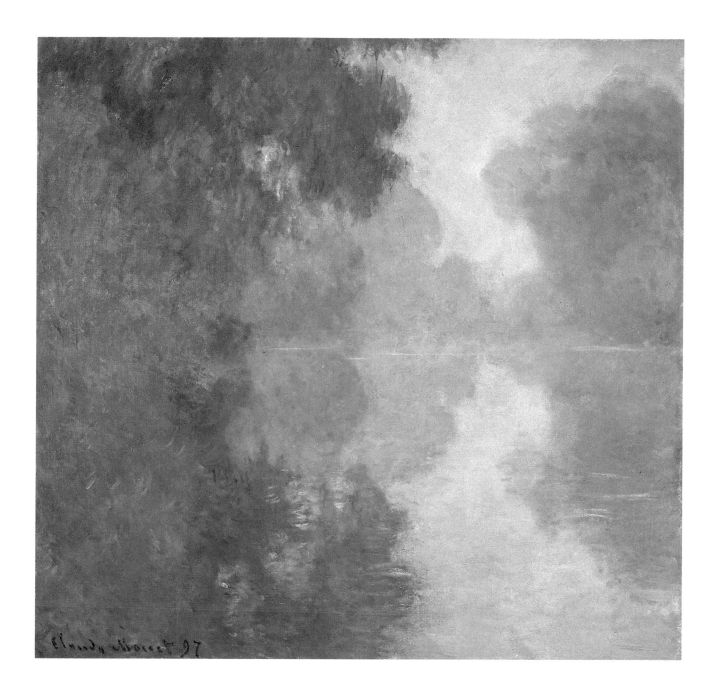

As with the cliff paintings, most of the twenty-one *Mornings on the Seine* that are known today are dated 1897. However, like those Norman canvases, these new pictures were begun in 1896, as two bear that date. Many others were probably roughed in during that first campaign but were left unfinished because of the weather. It had rained incessantly for forty-one days in September and October 1896, provoking Monet's usual cries of frustration.[2]

Monet may have selected his motif for this series for practical reasons. Having been away from Giverny for several months working on his Norman pictures, it is likely that he wanted to stay close to home for a while, particularly since Suzanne Hoschedé was still not well. Not having painted the Seine

Plate 83. (cat. 77) *Morning on the Seine, near Giverny. (Mist.)*, 1896-97. North Carolina Museum of Art, Raleigh

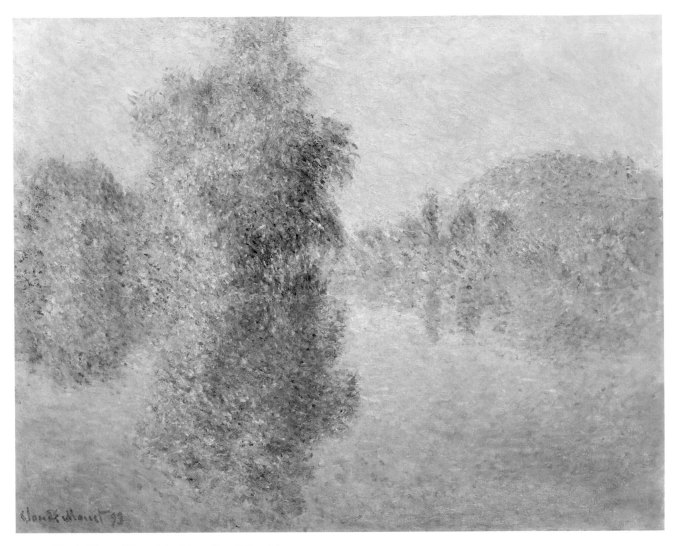

Fig. 95. Claude Monet, *View of the Seine*, 1893. [W.1365].
Private Collection.

for almost two years, he may also have felt the urge to return to his favorite motif and to avoid the difficulties he had experienced with his coastal series. In addition, he may have wanted to see if he could apply the formal tactics he had devised for those canvases to a different motif.[3]

Just as Monet's concurrent views of the Channel differ from those that he had done in the previous decade, so too do Monet's *Mornings on the Seine* contrast with his earlier treatments of this subject. This is apparent in a comparison of plate 81 to a similar view of the Seine that Monet had done only four years earlier (fig. 95). The later painting is much more restrained, much grander, and less finicky. Gone are the scintillating effects of the earlier work, the contrasts of color, and the discrete touches of paint. Everything has become more homogeneous, giving the scene a sedate, muffled quality. Paint is applied more broadly, with more overlapping, integrated brushstrokes. Colors are less particular, forms less plastic. The receding screens of foliage on either side of the water now seem less like leafy trees and more like a series of parallel flats on an illusionary stage.

In part, these differences result from Monet's vantage point. In the view of 1893, he had rowed his flat-bottomed boat downstream from his Giverny house and turned to look upriver from a spot that afforded him a broader vista. The main section of the Seine stretches across the entire canvas, uninter-

rupted except for the reflections of the trees on the island to the left of center; on the right, the view is wide enough to include the distant hills of Port-Villez. For the *Mornings on the Seine*, Monet also looked back upriver from a downstream location. But instead of floating in the middle of the waterway, he drew closer to the Giverny bank and to one of the many islands that dotted the Seine at that point (the bank appears on the left in the pictures, the island on the right). We are therefore looking not at the main body of the river but at an inlet, which by its very nature was calmer and more intimate.

Monet emphasizes the meditative qualities of the site by choosing a place where the trees on the Giverny shore were especially full. He also comes close enough to that bank to allow one tree to arch out over the water, as if reaching toward the foliage on the island to the right. Those arching branches fill the upper-left quadrant of the paintings in the series and act like a curtain that is being raised on a proscenium of natural wonder. Their reflections, while mirroring the curtain effect, define the entrance to a pathway that gently coaxes the viewer up the river to where the reflected light converges with its source in the sky.

Monet is quite artful in this group of pictures. Many of the canvases are almost square, a fact that Monet uses to considerable effect. For example, the arching branches and their reflections appear to cut the scenes in half vertically while the water rises to just about the middle horizontally, forming an almost perfect grid within the square. Monet counters the geometry of this format by having the branches and reflections on the left and right create generous but jagged curves. As the antithesis of the highly rational square, in line as well as feeling, these curves and the veering path of light that they define suggest the irregular qualities of nature. Similarly, the myriad, matte-like touches of paint, especially in the foliage on the left, challenge our sense of how form is perceived in the world and how it can be suggested in art.[4]

Monet had always been interested in subtleties of this kind, as is evident from the earlier view of the Seine from 1893. But at no time had they been carried so consistently to such visual and metaphorical lengths. Again, this is due in part to the site, as no other group of paintings deals so extensively with such soft, almost evanescent forms. In addition, the backlighting that the location dictated tends either to flatten the forms, as in plate 81, or to dematerialize them, particularly when the atmosphere thickens, as in plates 82-84. The extension of these concerns was also the result of the way that Monet composed and painted his pictures, as most of the works in the series have such harmonious compositions and are so subtly rendered that even when turned upside down they still function effectively both as descriptions of a particular site and as decorative objects with internal, aesthetic logic. But the ultimate reason for the extension of these subtleties has to do with what Monet was really addressing in this series and the moment in which he was working.

Two contemporaries who described Monet's efforts at the time can be enlisted as guides in this regard. The first is the painter-journalist Maurice Guillemot, who interviewed Monet in 1897 for *La Revue illustrée*; the second is Lilla Cabot Perry, the American artist who summered in Giverny beginning in 1889.[5] Both of these eyewitnesses attest to the fact that the series began with pictures that showed pre-

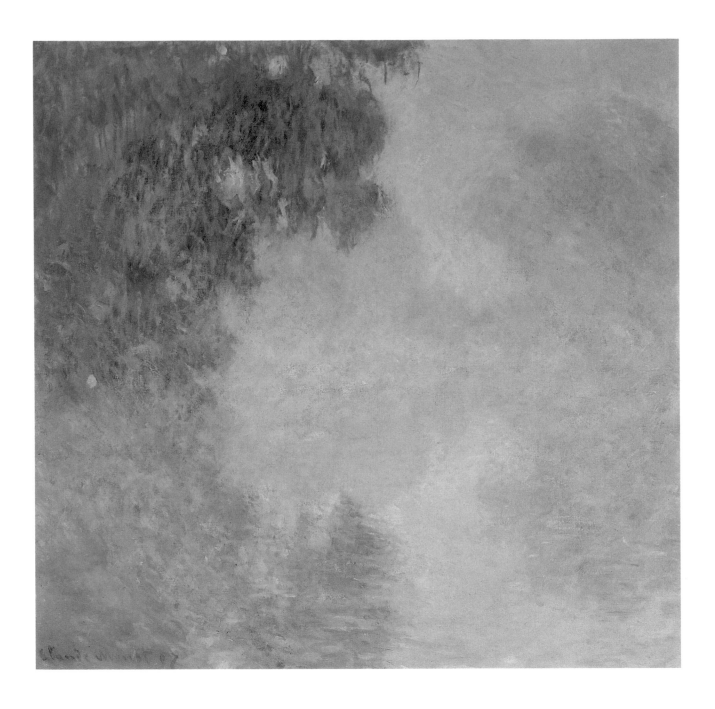

dawn light, that Monet painted them from the same flat-bottomed boat that he had used for the *Poplars*, and that they were painted in sequence as the light changed. For Guillemot, the series was "a marvel of contagious emotion [and] of intense poetry." For Perry, the group went beyond anything Monet had attempted until then, an impression that Monet qualified by telling her that "he always carried [his effects] as far as he could."

Both authors make several revealing remarks beyond these general observations. Perry, for example, claimed that Monet told her that he had been able to carry his effects further in this series because he had chosen "an easier subject and simpler lighting than usual." This has been taken to mean that he decided

Plate 84. (cat. 79) *Morning on the Seine, near Giverny. (Mist.)*, 1896-97. Private Collection, Washington D.C.

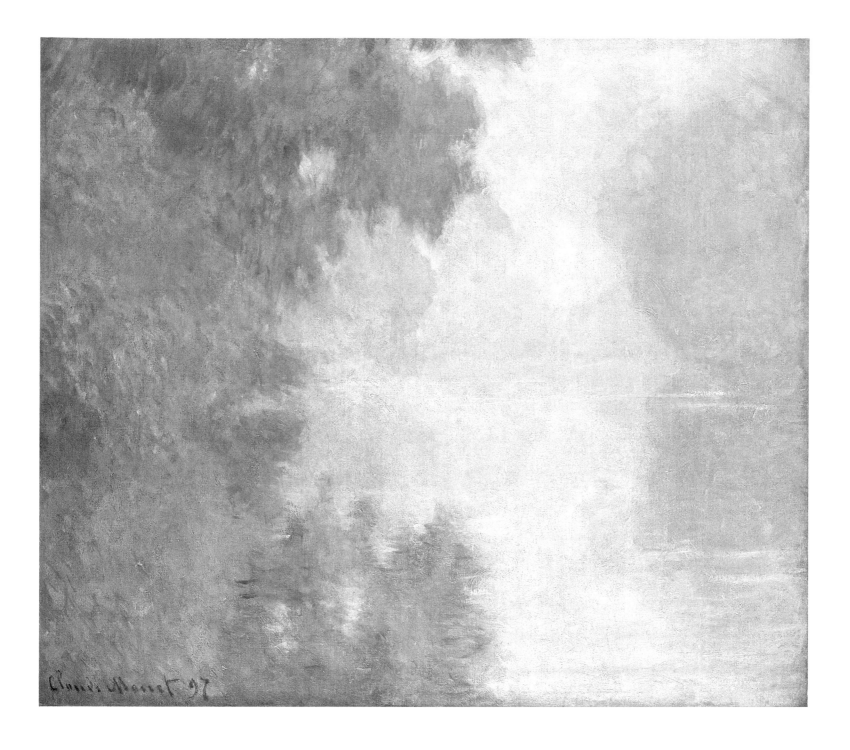

to paint the Seine at dawn because effects do not change as rapidly then.[6] However, this surely is not what Monet intended, as dawn and dusk are two of the most volatile times of day. More likely, he meant he had decided to paint something that was easier for him than anything else he had attempted – namely, to render successive moments in time, just as critics had said he had been doing throughout the decade. For, more than any previous series, the *Mornings on the Seine* document the progress of the sun over the river with the kind of meticulousness that permits a chronological ordering of most of the paintings in the group. Certain canvases are supposed to come before or after others in a fixed sequence. Guillemot even claimed that the stretchers were numbered. This procedure allowed Monet to

Plate 85. (cat. 80) *Morning on the Seine, near Giverny. (Mist.)*, 1896-97. Mead Art Museum, Amherst College, Amherst, MA

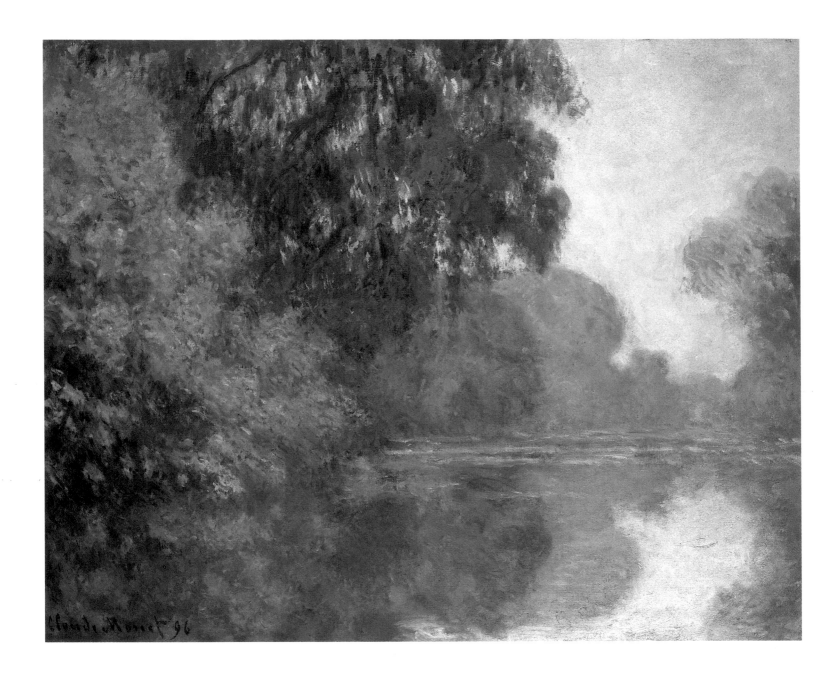

move from one view to the next, heightening his palette as he went, without being concerned about the less formulaic variations that he had attempted in other series. Thus, what had been partially evident throughout the decade, especially in the *Cathedral* paintings, now became explicit.

Why was this the case? And why in this particular series?

There is no one answer, but again Perry and Guillemot provide some leads. Perry, for example, declared that the *Mornings on the Seine* were more finished than many of Monet's previous pictures, implying that he was responding to critics who, as recently as 1895 and the *Cathedrals* exhibition, had castigated him for not paying enough attention to this important consideration. Perry also felt that the

Plate 86. (cat. 76) *Morning on the Seine, near Giverny,* 1896. Museum of Fine Arts, Boston Detail, plate 86 >

228 Plate 87. (cat. 82) *Morning on the Seine, near Giverny,* 1896-97. Private Collection

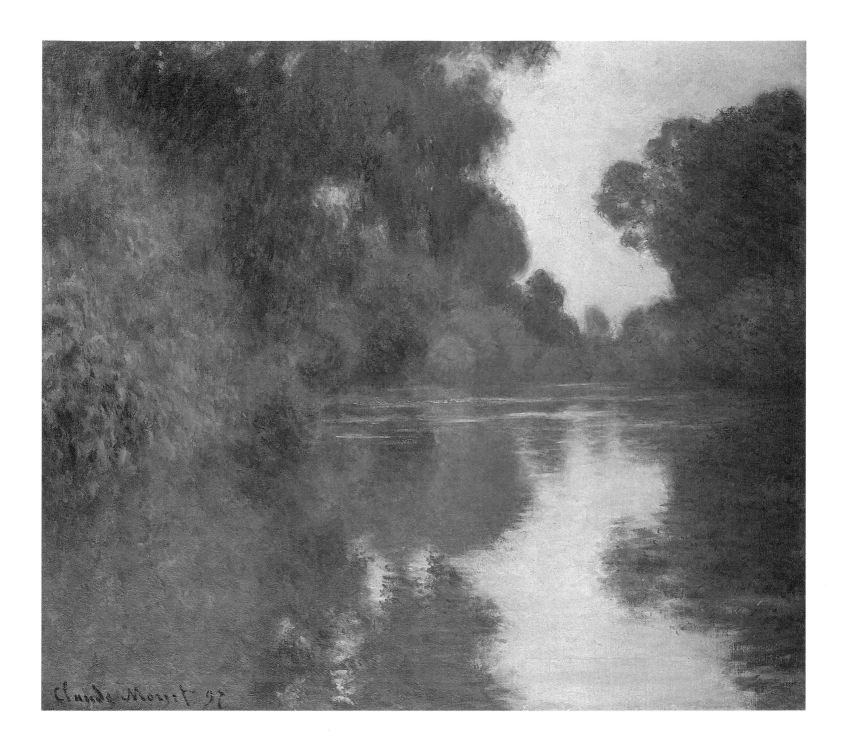

Plate 88. (cat. 83) *Morning on the Seine, near Giverny*, 1896-97. Museum of Fine Arts, Boston

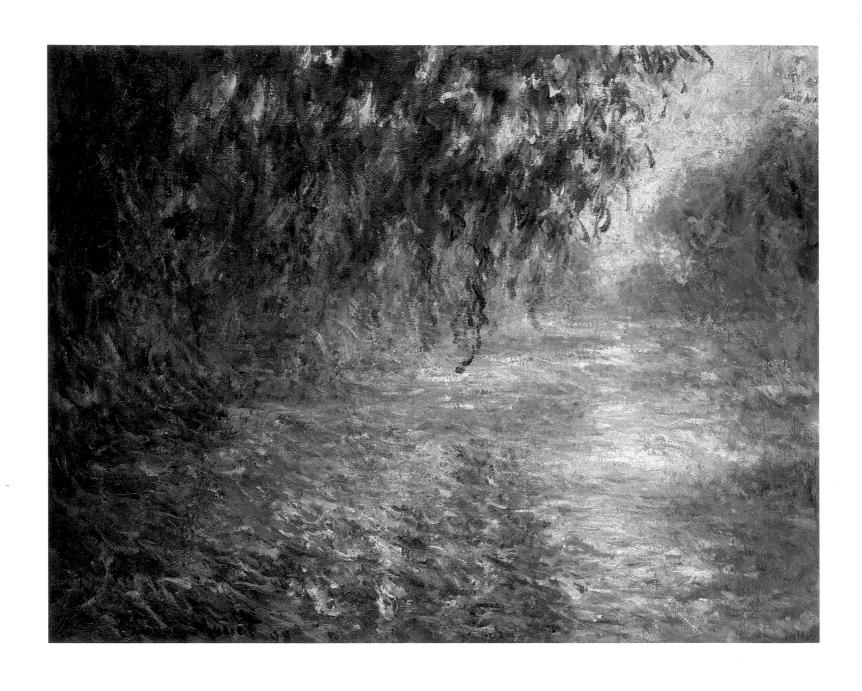

230 Plate 89. (cat. 84) *Morning on the Seine, near Giverny,* 1898. The National Museum of Western Art, Tokyo

Mornings on the Seine evoked past art, that they had "a certain Corot-like effect, Corot having been fond of painting at that [pre-dawn] hour." Hailing her hero's efforts as masterful, Perry lauded Monet for "having opened the eyes not merely of France but of the whole world to the real aspects of nature and [for] having led them along the path of beauty, truth, and light."

Although Perry's homage appeared long after the *Mornings on the Seine* were completed, similar points were central to Guillemot's more contemporaneous article. The series, for example, prompted Guillemot to recall a "phrase, formulated by the artist long ago – 'I would like to paint the way a bird sings.'" Beyond the simple association of birds and early morning, Guillemot may well have found the paintings to be as natural or as lyrical as the songs of feathered creatures. He may also have been asserting the musical qualities of the series – its harmonies, rhythms, and syncopations, as well as its ability to transport viewers to realms of reverie – an important association, given many artists' keen interest during the late 1890s in appropriating music's powers of rapture as well as its reliance on repetition. Guillemot proceeded to counter this notion, however, by informing his readers that the series, like all of Monet's work, was actually the product of "prolonged, patient labor, . . . anxiety, . . . conscientious study, [and] feverish obsession." "Unless you already knew that," he declared, "you would be astonished by Monet's wish, [which was] 'to keep everyone from knowing how it's done.'"

What Guillemot really wanted to affirm was something that Monet had made evident in the Norman coast pictures – the obligation of the landscape painter to struggle with the shifting elements of the natural world in order to make informed and novel landscape art. Guillemot felt that the *Mornings on the Seine* met those expectations and, indeed, were of the highest order. Predicting that posterity would label them "masterpieces," he claimed that they would "doubtlessly excite the wild prices currently reserved for Corot, Rousseau, and Daubigny."

Fig. 96. Camille Corot, *Memories of Mortefontaine*, 1864. Musée d'Orsay, Paris.

Guillemot's interview was part of Monet's now-standard pre-exhibition publicity campaign, just as Perry's article was one of many later reminiscences. Each, therefore, has its biases. But the fact that both of them relate the *Mornings on the Seine* to Barbizon art while seeing the series as a further extension of Monet's previous efforts is significant, as most critics who reviewed the paintings when they were shown in 1898 also noted the series' dichotomous combination of novelty and tradition. Struck by the subtlety of Monet's palette and his ability to evoke such sequential light effects, Arsène Alexandre, for example, felt that the series "gives the impression of light, refined joy, . . . [and] well-being that one can find, these days, only in the paintings of Corot."[7]

The ties to tradition, particularly to Corot, are evident in the vaporous quality of many of the pictures in the series, in the reverie that the soft, ill-defined forms generate, and in the bucolic world that the group as a whole suggests. Although Monet does not include flower-gathering figures in any of his views, he clearly devised a synthesis of observation and reflection that is similar to what can be found in paintings such as Corot's *Memories of Mortefontaine,* 1864 (fig. 96).

Monet's interest in Corot did not suddenly emerge in the late 1890s, but had been long standing. Like all landscape painters, he had been nurtured on the master's work as much as he had been guided by his own teachers, Boudin and Jongkind, as he mentioned in his interview with Guillemot. "In the old days, we'd all make rough sketches. Jongkind, whom I knew very well, used to note things down in watercolor so that later he could enlarge them in his paintings. Corot, with his quickly brushed studies from nature, would assemble those composites that his admirers fought over and in some of them you can actually see how he combined the original documents."[8] In addition to the freshness of Corot's work, Monet had to have been impressed with Corot's ability to paint a broad range of subjects, including historical landscapes, quick *plein-air* sketches, still lifes, portraits, and finished views of known sites. Monet had actually worked in many of the same places as Corot: the forest of Fontainebleau, the Île de France, the Norman coast, Holland, and Paris. He had even painted many of the very same motifs – the small church at Honfleur, the rock cliffs at Étretat, the canals in Amsterdam, the Seine at Chatou, and the Cathedral in Rouen.[9] Moreover, Corot had faced considerable difficulties during the first part of his career and had operated for a long time thereafter on the margins of success, achieving the heralded status he clearly deserved only in the decade before his death in 1875.

Monet would have found much to admire in Corot's many achievements. For example, the older artist was the first landscape painter to exhibit a Salon canvas that had been painted completely outdoors. He was also one of the few vanguard artists who had painted a picture of a factory. And when he turned to more poetic evocations of nature later in his life, he was able to mix the ideal with the real so uniquely that the past was given as much a role as the present or the future. This allowed his art to be both classical and modern, generalized and site-specific, combinations that Monet sought in his own work, particularly in the 1890s.[10]

Although Monet had demonstrated his debt to Corot in many individual paintings prior to that decade, at no time did he appear to set out so consciously to pay homage to the painter of Ville d'Avray

than in 1896 when he began his *Mornings on the Seine*. This initiative may have had something to do with the fact that, in 1895, when his *Cathedrals* were on view, several critics compared his work to that of the older artist. The comparisons were all quite favorable, although they were not always based on accurate knowledge of the painters' practices. "Both Corot and Monet are wonderful landscapists," observed the American Emma Bullet. "Both have made wonderful studies of light and its various influences upon atmosphere; both ignored studio work and did their painting in close communion with nature; both obtained effects that were revelations . . . both changed canvases as nature changed her lights and shadows . . . For Corot and Monet, a landscape was only a means to an end; it was not the landscape that preoccupied them, it was the various changes it underwent in the ever changing minutes of the day." Bullet even felt that Monet surpassed his predecessor. "Monet is more positive, more truthful. He professes to paint nature entirely as she presents herself and expects to be understood by minds which have more judgement than imagination in art."[11] By painting a series of pictures that describe the changing effects of light on a single location with exacting specificity, as the *Mornings on the Seine* do, he could assert the validity of these claims to those who may not have believed them from his *Cathedrals*.

Beyond specific comparisons between himself and his former mentor that critics made in the middle of the decade, Monet might have been induced to think seriously about Corot by the very event in 1895 that had prompted these critics' remarks – the huge retrospective of Corot's work that had been mounted to mark the centennial of the master's birth and that had run concurrently with Monet's *Cathedrals* show. Containing more than 140 paintings and accompanied by several lavish publications, it was the largest celebration of Corot's achievement since his posthumous exhibition in 1875, and was a resounding success. His simple but subtle views of rural France, so directly but so sensitively rendered, were precisely what the public wanted to see. In addition to reminding everyone of bygone days and the poetry of the French countryside, these touching paintings were perceived as the product of a humble but gifted man who, despite his time in Italy, was able to preserve his national identity. His mastery, according to Roger Marx, was the logical product of his "temperament, ancestry, and race."[12]

Monet's evocation of Corot in the *Mornings on the Seine*, though uncharacteristic in its directness, thus stands to reason, for no French landscape painter was more important to the history of the genre in the 19th century than the painter of Ville d'Avray. Even Pissarro readily admitted this.[13] So too did Monet. In fact, his first documented statement about Corot dates from February 1897, at the same time that he had resumed work on the *Mornings on the Seine* begun the previous year. Monet is reported to have made this remark while he was at Georges Petit's looking at Henri Vever's collection of Barbizon and Impressionist paintings. According to Raymond Koechlin, a collector and art historian who had accompanied Monet to the show, the fifty-six-year-old painter declared that "there is only one artist here, Corot; as for us [Impressionists], we are nothing, absolutely nothing. This is the saddest day in my life."[14]

By evoking Corot in this series, Monet was not only paying homage to the "greatest landscape painter" of all, as he would later describe Corot; he was also acknowledging his debt to the older artist

Supplément au Journal LE GAULOIS du 16 Juin 1898

Le Gaulois

A LA GALERIE GEORGES PETIT

EXPOSITION CLAUDE MONET

L'Exposition des Œuvres nouvelles de Claude Monet, ouverte en ce moment à la Galerie Georges Petit, est un événement trop important pour que Le Gaulois y demeure indifférent. Nous avons pensé que nos lecteurs seraient heureux d'en conserver un souvenir, et nous nous sommes fait un plaisir d'encadrer le portrait du célèbre artiste, et la reproduction de quelques œuvres de lui, de l'appréciation de son magnifique talent par les écrivains les plus autorisés de la critique contemporaine.

Dans son numéro du 7 juin 1898, Le Journal publiait cet éloquent article de M. Gustave Geffroy :

CLAUDE MONET

Claude Monet, qui n'avait pas fait d'exposition de ses œuvres depuis l'année où apparurent dans la lumière ses merveilleuses Cathédrales, réunit aujourd'hui, Galerie Petit, en une salle ouverte à tous, ses travaux de trois années. Il donne son point de départ, par une série de sept vues de la Cathédrale de Rouen : la grande forme dressée sur le sol, se perdant, s'évaporant dans le brouillard bleuâtre du matin, — le détail des sculptures, des anfractuosités, des creux et des reliefs, se précisant aux heures du jour, — le portail creusé comme une grotte marine, la pierre usée par le temps, dorée et verdie par le soleil, les mousses et les lichens, — la haute façade envahie d'ombre à sa base, le faîte éclairé par le soleil couchant, illuminé de la mourante lueur rose.

C'est le prodigieux poème de l'espace fixé aux aspects de la vieille église, une rencontre et une pénétration de la force naturelle et de l'œuvre humaine. L'artiste, toujours en travail et en recherche, accomplit là une

étape décisive, formula d'une manière neuve la loi d'unité qui régit les manifestations de la vie. Sa conception des choses, forte et subtile, se trouva davantage certifiée par une telle réalisation. Désormais, quelle que soit l'heure représentée sur la toile, un accord suprême se ,fera entre toutes les parties du sujet : l'eau, le ciel, les nuées, les feuillages, réunis par l'atmosphère, formeront un tout d'une irréprochable homogénéité, une image grandiose et charmante de l'harmonie naturelle.

Il en est ainsi dans les effets de neige étudiés en Norvège, malgré la dépaysation visible, la surprise de se trouver devant une nature très différente de la nôtre, aux contours plus nets, aperçus distinctement à travers une atmosphère glacée et transparente. Le Mont Kolsaas, le fjord près Christiania, les bords du fjord, ont une parenté avec les justes découpures des estampes japonaises, relèvent du calcul mathématique par lequel l'étendue se trouve représentée en quelques lignes bien inscrites. Notre surprise est la même que celle-là éprouvée par Monet devant ces représentations d'un pays du Septentrion que l'on rêverait presque invisible, enfoui dans la brume opaque, sous une ouate atmosphérique, et que l'on découvre éclairé par une lumière nette, avec un accord pur et froid du blanc de la neige et du bleu de l'eau.

Revenu chez lui, en son village paisible, en sa maison fleurie, parmi les champs familiers, aux bords du fleuve et de la rivière, Monet erre parmi les prairies, sous l'ombre légère des peupliers, il monte et descend le courant en bateau, côtoie les îles, cherche avec une lenteur et un soin infinis l'aspect de nature propice par son arrangement, sa forme, son horizon, au jeu de la lumière, des ombres, des colorations. Car c'est une des nombreuses fantaisies nées au hasard de l'étiquette d'« impressionnisme », que de croire au non-choix des sujets par ces artistes réfléchis et volontaires. Le choix fut au contraire toujours leur vive et importante

Fig. 97. *Le Gaulois* (supplement), 16 June 1898.

The Changing of the Light

and openly admitting his status as a descendant of the master. At the same time, however, he was usurping Corot's position, just as Corot had done to earlier landscape painters. As Pissarro noted to his son in March 1898, "That Corot came from [Claude] Lorrain and reflects him is evident, but it is also clear to what degree he transformed what he took, [and] in this lies all his genius." Corot's ability to be both an heir to Claude and an individual, respectful as well as novel, was, in Pissarro's mind, distinctly French. "It is only here [in France]," he asserted, "that artists are faithful to the tradition of the masters, without robbing them."[15] By transforming Claude, Corot may have revealed his own Frenchness, but, most important, he assumed the older artist's position as preeminent landscape painter. By doing the same to Corot, Monet was claiming that position for himself, and in the process asserting his ties to the time-honored French tradition.

Once again, Monet's tactics paid off, as his new exhibition was an unqualified critical success. In addition to Guillemot's important pre-opening interview in *La Revue illustrée*, there was a special supplement in *Le Gaulois* (fig. 97), published two weeks after the show opened, that was devoted exclusively to the reception that Monet's work had enjoyed over the previous ten years. Reprinted in this supplement were favorable articles that had appeared in other papers, including reviews by Geffroy and Alexandre of the *Mornings on the Seine*, Thiébault-Sisson on the *Cathedrals*, Roger Marx on the *Grainstacks*, and L. Roger-Milès on Monet's retrospective with Rodin in 1889. This anthology of critical praise, featuring a striking photograph by Nadar of the dapperly dressed Monet, was a carefully planned, promotional scheme for both the newspaper and the artist. A week after it appeared, the editor of *Le Moniteur des Arts* published a similarly conceived issue of his equally conservative magazine, even using the same photograph. It is impossible to know whether he was merely capitalizing on his rival's idea or was honestly moved by Monet's exhibition. He proclaimed the latter, of course, going so far as to admit to his readers that he had never been one of Monet's supporters but that this exhibition had made him a convert.[16]

Although not untypical of the kind of reaction that Monet's work had come to provoke, such enthusiastic responses suggest the opportune nature of these new paintings. They were clearly touching sensitive chords at just the right moment — primarily, it seems, because they looked different from Monet's previous work. Instead of dashed-off sketches, the *Mornings on the Seine* and Norman coast pictures were serious paintings with lofty associations. Unlike the jarring colors that Monet had used in the past, their palettes were quieter and more harmonious; their brushwork was also more restrained, and their motifs more meditative.

These apparent changes would have been particularly welcome in 1898, as Monet and his fellow Impressionists had recently been the focus of a long and vociferous public debate. The controversy, which had begun in 1894, concerned Gustave Caillebotte's bequest to the nation of sixty-seven Impressionist paintings and pastels. At first, according to press reports, it appeared that the State was going to refuse the gift, which prompted stiff protests, particularly from critics who had supported the Impressionists. The protesters believed that the government was hesitating because it did not want to give its impri-

matur to a movement that had done so much to undermine its own authority. Conservative artists fed this notion with a stream of derogatory comments. Gérôme went so far as to claim that accepting the bequest was tantamount to "the end of the nation."[17]

The Impressionists' apparent lack of aesthetic decorum was a stumbling block for some museum officials, but even those who were favorably disposed to accepting the collection faced a host of tricky problems. According to the terms of the bequest, the government had to accept the gift *en bloc* or not at all; keep the paintings in Paris, not send them to the provinces; exhibit all of them, not relegate some to storage; and hang them all together. Already overcrowded, the Musée Luxembourg did not have enough space to accommodate almost seventy more canvases. In addition, it had followed an unwritten policy of accepting only three or four works by any one artist. Caillebotte's collection contained four by Manet, five by Cézanne, eight by Renoir, nine by Sisley, eighteen by Pissarro, seven by Degas, and sixteen by Monet. If the bequest was accepted in full, the Impressionists would not only have set an undesirable precedent; as a group, they would have constituted an unbalanced percentage of the museum's entire collection.[18]

It took nearly two years to resolve the issue. Finally, in late February 1896, the government announced that it had come to an agreement with the heirs and that it was accepting two paintings by Manet, two by Cézanne, six by Renoir, six by Sisley, seven by Pissarro, seven by Degas, and eight by Monet. The works were delivered in November and hung in a new addition to the Luxembourg that opened in early 1897. The compromise did not satisfy the opposition. No sooner was the abbreviated bequest unveiled than the condemnations began anew, this time with greater truculence. In a formal protest to the Minister of Public Instruction, august members of the Institut de France and the Académie des Beaux-Arts called the bequest "an offense to the dignity of our school," which, if accepted, would create "a strange confusion [in the public's mind] between what is worthy of being admired and what deserves strong disapproval." The issue even made it to the Senate, where M. Hervé de Saisy attempted to convince his colleagues that the new acquisitions were "unhealthy" and "decadent" – "the antithesis of French art" – and that they would "pollute" the masterpieces in the Luxembourg's collection.[19]

No such criticisms were leveled at Monet's *Mornings on the Seine* or his Norman coast paintings. In fact, without mentioning the bequest specifically, reviewers went out of their way to make their readers understand that the Monet who had just painted these new series was not the same artist he had been when he had painted the pictures that Caillebotte had bought. More than at any other time in the past, they stressed the deliberateness with which Monet chose his subjects, as if to underscore the intelligence and forethought that went into his new work. Durand-Ruel even succeeded in extending these notions, by association, to Monet's older work. When scooped by his rival Georges Petit, who exhibited both of Monet's new series, Durand-Ruel staged a huge show of earlier Impressionist paintings by Monet, Pissarro, Sisley, and Renoir, drawn mostly from his own stock – devoting a whole room in his gallery to Monet and filling an adjacent room with works by Puvis de Chavannes. Few reviewers missed the point, and fewer still did not find the show to their liking. (Durand-Ruel would do the same thing the follow-

ing year, replacing Puvis with Corot as the featured representative of the French tradition.)

After the unqualified success of Monet's new work, it is perhaps surprising to find that he did not continue to pursue similar themes but instead radically redirected his art. The turn that he took is made most apparent by a simple statistic: Of the more than 500 paintings that he would complete between 1898 and his death in 1926, only a dozen depict recognizable French sites or subjects. What happened to his life-long interest in rendering his homeland and continuing the French tradition?

Only once before, twenty years earlier, had Monet's work changed as radically. That was when he abandoned the suburb of Argenteuil and contemporary motifs for the splendors of unspoiled nature, a change that had been prompted by Monet's unwillingness to continue to propagate the myth of modernity. Argenteuil, which he had perceived as idyllic when he first moved there in 1871, had been irrevocably altered by 1878, in his view at least, by the strident forces of progress. The town's population had nearly doubled as had its industries; its open acreage had been transformed by housing developments; and its once inspiring stretch of the Seine was by then polluted to the point that its surface bubbled from the fetid material in its bed. However, his devotion to particularly French phenomena and to French values did not diminish after that experience but actually increased, judging from his series paintings of the 1890s. Such would not be the case from 1898 onward.

This later change may have had something to do with Monet's advancing age or with his resounding success, which afforded him the opportunity to concentrate on his water lily pond and his flower garden. But given his steadfast devotion to painting *la France* for almost forty years, it also had to have been the result of developments that were as disillusioning as what he had experienced twenty years earlier. For like modernity, the promotion of French hegemony suddenly became an unacceptable enterprise.

There was one development in the 1890s that possessed that kind of extraordinary power. And it occurred in 1898. That was the fateful year in which France was torn apart by one of the most heinous developments in its entire history – the national tragedy of the Dreyfus Affair. Because it turned on issues that were so central to France – loyalty, patriotism, respect for the army, and fear of the enemy – and because it erupted at a moment when the country was so vulnerable, the Affair proved to be cataclysmic, affecting everyone, Monet included. Its sordid details merit review, for, as a staunch Dreyfusard, Monet was profoundly scarred by what happened to the accused Captain and his chief defender Zola, suggesting that this epic calamity led him from the Seine to the Thames, and from there to an immersion in a world of his own making.

Fig. 98. Lionel Royer, "The Degradation," *Le Journal Illustré*, 6 January 1895.

Fig. 99. Anon., *Zola-Mouquette*, ca. 1898. Musée Carnavalet, Paris.

THE DREYFUS AFFAIR began in October 1894 when Alfred Dreyfus, a captain in the French Army, assigned to the General Staff, was accused of passing military secrets to the Germans. Court-martialed in December, he was found guilty of treason. On January 5, 1895, he was stripped of his rank in a humiliating, saber-breaking ceremony in the courtyard of the École Militaire and condemned to permanent exile on Devil's Island in the Atlantic just off the coast of French Guiana in South America. There, he was expected to die in shame. The trial and its verdict brought the nation's bile to the surface. An Alsatian Jew, Dreyfus was widely perceived as the contemporary Judas who had received a just sentence, the "traitor [who] for thirty *deniers* wanted to make all the women of France widows, cause the small children to weep tears of blood, and turn his fellow soldiers over to enemy bullets" (fig. 98). "This wretch is not French," a reporter for *Le Figaro* assured his readers. "We have all understood as much from his act, his demeanor, his physiognomy. Although he plotted our disaster, his crime has exalted us."[1]

If Dreyfus had been executed instead of banished, the Affair might never have happened. But that was not to be France's fate. The verdict smoldered for more than a year while everyone tried to put it out of his mind. Then, in September 1896, on the basis of an article in *L'Éclair* suggesting judicial misconduct during the original proceedings, Dreyfus's wife requested a new trial. In the ensuing months, new evidence was uncovered, leading in November 1897 to an investigation of the real perpetrator, Charles Esterhazy. This investigation prompted Zola in early December 1897 to write an article in support of the wrongly accused captain and his defenders, which was published in *Le Figaro*, and to follow it with another later that month. When Esterhazy was tried and acquitted in January 1898, just as Monet began planning the exhibition of his *Mornings on the Seine* and Norman coast paintings, Zola wrote a third article, which Clemenceau published in his newspaper *L'Aurore* under the title *J'accuse*. This historic denunciation of the military and the government appeared on January 13, 1898, just two days after the court made its decision known. Then the Affair truly erupted, with venomous accusations, acrid denunciations, riots, and a trial and prison sentence for Zola. It was as if all the negative energies of the *fin de siècle* had been unleashed, granting everyone the right to claim moral superiority regardless of which side he might have been on.

Monet reacted to these developments with uncharacteristic forthrightness. After Zola's second article, Monet wrote his old friend a heartfelt letter. "Bravo and bravo again for the two beautiful articles . . . You alone have said what must be said and you have done it so well. I am happy to extend to you

all of my compliments."[2] The day after *J'accuse* appeared, Monet wrote Zola another poignant letter. "Bravo once again," he exclaimed, "and all of my heartfelt sentiments for your valor and your courage."[3] Moved by the captain's plight as much as he was outraged by the injustice of the system – unlike Degas or Renoir, for example, who became strident anti-Dreyfusards – Monet even signed his name to the so-called Manifesto of the Intellectuals that *L'Aurore* published on January 18, 1898, supporting the paper's demands for the truth. He also wanted to attend Zola's trial but was unable to do so because of an influenza that kept him and his family bed-ridden for three weeks. "It is not that I am indifferent to all that is happening," he wrote Geffroy as soon as he began to feel a little better, several days after the proceedings had begun. "I have followed this disgraceful trial from afar, and with passion. How I would like to be there! You must be disheartened and saddened by the conduct of many people, and of the newspapers above all; they are so vile. . . . If you should have a moment, however, I would like to know how people think this will all end." The following day, he wrote Zola once more. "Sick and surrounded by others who are ill, I could not come to your proceedings and shake your hand, as had been my desire. That has not stopped me from following all of the reports with passion. I want to tell you how much I admire your courageous and heroic conduct. You are admirable. It is possible that when calm is restored, all sensible and honest people will pay you homage. Courage, my dear Zola. With all my heart."[4]

Monet's heart was obviously in the right place, although it is difficult to know whether he really would have gone to Zola's trial if he had been healthy. Political action on a certain level was simply beyond him. When asked to sit on a pro-Dreyfus committee in March 1898, for example, he declined. "I signed *L'Aurore*'s protest," he told the solicitor, "I have written my friend Zola directly about what I think of his courageous and beautiful conduct. But being a part of some committee is not my business ['mon affair']."[5]

Monet believed that his business was to paint. It was through art that he defined himself and the world as he envisioned it. And it was through the dissemination of that art that he "acted." Like the rest of his efforts, the *Mornings on the Seine* and the Norman coast series attest to this fact, for they reveal his staunch individualism, his desire to expand the norms of landscape painting, and his heartfelt belief in the value of a deep relationship with nature. Rooted in experience, personal biography, and a sense of history, they also bear witness to his aim of translating specific sites into poetic statements about the beauties of rural France. That they were so well received when they went on view in June 1898 stands to considerable reason, for, in addition to their formal qualities and the associations they provoked, they were exhibited barely six months after the Affair divided the nation; they were therefore welcome evidence of beauty's ability to survive sordid circumstances and of the continuity of the French tradition. This is not to say that critics specifically compared the paintings to the horrors of the moment. In fact, the fury provoked by Zola's *J'accuse* had subsided to such an extent by May that during the elections that were held that month, Dreyfus was hardly mentioned. However, as historians have pointed out, "Silence concerning the Affair was a matter of political precaution [in May]. In speaking of it one faced

had come to him when he had turned sixty, which was in 1900, after he had initiated the *London* series. In addition, Monet said he had abandoned the idea, "because it would have taken a lot of traveling and a lot of time to revisit the various sites of my life as a painter, one after the other, recapturing my past emotions."

Nevertheless, the *London* pictures can be understood as the result of Monet's evident interest in re-working older motifs and in endowing them with the grandeur that he was now able to see in them. For like the Norman coast series and the *Mornings on the Seine*, the *London* views are far more monumental than his earlier Thames pictures. In their muffled qualities, brilliantly diffused light, and subject matter, they also appear to be tinged with nostalgia, a feeling reinforced by the purples and yellows, blues and roses with which they are painted.

It is this reprise of urban motifs that is the most perplexing aspect of the series. Why after twenty years would Monet return to painting factory chimneys spouting streams of smoke and railroads hurtling across iron trestles? Why would this appeal to him at the end of the decade and why did he go so far from home to paint it? He could have found similar subjects in Paris and its suburbs.

Once again, answers to these questions are neither simple nor certain. On the practical side, he may have just wanted to work in London again, a desire that Geffroy suggested was brewing as early as 1891. He also may have wanted to see more of his oldest son, or spend more time with his friend and fellow artist Whistler. But perhaps there were larger issues at stake that involve Monet's sense of himself and his position as a landscape painter in post-Dreyfus France.

Although quite popular at home and in many other European countries, Monet had sold very few paintings in England, primarily, it seems, because his work was generally more expensive than contemporary avant-garde English art. He therefore may have seen this London campaign as a way to enter the English market with a certain aplomb.

He would not have been interested in this challenge, however, if he had not cared for the English as much as he did. While he had bad memories of his first stay in London in 1871, when the Prussians were overrunning his homeland, and while he disapproved of England's involvement in the Boer War, Monet apparently enjoyed being around English men and women – even though he did not read or speak their language. When he was in Bordighera in 1884, for example, he stayed in an English pension. He could barely tolerate the German guests there, whom he called "crude and stupid." But he told Alice that the English patrons were good company. One of the few portraits he did during the 1880s was of an unknown English painter. That he could send his oldest son to London to learn English is itself testimony to his opinion of the country.[16]

Monet never offered an explanation for his esteem of the English. It may have stemmed from his respect for their Norman roots or from what he perceived as their genteel but robust character. For example, when he was in Bordighera he was particularly captivated by four elderly British women who were on a walking trip through Italy and who happened to stay in his pension, much to Alice's jealousy and displeasure.[17] His high regard may have also been the product of his appreciation for the English

way of life. During all the months he spent in London, for instance, he never complained about the food, the traffic, or the general difficulties of being a Frenchman in a foreign land. Although he worked hard while he was there, he found time to be a tourist. He visited the Tower at least once and viewed Queen Victoria's funeral procession in 1901, an event that he found well worthwhile, "a unique spectacle."[18] As in France, he disdained fancy dinner parties, but he went to enough of them in the course of his time in London to suggest his fascination with the English upper crust. He actually admitted to Alice that the dinners "make me feel good," declaring that they calmed his spirit after a day's work.[19] This fascination is understandable, for, in many ways, his own life at Giverny was similar to that of an English country gentleman, down to the English breakfast he had every morning complete with marmalade and tea, and

246 Plate 91. (cat. 88) *Waterloo Bridge. (Cloudy day.)*, 1899-1900. The Hugh Lane Municipal Gallery of Modern Art, Dublin

to the suits of English wool that he had made to order. There was perhaps something earthier about their aristocracy, in contrast to France's, that seems to have appealed to him, a characteristic that Reynolds and Gainsborough had captured in so many 18th-century portraits. He also must have appreciated the respect that he received while in London, from the aristocrats who owned the house on the Mall from which he viewed Victoria's funeral to the concierge of the Savoy who would meet him at the railroad station.[20] At the dinner parties he attended, guests always spoke his language even though he was generally the only French person invited.

Although something of a celebrity, Monet was always conscious of himself as a foreigner. When he returned to the Savoy for his second London campaign in 1900, for example, he found that his old

Plate 92. (cat. 86) *Charing Cross Bridge. (Overcast day.)*, 1899-1900. Museum of Fine Arts, Boston

sixth-floor room had been reserved by the Princess Louise for returning officers wounded in the Boer War. He thought about asking her to use another room but decided against it, since, as he told Alice, "I am 'un étranger.' "[21] As a foreigner, of course, he had a somewhat stilted view of England. He never would have been as critical of it as he would have been of his own country. He had not invested as much in it – at least not until this London series which pushed him to the limits of his artistic powers.

Although he was able to finish nearly a dozen views of Charing Cross and Waterloo bridges in 1899 and 1900, and to find a buyer for at least one of them, he became frustrated with the more than eighty others that he had started and was unable to bring them to completion for another four years. So upset was he in 1903 that he told Durand-Ruel to abandon hope of exhibiting them that year: "I don't even want to think about [them] any more."[22]

What was the problem?

Ostensibly, it was the variability of London's climate. By nine o'clock in the morning, he could have already worked on five canvases; by noon, fifteen. So radically could it change that Monet began to believe that he was in a country that would not submit to his Impressionist technique, and at one point even suggested that perhaps painting in France would be easier.[23]

Monet's difficulties also stemmed from the challenges that he had posed for himself. First, he was attempting to render a foreign city that he had not painted in thirty years. He also had selected contemporary motifs that he had not treated in more than twenty years. Timing compounded the problem. This campaign came shortly after he had abandoned his lifelong allegiance to distinctly French subjects. As a possible new direction for his art to take, the *London* series was thus critical. Given its importance, Monet must have asked himself whether this was the way he wanted his art to go. Was he committed to painting the modern metropolis? Initially, he believed that it was worth exploring. At the very least, London might provide him with a point of departure. It would also offer him the opportunity to reinvigorate his work by remaking paintings such as his infamous *Impression: Sunrise* (fig. 101), whose thick atmosphere, industrial subject, and broad application of rich impasto approximate aspects of his *London* views. However, doubts haunted him, which made it increasingly difficult for him to bring the campaign to a conclusion. His decision, in 1901, to finish the *London* series in his studio and not on the site was essentially a declaration of what he had probably felt all along but had been unwilling to admit – that modernity was not to be the focus of his attention, despite his fascination with the English capital.

The fact that he looked to England in 1899 as a possible alternative to France is significant and makes sense on several levels. Though one of France's historic rivals, England had often demonstrated its empathy for her neighbor in the 19th century, welcoming in particular many French refugees during problematic times. Soon after the Franco-Prussian War broke out, for instance, it had taken in a host of French painters, including Daubigny and Pissarro, in addition to Monet and his family. In 1898, it received Zola after his libel conviction for *J'accuse*. It therefore had a certain liberal bent that made it an appealing haven. It would have been especially attractive to someone like Monet after the debacle of Dreyfus. For although the country was not perfect, its problems were not as odious as those that

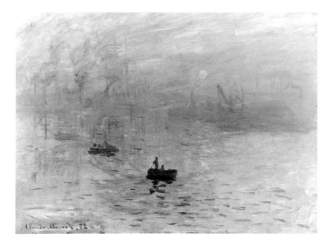

Fig. 101. Claude Monet, *Impression: Sunrise*, [W.263], 1872. Stolen from the Musée Marmottan, Paris.

Fig. 102. James McNeil Whistler, *Nocture: Blue and Silver – Batlersea Reach*, 1870-75. Freer Gallery of Art, Washington, D.C.

Fig. 103. J.M.W. Turner, *Rain, Steam, and Speed – The Great Western Railroad*, 1844. National Gallery, London.

plagued France, nor were they as detrimental to the nation's well-being. It was for that reason that Pissarro could tell his son in February 1898, "Now I see that you are right to stay in England, where you can expect a little more justice and common sense. Here, I fear the end has come."[24]

In addition to harboring refugees, England had been home to some of the greatest landscape painters in history, ever since it inherited the Northern tradition from the Dutch in the late 17th century. It had also contributed more to the advancement of the genre in the 19th century than any country outside of France, producing, among its many noted figures, the giants Constable and Turner. Although landscape painting had been central to France and its self-esteem, it was such an established practice for English men and women that *plein-air* sketching was considered a national pastime in the 19th century. Everyone drew outdoors, whether at home or abroad. Monet came upon groups of English watercolorists everywhere he went in Bordighera, a situation he found amusing but quite natural.[25]

The notion of England as a country of landscape artists would have made the prospect of working in London all the more appealing to Monet, but it would also have put more pressure on him. For it was inevitable that his canvases would be compared to what centuries of English artists had been able to achieve. Monet would not have wanted it any other way, however, especially since he had already triumphed in his bout with Corot. Having paid vicarious homage nearly all of his life to his competition across the Channel, he now had to meet it head-on, just as he had with Barbizon art in his *Mornings on*

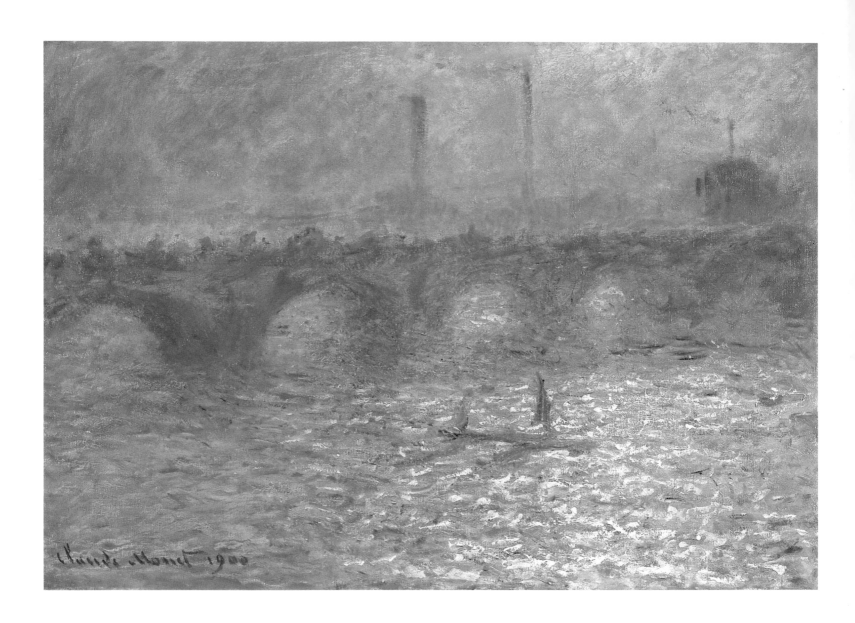

the Seine. If one were going to be a truly great landscape painter, this was necessary business to settle. It was also a way to assert the superiority of the French tradition and rise above the scandal of the Affair.

English artists of the 19th century had understood this themselves and had relegated their forebears to history with equal decisiveness. None were more blatant or more successful about it than Turner. In addition to painting pictures that invoked direct comparison with 17th-century Dutch masters, Claude Lorrain, and 18th-century English predecessors, Turner had the audacity to bequeath two canvases to

Plate 93. (cat. 87) *Waterloo Bridge*, 1899-1900. Santa Barbara Museum of Art Detail, plate 93 >

the National Gallery on the condition that they be hung next to paintings by Claude, a provision that was accepted and is still honored today.[26]

When Monet began his *London* paintings, he may have initially had various contemporaries in mind, although none of them would have been more important than the American artist Whistler, who had also painted what Monet described as "that mysterious cloak" of London fog which made "those regular, massive blocks [of the city] grandiose." From the time the two had met in the mid-1880s, Whistler and Monet had become good friends.[27] When the Frenchman visited London in 1887, he stayed with the expatriate. Monet also exhibited at the Royal Society of British Artists for the first time in the winter of 1887 at Whistler's invitation. In addition, it was Whistler who encouraged Monet to exhibit at the New English Arts Club in 1891. Monet wrote Whistler a hearty letter of congratulations in 1889 when he was made *chevalier* in the Legion of Honor, hosted him several times in the 1890s when he was in France, and hailed him when the Musée Luxembourg purchased his soon-to-be-famous *Arrangement in Black and Gray: Portrait of the Artist's Mother*, 1871.[28] While Monet admired Whistler as a portraitist, he found the American's abilities as a landscape painter even more impressive, especially his uncanny power to evoke the mystery of early evening light on the Thames in his numerous *Nocturnes* (fig. 102), which Monet surely thought of when he began his own *London* series.

However, like Whistler, Monet was ultimately doing battle with Turner. No one could paint atmospheric effects in England without having Turner as a point of comparison. His name was even raised in France whenever artists painted sites that he had rendered there. Monet's *Rouen Cathedrals*, for example, were often compared to Turner's views of the same structure. In the opinion of Jules de Goncourt, Turner was a truly inspired individual who put everyone else to shame, Monet included. "In the name of God," he exclaimed in 1890 when looking at a painting of an ethereal blue lake by Turner, "if that doesn't make you despise Monet's originality and people of his ilk" – an evaluation that Monet was out to contest in 1899.[29]

Once in London, the Frenchman would have had ample opportunity to see Turner's works. (The Louvre, as Pissarro bemoaned, had no paintings by him at that time.)[30] Of all those that Monet would have seen, Turner's famous *Rain, Steam, and Speed – The Great Western Railroad*, 1844 (then as well as now in the National Gallery of London) was undoubtedly one of the most important (fig. 103). It not only captured an extraordinary "envelope" of light and atmosphere but also focused on the railroad, which, as the symbol of 19th-century industrial progress, was the antithesis of Turner's natural effects. Monet concentrated on a similar combination of romance and reality in his views of the Charing Cross and Waterloo Bridges and underscored the significance of Turner's canvas by admitting in the early 1890s that he had studied it closely, making it one of the few paintings that he ever specifically cited.[31]

As with his relationship to Corot, Monet's interest in Turner went back many years. It began with his first visit to London in 1870 and continued for the course of his career. Although later in his life Monet declared that the Englishman was not a sophisticated colorist, he spoke highly of him in the 1890s, referring not only to "the railroad one" but also to "many of the watercolor studies from na-

ture."[32] This interest was as natural as it was enduring. Few landscape painters in the history of art had been as inventive or as passionate, or had captured nature's elusive ways with as much power and poetry. Few were as individualistic or as moody, and few loved the sea more. Turner, therefore, was a soulmate, a guide, and a distinct challenge for Monet.

Given Turner's stature and that of the English landscape tradition that he headed, it is not surprising that it took Monet so long to finish his pictures and put them in front of the Paris public. He was attempting to put an enormous chapter of history behind him. But when he unveiled thirty-seven of them at Durand-Ruel's in 1904, he received the accolades he had set out to earn. For Marc Joel of *La Petite Loire*, the exhibition was "marvelous . . . one of the most beautiful demonstrations of pure art." Georges Lecomte believed that Monet had never "attained such a vaporous subtlety, such power of abstraction and synthesis." Even the rather stunned critic for *L'Action* had to agree. "In his desire to paint the most complex effects of light," he observed, "Monet seems to have attained the extreme limits of art. . . . He wanted to explore the inexplorable, to express the inexpressible, to build, as the popular expression has it, on the fogs of the Thames! And worse still, he succeeded." Gustave Kahn understood precisely what Monet was building on: "If it is true that Turner liked to compare certain of his works to certain of Claude Lorrains, then one might place certain Monets beside certain Turners. One would thereby compare two branches, two moments of Impressionism, or rather . . . integrate two moments in a history of visual sensitivity."[33]

So pleased was Monet with the results of this exhibition that he toyed with the idea of staging a similar show on his own, in the English capital itself. He was going to do it, he told Durand-Ruel, "as an artist . . . for my personal satisfaction." And he was going to limit it to *London* paintings alone. He even went to London to see what spaces would be available to him. He also insisted that Durand-Ruel not include any canvases from this series in a group show the dealer was thinking about mounting around the same time.[34]

Monet's show never occurred. In early March he abandoned the plan, feeling that the *London* canvases he was trying to finish were not ready to be shown. However, he was not depressed – "far from it," he told Durand-Ruel – primarily because of the highly favorable reception of the London exhibition that the dealer had indeed gone ahead with, in which Monet had been handsomely represented. In his mind, the desired end had been achieved. "I am delighted with the success [of your show]," he admitted to the dealer. "It is an excellent thing to have dealt London such a decisive blow," an aggressive expression of satisfaction that attests to how much Monet had invested in this reckoning.[35] With victory thus declared and the historical ledger rewritten, he returned to painting his water lily pond, a project he that he had begun in 1899 and that would preoccupy him for the rest of his life.

254 Plate 94. (cat. 90) *The Water Lily Pond [Japanese Bridge]*, 1899. The Metropolitan Museum of Art, New York

Where East Becomes West: Monet's Paintings of His Japanese Bridge of 1899 and 1900

FROM 1871 when he rented his first house in Argenteuil to his death on his Giverny estate in 1926, Monet devoted an enormous amount of his time and money to floral and landscape projects. Even when he claimed that he could not pay his bills during the second decade of his career, he made certain that his garden flourished. By the 1890s, having amassed tremendous wealth, he developed his property into a horticultural paradise. He also employed a team of outdoor workers to keep it that way. Gardening was so important to him that had he not been a painter, he probably would have been a botanist.

In his early years, he tended to cultivate local flowers – dahlias, hollyhocks, nasturtiums, gladioli, and roses. By the end of the century, his range had expanded, for he was receiving advice from French gardening experts, subscribing to horticultural magazines, and ordering his plants from around the world. One critic said that "he reads more catalogues and horticultural price lists than articles by aesthetes."[1]

His Giverny gardens in particular were testimony to his passion. When Monet moved to that rural community in 1883, he leased a house from a major landlord there (who had retired to the nearby village of Vernon). In front of the house was a typical Norman kitchen garden, planted with vegetables, potatoes, berry bushes, and fruit trees, which had provided the former resident with his fresh produce. Although Monet did not buy the house until 1890, the kitchen garden was the first thing to go when he moved in, visual beauty quickly replacing practicality. The trees and bushes were uprooted, the vegetables plowed under, and the more than two acres completely redesigned. Sand paths were imposed on the plot and dozens of planters raised on either side of the garden's main alley, which was lined with trellises to support climbing roses. The fertilized beds were sown with a spectrum of flowers that were coordinated to bloom continuously from early spring to late fall.[2]

Thirty paces from this floral fantasia, on the other side of the road and railroad tracks that ran through his property, was where Monet built his famous water lily garden. When Monet came to Giverny, the water garden was merely a pond that sat in a meadow outside the boundaries of his estate. Monet purchased the land in 1893 with the intention of constructing something "for the pleasure of the eye and also for motifs to paint," as he stated to the Department Prefect when he applied for a building permit. This was a much more ambitious undertaking than the conversion of the kitchen garden. Monet needed a regulated water supply, an engineer, a horde of laborers, and bushels of plantings. He also needed the approval of the Giverny town council. The latter proved to be the most difficult, as local re-

sidents objected to Monet's idea of diverting the nearby Epte with a system of sluices to obtain the necessary water. They claimed that it would lessen the river's flow. They also thought that the water garden might turn into an unsanitary hole which would pollute the river. They found the idea of foreign plants equally suspicious.[3]

When Monet learned of the opposition, he became enraged. "The hell with the natives of Giverny and the engineers. I don't need to hire any of them nor order any lattice. Throw all of the aquatic plants in the river." After he calmed down, he applied his political acumen. He contacted the former publisher of an influential Rouen newspaper who offered to support his case. He also wrote a long letter to the prefect. In July 1893, three months after his initial request, he ultimately won approval. Work on the pond and the trough from the Epte began immediately. The project was completed sometime late that fall.[4] Covering approximately 1,000 square meters, the water pond was soon ringed by an artful arrangement of flowers, trees, and bushes, crossed by a Japanese-style wooden bridge, and filled with water lilies. Monet eventually enlarged the pond several times (in 1901, 1903, and again in 1910), expanded its plantings, added a trellis to the Japanese bridge, and removed the concrete that he had originally poured for a floor in part of the pond. Except for his campaigns in London and Venice, this aquatic wonderland and the flower garden across the road became his principal preoccupation for the last twenty-six years of his life.

As the culmination of his horticultural interests and his artistic career, the two gardens were conceived and designed as complementary environments. The flower garden was the more traditional of the two and the more Western. Although not as regimented as many French examples, it harked back to designs for formal, country-house gardens that had been devised in the 18th century and followed with some frequency thereafter. The water lily garden was more Eastern in flavor, with its less geometric layout and quiet, reflective waters. The Japanese bridge also marked it as Oriental, as did the bamboo, the ginkgo trees, and the various Japanese fruit trees that dotted the banks of the pond. In contrast to the flower garden, which was bold, profuse, and more familiar in its harmonies of color and shape, the water garden was silent and meditative, mysterious and foreign.

It would be incorrect, however, to see the two environments as absolute opposites. As physical realizations of aesthetic philosophies about the world, they were merely two ways of appreciating the same majestic spectacle of nature. For example, neither was planted exclusively with species from its own Eastern or Western regions. There were azaleas, raspberry bushes, peonies, holly trees, and poplars in the water garden, while Japanese cherry, apple, and maple trees dotted the flower garden, as did Oriental poppies and pink and white Japanese anemones. The water garden appeared less contrived but it had been laid out with as much rigor as its complement across the tracks. Similarly, the flower garden, though strongly geometric in plan, was actually planted in such a way as to disguise the crisp divisions of its design. Nasturtium and wild geraniums softened the edges of the planters, while aubrieta and pink saxifrage spilled out onto the intersecting paths. Most important, both gardens offered endlessly varied vistas that were as rich in visual incident as they were emotionally invigorating. Particularly

Fig. 104. Photograph of Monet's Water lily pond, ca. 1895. Perry Archives, Archives of American Art, Smithsonian Institution, Washington.

suited to the painter who created them, the gardens were Monet's consummate triumph. "Everything I have earned has gone into these gardens," he once told an interviewer. "I do not deny that I am proud of [them]."[5]

This being the case, it is curious that Monet did not paint them more often in the 1890s. In fact, of the nearly 150 canvases he completed between 1893, when he received permission to construct his water garden, and 1897, when Maurice Guillemot noticed some paintings of the pond in Monet's studio, Monet painted only three pictures of this aquatic garden. He did none of its floral counterpart.

Several practical considerations may explain this neglect. First, Monet was too preoccupied with his other series to indulge in views of his own backyard. In addition, he had not painted pictures of his personal handiwork for many years. Having gardens to look at and admire was one thing; committing them to art was another. His plantings also took time to mature. Views of the pond that may date from 1895 and photographs of the site that Lilla Cabot Perry might have taken at mid-decade show a pond that is considerably sparser than it would be at the end of the decade (fig. 104). Monet therefore probably waited until everything was as resplendent as possible, although he also might have been concerned about how these views would have contributed to his goal of becoming the great national painter. For the gardens would not have appeared to have been as distinctly French as grainstacks, poplars, or Rouen Cathedral.[6]

258 Plate 95. (cat. 89) *The Water Lily Pond* [Japanese Bridge], 1899. The Trustees of the National Gallery, London

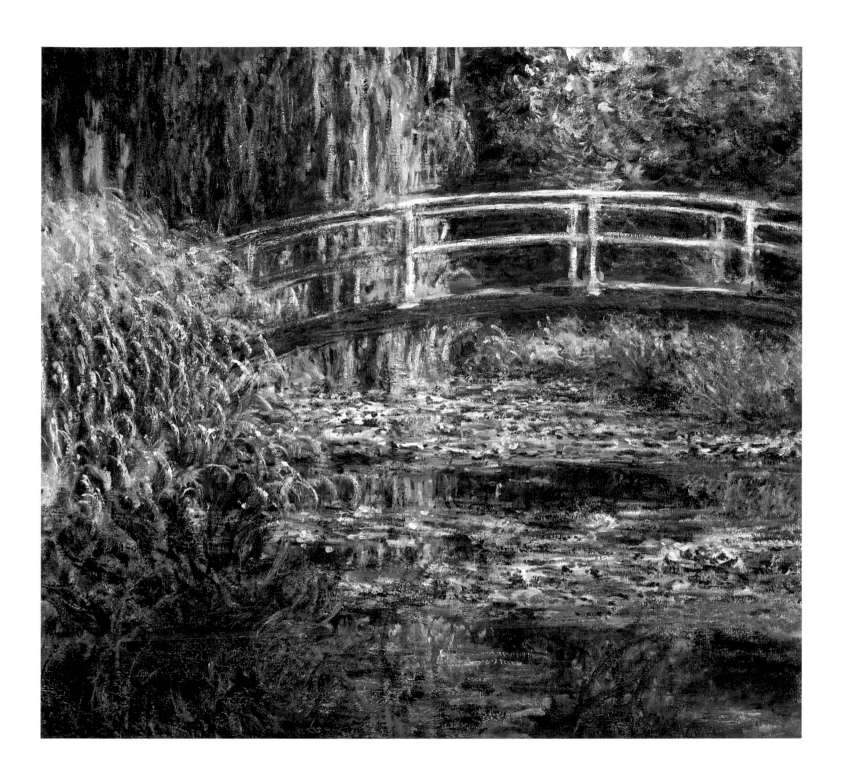

Plate 96. (cat. 92) *The Water Lily Pond* [Japanese Bridge], 1900. Musée d'Orsay, Paris

These considerations still do not fully explain why Monet finally turned to the pond in 1899 to produce a series of eighteen views of its light-dappled surface and arching footbridge, twelve examples of which he exhibited at Durand-Ruel's between November 22 and December 15, 1900 (plates 94-98). Why did he feel confident enough at the end of the decade to exploit his investment and stake his reputation on such canvases?

Monet's decision may well have had something to do with the fact that he had been granted the status he had sought for so long. His exhibition in 1898, for example, had brought him great critical acclaim. Georges Lecomte had been particularly ecstatic. In his opinion, Monet's new paintings were so rich and subtle, so grand and harmonious that they surpassed anything even Turner had produced. "If one wants to relate his work to the past," he asserted, "it is to Claude Lorrain that he must be compared." For, in his eyes, Monet was "the epic poet of nature . . . full of enthusiasm, indulgence, and serenity, extracting from nature all of its joy. Such a painter," he concluded, "passionate in his solitude about all of the hopes and fears of his time . . . is one of the crowning jewels of our epoch." Reviewing Monet's work in the group show that Durand-Ruel mounted in 1899, Raymond Bouyer stated what Lecomte had implied – that "Monet's work above all expresses France, at once subtle and ungainly, refined and rough, nuanced and flashy." In Bouyer's opinion, Monet was "our great national painter; he knows the beautiful elements of our countryside whether harmonious or contradictory: the red pine trees against the blue sea, clear and hot; the contours of the cliffs effaced by the fog, the water running under the fresh foliage, the grainstacks erected on the naked plains; he has expressed everything that forms the soul of our race." Although he felt that some readers would not believe him, Bouyer proclaimed "an article of faith: for me, [Monet] is the most significant painter of the century," he cried, "yes, of the century." Such support perhaps encouraged Monet to expand his repertoire, as he clearly no longer had to prove his status or abilities.

However, Monet was not about to compromise his position. Thus, while focusing on a completely different subject for his *Water Lily* paintings featuring the Japanese bridge, he followed many of the leads that he had recently established in the *Mornings on the Seine*. For example, fourteen of the eighteen works have essentially square formats, like most of the *Mornings on the Seine*, and many are almost exactly the same size as those earlier paintings. The *Japanese Bridge* pictures, though not nearly as atmospheric or as precise in the moments that they capture, nonetheless evoke an even greater sense of Monet's personal communion with nature, for they concentrate on an even more confined and individualized site. Their surfaces may be more activated and the scenes filled with many more elements, but most of the compositions are similar to the *Mornings on the Seine*, particularly those from 1899. The water in these pictures (plates 94 and 95) once again is a wedgelike shape that stretches across the entire foreground of the scenes. Like the Seine in the earlier series, it leads the viewer into the distance, where billowing foliage cushion the eye on either side. The wedge of the pond also rises to a point that is slightly more than half the height of the canvas, just as the river had previously.

These ties suggest an internal logic for Monet's move from one campaign to another that could help

explain the time lag between the completion of the water garden and the appearance of the *Japanese Bridge* pictures. By the middle of the decade, when the garden had been dug and planted, Monet had simply not arrived at a point in his thinking about his art that would have allowed him to focus on such a limited motif. The *Mornings on the Seine* provided him with the necessary impetus and experience.

Such a suggestion is not completely satisfying to the extent that it might imply Monet's work progressed along a strictly charted course, with the ultimate goal of painting this personally designed environment in a style that somehow extended previous discoveries. It also presumes Monet's immunity to the world in which he lived, and requires us to believe that he had an intuitive desire to narrow his scope for the sole purpose of aesthetic refinement, all of which his previous efforts of the decade tend to contradict.

The *Japanese Bridge* paintings themselves refute these ideas. For despite their proximity to the *Mornings on the Seine*, these canvases are by no means as synchronized or as refined in their evocations of particular moments in time. Nor are they painted with the same delicacy as most of the *Mornings on the Seine*. Instead of the extraordinarily unified surfaces of those river pictures, with their consistently rich but even application of paint, the *Japanese Bridges* are almost a step backward, as they are rendered with the finickiness that Monet had exhibited in much earlier canvases, such as fig. 95.

Why then did he finally return to his pond after his *Mornings on the Seine*? And why did he paint it in a less adventurous style? Although again answers are by no means secure, it is surely significant that Monet took refuge there at the very time that the Dreyfus Affair divided the nation and destroyed any romantic notions worth propagating about France's character. Having been disillusioned first by modernity and then by the horrors of this discordant scandal, it was better to find meaning in the depths of nature than to fabricate a mythical image of the country out of her depressingly shallow state. It was also reassuring to return to the firmness and clarity of his former Impressionist touch.

By withdrawing into his own world at Giverny, Monet appeared to be removing himself from contemporaneity and indulging in the unparalleled pleasure of painting his self-styled Eden. On one level, of course, that was true, just as it was in the 1870s, when, surrounded by his trees and flowers in suburban Argenteuil, he had attempted to shield himself from the industrial and commercial development of that once-idyllic town. That he understood what such a retreat meant financially at the end of the century is indisputable, for in the year 1900 alone he made 213,000 francs, a fabulous sum.[8]

But Monet's concentration on his Giverny gardens went beyond monetary concerns. By 1900, he had made more than enough money to live on comfortably for many years. It also went beyond indulgence. For as Monet grew older, painting often became an almost unbearable burden, as is evident from his many cries of rage when struggling with his work during the last three decades of his life. Instead, Monet's focus on his garden should be seen as his attempt to express his primary concerns as an artist and an individual in *fin-de-siècle* France. For what Monet was propounding in the *Japanese Bridges*, and in the *Water Lilies* that preoccupied him for so many of the ensuing years, was something he had always believed in but now felt obliged, in post-Dreyfus France, to profess in more unabashed terms than ever

Plate 97. (cat. 93) *The Water Lily Pond* [Japanese Bridge], 1900. Museum of Fine Arts, Boston

Plate 98. (cat. 91) *The Water Lily Pond* [Japanese Bridge], 1900. The Art Institute of Chicago

before: the need to submit to the primacy of nature and the obligation of the artist to evoke her regenerative powers and decorative beauty. That Monet decided to demonstrate these beliefs so forcefully in 1899 and 1900 by concentrating on the Japanese bridge and water garden first, as opposed to the flowers across the tracks, is revealing, for the bridge and the water garden immediately mark these paintings as Eastern. (The bridge would appear in only three other paintings of his water garden over the course of the next 20 years.)

Monet would have wanted to provoke an association with the East to underscore several points. First, that France could gain essential guidance at this critical juncture in her history by looking seriously to the Orient, specifically to Japan, and learning from the deep engagement with nature that the Japanese in particular so amply demonstrated. Such a relationship to the visible world allowed the Japanese to operate on a higher level of awareness and made them, in Monet's opinion, "a profoundly artistic people. I once read something that struck me," he admitted to a journalist who had come to see his gardens in 1904. "A [Japanese] bricklayer was building a wall and he placed a rose in front of him so that from time to time he could look at it and inhale its scent as he worked. As his wall progressed, he would move the rose so that it was always there before him. Don't you find that charming?" he asked his guest.[9] That was the kind of relationship to nature that Monet held dear. If everyone were so conscientious in his task, and so aesthetically attuned, the world was bound to be a better place.

Fig. 105. Utagawa Hiroshige, *Wisteria*. Museum of Fine Arts, Boston.

Associations with the East would also have made viewers realize that Monet had been able to appropriate aspects of this foreign culture and adapt them to his own use. The bridge, for example, recalls structures that appear in Japanese prints, such as Hiroshige's *Wisteria* (fig 105.). However, when Monet began his series, he depicted his bridge in quite a different manner. Instead of setting it off to one side and giving it an almost impossibly high arc, as Hiroshige does, Monet places his weightier structure squarely in the center of most of his scenes and stretches it from one side of the canvas to the other, as if to emphasize its practicality as well as its decorative appeal. No unexpected forms enter his scenes, unlike in Hiroshige's, making Monet's far more "rational" and thus more reassuring. The elements that Monet includes in this first group of paintings are also so pulsating with life that one doubts their reality much less than one does the flattened, artificial forms in the Hiroshige. Monet's color scheme is also distinctly European, with its classical balance of blues and yellows, reds and greens. Even the way he applies the paint in discrete, almost labored, touches is unusually reserved. With such foreign subject matter, he clearly did not want to pursue the surfaces he had achieved in the *Mornings on the Seine*, opting instead to reinstate his familiar, French Impressionist style. Monet's formal tactics are understandable, for what he is attempting to suggest in these *Japanese Bridge* paintings is the existence of a hybrid environment, a place where East becomes West through the powers of French culture and where nature becomes art through the tenacity of an Impressionist's vision.

Such suggestions are even more boldly stated in the second group of *Japanese Bridges* from 1900, where the bridge is now shifted to a much more asymmetrical location (plates 96-98). Monet's palette is also much less tied to naturalistic colors, with various shades of red, yellow, and orange mixed with the predominant blue-greens of the first group to create a much hotter, almost garish effect, reminiscent of certain moments in some of the *Poplars*.

The ties to the East were not overlooked by reviewers in 1900. Some of them noted the existence of Japanese prints in which similar bridges appeared. One of them complained that Monet did not vary his view as much as his Oriental predecessors. Another felt that these new pictures were cause for concern. "I only fear that these artistic divergences will make us lose the delicate and often very just sense that earned us so good and high a reputation in the past," a reminder that national status was a preeminent issue.[10] Others preferred Monet's earlier work, particularly his *Grainstacks*, *Poplars*, and *Cathedrals*.

However, there were those who strongly disagreed, such as Julien Leclercq, the critic for *La Chronique des Arts*. Having defended Monet and his Impressionist colleagues in prior years, calling their movement in 1899 "a glorious chapter to add to our history of French art," Leclercq believed that Monet surpassed the Japanese with his new series. By maintaining a consistent vantage point in these pictures, Monet was able to achieve a much broader range of lighting effects, and had thus endowed his naturalism with a freshness and vitality not evident in Oriental prints. As a group, Monet's series also engendered a sense of the ideal and the 18th century, a fact, Leclercq felt, that would be better appreciated in the future. "We will understand one day better than we do now . . . what limpidity of the soul,

what incantation of the beautiful things of nature [these paintings represent], and how much the creator of these powerful and beautiful marvels belongs to the race of those lucid, welcoming, brilliant, sensible, and penetrating men who were the ever gracious and intelligent painters of the 18th century." Like other writers who had come to associate Monet's work with French values, Leclercq defended this new series on the grounds that it embodied "the genius of an impassioned and measured people," going so far as to assert that "to discredit it is to discredit France."[11] Such statements would have been unthinkable at the beginning of the decade. That they appear as the century drew to a close attests to how far Monet had come in ten years.

Monet's altered status was also evident in the fact that he had been well represented in the Centennial show in the Fine Arts section of the Universal Exposition, which had opened in April 1900 and had closed just prior to the *vernissage* for his *Japanese Bridge* exhibition in November. Initially, Monet had refused to participate in this gathering of work from 1789 to 1889. True to his feelings about government functions, he had been wary about what paintings the committee would select, about how they would hang them, and about appearing to have been co-opted. However, after protracted negotiations and considerable bitterness, he finally backed down, primarily because Pissarro and Renoir had decided to exhibit, and because Roger Marx, who had written so brilliantly about his work during the decade, pressured him as one of the primary organizers.[12] Monet had also been able to extract important guarantees: he would have a say in what paintings would be chosen, all his canvases would be hung together, and only works by other Impressionists would be grouped in the same rooms. Like Pissarro, who first told his son that the show was going to be "a monstrosity" and then felt that it would be "very fine," Monet must have been pleased with the results. He was represented by fourteen paintings, more than any other Impressionist and more than four times as many as had been included of his work in the Universal Exposition of 1889. It also was more than any Barbizon artist except for Corot, even twice as many as had been selected for Millet, Troyon, and Charles Jacques. This latter ratio caused some critics to cry that those earlier landscape painters had been treated unfairly, a complaint that rang with a certain irony, as eleven years earlier, at the last such gathering, the exact opposite had been the case.[13]

Although not all writers agreed on the extent of the Impressionists' achievement, most of them, such as the critic for *La Liberté*, conceded its impact: "In the work of numerous artists, the effects of light are studied and expressed with more intelligence and truth than before; this represents progress in the discipline for which it is necessary to be grateful to the Impressionists." Even the staunchly conservative Robert de Sizeranne admitted in his august *Revue des Deux Mondes* that "if you walk through the rooms of the *Décennale* [the 1889-1900 exhibition in which Monet was not included] you will see traces [of Impressionism] not only among the quasi-Impressionists, such as M. Besnard, but also in the work of the most restrained people, such as Henri Martin, [and] Duez." He also found their influence "in the lingering Romantics . . . in France, . . . the Alps, . . . Hungary, even in the paintings coming from Oslo and Stockholm."[14] Monet's absence from that survey of recent art caused André Mellerio to call

for a separate retrospective of Impressionism. However, people knew what Monet had accomplished, as Roger Marx most euphorically expressed: "Never were pictorial faculties put to the service of such a refined and sensitive eye. . . . Outside of Turner and Corot, modern landscape cannot count a master of more noble ability."[15] The historical record was finally being written the way that Monet had envisioned it.

That Monet's *Japanese Bridge* exhibition opened only three weeks after the Universal Exposition closed partially explains the mixed reception his new series received, for the paintings were in striking contrast to what people had just seen. They were also quite different from anything else that Monet had previously exhibited, which is perhaps one reason why he supplemented them with a selection of twelve other paintings from the previous ten years, beginning with two views of the Creuse and ending with three *Mornings on the Seine*. In addition to taking advantage of the interest his work had generated at the Universal Exposition and making up for his absence in the *Décennale*, Monet clearly wanted to provide a context for his new series and to underscore his continued devotion to rendering the splendors of nature.

Given the novelty of the *Japanese Bridge* pictures, continuity would have been particularly important for Monet to establish, not because he needed to sell the paintings – he had sold most of them long before the show opened – but because two important principles were at stake: First, these paintings were the product of a French artist, practicing a vital but now forty-year-old style; second, they possessed as much regenerative power as his views of the Norman cliffs, or of the old, gnarled oak from the Creuse, and demonstrated once more that nature, even in the form of a man-made water garden, could be the ultimate source of strength for the contemporary world.

Monet was not the only one propagating these principles. Pissarro was adamant about them as well. When the English critic Wynford Dewhurst claimed three years after Monet showed his *Japanese Bridges* that Pissarro and Monet had had no conception of light before they went to London in 1870, the oldest Impressionist showed his national bias. "It is true that Turner and Constable have been useful to us, as all painters of great talent have," he told the critic. "But the basis of our art is evidently French. . . . our masters are Clouet, Nicolas Poussin, Claude Lorrain, the eighteenth century with Chardin, and 1830 with Corot."[16] Pissarro was even more insistent about the importance of nature to contemporary art and society. When his son turned to Italian primitives to counter the commercialization of art in England in 1900, Pissarro reprimanded him harshly: "Commercialism can vulgarize these [arts] as easily as any other style, hence it's useless. Wouldn't it be better to immerse yourself in nature? I don't hold the view that we have been fooling ourselves and ought rightly to worship the steam engine with the great majority. No, a thousand times no!. We are here to show the way! According to you, salvation lies with the primitives, the Italians. According to me, this is incorrect. Salvation lies in nature, now more than ever."[17] Pissarro's paintings of 1900, like Monet's *Japanese Bridge* pictures, suggest none of this urgency. They are poetic, light-filled views of Paris, Moret-sur-Loing, and

Dieppe. Yet, like Monet, he obviously felt that the troubled times in which they lived demanded a keen awareness of the visual world, and that developing a sensitivity to nature was vital not only to good art but also to a meaningful existence.

Unfortunately, Pissarro would not live long enough to see how Monet would pursue that belief; he died just six months after he defended Impressionism against Dewhurst's reading of the movement. Monet, however, would continue working for more than two decades, producing more than 500 paintings of his ever-fertile Giverny gardens. In his obsessive concentration on these seemingly limited motifs, Monet carried his idea of series paintings to its logical extreme, culminating in the magisterial *Water Lily* canvases now in the Orangerie.

Born from his deep involvement with nature and from his desire to become the leading landscape painter in France, the notion of series painting had led him to produce some of the most extraordinary pictures of his career, from the somber *Creuse Valley* series to the controlled drama of the *Japanese Bridge* paintings. The notion had also brought him the honors that he had set out to claim. "Transport these *Mornings on the Seine*, *Grainstacks*, and *Cathedrals* around the world," wrote the critic for *La Revue Blanche*, Charles Saunier, in December 1900, "and no matter where these paintings will be, the spectator, whoever he is, will admire and envy a country where the hand of man . . . built such monuments in the middle of such beautiful sites. Glory thus to the artist who with the aid of a few lines and some dashes of color can so grandly synthesize the land where he lives."[18]

Notes

Abbreviations Used in the Notes:

AH – Alice Hoschedé

BM – Berthe Morisot

CAC – *La Chronique des Arts et de la Curiosité*

DR – Charles Durand-Ruel

GG – Gustave Geffroy

GP – Georges Petit

LVA – Gustave Geffroy, *La Vie artistique*, 8 vols. Paris: E. Dentu (vols. 1-4) and H. Floury (vols. 5-8), 1892-1903.

W.I, II, III, IV – Daniel Wildenstein, *Claude Monet, biographie et catalogue raisonné*, Vol. I, 1840-1881, Vol. II, 1882-1886, Vol. III, 1887-1898, Vol. IV, 1899-1926, Lausanne: La Bibliothèque des Arts, 1974-1985.

W.XXX – Monet's paintings as numbered by Wildenstein

w.xxx – Monet's letters as compiled by Wildenstein and found at the end of each volume of his catalogue.

"XXX" – Untitled article or articles among Monet's press clippings whose title is unknown

City followed by date – Exhibition and accompanying catalogue

Notes for Introduction

1. w.1076 to GG 7 October 1890.

2. Louis, 1891.

3. Fouquier, 1891.

Notes for Chapter 1

1. Of the many books on the Third Republic and the fin de siècle, the following are among the most helpful: Cobban, 1965; Hanotaux, 1908; Mayeur and Reberious, 1984; McManners, 1972; Sedgwick, 1965; Shattuck, 1969; Silverman, 1977 and 1983; Sonn, 1981; Swart, 1964; Weber, 1986; Williams, 1982; Wright, 1960.

2. On this song see Théodore Botrel, *Refrains de Guerre. Les Chants du Bivouac*, Paris, 1914, 25. Also see P. Barbier and F. Vernillat, *Histoire de France par les chansons*, Paris, 1961; on the legacy of the Franco-Prussian War see Digeon, 1959 and Mitchell, 1979. My thanks to Filiz Eda Burhan for obtaining a copy of Digeon's monumental work for me.

3. On the Dreyfus Affair, which will be discussed further in Chapter 9, see Bredin, 1986 and Kleeblatt, 1988.

4. Olivie, 75.

5. Paul Mantz, "Le Salon de 1865," *Gazette des Beaux-Arts*, ser.1, vol. 19 (July 1865):26.

6. Monet's earnings can be tabulated from his account books which are in the collection of the Musée Marmottan. My thanks to Marianne Delafond and Yves Brayer for allowing me to consult this and other material in the museum's collection. Daniel Wildenstein was the first to publish Monet's finances in his indispensable biography and catalogue raisonné on the artist.

7. G. Jean-Aubry, *La Vie et l'oeuvre d'après les lettres et les documents inédits d'Éugène Boudin*, Neuchâtel, 1968, 82.

8. w.910 to BM 15 February 1889.

9. The following is a representative sampling of the authors in Monet's library: Aristophanes, Berlioz, Cervantes, Chateaubriand, Collignon (on Diderot), Corneille, Dante, Delacroix, Dostoievski, Gorki, Hardy, Heine, Homer, Ibsen, Kipling, La Fontaine, Lamartine, Lucien de Samosate, Lucretius, Michelangelo, Michelet, Molière, Montaigne, Pascal, Petrarch, Poe, Reynolds, Ruskin, Ste. Beuve, St. Simon, Shakespeare, de Staël, Stendhal, Tacitus, Tchekhov, Tolstoi, Voltaire. He also owned works by all of the leading French 19th-century novelists. My thanks to Madame Lindsay and Mr. Gerald van der Kemp of the Musée Claude Monet for allowing me the opportunity to study these holdings. On Monet's association with his contemporaries and a sense of his interests see House, 1986, 5-13.

10. GG, *LVA*, vol. 3, 1894, 64-5.

11. On Monet and Dreyfus see Chapter 9; on the visit of the Czar see Joyes, 1975, 22-23 and W.III, 56, n.1165; on Boulanger see w.908 to Whistler [end of January 1889]; and on Monet's concern about the elections of 1888 see w.878 to AH [23 April 1888].

12. w.1081 to BM 26 November 1890.

13. w.1020 to BM 5 December 1889. For a full list of the subscribers see w.1047.

14. *La Liberté*, 26 June 1889. Also see Mallarmé's note to Monet in 1888 linking Monet to Manet in Levine, 1976, 89 and Félix Fénéon's review of Monet's 1889 show in which the critic declared Monet influenced Manet, in Levine, 1976, 114. Monet's challenge to Manet in the 1860s was not lost on critics; see for example André Gill, "The Joke of the Salon," *La Lune*, 13 May 1866 as translated in Stuckey, 1985, 33.

15. Lecomte, 25 June 1898, 60.

Notes for Chapter 2

1. The group of earlier *Grainstacks* are W.1213-17.

2. See for example Rewald, 1973, 439-45; Berger, 1963; Isaacson, 1980; and Cecil Gould, *Seurat's 'Bathers, Asnières' and the Crisis of Impressionism*, London, 1976. House, 1986, 2, treats the issue in a more sensible way, noting that "there was no single moment when . . . questions simultaneously came to a head and more significantly, that the debates about these issues were essentially continuous involving constant discussion and disagreement."

3. Why all of this occurred might have had something to do with a number of considerations – with the inherent qualities of Impressionism as a style, for example; with how adequately it could claim to describe the visual world and be the bearer of meaning; with the personalities of specific individuals and with

developments in their lives; with the nature of the subjects that the group chose to paint in the 1860s and '70s and those that they focused upon in the 1880s, a change that suggests a different concept of modernism; with developments in the art market and with the changing relationships between Impressionism and mainstream artistic production. In any case, it certainly merits further study. On the eighth Impressionist exhibition see Ward, "The Rhetoric of Independence and Innovation," in San Francisco, 1984, 421-42.

4. On Seurat and the *Grande Jatte* see Ward, in San Francisco, 1984, 421-42; Clark, 1985, 259-68; Richard Thompson, *Seurat*, Oxford, 1985, 97-126; and John House, "Meaning in Seurat's Figure Paintings," *Art History*, vol.3, no.3 (September 1980): 345-56. The most complete collection of contemporary reactions to Seurat's work in 1886 is found in Henri Dorra and John Rewald, *Seurat; l'oeuvre peint; biographie et catalogue critique*, Paris, 1959, 292-93.

5. Halperin, 1970, 29-38. This is a slightly revised version of his original review of the eighth Impressionist exhibition, "Les Impressionnistes en 1886 (VIIIe Exposition impressionniste)," *La Vogue* (13-20 June 1886):261-75. The standard work on Seurat's methods is William Innes Homer, *Seurat and the Science of Painting*, Cambridge, 1964. Many of Homer's basic premises have recently been challenged. See e.g. John Gage, "The Technique of Seurat: A Reappraisal," *Art History*, vol. 10, no.3 (September 1987):448-54 and Alan Less, "Seurat and Science," *Art History*, vol. 10, no.2 (June 1987):203-26. Although both of these articles rightfully debunk the idea of Seurat's "science," they do not alter the argument presented here, which is based on the perception of Seurat's public in the 1880s.

6. See Rewald, 1978, 83-84. Monet and Renoir had been seeking other markets prior to this show and had declined to participate in the Impressionists' exhibitions as early as 1880. In 1886 Monet had also committed his work to Georges Petit's 5th International Exhibition which meant he could not show elsewhere; see w.616 to Pissarro 9 November 1885. On Pissarro's acrid comments about Impressionism see e.g. letters of 7 and 9 January and March 1886, Rewald, 1980, 71-72, 89-92.

7. According to W.I and II, Monet produced approximately 480 paintings between 1880 and 1885 (W.557-1040) and only about 240 between 1870 and 1875 (W.146-389).

8. See Taboureux, 1880, in Stuckey, 1985, 89-93. On Monet's interest in expanding his market see w.173 to Duret 8 March 1880.

9. w.852 to BM 10 March 1888.

10. On the ties between Impressionism and Paris see Herbert, 1988; Clark, 1985; and Tom Crow, "Modernism and Mass Culture in the Visual Arts," in Benjamin H. D. Buchloh et al. (eds.), *Modernism and Modernity*, Halifax, 1983. On Monet in particular see Tucker, 1982. On Monet's participation in provincial exhibitions see Seiberling, 1981, 307. For Grenoble see Nemo, "Exposition de Grenoble," *Moniteur des Arts* (13 August 1886): 272-73; for Limoges see Jean Limousin,

"Exposition de Limoges: Partie moderne," *Moniteur des Arts* (29 November 1888):110. According to Raymond Moulin, "Les Expositions des Beaux-Arts en Province, 1885-87," thèse, Faculté des lettres, Paris, 1967, 174-75, Monet also exhibited in Le Havre and Rouen in the 1880s.

11. On Monet's Belle Isle campaign see W.II, 50-58; Delouche, 1980; and House, 1986, 150, 195-96.

12. Herbert noted this more than twenty years ago in *Neo-Impressionism*, exh. cat., New York, 1968, 157.

13. On Monet's brushwork and his apparent spontaneity see Herbert, 1979; House, 1986, 75-108, 162-65; and Ronald R. Bernier, "The Subject and Painting: Monet's 'Language of the Sketch'," *Art History*, vol. 12, no. 3 (September 1989): 298-321.

14. w.794 to Théodore Duret 13 August 1887.

15. See Herbert, 1987.

16. Taboureux, 1880.

17. The most quoted of these is Guy de Maupassant's "The life of a landscapist," *Gil Blas*, 28 September 1886, as cited and translated in Stuckey, 1985, 121-24. Also see Georges Jeanniot, "Notes sur l'art: Claude Monet," *La Cravache parisienne*, 23 June 1888, in Stuckey, 1985, 129.

18. GG, February 1889.

19. On Monet's pairs see Levine, 1975.

20. See Lionello Venturi, *Impressionists and Symbolists*, New York, 1950, 61; John Coplans, *Serial Imagery*, exh. cat., Pasadena, 1968, 21.

21. De Lostalot, "Exposition Internationale de peinture et de sculpture (Galerie Georges Petit)," *Gazette des Beaux-Arts*, 2nd ser., vol. 35 (June 1887):522-27, and Joris-Karl Huysmans, "L'Exposition Internationale de la rue de Sèze," *La Revue indépendante de Littérature et d'Art*, NS (3 June 1887):345-55, cited in Levine, 1976, 84-85.

22. On Monet's use of the term "series" see e.g. w.90 to de Bellio 20 June 1876, w.200 to Duret 3 Oct. 1880, w.388 to DR 12 January 1884, w.405 to AH 4 February 1884, w.543 to DR 20 January 1885, w.563 to DR ca. 25 April 1885.

23. Zola, 1970, 154; *La Presse*, 31 March 1876, reprinted in GG, 1924, vol. 1, 80. Also see House, 1986, 193-94.

24. GG, "Salon de 1887, Hors du Salon," *Le Journal*, 2 June 1887, cited in Paradise, 1985, 269. Paradise provides a very sensitive analysis of Geffroy's art criticism.

25. Levine, 1976, 88 calls it a "critical paradigm"; also see Paradise, 1985, 269.

26. Wildenstein tentatively identified seven of them as: W.1084, W.1093, W.1096, W.1097, W.1101, W.1106, W.1114. See W.III, 2. Monet showed ten Belle Isle canvases in his retrospective with Rodin in 1889. See W.II, 21.

27. w.705 to AH 5 October 1886.

28. w.730 to AH 30 October 1886; also w.701 to DR 1 October 1886.

29. On being called "the prince of the Impressionists" see w.688 to AH 18 September 1886. On his correspondence see w.701, w.726, w.727, w.728.

30. w.702 to AH 2 October 1886.

31. GG, "La Chronique: Claude Monet," *La Justice*, 15 March 1883.

32. w.712 to AH 14 October 1886.

33. w.727 to DR 28 October 1886.

34. w.808 to AH 17 January 1888.

35. w.807 to AH 15 January 1888.

36. w.836 to GG 12 February 1888.

37. GG, "Dix tableaux de Claude Monet," *La Justice*, 17 June 1888; reprinted in *LVA*, vol. 3, 1894, 77-81.

38. For the most provocative discussion of the *Grainstack* series see Herbert, 1979 and Brettell, 1984. For differing views see Moffett, 1984, 140-59; House, 1985, 19-23 and 1986, 28-32, 193-204.

39. Mirbeau, *Exposition Claude Monet...*, 1889, 10-11, cited in Levine, 1976, 104.

40. w.810 to AH 19 January 1888.

41. GG, 7 June 1898.

42. Mirbeau, *Exposition Claude Monet...*, 1889, 16, cited in Levine, 1976, 107.

43. On returning to France w.409 and w.446 to AH 6 February and 14 March 1884; on the vile food w.879 to AH 24 April 1888.

44. w.427 to Pissarro 2 June 1871; on Monet's disparaging remarks about the government during the *Olympia* subscription see Chapter 3.

45. w.573 to DR 27 June 1885.

46. w.578 to DR 28 July 1885.

47. w.651 to DR 23 January 1886.

48. "I would always be happy to do business with you again, although I am broken-hearted to see all of my paintings leave for America." w.868 to DR 11 April 1888.

49. Unfortunately, there is no record of Monet being offered the Cross and no letter indicating his refusal. However, we can surmise that he was in fact in line for this national honor from Mirbeau's correspondence in which the idea of turning the offer down is discussed. See Octave Mirbeau, "Lettres à Claude Monet," *Cahiers d'aujourd'hui*, 5 (29 November 1922):165, and W.III, 11, n.724. Monet raised the issue obliquely two years later in a letter to GG when he claimed that he did not need government officials such as Antonin Proust or their crosses; see w.1023 to GG 21 January 1890. Refusing the Cross would have been in keeping with Monet's disdain of such awards, particularly those given by the government, something he made clear more than a decade later when he criticized Renoir for being inducted into the Legion in 1900; see w.1566 to Renoir end of August 1900. He expressed his regrets to Geffroy as well. "Isn't it sad to see a man of his tal-

ent accept the decoration at the age of 60, after having fought for so many years and having been so valiant when he emerged from the struggle despite the administration?"; see w.1565 to GG 23 August 1900.

50. This reading of the *Grainstacks* was first offered by Herbert, 1979. I am much indebted to his interpretations.

51. For a description of the difficulties of constructing these stacks see Émile Zola, *The Earth*, Harmondsworth, 1980, 237-41.

52. On Pissarro's treatment of this subject see e.g. Sotheby's London, 30 April 1969, no. 24 of 1878 and Venturi no.589 of 1883 as well as his series of prints of grainstacks which are discussed by Melot, *L'Estampe impressionniste*, exh. cat., Paris, 1974, 16, and his "La Practique d'un artiste: Pissarro graveur en 1880," *Histoire et Critique des Arts*, vol. 2 (June 1977):16.

53. On Monet wanting to do something else see w.1425 to GG 20 June 1888.

54. See Pissarro letter of 6 September 1888, Rewald, 1980, 130-32. Also see letter of 20 February 1889, Rewald, 1980, 134-35, for complaints about the "dot." For Pissarro's first *plein-air* painting since 1889, see letter of 21 July 1891 to Monet in Bailly-Herzberg, 1988, 111. For Monet's quip to Perry, see Cecilia Beaux, *Background with figures*, Boston/N.Y.: 1930, 201 as cited in David Sellin, *Americans in Brittany and Normandy, 1860-1910*, exh. cat., Phoenix, 1982. Like Pissarro, Renoir recognized the value of Monet's allegiance to Impressionism. In 1891, after eight years of studio painting, he confessed to Durand-Ruel, "I have lost a lot of time by working within the four square meters of my studio. I would have gained ten years by doing a little of what Monet has done." See Venturi, 1939, vol.1, 130.

Notes for Chapter 3

1. Pissarro letter of 8 July 1888, Rewald, 1980, 126-27.

2. Pissarro letter of 10 July 1888, Rewald, 1980, 127.

3. On Monet's quip to Van Gogh see Pissarro letter as in note 1; on Pissarro's remarks about Monet see note 2.

4. GG, "Dix tableaux de Claude Monet," *La Justice*, 17 June 1888, reprinted in *LVA*, vol. 3, 1894, 77-81.

5. w.878 to AH 23 April 1888.

6. See Theo van Gogh letter of 9 February 1889 to his fiancée Johanna Bonger cited and translated in Amsterdam, 1986, 91-92.

7. w.1425 to GG ca. 20 June 1888.

8. Ibid.

9. w.910 to BM 15 February 1889.

10. On Fresselines and the Creuse see Dausset, *Les Gloires littéraires de la Creuse*, Paris, 1894. Also see Alfred Sensier, *Rousseau*, Paris, 128-29 about Rousseau's response in 1842 to

the austerity of the area. Also see *La Creuse, terre inconnue*, Gueret, 1980 for Georges Sand's reaction.

11. w.943 to BM 8 April 1889.

12. Ibid.

13. w.937 to AH 4 April 1889.

14. My thanks to Robert Herbert for identifying this site.

15. w.974 to AH 6 May 1889.

16. w.943 to BM 8 April 1889.

17. w.975 and w.976 to AH 8 and 9 May 1889.

18. w.926 to AH 25 March 1889.

19. w.936 to Rodin 3 April 1889.

20. w.979 to AH 14 May 1889.

21. w.912 to Rodin 28 February 1889. The show was most likely in its nascent stage in 1888, as Monet mentions the possiblity of exhibiting on the rue de Sèze in a letter to Durand-Ruel in April of that year. See w.868 to DR 11 April 1888. Dunn, 1979, 73, suggests this as well.

22. w.949 to Rodin 12 April 1889.

23. w.912 as in note 21. Monet's sense of the magnitude of the show is also evident in w.926 to AH 25 March 1889 and w.969 to DR 1 May 1890. Initially, the contract for the show called for a run from 5 July to 5 October 1889, a 10 percent commission for Petit, and 8,000 francs from each artist for rent (w.948 to GP 12 April 1889). Petit appears to have wanted a July opening to accommodate the Secrétan sale in June, but in mid-April the sale looked as if it were not going to occur, prompting Monet to inquire about an earlier date for his show with Rodin (w.952 to GP ca. 15 April 1889); Petit agreed, but only if Monet consented to the higher rates. After initially refusing (w.955 to Rodin 18 April 1889), Monet followed Rodin and accepted the earlier opening and dearer fees, although he tried to negotiate a compromise on the latter (w.957 to Rodin 20 April 1889 and w.958 to GP 21 April 1889). The agreed-upon date at that point was 15 June, but that must have been pushed back by the Secrétan sale, which Petit finally managed to secure.

24. About causing problems for himself see w.970 to AH 1 May 1889.

25. Wildenstein has attempted to identify the pictures Monet exhibited. See W.III, 21, n.825.

26. On the hanging of the show see Fitzgerald, 1905, 184. The catalogue for the exhibition lists 145 works for Monet. However, given the fact that he was adding paintings at the last minute, that number should not be taken as an absolute figure, a supposition Dunn, 1979, 76, makes as well. On late additions see w.991 to Hamman 12 June 1889.

27. For a thorough analysis of these two articles see Levine, 1976, 102-12. According to Theo van Gogh, Mirbeau's review was critical to the success of the show; see his letter of 11 March 1889 to his fiancée, cited and translated in Amsterdam, 1986, 92.

28. w.969 to DR 1 May 1889.

29. J[ules] A[ntoine], 1889, also cited in W.III, 22.

30. On Monet's complaints see for example w.996 and w.998 to GP 21 June and 15 July 1889.

31. Frémine, 1889; Maus, 1889; see also Anon., *Le Matin*, 1889.

32. On Americans collecting Monet and Impressionist paintings see Pissarro letter 13 September 1889, Rewald, 1980, 137. Also see Huth, 1946, 225-52; Venturi, vol. 2, 1939, 214ff; F. Weitzenhoffer, "The Earliest American Collectors of Monet," in Rewald and Weitzenhoffer, 1984, 74-91; and Rewald, "Van Gogh, Goupil and the Impressionists," *Gazette des Beaux-Arts*, ser. 6, vol. 81 (January-February 1973):23-26.

33. At some unknown date, Monet gave another to Geffroy. In 1899 he gave Clemenceau *The Rock*, and in 1900 he sold two more to Durand-Ruel. The last picture in the series left his hands in the early 1920s when it was purchased by the Japanese collector Matsukatu.

34. Maus, 1889; Foucher, 1889, cited in Seiberling, 1981, 81. See also Santos, 1889.

35. On Monet's possible return to the Creuse see Rollinat letters to Monet 28 February 1890 and January 1891 in M. Rollinat, *Fin d'oeuvre*, Paris, 1919, 277-78, 292.

36. See for example w.960 to AH [22 April 1889] in which he also expresses his preference for being home at Giverny, a desire he often repeated during this campaign.

37. As Monet said in his letters of appeal, the subscription was "not only the most beautiful homage we could render to Manet but also a discreet way of coming to the aid of his widow." See e.g. w.1000 and w.1001 to Émile Zola and Alfred Roll both 22 July 1889. The *Olympia* had been offered at Manet's death sale but it had not met its reserve of 10,000 francs. It had therefore been bought in by the family. See Cachin et al, *Manet*, exh. cat., New York, 1983, 183. The subscription's goal of 20,000 francs was undoubtedly based on the fact that Manet himself had set that amount on the picture. Monet's interest in doing something for Manet predates the rumor of *Olympia's* departure; see for example w.897 to Mallarmé 19 June 1888. "Oui, ce pauvre Manet m'aimait bien, mais nous la lui rendons bien cette amitié et je suis exaspéré du silence et de l'injustice de tous pour sa mémoire et son grand talent." This may well have been prompted by Mallarmé's desire to use Manet's illustrations of Poe's work in his own translation of the American's poems which appeared in 1888.

38. For subscription amounts see w.1007 to Mallarmé 12 October 1889; w.1010 to Pissarro 23 October 1889; and w.1018 to Vollon 23 November 1889.

39. w. 1020 to BM 5 December 1889.

40. w.1072 to Gustave Larroumet 7 February 1890.

41. w.1034 to Bracquemond 9 February 1889.

42. w.1061 and w.1062 to Gustave Larroumet 24 June and 8 July 1890; w.1056 to Léon Bourgeois, Minister of Public In-

struction, 11 May 1890; w.1049 to Gustave Larroumet 5 April 1890.

43. "Olympia au Louvre," *La Liberté*, 25 February 1890.

44. Many people felt that these two paintings were more appropriate choices for Manet's legacy to the nation; Monet retorted that neither of them was available. Anon., "XXX," *Progrès*, 10 February 1889.

45. H.D., "XXX," *Le Monde*, 10 February 1889.

46. On the Gallery of Machines, see "The Prize for the Most Remarkable Work shown at the Paris Exhibition . . ." *The American Architect and Building News*, vol. 26, no.724 (9 November 1889): 214 and Harriss, 1975, 129-32. The best accounts of the Exposition are Nelms, 1987; Harriss, 1975; and Silverman, 1977 and 1983. Also see E. Monod, *L'Exposition Universelle de 1889*, Paris, 1890. On the Palace of Fine Arts see *Journal Universel L'Illustration: Un siècle de vie française*, exh. cat. Paris, 1987, 112 and Harriss, 1975, 134-35.

47. On these exhibitions see L. Gonse and A. de Lostalot, *Exposition Universelle de 1889: Les Beaux-Arts et les Arts Décoratifs*, Paris, 1889.

48. Jacques Néré, "The French Republic," in *The New Cambridge Modern History, Vol. 11: Material Progress and World-Wide Problems, 1878-1898*, Cambridge, 1962, 307-09, as cited in Silverman, 1983, 65.

49. Gustave de Violaine, "XXX," *Moniteur Universelle*, 24 March 1889.

Notes for Chapter 4

1. On the beatification of Jeanne d'Arc and the dedication of Mont Saint-Michel see "Les Projets des monuments à Jeanne d'Arc," *CAC* (18 January 1890):18. Falguière, Bartholdi, Mercié, and Frémiet all received commissions for statues of the maid. See *CAC* (31 October 1891):261; *CAC* (17 October 1891):251; *CAC* (4 January 1890):2; and *CAC* (27 December 1890):322. For other statues see *CAC* (27 April 1890):2. For general trend see Anon., "Échos: Jeanne d'Arc for ever!," *L'Art dans les deux Mondes* (January 1891):88.

2. This notion recently informed Richard Brettell's insightful essays in Los Angeles, 1984.

3. Daniel Faucher, "Le Fonds paysan de France," in *La Vie rurale vue par un géographe*, Toulouse, 1962, 181, as cited by Brettell in Los Angeles, 1984, 36.

4. w.1072 to Director of Fine Arts, G. Larroumet 27 August 1890.

5. w.1066 to GG 21 July 1890.

6. w.1060 to GG 22 June 1890.

7. On the grass being raked see Mirbeau letter to Monet undated though probably from the end of July or the beginning of August 1890 in *Cahiers d'aujourd'hui*, 5 (29 November 1922):167-68; on Monet's stepdaughters see w.1064 to BM 1 July 1890.

8. Angelo de Gubernatis, *La France: lectures, impressions et réflexions*, Florence, 1891, 182. On the dinner in the Palais de l'Industrie see Nelms, 1987, 241-44.

9. Sedgwick, 1965, 159.

10. On anarchist violence see Sonn, 1981, 13-14, 67-68; on the number of strikes in France see Michael Curtis, *Three Against the Third Republic: Sorel, Barrès, Maurras*, Princeton, 1959, 19, as cited in Silverman, 1983, 66-67 and 80, n.27.

11. The four were W.1247, W.1251, W.1256, and W.1259. The hay and poppy pictures depict the area known as Les Essarts, a tract of land that lay between the Epte and the Bras de Limetz, a 10-minute walk south of Monet's water lily pond. This is evident from the hills that appear in the background on the right in all eight pictures in these groups. These are the hills that rose up behind Monet's house and ran northwest behind Giverny itself. Given the openness of the fields in the poppy paintings and the greater prominence of the hills in those views, it is likely that they were executed just slightly further to the west of Monet's pond, in the direction of Vernon, than the paintings of the hay fields. The views of oat fields, in contrast, were done to the northeast on the opposite side of the road that ran through Giverny and Monet's property. They are linked to the other paintings, however, by the fact that they depict the plateau that began at the ridge of the hills in the hay and poppy paintings and stretched northeast toward Gasny.

12. For example, compare W.993-995 with W.1245-1248 or W.991-992 and W.1135-1136 with W.1251-1254 or W.1256-1260. Clemenceau stressed the importance of the poppy pictures in particular, basing his opinion apparently on having watched Monet paint them in the summer of 1890. In 1895, in his famous article on Monet's *Cathedrals*, the radical Republican told his readers how he had seen Monet "with four canvases [in front of the poppy fields] changing palettes as fast as the sun pursued its course ." Clemenceau's recollections of this event were slightly different in 1924 when he repeated them. Then, Monet was working "with four easels, on which, in turn, he gave a vigorous stroke of the brush, as the light changed." (Clemenceau, 1895 and 1928, 85). There is some hyperbole here; the color schemes in the three best-known versions of the poppy pictures, for example, are not radically different. In addition, there is no other report of Monet using more than one easel prior to this time. Such details aside, Clemenceau was right to feel that Monet's activities that summer were significant as in subject and rigor the agrarian paintings he began in those hot and sticky months were the perfect prelude to the *Grainstack* paintings that he took up as soon as the harvest was complete.

13. The two that Durand-Ruel purchased were W.1245 and W.1257. Monet finished W.1251, W.1256, and W.1259 by May 1891 when Durand-Ruel bought them and W.1247 by June when the dealer took this canvas as well. W.1246 and W.1258 went to Durand-Ruel in December 1892.

14. w.1067 and w.1071 to DR 6 and 26 August 1890; w.1069 to de Bellio 24 August 1890; and w.1072 to Larroumet.

15. w.1077 to DR 9 October 1890; on his trips to Le Havre and troubles because of the maid see w.1073 to Mallarmé and w.1074 to BM both 22 September 1890.

16. w.1096 to DR 21 January 1891; on earlier delays see w.1085 to DR 14 December 1890; w.1088 to DR 21 December 1890; w.1090 to DR 26 December 1890; w.1093 to DR 4 January 1891.

17. See M. Garnier, *Climatologie de la France*, Paris, 1967, 273-74, cited in W.III, 38.

18. w.1079 to DR of 27 October 1890. On the purchase of the property see W.III, 37. Monet underscored his pleasure in an unpublished letter to Geffroy of 15 November 1890. "Je suis enfin content, me voilà devenu propriétaire et certain de rester dans notre cher Giverny." My thanks to M. Daniel Wildenstein for sharing this letter with me.

19. Trévise, 1927, 126, translated in Stuckey, 1985, 318-40. Arsène Alexandre recites a similar tale in *Claude Monet*, 1921 as does GG in "Les Meules de Claude Monet," preface to catalogue of *Grainstack* exhibition, reprinted in *LVA*, vol. 1, 1892, 22-29 and translated in Stuckey, 1985, 262-65. Also see Fels, 1929 and René Barotte, "Blanche Hoschedé nous parle de Monet," *Comoedia* and *Le Figaro*, 24 October 1942.

20. Thiébault-Sisson, January 1927, translated in Stuckey, 1985, 345-48.

21. See for example Henri Beraldi's letter to Félix Bracquemond of 2 May 1891, quoted in W.III, 38; on the series being prompted by the experience of the sun breaking through the mist see House, 1986, 199. A dozen years' worth of work, resulting in 700 paintings would seem to go farther to explain certain aspects of the *Grainstack* series than Monet's attachment to the Vétheuil canvas or his recollections of a particular day in his past.

22. Geffroy used the term "harmonize" on several occasions when describing Monet's working methods. See e.g. GG, "Salon de 1887. V and VI. Hors du Salon – Claude Monet," *La Justice*, 25 May and 2 June 1887 and GG, 1924, 185-86.

23. Only once does a stack stand so high in the fields that its whole cone is above the buildings. That occurs in W.1288. As if to compensate for the stack's overbearing presence, Monet tucks the house that appears on the right neatly under the skirt of the cone and has several stalks shoot out from that side of the stack to call attention to the building. The left edge of the cone in contrast is much less activated.

24. Trévise, as in note 19.

25. On "éprouver" see Hamilton, 1960, 18-19; Herbert, 1979, 106-07; Moffett, 1984, 145-49; and House, 1986, 204. On Monet's use of it previously see w.44 to Bazille [December 1868].

26. Philosopher, author, and eventual Nobel Prize winner, Bergson was responsible for the remarkable theory that consciousness is not something we can chart like the ticking of a clock. Instead, it is the product of what he called "duration" (*la durée*), by which he meant the interpenetration of prior experiences and the realities of the moment. Crudely put, he claimed that there is no such thing as pure objectivity, that everything is a part of everything else, and that the richness of human experience lies in being an intimate part of the vital flow of all things.

27. GG, as in note 19.

28. The painting was W.912; on Monet's relationship with Mallarmé see D. Rouart, *Correspondance de Berthe Morisot*, Paris, 1950, 130, 132-34, and C.P. Barbier (ed.), *Correspondance Mallarmé-Whistler*, Paris, 1964, 6ff and 911. On Mirbeau's rapture over Monet's gift see H. Mondor et L.J. Austin (eds.), *Stèphane Mallarmé. Correspondance*, vol. 4, Paris, 1973, 123-24 and W.II, pièce justificative, no. 92, 293. Also see House, 1986, 222-23.

29. Mallarmé as quoted in J. Huret, *Enquête sur l'évolution littéraire*, Paris, 1891, 60, and in House, 1986, 223.

30. Byvanck, 1892, 177.

31. This notion is richly explored by Shiff, 1984 and 1986. It should be stressed that Mirbeau never denied Monet's deliberateness or dependence on nature, as is evident from his catalogue essay for Monet's exhibition with Rodin. Mirbeau based all of his observations not only on his conversations with Monet but also on his intimate knowledge of Monet's work, as he owned three of his paintings, all of which revealed Monet's interest in the visual, not the imaginary, world. They were W.734, a view of the customs house at Varengeville, W.870, which depicts the gnarled trees of Bordighera, and W.1117, which captures a raging tempest on Belle Isle. Mallarmé had a similar reference point, as the painting Monet gave him, W.910, had little to do with Symbolism. It even included the smoke of a train hurtling its way to Paris. Ironically, Mirbeau was a Sunday painter who practiced a style reminiscent of Monet's; see Edmond Renoir, "Beaux-Arts: poil et plume," *La Liberté*, 12 April 1891.

32. Carr, 1977, 26. Even Pissarro recognized Mirbeau's influence, calling him and Geffroy "the master critics of Paris who led the way and whose good opinion is sought after by the most fashionable." See letter of 15 January 1891, Rewald, 1980, 145-46.

33. w.1083 to DR 5 December 1890.

34. w.1096 to DR 21 January 1891. Boussod & Valadon purchased W.1267, W.1276, and presumably W.1275. See John Rewald, "Van Gogh, Goupil, and the Impressionists," *Gazette des Beaux-Arts*, vol. 81 (January 1973):1-64 and (February 1973):65-108.

35. w.1097 to DR 3 February 1891.

36. Those sold include W.1217(?), W.1266, W.1269, W.1272, W.1275, W.1280, W.1281, W.1282, W.1286, and

W.1287. In addition, W.1274, W.1277, and W.1278 were sold in July 1891. W.1215, W.1267, W.1275, and W.1276 were not in the show, but the first was sold in June 1889, the second and fourth in February 1891, and the third in March 1891. Thus, 17 of the 30 stack pictures that Monet painted were placed by the middle of 1891.

37. Mirbeau, 7 March 1891, translated in Stuckey, 1985, 157-62. On Montaignac's visit to Giverny see w.1101 to Pissarro 13 March 1891 and Pissarro letter of 19 March 1891, Rewald, 1980, 154; on Monet's trips to Paris see e.g. w.1091 to Mallarmé 27 December 1890.

38. Pissarro letter of 3 April 1891, Rewald, 1980, 158-60.

39. Pissarro letter of 9 April 1891, Rewald, 1980, 161.

40. w.1085 to DR 14 December 1890.

41. We know these paintings were hung above the *Grainstacks* from Byvanck, 1892, 177. Unfortunately, we know very little about other aspects of the show. For example, it is impossible to identify 5 of the 15 canvases that Monet selected from the 30 that he completed during his two campaigns. Contemporary descriptions, including the catalogue of the exhibition, are simply not detailed enough, and Monet's titles are not sufficiently specific. From a letter Monet wrote to Durand-Ruel just prior to the opening of the show (w.1104 to DR 12 April 1891), we know that he wanted to have white frames on two of his canvases, but it is impossible to determine exactly which ones. We also do not know how Monet hung the *Grainstacks*, although we are certain it was not in a temporal sequence. Nor are we sure of when the hanging itself was devised. It may have been done on the spot when all 15 canvases were assembled in Durand-Ruel's gallery. One of the paintings that Monet included was in Paul Gallimard's possession prior to the opening. Monet also had shipped a number of them to the dealer in early April and was still in Giverny on the first of May, three days before the show was scheduled to open. (See w.1107 to Pissarro 1 May 1891.) However, given the importance of the exhibition, it is unlikely that Monet would have left the hanging to the last moment. When it came to his career, he was more careful than that. He therefore probably mapped out the exhibition in the comfort of his studio beforehand, lining up selections and testing alternatives. The fact that he had a major hand in the catalogue lends credence to this possibility. For it was Monet who had asked Geffroy to write the essay and he who had sent Durand-Ruel the information on the pictures to be included. He even sent Durand-Ruel a follow-up telegram when he noted an error in his original packet (w.1106 to DR 28 April 1891). Brettell, 1984, suggests an intriguing theory about the hanging based on the way the stacks are listed in the catalogue. His ordering creates quite satisfying formal sequences. However, as House, 1986, 215 points out, a late summer picture was described by Byvanck, 1892, 177, as being in the middle of the show, which is not how it appears in the catalogue. Thus, until new evidence comes to light, the hanging must remain something of a mystery.

42. Pissarro letter of 5 May 1891, Rewald, 1980, 165-66.

43. Fénéon, 1891; Mauclair, 1891; Marx, 1891.

44. GG, as in note 19.

45. Pissarro, as in note 42.

46. Ibid.

47. Émile Zola, *Salons*, eds. F. Hemmings and R. Niess, Geneva, 1959, 133.

48. Anon., "Gambetta et 'L'Angelus'," *Paris*, 10 July 1889. On the sale of the *Angelus* see Robert L. Herbert, *Jean-François Millet*, exh. cat., Paris, 1975, 106.

49. Anon., "Causerie (Millet)," *L'Art dans les deux Mondes*, (24 January 1891):106. The furor over Millet's paintings sparked archival research on the artist; see e.g. Paul Bluysen, "Les Derniers 'Millets'," *Le Figaro*, 10 March 1891, 1.

50. Louis Ernault, *Paris-Salon 1889*, Paris, 1889, LXXX.

51. Marx, 1891; on the exposition of 1889 see *Catalogue illustré des Beaux-Arts, 1789-1889*, Lille, 1889, 43-56. Théodore Rousseau was represented by 16 works, Millet by 13, Dupré by 12, Daubigny by 11, and Diaz and Troyon by 10 apiece. The artist who dominated the show, however, was Corot; organizers chose 40 of his paintings, more than twice as many as by any other artist.

52. Fouquier, 1891; Louis, 1891; Louis's experiences as a prisoner of war were so strong that in 1898 he wrote a book about them. Entitled *Souvenirs d'un Prisonnier de Guerre en Allemagne (1870-1871)*, Paris, 1898, it featured a preface by Geffroy.

Notes for Chapter 5

1. The story is told by Elder, 1924, 12; J.P. Hoschedé, *Claude Monet si mal connu*, Paris, 1960, 47; and Gimpel, 1963, 318-19; my thanks to the staff of the Arnold Arboretum for information about poplars; on the decision of Limetz to cut the trees down see Limetz town council minutes, cited in W.III, 43, n.1047.

2. My thanks to Linda Nochlin for having brought this to my attention. It is discussed further at the end of this chapter.

3. w.1122 and 1123 to DR 19 and 20 October 1891, and w.1124 to an unknown painter November 1891.

4. In addition to the "unnatural" colors, Monet employs compositional tactics to enhance the artfulness of his scenes. In Plate 34, for example, he has the lighter section of the trunk of the first tree on the left rise to the top of the bulbous tree in the background, the second to the bottom of the foliage in the distance, and the third to the same level of those background leaves. The lighter section of the third also ends precisely where the trees reverse direction.

5. See e.g. Armand Silvestre, "Exposition de la rue La Peletier," *L'Opinion Nationale*, 2 April 1876.

6. On Degas's comments and Pissarro's opinion of the Antibes pictures see Pissarro letters of 8 and 10 July 1888, Rewald, 1980, 126-27. On Geffroy's reaction see GG, "Dix tableaux de Claude Monet," *Le Journal*, 17 June 1888, reprinted in *LVA*, vol. 3, 1894, 77-81 and discussed in Paradise, 1985, 271-81. For a thoughtful discussion of the ways in which "decorative" and "decoration" were understood at the time see Levine, 1977 and Herbert, 1984. In 1892 Pissarro told his son that he wholly agreed with Degas about "what is known as 'decoration.' . . . For him [Degas] it is an ornament that should be made with a view to its place in an ensemble; it requires the collaboration of architect and painter. The decorative picture is an absurdity; a picture complete in itself is not a decoration." See Pissarro letter of 2 October 1892, Rewald, 1980, 203-04.

7. Byvanck, 1892, 177.

8. Pissarro letter of 14 May 1887, Rewald, 1980, 107-08. On Renoir's interest in Pompeian frescoes see Barbara White, *Renoir; His Life, Art and Letters*, New York, 1984, 115.

9. See Gauguin letters to Schauffenecker and Bernard of 14 August 1888 and November 1888 as quoted in Herschel Chipp, *Theories of Modern Art*, Berkeley, 1968, 60.

10. Chipp, as in note 9, 94 and 100.

11. Ibid., 92.

12. On the Museum of French Furniture, the Department of art objects, and the Union Centrale see Silverman, 1983, 334-35, 204-81, and 457-516.

13. Ocquoted Mirbeau, "La Grande Kermess," *Le Figaro*, 18 July 1889, quoted in Carr, 1977, 29ff. On the seriousness of the situation see Pierre du Maroussem, *La Question ouvrière*. Tome II: Ébénistes du Faubourg St. Antoine, Cours Libre professé à la Faculté de droit à Paris, Paris, 1892, 167, as quoted in Silverman, 1983, 89 and 113-14, notes 11-14.

14. See Henry Harvard et Marius Vachon, *Les Manufactures nationales: Les Gobelins, la Savonnerie, Sèvres, Beauvais*, Paris, 1889, as cited in Silverman, 1983, 114, note 18.

15. Edmond Plauchet, "La Rivalité des industries d'art en Europe," *Revue des Deux-Mondes*, vol. 105 (May-June 1891):644, as quoted and translated in Silverman, 1983, 92. Also see Lefebvre, "Les pays étrangers à l'Exposition des arts de la femme," *L'Estrafette*, 3 August 1892.

16. Plauchet and Silverman, as in note 15.

17. Roger Marx, "Le Salon de 1892," *Le Voltaire*, 7 May 1892, 2; on restorations see *CAC* (7 February 1891):45-46 and Silverman, 1983, 303-58; on the exhibition of Renaissance and Medieval art see *CAC* (28 February 1891):68; on the government's subvention of decorative programs see e.g. *CAC* (28 February 1891):67 and Paris, *Le Triomphe des Mairies*, 1986. The government also sponsored ambitious conservation projects of paintings in the Louvre; see e.g. *CAC* (7 February 1891):46. Later in the decade, Pissarro mocked the way the Union Centrale used patriotism to incite crafts

people to combat international competition; see letter of 14 February 1895, Rewald, 1980, 258-60.

18. On Poussin as a decorative artist see Alphonse Germain, "De Poussin et des bases de l'art figuratif," *L'Ermitage*, vol. 4 (February 1893):101-06; Germain, November 1891; and Comtesse Viviane de Brocélyande, "Interviews: Nicolas Poussin [6 August 1892]," *La Plume*, 92 (February 1893):83-84. My thanks to Alisa Luxenberg for her seminar paper on Poussin in the 1890's.

19. Roger Marx, "Sur le rôle et l'influence des arts de l'Extrême-Orient et du Japon," *Le Japon Artistique*, vol. 6, no.36 (April 1891):142, extracted in Paris, *Le Japonisme*, 1988, 137-38.

20. See Paris, *Le Japonisme*, 1988, 104-9. Other evidence of the significance of Japanese art include the founding of Tadamasa Hayashi's boutique in 1890 at 65 rue de la Victoire and the publication of Edmond de Goncourt's major study of Outamaro and Japanese art of the 18th century in 1891. See Ibid., and Evett, 1982, 22ff; Félix Fénéon hoped that the influence of Japan would ultimately cause French citizens not to pay taxes like the residents of Saga; see "Hourras, Tolles et Rires Maigres," *L'Endehors*, 29 May 1892, as quoted in Halperin, 1970, 899 and Sonn, 1981, 167. My thanks to Claire Sveltik for her seminar paper on France and Japan in the 1890's.

21. Ernest Chesneau, "Le Japonisme dans les arts," *Musée universel*, vol.2, 1873, 214-15, quoted in Paris, *Le Japonisme*, 1988, 129-30.

22. Le Blanc de Vernet as quoted in Evett, 1982, 101.

23. See MS Museum of Fine Arts, Boston, also quoted in House, 1986, 236, note 75; on the Japanese gardner see w.1111 bis to Paul Helleu 9 June 1891. On Monet's house see Joyes, 1975, 30. For association of Monet and Hokusai through yellow see Edmond de Goncourt, *Journal*, vol. 4, Paris, 1956, 195, quoted in Paris, *Le Japonisme*, 1988, 138. On Monet's collection of Japanese prints see Aiken and Delafond, 1983; on the influx of Japanese material into France see Johnson, 1986.

24. Duret, 1906, 144. This claim is dubious, however, as Monet did not own a copy of this print. In addition, there are many others that could be associated with this series. On Monet's reference to the *Terrace* see w.45 to Bazille [end of December 1868-beginning of January 1869].

25. Evett, 1982, 44 and 49.

26. Ibid., 43.

27. Ibid.

28. Marx, as in note 19.

29. Germain, November 1891, 641-45.

30. Georges Lecomte, "Japon," *Entretiens, politiques et littéraires* (June 1890):92.

31. Ibid.

32. Alphonse Germain, "Contre le japonisme," *L'Ermitage*, vol. 4 (July-December 1892):27.

33. For Pissarro's condemnation of Hayashi see letter of 13 April 1891, Rewald, 1980, 161-2; for Hiroshige as an Impressionist see letter of 3 February 1893, Bailly-Herzberg, 1988, 309-10, Rewald, 1980, 206-7; for Hiroshige's Impressionst sunsets see letter of 2 February 1893, Bailly-Herzberg, 1988, 307-8 and Rewald, 1980, 206. Pissarro's incredulity stemmed from the fact that in 1891, when he made this statement, he had abandoned Seurat's divisionism for his former Impressionist style, painting his first *plein-air* pictures in more than four years. See letter of 21 July 1891 to Monet, Bailly-Herzberg, 1988, 111.

34. Anne McCaulley intelligently underscores the association between this painting and the vogue for things Japanese in her study of commercial photography of the period; see Elizabeth Anne McCauley, *A.A.E. Disideri and the Carte de Visite Portrait Photograph*, New Haven, 1985, 97.

35. The four that Boussod & Valadon purchased were W.1293, W.1298, W.1304, and W.1306. Durand-Ruel bought W.1294, W.1296, W.1297, W.1299, W.1303, W.1308, and W.1312 while Montaignac acquired W.1307.

36. See letter of 17 February 1891 in "Lettres à Monet," *Cahiers d'aujourd'hui*, 5 (29 November 1922):170-71.

37. Raymond Bouyer, "Le Paysage dans l'art: V. Projet d'une exposition historique du paysage," *L'Artiste*, NS 6 (August 1893):118. Bouyer's series of articles on French landscape painting is perceptively analyzed by Levine, 1976, 160-76.

38. Lecomte, 1892.

39. Ibid.

40. The rococo revival is central to Silverman's immensely rich thesis, Silverman, 1983; see particularly, 303-426 and 617-35. Interest in the 18th century was also felt on the local level in the 1890s as ormolu and ornate woodwork made their reappearance not only in the town houses of the rich but also in neighborhood cafés throughout Paris, befitting the tendency toward excess that came to characterize the Belle Époque. It was in the 1890s as well that Edmond de Goncourt, who had been the primary spokesperson for the rococo since the 1860s, was recognized for his efforts and made Commander in the Legion of Honor, an event that occurred in 1895. Small wonder, therefore, that Henri Bouchot could observe in 1891 in the *Revue des Arts Décoratifs* that taste in France had changed. "When [Labrouste] tore . . . Boucher's paintings [from the walls of the Bibliothèque National], he shocked only a very small number of supporters of the Old Regime . . . Since Labrouste's time, our thinking has changed enormously. De Cotte's architecture, long despised, is once again fashionable, as is all that relates to 18th-century art . . . [Even] the colored engravings of Déboucourt, disdained by our fathers, are coveted by today's amateurs with senselessly high bids." See Henri Bouchot, "Les Dernièrs travaux de décoration exécutés à la Bibliothèque Nationale," *Revue des Arts Décoratifs*, vol. 11 (1891-92): 95, as quoted in Silverman, 1983, 324. As Silverman also points out, Clemenceau played an active part

in the Museum of French furniture, scouring government offices to find 18th-century examples for the collection. On the high prices for 18th-century prints see e.g. *CAC* (11 April 1891):113.

41. The Gallery of Machines itself was transformed into the Château d'Eau with an extravagant stucco facade that masked the structure's industrial character so celebrated in 1889. The elaborate facelift combined the old and the new as it utilized mechanically driven water fountains and an intricate network of electric lights; see Silverman, 1983, 630-32.

42. Sonn, 1981, 195.

43. Evett, 1982, 113-14.

44. See e.g. C. Couillault and H. Legran, *L'Arbre dans nos campagnes*, Paris, 1924, 19; and Mona Ozouf, *La fête révolutionnaire, 1789-99*, Paris, 1976. My thanks to Linda Nochlin for sharing this bibliographical material.

45. See Émile Zola, *The Earth*, Hammondsworth, 1980, 317; Guy de Maupassant, *Bouvard et Pécuchet* in *Oeuvres complètes*, Paris, 1972, 153-54; Maupassant even named the château in which he set *A Woman's Life* "The Poplars."

46. L'Angèle, 1899, 399.

Notes for Chapter 6

1. On Pissarro's reaction see letter of 26 May 1895, Rewald, 1980, 269. On the buzzing of Paris about the show see Pissarro's letters of 11 May 1895 and 21 October 1894, Rewald, 1980, 268 and 248. For Mauclair's opinion see Mauclair, June 1895, 357. On Renan see Renan, 1895. For the most illuminating discussion of the *Cathedrals* see Herbert, 1984, and Hamilton, 1960. For the fullest discussion of the *Cathedrals'* reception see Levine, 1976, 176-222, and Seiberling, 1980, 170-87. The beginning of the Rouen campaign is established by Monet's letters w.1132 and w.1133 to AH 12 and 21 February 1892.

2. See Pissarro letter of 13 May 1891, Rewald, 1980, 169-70; on the religious revival in France see Sedgwick, 1965 and Jules Bois, *Les Petites Religions de Paris*, Paris, 1894; on mysticism see F. Paulhan, *Le Nouveau Mysticisme*, Paris, 1891; Robert Amadou, *L'Occultisme*, Paris, 1950; and Colin Wilson, *The Occult*, New York, 1977.

3. On Depeaux's request see w.1137 to AH 8 March 1892; on Gonse's opinion see Louis Gonse, *L'Art Gothique: L'Architecture, La Peinture, La Sculpture, Le Décor*, Paris, 1890; on Pissarro and the gothic see e.g. letters of 28 February, 6 March, 8 April 1895, and 20 October 1896, Rewald, 1980, 261-63, 264-66, and 298-99. On perceptions of the Gothic as distinctly French see e.g. Louis Courajod, "Les origines de l'art gothique, leçon d'ouverture du cours d'histoire de la sculpture française (École du Louvre 1890-1891), *Bulletin monumental* (1891):42-79 and Louis de Fourcaud, "L'Art

gothique," *Gazette des Beaux-Arts,* 3rd. per., vol. 6 (August 1891):89-111 and (October 1891):310-34; 3rd. per., vol. 7 (January 1892):59-76 and (April 1892):334-48.

4. On Clemenceau's call see Clemenceau, 1895, reprinted in Clemenceau, 1928, 88, and translated in Stuckey, 1985, 175-80.

5. See GG, 1891. These references more than likely came directly from Monet, as Geffroy would have had no reason to fabricate them.

6. On Rouen see André Pottier, *Revue rétrospective normande: Documents inédits pour servir à l'histoire de Rouen et de la Normandie,* Rouen, 1842; Jules Adeline, *Rouen qui s'en va,* Rouen 1876; d'Hura, *Rouen, ses monuments et leurs souvenirs historiques,* Paris, 1877; Louis de Fourcaud, "Rouen: Les monuments religieux," *La France Artistique et Monumental,* vol. 2, Paris, 1892-93, 49-88. On Pissarro's displeasure with Rouen's renovations and his love of the city see letters of 16 and 19 August 1892, Rewald, 1980, 201 and 202. For Pissarro's work in the city see Christopher Lloyd, "Camille Pissarro and Rouen," in *Studies on Pissarro,* London, 1986, 75-92. Monet's prior work in the city includes W.206-218, 267-268.

7. The Tour d'Albane, for example, was completed in the 12th century but was given a new crown in the 15th when the Tour de Beurre on the other side of the façade was built. The two side aisle portals date from the 12th and 13th centuries, the center one from the 16th. The screen above the portals was built between the 13th and 16th centuries while the iron spire that hovers over the church was completed in the 1870s. On the Cathedral see e.g. L. Petit, *Histoire de la Cathédrale de Rouen,* Rouen, 1858 and Louis de Fourcaud, as in note 6, 52-79.

8. The colored glass in the houses is most likely either reflections (permitted by the open courtyard) or painted paper that has been applied to the windows as a decorative treatment, a popular 19th-century phenomenon. My thanks to Robert Herbert for alerting me to the latter possiblity. In either case, Monet clearly maximizes the effect.

9. The second version is W.1318. In this work, Monet increased the drama of the scene by pulling everything closer to the surface of the canvas, thus making forms appear slightly larger. To maintain a balance between the tower and the houses, however, he has the latter rise slightly higher than they had in the other version. He also creates a more open foreground by cropping the scene on the left and signing the picture below the tower on that side. These differences allow the eye to move quickly across the canvas and to become engaged with the houses on the right.

10. The people appear in W.1324, the birds in W.1345 and W.1346, and houses in W.1316-1318 and W.1345-1349.

11. w.1136 to AH 25 February 1892. On Monet's makeshift ateliers in Rouen and his departure due to illness see w.1133 to DR 21 February 1892. The fact that his first studio was

directly across from the Cathedral might suggest that the head-on view now in the Musée d'Orsay (W.1319) was begun before Monet moved to his new location, but that is not the case, as the painting has been considerably reworked. Originally, the Cathedral in this canvas was not parallel to the picture plane as it now appears but rather on an angle to it, making it closer to the other views in the series. After having begun it in the draper's shop, Monet must have decided at some point to return to his first apartment to repaint it. The urge to return to that original location struck Monet on the first day that he was back in Rouen in 1892. He was unable to fulfill his wishes, however, as men were repairing the parquet floor in the place; see w.1136 to AH [25 February 1892]. The urge was probably not prompted by his dissatisfaction with the view from the dressmaker's shop but by a natural desire either to return to something that was familiar or to diversify the series, as most of the pictures he had begun were sunlight scenes; see w.1140 to AH 18 March 1892.

12. w.1137 to AH 8 March 1892; w.1138 to DR 9 March 1892. The rings around the moon are caused by high-level ice crystals and often indicate potential snow or rain, a meteorological fact which Robert Herbert was kind enough to share.

13. w.1114 to AH 31 March 1892.

14. w.1153 to DR 13 April 1892; on his nightmare see w.1146 to AH 3 April 1892.

15. w.1206 to AH 4 April 1893.

16. w.1156 to DR 11 May 1892.

17. w.1151 to AH 9 April 1892. Also see w.1139 to AH 10 March 1892.

18. w.1164 to DR 8 September 1892. On Monet's marriage see W. III, 47.

19. w.1172, w.1173, w.1174 to DR 12 and 19 December 1892 and 24 January 1893.

20. w.1179 to AH 22 February 1893; on setbacks see w.1177 and w.1178 to AH 20 and 21 February 1892; on getting back into his subject see w.1175 to AH 16 February 1893.

21. w.1201 to GG 28 March 1893; on the number of canvases see w.1184 to AH 7 March 1893.

22. w.1212 to Paul Helleu 19 April 1893; on self-esteem see w.1209 to AH 7 April 1893.

23. w.1232 to DR 20 February 1894.

24. w.1243 to DR 21 May 1894; on taking a *Cathedral* painting with him see Prins Eugen, "Monet och hans malerei: Minnen och intryck," (ed. Oscar Reutersward), *Ord och Bild,* 56, 1947, 452, quoted and translated in Seiberling, 1980, 327, n.60.; on preoccupation with work see w.1242 to Paul Helleu 10 May 1894 and w.1241 to DR 7 May 1894.

25. w.1188 and w.1198 to AH 15 and 24 March 1893; on missing Giverny also see w.1141 to DR 22 March 1892 and w.1151 to AH 9 April 1892. On cities not being his business see w.1132 to AH 12 February 1892.

26. On the Duret sale see "Collection Th. Duret," *CAC* (24 March 1894): 89 and W. III, 58 and n.1188. According to Pissarro, all of Paris was buzzing about Monet's prices for the *Cathedrals*; see letter of 21 October 1894, Rewald, 1980, 248. On the sale of his earlier Rouen picture see w.1151 to AH 9 April 1892.

27. w.1243 to DR 21 May 1894; on canceling the show see w.1241 to DR 7 May 1894; on suggesting the postponement see w.1240 to DR 2 May 1894; on DR's refusal to purchase works see W.III, pièce justificative 122, DR to Monet 24 December 1895.

28. w.1251 and w.1252 to DR 10 and 12 September 1894.

29. w.1265 to AH 3 February; on the voyage w.1263 to AH 31 January 1895.

30. Ibid.

31. w.1266 to AH 9 February 1895; on having his fill see w.1268 to AH 13 February 1895.

32. See w.1280 to DR 9 March 1895 about postponing exhibition; w.1276 to BH 1 March 1895 about pleasure of Norway; on not being the same person see w.1279 to AH 7 March 1895; about needing a year to get to know the place see w.1274 to GG 26 February 1895; on beginning to work see w.1271 and 1272 to AH 21 and 24 February 1895.

33. w.1291 to DR 7 April 1895.

34. w.1276 to BH 1 March 1895.

35. On the Norwegians' testimony see w.1290 to AH 30 March 1895; on reading *Le Figaro* see w.1279 to AH 7 March 1895; on the royal visit and newspaper articles see w.1287 and w.1290 to AH 23 and 30 March 1895; on dinners and the *Marseillaise* see w.1272 and w.1287 to AH 24 February and 23 March 1895.

36. w.1294 to DR 5 May 1895; on settling plans see w.1291 to DR 7 April 1895.

37. On obtaining the Dutch picture see w.1294 to DR 5 May 1895; on the final 14 paintings see GG, 1895.

38. Clemenceau, 1895; and Pellier, 1895 as cited in Seiberling, 1981, 176. The Norwegian poet Hermann Bang felt similar anthropomorphic sentiments when looking at Monet's views of Mount Kolsaas, associating them with women of various ages in an array of clothing. See Stuckey, 1985, 170. On associations with music see e.g. Renan, 1895; on poetry see e.g. Lumet, 1895.

39. Robinson to J. Alden Weir, May 1892, cited in Dorothy Weir Young, *The Life and Letters of J. Alden Weir* (edited with introduction by Lawrence W. Chisolm), New Haven, 1960, 190; also quoted in Seiberling, 1981, 146-47. Unfortunately, we again do not have any clear indication of how Monet hung the *Cathedrals*, or any of the other paintings that he included in the show. He certainly did not arrange the *Cathedrals* chronologically or according to weather conditions. Nor did he do it on the basis of when he may have begun or completed individual canvases. Most likely, it was

based on visual relationships between pictures, which would have taken into consideration the orientation of the Cathedral, the light and weather effects, and, most important, the color schemes. Any theories about the installation, however, must remain tentative, given the lack of secure documentation.

40. Mauclair, 1895; Anon., *Le Matin*, 1895.

41. See A.F., 1895; Lecomte, 1895; and Frémine, 1895.

42. Anon., "Les Peintres à Berlin," *L'Idée Nationale*, 15 April, 1895.

43. Boyer d'Agen, "Les Peintres à Berlin: chez M. Bonnat," *Le Figaro*, 24 February 1891.

44. Anon., "La Musique anti-française," *L'Intransigeant*, 14 May 1895, 2; and Montretout, "Gazette de Montretout," *Le Grelot*, 26 May 1895, 2.

45. Montretout, "Gazette de Montretout," *Le Grelot*, 9 June 1895, 2.

46. My thanks to Kermit Champa for having brought this information about Mauclair to my attention.

47. Anon., "Kiel," *L'Idée Nationale*, 4 May 1895, 1. Also see Juliette Adam, "Lettres sur la politique extérieure," *La Nouvelle Revue*, vol. 93 (1 April 1895):631-37.

48. E. de Menorval, "Ne touchez pas à Jeanne d'Arc!" *L'Idée Nationale*, 18 May 1895, 1. Only a week earlier, the French Senate had passed a law making 12 May the national feast day for the medieval heroine, although typical of the decade, *Le Radical* at the same time began serializing Zola's newest novel *Lourdes*, which was a scathing attack on blind faith and the Church. On the former see "La Fête de Jeanne d'Arc à Notre Dame," *Le Soleil*, 13 May 1895.

49. Edouard Lockroy, "L'Opinion: nouveau ministère, nouveau programme," *L'Eclair*, 3 March 1892.

50. On Pissarro's donation to the Luxembourg see letter of 1 March 1891, Rewald, 1980, 152-53 and note 1. Pissarro even decided that upon his death the Seurat drawings that he owned would go to the Musée Luxembourg; see Rewald, 1980, 169 note 1.

51. Anon., "L'Exposition de Renoir," *Le Voltaire*, 9 May 1892. Renoir's commission was partly in response to the intervention of people such as Roger Marx and Mallarmé; it also was a reaction to the many calls at the time for the Impressionists to be represented in the Musée Luxembourg. That the Museum chose Renoir over Monet or Pissarro stood to some reason. In 1890 Théodore de Wyzewa, for example, could claim that Renoir was "moving more and more toward an art of discrete and simple harmony. . . . he worries about formal perfection [and] has a horror of exaggeration." Taking his cues from the great French masters Poussin and Watteau as well as from Rubens, Renoir, in de Wyzewa's opinion, was "the most delicate and feminine [of artists], the most classical and the most French." T. de Wyzewa, "Pierre-Auguste Renoir," *L'Art dans les deux Mondes* (6 December 1890): 27-28.

52. Viollet le Duc as quoted in Georg Germann, *Gothic Revival in Europe and Britain: Sources, Influences and Ideas*, London, 1972, 7. In addition to the innumerable Gothic monuments that he restored, Viollet wrote a ten-volume *Dictionnaire raisonné de l'architecture française du XIe au XVIe siècle*, Paris, 1858-68 which remained the century's primary source of technical information about the Gothic and the theoretical underpinnings of the era. A strident anti-cleric, Viollet grounded his opinion of the Gothic in strictly secular terms; see Paris, Grand Palais, *Viollet-le Duc*, Paris, 1980. Hugo's great novel *Notre-Dame de Paris* brought the Gothic into the popular realm with great poetic and nationalistic effect. Calling the cathedral "a vast symphony in stone. . .the gigantic work of both a man and a people. . .powerful and fertile like the divine creations from which it has taken its double character of variety and eternity," Hugo saw these Gothic structures as products of democracy, as approachable and as easily read as nature; see Neil Levine, "The book and the building: Hugo's theory of architecture and Labrouste's Bibliothèque Ste-Geneviève," *The Beaux-Arts and nineteenth-century French architecture*, New York, 1982, 150; Paris, Galeries nationales du Grand Palais, *La Gloire de Victor Hugo*, Paris, 1985. For the Hugo quote see J.A. Herschmann and W.W. Clark, *Un Voyage héliographique à faire (The Mission of 1851: The First Photographic Survey of Historical Monuments in France)*, New York, 1981, 10. On Vitet see Louis Hautecoeur, *Histoire de l'architecture classique*, vol. 6, 1955, 285 as translated in Germann, op. cit., 79. My thanks to Anne Umland for her seminar paper on Rouen and the Gothic.

53. Louis Courajod, *Les Origines de l'Art Moderne*, Paris, 1894, 34; Fourcaud, 1890, 7-10.

54. Ch.-V. Langlois, "L'Eloquence sacrée au moyen age," *Revue des Deux-Mondes*, 115 (1893):171; on Taine's chair see S. Rocheblave, *Louis de Fourcaud et le mouvement artistique en France de 1875 à 1914*, Paris, 1926, 217-19.

55. Germain, 1893; also see Alphonse Germain, "La Vrai Renaissance," *L'Ermitage*, vol. 5 (June 1894): 343.

56. Fourcaud as in note 53.

57. w.1196 to AH 23 March 1895.

58. Olivie, 1892, 53-55.

59. Bazalgette, 1898, 386-89 as quoted and translated in Herbert, 1984, 168-70. Bazalette was a good friend of Geffroy and may have discussed the essay with him. He felt close enough to Monet to send him a copy of the book in which the essay appeared and even dedicated that copy to the artist.

Notes for Chapter 7

1. Located in Allouville-Bellefosse near Yvetot, the tree is now more than 1,000 years old. For the history and lore of Normandy see Jules Janin, *La Normandie*, Paris, 1862, and Paul Joanne, *La Normandie*, Paris, 1882.

2. w.1327 to GG 28 February 1896.

3. Suzanne would die from the paralysis she contracted in 1894 after the birth of her daughter Lily; see Joyes, 1975, 31 and w.1319 to an unknown person 20 November 1895.

4. On this controversy see W.III, 69 and n.1314 as well as letters w.1300, w.1301, w.1303, w.1305, w.1313, w.1314 to various government officials written between May and August 1895.

5. See w.1322 to Joyant 8 February 1896.

6. The first pictures from this series would not be purchased until 1900. The majority remained in his studio until long after his death.

7. See Charles Laurent, "La Fleur du Salon," *Le Jour*, 30 April 1891. Roger-Milès felt that exhibitions had become a form of epidemic; see "Beaux-Arts," *Le Soir*, 23 April 1891. Similar complaints would be voiced in ensuing years. In 1892, for example, a writer for *Le Dix-neuvième siècle* questioned whether Paris needed yet another artists' group that was about to be formed. In addition to the two Salons and all of the dealers he moaned, there were "les Pastellistes, les Aquarellistes, les Acqua-Fortistes, les Internationaux, le Blanc et Noir, les Indépendants, les Peintres-Graveurs, la Rose-Croix and all of the others that I have forgotten." See "Les Inquiets," *Le Dix-neuvième siècle*, 20 April 1892. Raymond Bouyer reiterated this point three years later; see "Les Arts," *L'Ermitage*, vol. 7 (February 1895):123-24.

8. Barlet and Lejay, 1897, 154-60. They were not alone, as many other critics found the situation equally confusing. See, for example, Camille Mauclair's review of the Salon of 1896 in *La Nouvelle Revue*, 1896, 345. On the government's purchase of works from outside the Salon see the letter of 23 February 1893 from the Minister of Public Instruction and Fine Arts to an Inspector of Fine Arts and the letter of 21 February 1893 from Charles Yriarte, an Inspector of Fine Arts, to the same Minister in Archives Nationales F21, 4079. On the former policy see the letter of 20 April 1891 from Emil Nol and others to Léon Bourgeois, Minister of Public Instruction and Fine Arts, in Archives Nationales F21, 4082.

9. Joanne, as in note 1, 167.

10. w.241 and w.242 to AH 14 and 15 February 1882; on Dieppe w.233, w.235, and w.236 to AH 6, 7, and 8 February 1882.

11. w.1337, w.1328, and w.1332 to AH 18 and 11 March and 29 February 1896.

12. Strong winds prevented Monet from working on top of the cliffs when he first arrived. When he tried painting there once, he only lasted an hour, blown off by what he described as gusts of Arctic air; see w.1335 to AH 13 March 1896. For Monet's enthusiasm for "all of the beautiful movements of the land" at the Val St-Nicholas see w.1367 to AH 6 February 1897.

13. See Jacque-Emile Blanche, *Propos de peinture, III, De Gauguin à la Revue nègre*, Paris, 1928, 34-5, as quoted in House, 1986, 26. On Poly's statement see A. Le Braz, *Iles*

Bretonnes (Belle-Île – Sein), Paris, 1939, 49 as quoted in House, 1986, 26; and w.730 to AH 30 October 1886.

14. See e.g. the photograph of Monet in his first studio, reproduced in Joyes, 1975, 88-89. Monet even gave a photograph of Poly's portrait to Rollinant; see w.939 to AH 6 April 1889. Monet also did portraits of the husband and wife who owned the hotel-restaurant in Pourville (W.1122 and W.1123), another suggestion of his vicarious attachment to people who lived and worked by the sea.

15. w.1342 to AH 31 March 1896.

16. w.1358 to AH [18] January 1897; on conversion of Val St.-Nicholas see w.1367 to AH 6 February 1897.

17. Levine, 1971-1972, 38, suggests that they were the seed for the series.

18. When Pissarro visited Trouville in 1901, he found it "horrible;" see letter of 19 June 1901, Rewald, 1980, 346.

19. Taine, 1875.

20. See Raymond Bouyer, "L'Art et beauté aux Salons de 1898," *L'Artiste* (January-March 1898):158.

21. See O. Mirbeau, "Botticelli proteste!" in *Des Artistes*, vol. 1, Paris, 1922, 279-80. On the rise of Botticelli in particular see Greenspan, 1981, 215-18. On idealism being discussed in non-art books see e.g. Victor Charbonnel, *Les Mystiques dans la littérature présente*, Paris, 1897, 77 in which Charbonnel hails those "great and true artists [who] by the incontestable superiority of their talent . . . reaffirm this reemergence of idealism which has so rapidly and so powerfully transformed our art in the last few years;" quoted in Greenspan, 1981, 175. Also see Mellerio, 1896.

22. Spuller as quoted in Jean Mayeur, *Les Débuts de la Troisième République, 1871-1898*, Paris, 1973, 212 and Silverman, 1983, 70-71. The term "l'esprit nouveau" originated with Edgar Quinet's highly influential book of the same title which appeared in 1874 and went through numerous editions in the years thereafter. The appropriation of the term in the 1890s – and subsequently in 1921 with Le Corbusier's magazine – is significant, as it underscores the continuity of essential concerns about the nation when she faced both internal and international challenges. It also suggests the profundity of the Franco-Prussian legacy.

23. See Taine, 1875, 145. "We are warranted in saying that at this epoch [17th-century] France was the educator of Europe; she was the source from which was derived all that was elegant and agreeable, whatever was proper in style, delicate in ideas, and perfect in the art of social intercourse. If a savage Muscovite, a dull German, a stolid Englishman, or any other uncivilized or half-civilized man of the North quit his brandy, pipe, and furs, his feudal, hunting, or rural life, it was to French salons and to French books he betook himself in order to acquire the arts of politeness, urbanity, and conversation."

24. Charles Maurras, "Barbares et Romans," *La Plume* (July 1891), reprinted in *Revue Encyclopédique*, 26 December

1896, quoted and translated in Raymond, 1940, 55, and Greenspan, 1981, 324. On Moreas's denunciation see Raymond, 1940, 46. On the role of *La Plume* in all of this see W. Kenneth Cornell, "*La Plume* and Poetry in the 1890s," *Yale Romantic Review*, vol.18 (1941):34ff.

25. Ernest Raymaud, "L'Ecole romain française," *Mercure de France* (May 1895):144.

26. This became particularly apparent from 1895 onward following the conviction of Captain Alfred Dreyfus. Compare the observations of the journalist from the *Mercure de France*, for example, to the following description from *Le Figaro* of the military parade held in January 1895 as part of Dreyfus's rank-stripping ceremony. "The soldiers march briskly, and the spectacle is forever fixed in their eyes. For the idea of the Homeland is so fundamental and so elevated that . . . even . . . assaults against it drive it to excess of inspiration. Above the wreckage of so many beliefs, a single faith remains authentic and sincere: that which keeps us all in solidarity, that which safeguards our race, our language, the blood of our blood." *Le Figaro*, 6 January 1895, quoted and translated in Bredin, 1986, 7. The Dreyfus Affair is discussed in Chapter 9.

Notes for Chapter 8

1. Anna Bowman Dobb, *Up the Seine to the Battlefields*, New York, 1920, 1. Also see Brettell, "The Cradle of Impressionism," and Scott Schaefer, "Rivers, Roads, and Trains," in Los Angeles, 1984, 79-87 and 137-45.

2. On the rains in September and October see *Les Annales du bureau central météorologique de France* for 1896 as cited in W.III, 75, n.1357; on Monet's cries of frustration see e.g. w.1353 to DR 17 November 1896; the two *Mornings* that are dated 1896 are W.1435 and W.1436.

3. The consciousness with which Monet selected this motif was emphasized by several reviewers; see e.g. GG, 1898 (reprinted in *LVA*, vol. 6, 1900, 170-71) who declared "the choice of subject was always [the Impressionists'] keen and important preoccupation." Also see Fontainas, July 1898. The implications of these rare admissions are discussed later in this chapter. On Suzanne's illness see w.1353 to DR 17 November 1896.

4. There are many other subtleties to be appreciated in this series. The reflections of the foliage in the foreground, for example, rise just high enough to touch the reflections of the mounds of foliage on the distance; in many versions such as plate 84, the foliage in the foreground arches downward in such a way as to caress the edge of the first mound of trees on the left and then merge with the outline of the second in the middleground. In the version now in the White House (W.1485), those mounds alternate in color to create a rhythmic effect that appears to have as much to do with aesthetic criteria as with documenting the rising of the sun.

5. Perry, 1927, and Guillemot, 1898, both in Stuckey, 1985, 181-95, 195-201.

6. See House, 1986, 143.

7. Alexandre, 1898.

8. Stuckey, 1985, 196.

9. Comparisons can be made between many Monet and Corot paintings, the most often cited being Monet's *Bridge at Argenteuil* of 1875 and Corot's *Bridge at Mantes* of 1865. Monet made the connection between the Honfleur views himself; see Gimpel, 1963, entry for 28 November 1918, quoted in Stuckey, 1985, 307.

10. Corot always gave titles to his works specifying the sites they depicted. The *plein-air* painting he exhibited in the Salon was the *Port of La Rochelle* of 1851, now in the Yale University Art Gallery. The factory picture is *M. Henry's House and Factory* of 1833, now in the Philadelphia Museum of Art.

11. Bullet, 1895; also see Fierens-Gevaert, 1895. For a slightly later association between the two artists see Buisson, 1899.

12. Roger Marx, "Claude Lorrain," *Le Voltaire*, 7 June 1892, 1. On Corot's retrospective see Georges Lecomte, "Corot," *La Nouvelle Revue*, 94 (May-June 1895): 616-23; Louis de Foucaud, "Camille Corot," *Le Gaulois*, 24 May 1895; and L. Roger-Milès, *Album classique des chefs-d'oeuvre de Corot*, Paris, 1895.

13. On Pissarro's opinion of Corot see letters of 26 July 1893, 19 April 1895, and 19 August 1898, Rewald, 1980, 211-12, 266-67, 328-29.

14. R. Koechlin, "Claude Monet," *Art et Décoration* (February 1927):47. Three years later, Monet told Thiébault-Sisson that Corot had been an excellent model and that he had followed the older artist's example when he began his career as a painter; see Thiébault-Sisson, 1900. In the 1920s he categorically declared that Corot was "the greatest landscapist;" see Gimpel, 1963, entry for 11 October 1920, quoted in Stuckey, 1985, 309. So enthused was Monet with the older artist that he bought one of Corot's paintings from the Doria Sale in 1899 and would have purchased a second if it had not exceeded his limit of 7,000 francs. The Corot that he acquired was no. 66 in the sale, no. 159 in Robaut. For Monet's interest in these works see w.1463 to GP 3 May 1897. In keeping with his contradictory personality, however, Monet condemned Corot in 1920 for not having helped the Impressionists with Salon juries; see Gimpel, 1963, entry for 11 October 1920, quoted in Stuckey, 1985, 309. My thanks to Susan Earle for her seminar paper on Monet and Corot.

15. Pissarro letter of 23 March 1898, Rewald, 1980, 323.

16. Mery, 1898.

17. On Gérôme's remark see *Le Journal des Artistes*, 8 April 1894, quoted in Jeanne Laurent, *Arts et pouvoirs en France de 1793 à 1981*, St.-Etienne, 1982, 89-90, and in Varnadoe, 1987, 198 and 209, n.1. On the Caillebotte bequest see Berhaut and Vaisse, 1983 and Varnadoe, 1987, 197-204. Monet was the voice of conscience in Renoir's negotiations with the government, steadfastly urging his friend (who was the ex-

ecutor of Caillebotte's estate) to accept nothing less than what the will stipulated. See Monet letter to Renoir 22 April 1894, in Berhaut and Vaisse, 1983, Appendix X: "Il faut obtenir de l'Administration des Beaux-Arts qu'aucun des tableaux donnés par Gustave ne soient relégués dans des greniers ou envoyés en province." Quoted in Varnadoe, 1987, 210 n. 16.

18. On the Luxembourg's collection, policies, and limitations see Geneviève Lacambre, "Introduction," *Le Musée du Luxembourg en 1874*, exh. cat., Paris, 1974; Anon., "Le Luxembourg: ce qui sera le successeur de M. Argo," *L'Eclair*, 20 May 1892; and Varnadoe, as in note 17.

19. Berhaut and Vaisse, 1983, Appendix XXVI; on the letter from the members of the Academy and the Institute see Berhaut and Vaisse, 1983, Appendix XXIII and XXIV; on the ministerial decree accepting the bequest see Berhaut and Vaisse, 1983, Appendix XXI I.

Notes for Chapter 9

1. *Le Figaro*, 6 January 1895, as quoted in Bredin, 1986, 7. For the association of Dreyfus and Judas, see "Le Traître," *Le Rire*, 5 January 1895. The best recent book on the Dreyfus Affair is Bredin's magisterial work of 1986. Also see Kleebatt, 1988; Patrice Boussel, *L'Affaire Dreyfus et la presse*, Paris, 1960; and John Grand-Carteret, *L'Affaire Dreyfus et l'image*, Paris, n.d.

2. w.1397 to Zola 3 December 1897.

3. w.1399 to Zola 14 January 1898.

4. w.1402 to Zola 24 February 1898. On the letter to Geffroy see w.1401 to GG 15 February 1898. He expressed his concern in two other letters to Geffroy, w.1403 25 February 1898 and one dated 14 February 1898 that is in the Stanford University Art Museum and was previously unknown to Wildenstein. My thanks to JoAnne Culler Paradise for bringing this letter to my attention.

5. w.1404 to unknown solicitor 3 March 1898.

6. Bredin, 1986, 303.

7. On Cavaignac's speech and the division in the government see, Ibid., 309-10 and 303-06.

8. Ibid., 323.

9. Ibid., 350-53. On the reactivation of "patriotic" groups see Ibid., 1986, 348-49.

10. Ibid., 290, 309.

11. Pissarro letters of 19 November and 10 February 1898, Rewald, 1980, 332 and 321-22.

12. Ibid, 332.

13. For reference to the fifty see w.1522 to AH 4 March 1900; for claims about working in London prior to 1899 see w.1126 to DR 25 December 1891; w.1130 to Mirbeau 14 January 1892; and Geffroy, 1891. Monet had expressed interest in working in London as early as 1880; see w.203 to Duret 9 December 1880. For his visits in 1891 and 1898 see w.1126;

w.1129 to Whistler 3 January 1891; and w.1114 and w.1115 to DR 10 and 14 November 1898. For the most recent and most extensive discussion of Monet's *London* series see Seiberling, 1988. Also see House, 1980, and London, Arts Council, 1973.

14. Gimpel, 1963, 88, 156.

15. Thiébault-Sisson, July 1927, 48, quoted in Stuckey, 1985, 290-91.

16. On his high opinion of the English see w.421 and w.466 to AH 17 February and 29 March 1884. The portrait is W.886. On Monet's horror of the Germans see w.434, w.435, w.454, w.471 (with reference to "crude and stupid") all to AH 29 February, 1 and 22 March, and 3 April 1884. On his disapproval of the Boer War see w.1517 to AH 24 February 1900; and on his apparent bad memories of London in 1870 see w.1530 to AH 16 March [1900].

17. w.417 and w.418 to AH 13 and 14 February 1884.

18. w.1592 to AH 2 February 1901; on the visit to the Tower see w.1533 to AH 19 March 1900.

19. w.1528 to AH 11 March 1900. Some of these dinners were with quite prominent figures: the Asquiths (w.1519), the Sainsburys (w.1519), the Director of the British Museum (w.1509), Henry James and the Secretary of War (w.1525), George Moore (w.1527, w.1539, w.1541), and various painters and poets.

20. w.1503 to AH 10 February 1900. On Monet's English suits and eating habits see Joyes, 1975, 23 and 31.

21. w.1504 to AH 11 February 1900.

22. w.1693 to DR 10 May 1903, quoted in Seiberling, 1988, 87.

23. w.1522 to AH 4 March 1900; on number of canvases see e.g. w.1533 and w.1593 to AH 19 March 1900 and 3 February 1901.

24. Pissarro letter of 10 February 1898, Rewald, 1980, 321-22.

25. w.418 to AH 14 February 1884. "There is not an English person who doesn't do it, and here you cannot take a step without seeing the young and old working away in every corner."

26. The two Turners were *Sun rising through the vapor*, exhibited 1807 (Butlin no. 69) and *Dido building Carthage*, exhibited 1815 (Butlin no. 131). On the bequest see Martin Butlin and Evelyn Joll, *The Paintings of J.M.W.Turner*, revised edition, London, 1984, xxii, 54, 96.

27. On Monet's friendship with Whistler see e.g. *From Realism to Symbolism: Whistler and his world*, New York, 1971, 104-05 and various Monet letters such as w.794 to Duret 13 August 1887. On Whistler's importance to the London campaign see Seiberling, 1988, 36-37, 44-45 and House, 1986, 222. On Monet's description of the London fog see Gimpel, 1963, 88, 156 quoted in House, 1986, 222.

28. w.1019 and w.1125 to Whistler 1 December 1890 and 4 December 1891.

29. Edmond and Jules de Goncourt, *Journal*, vol. 16, Monaco, 1956, 207.

30. Pissarro letter of 6 September 1898, Rewald, 1980, 130-32.

31. See Theodore Butler, Diary, September 1892, quoted in John Gage, *Turner*, *Rain*, *Steam and Speed*, New York, 1972, 75 and in Seiberling, 1988, 42. See Gage for a further discussion of Impressionism and Turner.

32. Butler as in note 31.

33. Gustave Kahn, "L'Exposition Claude Monet," *Gazette des Beaux-Arts*, ser.3, vol. 32 (July 1904):82-88; Le Masque Rouge, "Notes d'Art: Exposition Claude Monet," *L'Action*, 12 May 1904; and Marc Joel, "À travers les expositions," *La Petite Loire*, 7 June 1904.

34. w.1748 and w. 1751 to DR 5 and 8 December 1904.

35. w.1768 to DR 8 March 1905. Monet had been keen to learn about the critical reaction to the show and had even written Lucien Pissarro for information; see w.1758 and w.1760 of 16 and 31 January 1905. Monet would finalize his triumph over the past by going to Venice in 1908, a city that every major landscape painter had to conquer. As with the *London* series, however, all of the paintings that Monet did of that magical city were finished in his studio.

Notes for Chapter 10

1. Guillemot, 1898. Monet himself claimed that flowers got him into the business of painting. See Joyes, 1975, 37.

2. On Monet's flower garden see Joyes, 1975, 33-35, 37-38; J.-P. Hoschedé, *Claude Monet si mal connu*, vol. 1, Paris, 1960, 57-70; and Varnadoe, 1978. Also see Arsène Alexandre, "Le Jardin de Monet," *Le Figaro*, 9 August 1901.

3. On the objections of Giverny residents see w.1219 to the Prefect of the Eure 17 July 1893. On the development of the water garden see Gordon, 1973 and W.III, 50. For Monet's initial request see w.1191 to the Prefect of the Eure 17 March 1893.

4. Juliet Manet recalled seeing the bridge completed in October; see J. Manet, *Journal (1893-1898)*, Paris, 1979, 23 and W.III, 50; on Monet's letter to the prefect see w.1219, as in note 3; on his solicitation of the Rouen journalist see w.1195 to AH [21 March 1893]; on Monet's reaction to the Giverny opposition see w.1193 to AH 20 March 1893.

5. Joyes, 1975, 37. Joyes is also the source for all plant identifications.

6. Although the trees and bushes would have taken some time to mature, the water lilies would not have. They actually have to be replanted every year. Monet, therefore, could have made the pond more resplendent if he had chosen.

7. Bouyer, under the pseudonym of L'Angèle, 1899; Lecomte, 1898.

8. W. IV, 23. In 1899 he made 227,400FF and in 1898, 173,500FF; see W.IV, 10.

9. Maurice Kahn, "Le Jardin de Claude Monet," *Le Temps*, 7 June 1904, quoted in Stuckey, 1985, 244. Monet was conscious of the potential blight he was bringing to the landscape when he was building his third studio; see w.2155 to his stepson Jean-Pierre Hoschedé 19 August 1915.

10. Calonne, 1900; D.G., 1900, preferred Monet's earlier work.

11. Leclercq, 1900 and 1899. Other positive reviews include those by Aubry; Bretonne; Darges; Dourliac; Geffroy; H.P.; Haber; Hoffman; Morot; Mortier; Quolobet; and Rais, 1900.

12. w.1491, w.1496, and w.1522 to Roger Marx 9 and 22 January and 21 April 1900, and w.2633, w.1492, w.1493, w.1495, w.1497, and w.1553 to DR 4, 15, 16, 22, 23 January and 22 April 1900. All of this also brought out his prejudices; see w.1510 to DR 17 February 1900.

13. Roger-Milès, 1898 and Pierrelée, 1900. In addition to Monet's 14 paintings, Manet was represented by 13, Renoir 11, Sisley 8, and Pissarro 7. In the illustrated version of the catalogue, 3 of Manet's works were reproduced, which was as many as artists, such as David and Puvis. Two of Monet's were illustrated which was as many as Baron Gros, Delacroix, and Millet. On the exhibition see *Catalogue Officiel illustré de L'Exposition Centennale de l'art français de 1800 à 1889*, Paris, 1900 and *Catalogue général officiel, oeuvres d'art centennale de l'art français, 1800-1889*, Paris, 1900; on Pissarro's opinion of the show as a monstrosity see letter of 16 March 1900, Rewald, 1980, 340; on his change of view see letter of 21 April 1900, Rewald, 1980, 340.

14. Sizeranne, 1900; A.Pallier, "XXX," *La Liberté*, 8 June 1898. Armand Silvestre even declared that the Impressionists had affected "their worst enemies" at the Salon des Champs-Elysées who were finally "condescending not to disdain all of their methods." See Armand Silvestre, "Notes d'art. Plein air," *La Petite Gironde*, 3 February 1899. Louis de Fourcaud asserted in 1900 that if Monet and Manet, "the two masters of Impressionism," were written out of the history of French art, "aestheticians would no longer understand anything about the transformation of French color at the close of the 19th century." See Fourcaud, 1900.

15. Marx, 1900; and Mellerio, 1900 on the call for an independent show of Impressionism.

16. Rewald, 1980, 391, note z; also see Pissarro letter of 8 May 1903, Rewald, 1980, 355-56.

17. Pissarro letter of 26 April 1900, Rewald, 1980, 340-41.

18. Saunier, 1900.

Selected Bibliography

Histories of the Period

Agulhon, Maurice. *Marianne into Combat*. New York: Cambridge University Press, 1980.

Anderson, Robert D. *France, 1870-1914: Politics and Society*. London: Routledge & Kegan Paul, 1977.

Billy, André. *L'Époque 1900: 1885-1905*. Paris: Jules Tallandier, 1951.

Bredin, Jean-Denis. *The Affair: The Case of Alfred Dreyfus*. New York: George Braziller, 1986.

Carr, Reg. *Anarchism in France: The Case of Octave Mirbeau*. Manchester: Manchester University Press, 1977.

Chastenet, Jacques. *Histoire de la Troisième République, II: Triomphes et Malaises*. Paris: Librairie Hachette, 1962.

Cobban, Alfred. *A History of Modern France*. Vol III: 1871-1962. London: Penguin, 1965.

Coubertin, Pierre de. "L'Évolution française sous la troisième république." *La Nouvelle Revue*, 98 & 99 (January-February and March-April 1896): 707-30 and 52-69, 265-84.

Digeon, Claude. *La Crise allemande de la pensée française, 1870-1914*. Paris: Presses Universitaires de France, 1959.

Ducatel, Paul. *La Belle Époque, 1890-1910, vue à travers l'imagerie populaire et la presse satirique*. Paris: Jean Grassin, 1973.

Fouillée, André. *Le Mouvement idéaliste et la réaction contre la science positive*. Paris: Alcan, 1896.

Girardet, Raoul. *Le Nationalisme français 1871-1914*. Paris: Armand Colin, 1966.

Hanotaux, George. *Histoire de la France contemporaine (1871-1900)*. Paris: Combet, 1908.

Harriss, Joseph. *The Tallest Tower: Eiffel and the Belle Époque*. Boston: Houghton Mifflin Company, 1975.

Hughes, Stuart. *Consciousness and Society: The Reorientation of European Social Thought, 1890-1930*. New York: Vintage Books, 1958.

Kern, Stephen. *The Culture of Time and Space: 1880-1918*. Cambridge: Harvard University Press, 1983.

Kleeblatt, Norman L. (ed.). *The Dreyfus Affair: Art, Truth, and Justice*. Berkeley: University of California Press, 1988.

Mayeur, Jean-Marie and Madeleine Reberious. *The Third Republic from its Origins to the Great War, 1871-1914*. Cambridge: Cambridge University Press, 1984.

McManners, John. *Church and State in France, 1870-1914*. New York: Harper & Row, 1972.

Merriman, John (ed.). *Consciousness and Class Experience in Nineteenth-Century Europe*. New York: Holmes and Meier, 1980.

Mitchell, Alan. *The German Influence in France after 1870.* Chapel Hill: University of North Carolina Press, 1979.

Nelms, Brenda. *The Third Republic and the Centennial of 1789*. New York: Garland Publishing, 1987.

Olivie, Eugène. *Dialogues des vivantes*. Paris: Bibliothèque Charpentier, 1892.

Rearick, Charles. *Pleasures of the Belle Époque: Entertainment and Festivity in Turn of the Century France*. New Haven: Yale University Press, 1985.

Roche, Jules. *Allemagne et France*. Paris: Flammarion, 1898.

Rommel, Dr. *Au Pays de la Revanche*. Genève: Librairie Stapelmohr, 1886.

Routhier, Gaston. *Grandeur et décadence des français*. 4th ed. Paris: Arthur Savaete, [ca. 1898].

Rudorff, Raymond. *Belle Époque: Paris in the Nineties*. London: Hamish Hamilton, 1972.

Sedgwick, Alexander. *The Ralliement in French Politics, 1890-1898*. Cambridge: Harvard University Press, 1965.

—. *The Third French Republic, 1870-1914*. New York: Thomas Cromwell and Company, 1968.

Shapiro, David. "The Ralliement in the Politics of the 1890s," in David Shapiro (ed.), *The Right in France, 1890-1919*. London: Chatto & Windus, 1962.

Shattuck, Roger. *The Banquet Years: The Origins of the Avant-Garde in France 1885 to World War I*. London: Jonathan Cape, revised edition, 1969.

Siegel, Jerrold. *Bohemian Paris: Culture, Politics, and the Boundaries of Bourgeois Life, 1830-1930*. New York: Viking Penguin, 1986.

Silverman, Deborah. "Nature, Nobility, and Neurology: Origins of Art Nouveau in France, 1889-1900." Ph.D. dissertation, Princeton University, 1983, forthcoming as a book.

—. "The Paris Exhibition of 1889: Architecture and the Crisis of Bourgeois Individualism." *Oppositions*, vol. 8 (Spring 1977): 72-92.

Sonn, Richard David. "French Anarchism as Cultural Politics in the 1890's." Ph.D. Dissertation, University of California, Berkeley, 1981.

Swart, Koenraad W. *The Sense of Decadence in Nineteenth-Century France*. The Hague: M. Nijhoff, 1964.

Weber, Eugen. *France, fin de siècle*. Cambridge: Belknap Press, 1986.

Williams, Rosalind A. *Dream Worlds: Mass Consumption in Late Nineteenth-Century France*. Berkeley: University of California Press, 1982.

Wright, Gordon. *France in Modern Times: 1760 to the Present*. Chicago: Rand McNally, 1960.

Zeldon, Theodore. *France, 1848-1945*. 2 vols. Oxford: The Clarendon Press, 1973.

Monet and Impressionist Studies

Aiken, Geneviève and Marianne Delafond. *La Collection d'estampes japonaises de Claude Monet à Giverny*. Paris: La Bibliothèque des Arts, 1983.

Amsterdam, Rijksmuseum Vincent Van Gogh. *Monet in Holland*. Exh. cat. Zwolle: Waander, 1986.

Bailly-Herzberg, Janine (ed.). *Correspondance de Camille Pissarro*. vol. 1, 1865-1885, Paris: Presses Universitaires de France, 1980; vol. 2, 1886-1890, and vol. 3, 1891-1894, Paris: Éditions du Valhermeil, 1986 and 1988.

Berger, Klaus. "Monet's Crisis." *Register of the Museum of Art*, University of Kansas, vol. 2, nos. 9-10 (May 1963): 17-21.

Berhaut, Marie. "Le Legs Caillebotte: Vérités et contre-vérités." *Bulletin de la Société de l'Histoire de l'Art français*, (1983): 209-23.

— and Pierre Vaisse. "Le Legs Caillebotte; Annexe: documents." *Bulletin de la Société de l'Histoire de l'Art français* (1983): 223-39.

Brettell, Richard, R. "Monet's Haystacks Reconsidered." *The Art Institute of Chicago Museum Studies*, vol. 11, no. 1 (Fall 1984): 4-21.

Chicago, The Art Institute of Chicago. *Paintings by Monet*. Exh. cat. Chicago: The Art Institute of Chicago, 1975.

Clark, T.J. *The Painting of Modern Life: Paris in the Art of Manet and His Followers*. New York: Knopf, 1985.

Delouche, Denise. "Monet et Belle-Île en 1886." *Bulletin des Amis du Musée de Rennes*, no. 4 (1980): 27-55.

Dunn, Roger Terry. *The Monet-Rodin Exhibition at the Galerie Georges Petit in 1889*. New York: Garland Publishing, 1979.

Elderfield, John. "Monet's Series." *Art International*, vol. 18, no. 9 (15 November 1974): 28, 45-46.

Evett, Elisa. *The Critical Reception of Japanese Art in Europe in the Late Nineteenth Century*. Ann Arbor: UMI Research Press, 1982.

Flint, Kate (ed.). *Impressionists in England: The Critical Reception*. London: Routledge & Kegan Paul, 1984.

Floyd, Phyllis Anne. *Japonisme in Context: Documentation, Criticism, Aesthetic Reactions*. 3 vols. Ann Arbor: UMI Research Press, 1986.

Geffroy, Gustave. *Claude Monet: sa vie, son temps, son oeuvre*. 2 vols. Paris: G.Crès & Cie., 1924.

—. *La Vie artistique*. 8 vols. Paris: E. Dentu (1-4) and H. Floury (5-8), 1892-1903.

Goldwater, Robert. "Symbolic Form: Symbolic Content," in *The Reaction against Impressionism in the 1880s: Its Nature and Causes*, in *Problems of the 19th and 20th Centuries*, Acts of the 20th International Congress of the History of Art, IV. Princeton: Princeton University Press, 1963, 111-21.

Gordon Robert. "The lily pond at Giverny: the changing inspiration of Monet." *The Connoisseur*, vol. 184, no. 741 (November 1973): 154-65.

— and Andrew Forge. *Monet*. New York: Abrams, 1983.

— and Charles F. Stuckey. "Blossoms and Blunders. Monet and the State." *Art in America*, vol. 67, no. 1 (January-February 1979): 102-17.

Halperin, Joan U. (ed.). *Félix Fénéon: Oeuvres plus que complètes*. 2 vols. Geneva: Librairie Droz, 1970.

—. "Jamais qu'unique: Paradoxes in a Critic's View of Monet," in Mechthild Cranston (ed.), *Le Gai Savoir: Essays in Linguistics, Philology, and Criticism*. Potomac, Maryland: Studia Humanitatis, 1983.

Hamilton, George Heard. *Claude Monet's Paintings of Rouen Cathedral*. Charleton Lecture, 1959. London: Oxford University Press, 1960.

Herbert, Robert L. *Impressionism. Art, Leisure, and Parisian Society*. London: Yale University Press, 1988.

—. "The Decorative and the Natural in Monet's Cathedrals," in Rewald and Weitzenhoffer, 1984, 160-79.

—. "Impressionism, Originality, and Laissez-Faire." *Radical History Review*, vol. 38 (Spring 1987): 7-15.

—. "Industry and the Changing Landscape from Daubigny to Monet," in J.M. Merriman (ed.), *French Cities in the Nineteenth Century*. London: Yale University Press, 1982.

—. "Method and Meaning in Monet." *Art in America*, vol. 67, no. 5 (September 1979): 90-108.

Hoog, Michel. *Les Nymphéas de Claude Monet au Musée de l'Orangerie*. Paris: Éditions de la Réunion des musées nationaux, 1987.

House, John. *Monet: Nature into Art*. London: Yale University Press, 1986.

—. "The Impressionist Vision of London," in Ira Bruce Nadel and F.S. Schwarzbach (eds.), *Victorian Artists and the City*. New York: Pergamon Press, 1980.

—. "Monet in 1890," in Rewald and Weitzenhoffer, 1984, 124-39.

—. "The Origins of Monet's Series Paintings," in *Claude Monet, Painter of Light*. Exh. cat. Auckland: Auckland City Art Gallery, 1985.

Huth, Hans. "Impressionism Comes to America." *Gazette des Beaux-Arts*, ser. 6, vol. 29 (April 1946): 225-52.

Isaacson, Joel. *Claude Monet: Observation and Reflection*. Oxford: Phaidon, 1978.

—. *The Crisis of Impressionism: 1878-1882*. Exh. cat. Ann Arbor: The University of Michigan Museum of Art, 1980.

—. "Monet's Views of the Thames." *Bulletin of the Art Association of Indianapolis*, vol. 52, no. 3 (1965): 44-51.

Johnson, Deborah Jean. *The Impact of East Asian Art Within the Early Impressionst Circle, 1856-1868*. Ann Arbor: UMI Research Press, 1986.

Joyes, Claire et al. *Monet at Giverny*. London: Mathews, Miller & Dunbar, 1975.

Levine, Steven Z. *Monet and His Critics*. New York: Garland Publishing, 1976.

—. "Décor/Decorative/Decoration in Claude Monet's Art." *Arts Magazine*, vol. 51, no. 6 (February 1977): 136-39.

—. "Instant of Criticism and Monet's Critical Instant." *Arts Magazine*, vol. 55, no. 7 (March 1981): 114-21.

—. "Monet, Fantasy, and Freud," in Mary Mathews Gedo (ed.), *Psychoanalytic Perspectives on Art*, vol. 1. no. 1. Hillsdale, N.J.: The Analytic Press, 1985, 29-55.

—. "Monet, Lumière and Cinematic Time." *The Journal of Aesthetics and Art Criticism*, vol. 36, no. 4 (Summer 1978): 441-47.

—. "Monet's 'Cabane du Douanier'." *Fogg Art Museum Annual Report (1971-1972)*. Cambridge: Harvard University, 32-44.

—. "Monet's Pairs." *Arts Magazine*, vol. 49, no. 10 (June 1975): 72-75.

—. "Monet's Series: Repetition, Obsession." *October*, vol. 37 (Summer 1986): 65-75.

London, Arts Council of Great Britain. *Claude Monet*. Exh. cat. London: Tate Gallery, 1957.

—. *The Impressionists in London*. Exh. cat. London: Arts Council of Great Britain, 1973.

London, Royal Academy of Arts. *Post-Impressionism: Cross Currents in European Painting*. Exh. cat. New York: Harper and Row, 1979.

Los Angeles, Los Angeles County Museum of Art. *A Day in the Country: Impressionism and the French Landscape*. Exh. cat. Los Angeles: The Los Angeles County Museum of Art, 1984.

Melot, Michel. "Camille Pissarro in 1880: an anarchistic artist in bourgeois society." *Marxist Perspectives*, vol. 2 (Winter 1979-80): 22-54.

Moffett, Charles S. "Monet's Haystacks," in Rewald and Weitzenhoffer, 1984, 140-59.

Monneret, Sophie. *L'Impressionnisme et son époque*. 4 vols. Paris: Denoël, 1978-81.

New York, Metropolitan Museum of Art. *Monet's Years at Giverny*. Exh. cat. New York: Metropolitan Museum of Art, 1979.

Nochlin, Linda. *Realism*. Harmondsworth: Penguin Books, 1971.

—. (ed.). *Impressionism and Post-Impressionism. Sources and Documents*. Englewood Cliffs: Prentice Hall, 1966.

Paradise, JoAnne Culler. *Gustave Geffroy and the Criticism of Painting*. New York: Garland Publishing, 1985.

—. "Three Letters from Claude Monet to Gustave Geffroy." *The Sanford Museum Bulletin*, vols. 12-13 (1982-83):3-12.

Paris, Centre Culturel du Marais. *Claude Monet au temps de Giverny*. Exh. cat. Paris: Centre Culturel du Marais, 1983.

Paris, Grand Palais. *Hommage à Monet*. Exh. cat. Paris: Éditions de la Réunion des musées nationaux, 1980.

—. *Le Japonisme*. Exh. cat. Paris: Éditions de la Réunion des musées nationaux, 1988.

Rewald, John. *The History of Impressionism*. 4th revised edition. New York: The Museum of Modern Art, 1973.

—. *Post-Impressionism. From Van Gogh to Gauguin*. 3rd revised edition. New York: The Museum of Modern Art, 1978.

—. (ed.). *Camille Pissarro. Letters to his son Lucien*. 4th edition. London: Routledge & Kegan Paul, 1980.

—. and R. Weitzenhoffer (eds.). *Aspects of Monet: A Symposium on the Artist's Life and Times*. New York: Abrams, 1984.

San Francisco, The Fine Arts Museums of San Francisco. *The New Painting: Impressionism 1874-1886*. Exh. cat. San Francisco: The Fine Arts Museums of San Francisco, 1986.

Seiberling, Grace. *Monet in London*. Exh. cat. Atlanta: High Museum, 1988.

—. "Monet's 'Les Roches à Pourville, marée basse'." *Porticus: The Journal of the Memorial Art Gallery of the University of Rochester*, vol. 3 (1980): 40-48.

—. *Monet's Series*. New York: Garland Publishing, 1981.

Seitz, William C. *Claude Monet*. New York: Abrams, 1960.

—. *Claude Monet. Seasons and Moments*. New York: Museum of Modern Art, 1960.

Shattuck, Roger. "Approaching the Abyss: Monet's Era." *Artforum*, vol. 20, no. 7 (March 1982): 35-42.

Shiff, Richard. *Cézanne and the End of Impressionism*. Chicago: University of Chicago Press, 1984.

—. "The End of Impressionism: A Study in Theories of Artistic Expressionism." *The Art Quarterly* (new series), vol. I, no. 4 (Autumn 1978): 338-78, revised in San Francisco, 1986.

Stuckey, Charles F. "Blossoms and Blunders: Monet and the State. II." *Art in America*, vol. 67, no. 5 (September 1979): 109-25

—. (ed.). *Monet: A Retrospective*. New York: Hugh Lauter Levin Associates, Inc., 1985.

Tucker, Paul Hayes. *Monet at Argenteuil*. London: Yale University Press, 1982.

—. "The First Impressionist Exhibition and Monet's 'Impression: Sunrise': A Tale of Timing, Commerce, and Patriotism." *Art History*, vol. 7, no.4 (December 1984): 465-76

—. "The First Impressionist Exhibition in Context," in *The New Painting: Impressionism 1874-1886*. Exh. cat. San Francisco: The Fine Arts Museums of San Francisco, 1986, 92-117.

Vaisse, Pierre. "Le Legs Caillebotte d'après les documents." *Bulletin de la Société de l'Histoire de l'Art français* (1983): 201-08.

Varnadoe, Kirk. *Gustave Caillebotte*. London: Yale University Press, 1987.

—. "In Monet's Gardens." *The New York Times Magazine*, 2 April 1978, 30-41.

Venturi, Lionello. *Les Archives de l'impressionnisme*. 2 vols. Paris: Durand-Ruel, 1939.

Webster, James Carsten. "The Technique of Impressionism: a reappraisal." *College Art Journal*, vol. 4, no. 1 (November 1944): 2-33.

Wildenstein, Daniel. *Claude Monet, biographie et catalogue raisonné*. 4 vols. Lausanne: La Bibliothèque des Arts 1974-1985.

Related Studies

Boyer, Patricia Eckert (ed.). *The Nabis and the Parisian Avant-garde*. New Brunswick: Rutgers University Press, 1988.

Burhan, Filiz Eda. "Vision and Visionaries: Nineteenth-Century Psychological Theory, the Occult Sciences, and the Formation of the Symbolist Aesthetic in France." Ph.D. dissertation, Princeton University, 1979.

Denis, Maurice. *Théories, 1890-1910, du Symbolisme et de Gauguin vers un nouvel ordre classique*. Paris: Bibliothèque de l'Occident, 1912.

Gimpel, René. *Journal d'un collectionneur, marchand du tableaux*. Paris: Calmann-Levy, 1963.

Goldwater, Robert. "Puvis de Chavannes: Some reasons for a reputation." *Art Bulletin*, vol. 28, no. 1 (1946): 32-43.

Greenspan, Taube G. " 'Les Nostalgiques' Re-examined: The Idyllic Landscape in France, 1890-1905." Ph.D. dissertation, City University of New York, 1981.

Herbert, Eugenia W. *The Artist and Social Reform: France and Belgium 1885-1895*. New Haven: Yale University Press, 1961.

Lehmann, A.G. *The Symbolist Aesthetic in France, 1885-1895*. Oxford: Basil Blackwell, 1968.

Lethève, Jacques. *Impressionnistes et symbolistes devant la presse*. Paris: Armand Colin, 1959.

Levin, Miriam R. *Republican Art and Ideology in Late Nineteenth-Century France*. Ann Arbor: UMI Research Press, 1986.

Loevgren, Sven. *The Genesis of Modernism*. Bloomington: Indiana University Press, 1971.

Mauner, George L. *The Nabis: Their History and Their Art, 1888-1896*. New York: Garland Publishing, 1978.

Paris, Musée de Petit Palais. *Le Triomphe des mairies. Grands décors républicains à Paris, 1870-1914*. Exh. cat. Paris: Éditions Paris Musées, 1986.

Pincus-Witten, Robert. *Occult Symbolism in France: Joséphin Peladan and the Salons de la Rose + Croix*. New York: Garland Publishing, 1976.

Raymond, Marcel. *De Baudelaire au surréalisme*. Paris: Librairie José Corti, 1940.

Rey, Robert. *La Peinture française à la fin du XIXe siècle: la renaissance du sentiment classique*. Paris: G. van Oest, 1931.

Roger-Marx, Claude. "Le Commerce des tableaux sous l'impressionnisme et à la fin du XIXe siècle." *Médecine de France*, vol. 95 (1958): 17-32.

Vaisse, Pierre. "La Troisième République et les peintres: recherches sur les rapports de pouvoirs publics et de la peinture en France de 1870 à 1914." Thèse de doctorat d'État, Université de Paris IV, 1980.

Wallis, Anne Armstrong. "The Symbolist Painters of 1890." *Marsyas*, vol. 1, no. 1(1941): 117-52.

White, Harrison C. and Cynthia A. *Canvases and Careers: Institutional Change in the French Painting World*. New York: John Wiley and Sons, 1965.

Critical Studies from the Period

Books

Barlet, F. Charles and J. Lejay. *L'Art de demain*. Paris: Chamuel, 1897.

Bazalgette, Léon. *L'Esprit nouveau dans la vie artistique, sociale et religieuse*. Paris: Société d'éditions littéraires, 1898.

Bouyer, Raymond. *French Art: Classic and Contemporary Painting and Sculpture*. New York: C. Scribner's Sons, 1892.

—. *Le Paysage dans l'art*. Paris: L'Artiste, Revue de Paris, 1894.

Byvanck, W.G.C. *Un Hollandais à Paris en 1891: Sensations de littérature et d'art*. Paris: Perrin, 1892.

Clemenceau, Georges. *Claude Monet: Les Nymphéas*. Paris: Librairie Plon, 1928, reprinted as *Claude Monet: Cinquante ans d'amitié*, Paris: Palatine, 1965.

Courajod, Louis. *Les Origines de l'art moderne*. Paris: E. Leroux, 1894.

Dewhurst, Wynford. *Impressionist Painting. Its Genesis and Development*. London: George Newnes, 1904.

Duret, Théodore. *Histoire des peintres impressionnistes*. Paris: H. Floury, 1906.

—. *Le Peintre Claude Monet*. Paris: La Vie moderne, G. Charpentier, éditeur, 1880.

Elder, Marc [Marc Tendron]. *Chez Claude Monet à Giverny.* Paris: Bernheim-Jeune, 1924.

Fels, Marthe de. *La Vie de Claude Monet.* Paris: Gallimard, 1929.

Fierens-Gevaert, Hippolyte. *Essai sur l'art contemporain.* Paris: Félix Alcan, 1897.

Fourcaud, M.L. de. *L'Évolution de la peinture en France au XIXe siècle.* Paris: Imprimerie nationale, 1890.

Fuller, William H. *Claude Monet.* New York: Gilliss Bros., 1891.

—. *Claude Monet and His Paintings.* New York: J.J. Little, 1899.

Germain, Alphonse. *Du Beau moral et du beau formel.* Paris: Edmond Girard, 1895.

—. *Notre art de France.* Paris: Edmond Girard, 1894.

—. *Pour le Beau. Essai de Kallistique.* Paris: Edmond Girard, 1893.

Hamerton, Philip Gilbert. *The Present State of the Fine Arts in France.* London: Seeley and Co., 1892.

Jourdain, Frantz. *Les Décorés, ceux qui ne le sont pas.* Paris: H. Simonis Empis, 1895.

Larroumet, Gustave. *L'Art et l'État en France.* Paris: Hachette, 1895.

Lecomte, Georges. *L'Art impressionniste d'après la collection privée de M. Durand-Ruel.* Paris: Chamerot et Renouard, 1892.

Mellerio, André. *L'Exposition de 1900 et l'impressionnisme.* Paris: H. Floury, 1900.

—. *Le Mouvement idéaliste en peinture.* Paris: H. Floury, 1896.

Mirbeau, Octave. *Des Artistes.* 2 vols. Paris: Flammarion, 1922.

Reymond, Marcel. *De l'influence néfaste de la Renaissance.* Paris: L'Artiste, 1890.

Robinson, Theodore. *Diary, 1892-1896.* Frick Art Reference Library, New York.

Sabbrin, Celen. *Science and Philosophy in Art.* Philadelphia: William F. Fell & Co., 1886.

Taine, Hippolyte. *Lectures on Art.* 2 vols. New York: Henry Holt & Co., 1875.

Zola, Émile. *Le bon combat de Courbet aux impressionnistes: anthologie d'écrits sur l'art,* Gaëton Picon and Jean-Paul Bouillon (eds.). Paris: Savoir/Hermann, 1974.

—. *Mon Salon, Manet, Écrits sur l'art.* Antoinette Ehrard (ed.). Paris, Garnier-Flammarion, 1970.

ARTICLES

Berthon, Paul. "La Décoration moderne." *L'Ermitage,* vol. 6 (February 1895): 65-73.

Bouyer, Raymond. "Sur le krach de l'art moderne." *L'Ermitage,* vol. 6 (August 1895): 78-86.

—. "Une évolution dans l'art du paysage." *L'Ermitage,* vol. 7 (May 1896): 298-302.

Bricon, Étienne. "L'art impressionniste au musée du Luxembourg." *La Nouvelle Revue,* no. 114 (15 September 1898): 288-304.

Bridgeman, F.A. "Enquête sur l'impressionnisme." *La Revue impressionniste* (Marseille-Paris), 1900.

Brunetière, Ferdinand. "La Critique impressionniste" (1891), in his *Essais sur la littérature contemporaine.* Paris: 1900, 1-30.

Dewhurst, Wynford. "Claude Monet – Impressionist: An Appreciation." *The Pall Mall Magazine,* vol. 6 (1900): 209-24.

Fitzgerald, Desmond. "Claude Monet: Master of Impressionism." *Brush and Pencil,* vol. 15 (March 1905): 181-95.

Geffroy, Gustave. "Histoire de l'impressionnisme," in *La Vie artistique,* vol. 3, Paris: E.Dentu, 1894.

—. "L'Impressionnisme." *Revue encyclopédique,* 15 December 1893.

Germain, Alphonse. "Contre le Japonisme." *L'Ermitage,* vol. 3 (July-December 1892): 24-28.

—. "Du Caractère de race dans l'art français." *L'Ermitage,* vol. 8 (February 1897): 4-12.

—. "La Décoration de l'intérieur." *L'Ermitage,* vol. 3 (15 February 1892): 65-68.

—. "Le Paysage décoratif." *L'Ermitage,* vol. 2 (November 1891): 641-45.

G.[ide], A.[ndré]. "Lettre à Angèle. Du Nationalisme artistique." *L'Ermitage,* vol. 10 (June 1899): 455-62.

Gsell, Paul. "La Tradition artistique française. I. L'Impressionnisme." *Revue bleue,* vol. 49, no. 13 (26 March 1892): 403-06.

Hamerton, P.G. "The Present State of the Fine Arts in France. IV. Impressionism." *The Portfolio* (1891): 67-74.

Lecomte, Georges. "Des Tendences de la peinture moderne." *L'Art moderne: Revue critique des arts et de la littérature* (Brussels), vol. 12 (21 February 1892): 58 ff.

—. "L'Art contemporain." *La Revue indépendante de Littérature et d'Art,* vol. 23, no. 66 (April 1892): 1-29.

Mauclair, Camille. "La Reform de l'art décoratif en France." *La Nouvelle Revue,* no. 98 (15 February 1896): 724-46.

Perry, Lilla Cabot. "Reminiscences of Claude Monet from 1889 to 1909." *The American Magazine of Art,* vol. 18, no. 3 (March 1927): 119-25.

Robinson, Theodore. "Claude Monet." *The Century Magazine,* vol. 44 (1892): 696-701.

Taboureux, Emile. "Claude Monet." *La Vie moderne,* 12 June 1880.

—. "Autour de Claude Monet, anecdotes et souvenirs." I and II, *Le Temps*, 29 December 1926 and 8 January 1927.

—. "Claude Monet." *Le Temps*, 6 April 1920.

Thiébault-Sisson, François. "Une histoire de l'impressionnisme." *Le Temps*, 17 April 1899.

—. "Un don de M. Claude Monet à l'État." *Le Temps*, 14 October 1920.

—. "Un nouveau musée parisien. Les Nymphéas de Claude Monet à l'Orangerie des Tuileries." *La Revue de l'art ancien et moderne*, vol. 52 (July 1927): 41-52.

Thorel, Jean. "Les Romantiques allemands et les Symbolistes français." *Entretiens Politiques et Littéraires* (July-December 1891): 95-109.

Trévise, Duc de. "Le Pèlerinage de Giverny." *La Revue de l'art ancien et moderne*, special edition, vol. 51 (January-February 1927): 42-50 and 121-34.

Waern, Cecilia. "Some notes on French Impressionism." *Atlantic Monthly*, vol. 69, no. 414 (April 1892): 535-41.

Critical Responses to Monet's Work

1889

Anon. "Concours & Expositions." *La Chronique des Arts et de la Curiosité* (6 July 1889): 197.

—. "L'Exposition Claude Monet et Auguste Rodin." *Le Matin*, 23 June 1889.

—. "XXX." *La Nouvelliste* (Rouen), 24 June 1889.

Alexandre, Arsène. "Claude Monet et Auguste Rodin." *Le Figaro*, 21 June 1889.

A[ntoine], J[ules]. "Beaux-Arts: Exposition de la Galerie Georges Petit." *Art et Critique*, 29 June 1889.

Bourgeat, Fernand. "Paris vivant: À la Galerie G. Petit." *Le Siècle*, 22 June 1889.

Bricon, Étienne. "Claude Monet et Rodin à la Galerie Georges Petit." *Le Constitutionnel*, June 1889.

Calonne, A. de. "L'Art contre nature." *Le Soleil* (supplément), 23 June 1889.

Cardon, Emile. "Exposition des oeuvres de MM. A. Rodin et Claude Monet." *Moniteur des Arts*, 31 (28 June 1889): 237-39.

Dalligny, A. "A. Rodin et Cl. Monet à la rue de Sèze." *Le Journal des Arts*, 5 July 1889.

Ernst, Alfred. "Claude Monet et Rodin." *La Paix*, 3 July 1889.

Fénéon, Félix. "Certains." *Art et Critique*, 14 December 1889.

—. "Exposition de M. Claude Monet." *La Vogue*, September 1889.

Foucher, Paul. "Libres chroniques." *Gil Blas*, 28 June 1889.

Fouquier, Marcel. "Petites Expositions: L'Exposition Claude Monet." *Le XIXe Siècle*, 6 March 1889.

—. "XXX." *La France*, 5 July 1889.

Frémine, Charles. "Claude Monet et Auguste Rodin." *Le Rappel*, 23 June 1889.

G., F. "XXX." *Journal de l'Oise*, 29 June 1889.

Gayda, J. "L'Exposition à la rue de Sèze, Monet et Rodin." *La Presse*, 25 June 1889.

Geffroy, Gustave. "Chronique: L'Exposition Monet-Rodin." *La Justice*, 21 June 1889.

—. "Chronique: Paysages et figures." *La Justice*, 26 February 1889.

Guillemot, Maurice. "Chronique: Notes d'art." *Le Parisien*, 25 June 1889.

Jourdain, F. "Claude Monet: Exposition du Boulevard Montmartre." *Revue indépendante de Littérature et d'Art*, NS 10 (March 1889): 513-18.

Le Fustec, J. "Au jour le jour: L'Exposition Monet-Rodin." *La République française*, 28 June 1889.

Le Roux, Hugues. "Silhouettes parisiennes: L'Exposition Claude Monet." *Gil Blas*, 3 March 1889.

Maus, Octave. "Claude Monet-Auguste Rodin." *L'Art moderne*, vol. 9 (7 July 1889): 209-11.

Mirbeau, Octave. "Claude Monet." *Le Figaro*, 10 March 1889.

—. *Exposition Claude Monet – Auguste Rodin: Galerie Georges Petit*. Paris: Imprimerie de l'Art, 1889.

—. "Exposition Monet-Rodin." *Gil Blas*, 22 June 1889.

Roger-Milès, Léon. "Beaux-Arts: Claude Monet." *L'Événement*, 15 March 1889, reprinted in *Le Gaulois* (supplément), 16 June 1898.

Santos, Raoul dos. "Chronique: Claude Monet et Auguste Rodin chez M. Georges Petit." *Le Journal des Artistes*, 30 June 1889.

Vezan, Aubry. "Exposition Claude Monet." *La Bataille*, 27 June 1889.

Violaine, Gustave de. "XXX." *Moniteur Universel*, 24 March 1889.

1891

Anon. "L'Exposition Claude Monet." *Le Journal des Artistes*, 10 May 1891.

—. "XXX." *Le Courrier de France*, 2 May 1891.

—. "XXX." *Le Petit Journal*, 8 May 1891.

Bouyer, Raymond. "Le Paysage contemporain: III. Claude Monet et le paysage impressionniste." *La Revue d'Histoire Contemporaine* (2 May 1891): 727-32.

Byvanck, W. G. C. "Une impression (Claude Monet)," in *Un Hollandais à Paris en 1891: Sensations de littérature et d'art*. Paris: Perrin, 1892.

Court, Jehan de. "Exposition Claude Monet." *Moniteur des Arts*, 34 (8 May 1891): 594.

Ernst, Alfred. "Exposition Claude Monet." *Le Siècle*, 8 May 1891.

Fénéon, Félix. "Oeuvres récentes de Claude Monet." *Le Chat Noir*, 16 May 1891.

Fouquier, Marcel. "L'Exposition Claude Monet: le triomphe d'un maître – la série des meules." *Le XIXe Siècle*, 7 May 1891.

Geffroy, Gustave. *Exposition d'oeuvres récentes de Claude Monet dans les galeries Durand-Ruel*. Paris: Imprimeur de l'Art, 1891.

—. "Exposition Claude Monet: Galerie Durand-Ruel." *L'Art dans les deux Mondes*, 10 May 1891.

Javel, Firmin. "L'Exposition Claude Monet." *Gil Blas*, 12 May 1891.

Le Passant. "Les On-dits." *Le Rappel*, 6 May 1891.

Louis, Désiré. "Claude Monet." *L'Événement*, 19 May 1891.

Marx, Roger. "Les Meules de M. Claude Monet." *Le Voltaire*, 7 May 1891, parts reprinted in *Le Journal des Artistes*, 10 May 1891, and in *Le Gaulois (supplément)*, 16 June 1898.

Mauclair, Camille. "L'Exposition Claude Monet: Durand-Ruel." *La Revue indépendante de Littérature et d'Art*, NS 19 (May 1891): 267-69.

Mirbeau, Octave. "Claude Monet." *L'Art dans les deux Mondes* (7 March 1891): 183-85.

P., H. "L'Exposition de Monet à l'Union League Club New York." *L'Art dans les deux Mondes* (28 February 1891): 173.

1892

Anon. "Chez les Peintres: Claude Monet – Albert Besnard." *Le Temps*, 1 March 1892.

—. "Choses d'art: Expositions: Chez Durand-Ruel: Exposition d'un série d'oeuvres de Claude Monet (peupliers des bords de l'Epte par divers effets de lumière)." *Mercure de France*, NS 4 (April 1892): 371.

—. "Exposition Claude Monet: Après les meules – le principe des variations – sur un thème unique." *L'Éclair*, 1 March 1892.

—. "Petite chronique." *L'Art moderne*, 24 January 1892.

Aurier, G.-Albert. "Claude Monet." *Mercure de France*, NS 4 (April 1892): 302-305.

C., D. "Notes d'Art: Galerie Georges Petit." *Le Matin*, 1 February 1892.

Cousturier, Edmond. "Les Maîtres impressionnistes." *L'Art moderne* (15 May 1892): 153-54.

F.[rémine], C.[harles]. "Les On-dits." *Le Rappel*, 2 March 1892.

Geffroy, Gustave. "Les peupliers [1892]." *La Vie artistique*, vol. 3 Paris: E. Dentu, 1894, 90-95.

Hennebault, C. d'. "Chose et autres." *Moniteur des Arts*, 36 (4 March 1892): 74.

Janin, Clément. "Chronique: Claude Monet." *L'Estafette*, 10 March 1892.

Javel, Firmin. "Claude Monet." *Gil Blas*, 2 March 1892.

Lecomte, Georges. "Beaux-Arts: Peupliers de M. Claude Monet." *Art et Critique* (5 March 1892): 124-25, partially reprinted in *Le Journal des Artistes*, 20 March 1892.

Louis, Désiré. "XXX." *La Justice*, 1 February 1892.

Mauclair, Camille. "Exposition Claude Monet: Durand-Ruel." *La Revue indépendante de Littérature et d'Art*, NS 23 (April 1892): 417-18.

Robinson, Theodore. "Claude Monet." *The Century Illustrated Magazine*, 44 (September 1892): 696-701.

Saunier, Charles. "L'Art impressionniste." *La Plume*, no. 79 (1 August 1892): 350.

Waern, Cecilia. "Some Notes on French Impressionism." *The Atlantic Monthly*, vol. 69, no. 144 (April 1892): 535-41.

1895

Anon. "Choses d'art: L'Exposition Claude Monet." *Le Voltaire*, 12 May 1895.

—. "Chronique locale: les Cathédrales de Claude Monet." *Journal de Rouen*, 11 May 1895.

—. "Claude Monet: Chez Durand-Ruel – le maître impressionniste – un doué." *Le Matin*, 10 May 1895.

—. "Échos et nouvelles." *Le Petit Parisien*, 12 May 1895.

—. "Exposition Claude Monet." *L'Art moderne* (26 May 1895): 164.

—. "Lettre Parisienne: Exposition de M. Claude Monet." *Le Journal de Genève*, 5 June 1895.

—. "Les Expositions: les Cathédrales de Claude Monet – Paysages de Norvège et vues de Vernon – important ensemble." *L'Éclair*, 12 May 1895.

—. "L'Exposition Claude Monet." *Le Cocarde*, 12 May 1895.

—. "L'Exposition Claude Monet." *Le National*, 12 May 1895.

—. "L'Exposition Claude Monet." *Paris*, 12 May 1895.

Albert, Henri. "Berichte: Paris." *Pan*, vol. 1 (1895): 125.

[Alexandre, Arsène.] "Les hommes du jour: M. Claude Monet, peintre français." *L'Éclair*, 26 May 1895.

Brisson, Adolphe. "Claude Monet." *La République française*, 28 May 1895.

Bullet, Emma. "Two Great Painters: Monet and Corot, Interpreters of Pure Nature." *The Daily Eagle* (Brooklyn), 16 June 1895.

Clemenceau, Georges. "Révolution de cathédrales." *La Justice*, 20 May 1895.

Denoinville, Georges. "Les Salons: Les Cathédrales." *Le Journal des Artistes*, 19 May 1895, reprinted in his *Sensations d'Art*, vol. 1. Paris: Edmond Girad, 1898.

Deschamps, Gaston. "La Vie littéraire: L'Histoire de l'impressionnisme." *Le Temps*, 13 June 1895.

Eon, Henry. "Les Cathédrales de Claude Monet." *La Plume*, no. 147 (1 June 1895): 259.

F., A. "Les Petits Salons: Claude Monet." *Gil Blas*, 12 May 1895.

Fierens-Gevaert, Hippoltye. "Chronique artistique de Paris: Exposition des oeuvres de Corot et de Claude Monet." *L'Indépendance Belge*, 20 June 1895.

Frémine, Charles. "Claude Monet." *Le Rappel*, 3 June 1895.

Geffroy, Gustave. "L'Art d'aujourd'hui: Claude Monet." *Le Journal*, 10 May 1895.

Jourdain, Frantz. "Les Salons: L'Exposition de Claude Monet chez Durand-Ruel." *La Patrie*, 20 May 1895.

Lecomte, Georges. "Les Cathédrales de M. Claude Monet." *La Nouvelle Revue*, 94 (1 June 1895): 672.

Le Passant. "Les On-dits." *Le Rappel*, 15 May 1895.

Lumet, Louis. "Sensations d'art: Claude Monet." *L'Enclos*, 1 (1895): 44-45.

Mauclair, Camille. "Choses d'art." *Mercure de France*, NS 14 (June 1895): 357-59.

—. "Critique de la peinture." *La Nouvelle Revue*, 96 (15 September 1895): 314-33.

—. "Destinées de la peinture française 1865-1898." *La Nouvelle Revue*, 93 (15 March 1895): 363-77.

Michel, André. "Les Salons de 1895. IV. De quelques manières de peintre. Huile et détrempé." *Journal des Débats*, 17 May 1895.

Mirbeau, Octave. "Çà et là." *Le Journal*, 12 May 1895.

Natanson, Thadée. "Expositions I: M. Claude Monet." *La Revue blanche*, 8 (1 June 1895): 521-23.

Pellier, Henri. "Claude Monet." [Durand-Ruel Press Book, 29 or 30 May 1895.]

R., G. "Lettre Parisienne." *Journal de Genève*, 5 May 1895.

Renan, Ary. "Petites Expositions: 50 Tableaux de M. Claude Monet." *La Chronique des Arts et de la Curiosité* (18 May 1895): 186.

Robe, Pierre. "Claude Monet." *Le Jour*, 13 May 1895.

S., Ed. "Au jour le jour." *Journal des Débats*, 12 May 1895.

Schmitt, J.-E. "Choses d'art: Exposition de M.Claude Monet." *Le Siècle*, 20 May 1895.

Thiébault-Sisson, François. "Au jour le jour: L'Exposition Claude Monet." *Le Temps*, 12 May 1895, reprinted in *Le Gaulois (supplément)*, 16 June 1898.

Un Domino. "Ce qui se passe. Échos de Paris, le monde des lettres et des arts." *Le Gaulois*, 27 May 1895.

1898

Anon. "Chronique: Claude Monet." *Gazette de France*, 8 June 1898.

—. "Exposition Claude Monet." *Le Figaro*, 25 June 1898.

—. "Exposition Claude Monet." *Le Gaulois*, 25 June 1898.

—. "Exposition Claude Monet." *Le Temps*, 26 June 1898.

—. "Exposition Claude Monet." *Moniteur des Arts*, 22 July 1898.

—. "Exposition d'oeuvres de M. Claude Monet." *La Chronique des Arts et de la Curiosité* (25 June 1898): 212.

—. "Galerie G. Petit: Claude Monet." *L'Éclair*, 7 June 1898.

—. "La Vie artistique: Claude Monet – Camille Pissarro." *Le Siècle*, 5 June 1898.

—. "*Le Gaulois* à la galerie Georges Petit: Exposition Claude Monet." *Le Gaulois (supplément)*, 16 June 1898.

—. "Monet à la galerie Georges Petit." *La Vie Parisienne*, 25 June 1898.

—. "XXX." *Journal des Débats*, 12 June 1898.

—. "XXX." *La Fronde*, 6 June 1898.

[Alexandre, Arsène.] "Les Expositions individuelles: I. Paysages de Claude Monet." *L'Estampe*, 29 May 1898, reprinted in *Le Figaro*, 3 June 1898, and in *Le Gaulois (supplément)*, 16 June 1898.

Baillet, E. "Claude Monet, Camille Pissarro . . ." *La Petite République*, 7 June 1898.

Bazalgette, Léon. "Les Deux Cathédrales, Claude Monet et J.-K. Huysmans," in his *L'Esprit nouveau dans la vie artistique, sociale et religieuse*. Paris: Société d'éditions littéraires, 1898.

Bricon, Étienne. "L'Art impressionniste au musée du Luxembourg." *La Nouvelle Revue*, 114 (15 September 1898): 288-304.

Fontainas, André. "Claude Monet," *Mercure de France*, NS 27 (July 1898): 159-66.

—. "Galerie G. Petit: Exposition Claude Monet . . ." *Mercure de France*, NS 27 (July 1898): 278-82.

Frémine, Charles. "Notes d'Art: Claude Monet." *Le Rappel*, 11 June 1898, reprinted in *Le XIXe Siécle*, 12 June 1898.

Geffroy, Gustave. "Claude Monet." *Le Journal*, 7 June 1898, reprinted in *Le Gaulois (supplément)*, 16 June 1898.

Guillemot, Maurice. "Claude Monet." *La Revue illustrée*, 13 (15 March 1898).

Ixe, André d'. "Chronique." *Le Progrès artistique*, 16 June 1898.

Lecomte, Georges. "La Vie artistique: Claude Monet." *Droits de l'homme*, 10 June 1898.

—. "Petites Expositions: Exposition Claude Monet." *Revue populaire des Beaux-Arts*, no. 58 (25 June 1898): 58-60.

Leszy, Arman. "Notes d'art: L'Oeuvre de Claude Monet chez Georges Petit." *L'Étoile*, 2-8 July 1898.

Manoff, Nicolas. "Claude Monet." *Revue Simple*, 1 June 1898.

Mery, Maurice. "Petit Salons: Oeuvres nouvelles de Claude Monet," *Moniteur des Arts* (10 June 1898): 574-75.

Pallier, A. "XXX." *La Liberté*, 8 June 1898.

Plancoet, F. H. de. "Silhouette artistique: Claude Monet." *Le Journal des Artistes*, 12 June 1898.

Roger-Milès, Léon. "Claude Monet." *L'Éclair*, June 1898; reprinted in *Le Gaulois* (*supplément*), 16 June 1898.

Séailles, Gabriel. "L'Impressionnisme," in *L'Almanach du bibliophile pour l'année 1898*. Paris: E. Pellatan, 1898.

Stenger, Gilbert. "Chronique locale: Le Peintre impressionniste Claude Monet." *Le Havre*, 17 June 1898.

Strong, Rowland. "Pictures by Claude Monet." *The New York Times*, 19 June 1898.

1899

Anon. "Chronique du jeudi. Chose d'art." *Le Jour*, 24 February 1899.

—. "Petites expositions Galeries Durand-Ruel." *L'Éclair* 14 April 1899.

—. "XXX." *Petites Chroniques*, 16 April 1899.

Alexandre, Arsène. "La Vie artistique: I. – Exposition de six maîtres." *Le Figaro*, 16 February 1899.

—. "La Vie artistique: Exposition de Corot et des impressionnistes." *Le Figaro*, 21 April 1899.

Buisson, L. "Un Claude Monet de l'exposition Petit." *La Chronique des Arts et de la Curiosité*, 8 (25 February 1899): 70-71.

Calonne, Alphonse de. "Beaux-Arts." *Le Soleil*, 20 February 1899.

Coquiot, Gustave. "Quatre maîtres." *Gil Blas*, 10 April 1899.

Dalligny, Auguste. "L'Exposition de la rue de Sèze." *Le Journal des Artistes*, 25 February 1899.

Domino [Ferninand Bloch]. "Ce qui se passe: Échos de Paris." *Le Gaulois*, 18 February 1899.

Fagus, Félicier. "Chez Durand-Ruel." *Revue des Beaux-Arts*, 1 May 1899.

Fontainas, André. "Exposition de tableaux de Monet, Pissarro, Renoir et Sisley." *Mercure de France*, NS 30 (May 1899): 529-34.

Frémine, Charles. "Notes d'art." *Le Rappel*, 7 March 1899.

Fuller, W. H. "Claude Monet and His Paintings." *The Evening Sun* (New York), 26 January 1899.

Geffroy, Gustave. "Musée d'un instant." *Le Journal*, 23 April 1899.

L'Angèle. [Raymond Bouyer]. "Lettre d'Angèle. Chronique du mois: L'impressionnisme: Corot-Monet, etc." *L'Ermitage*, vol. 10 (May 1899): 390-400.

Leclercq, Julien. "Petites Expositions: Galerie Durand-Ruel." *La Chronique des Arts et de la Curiosité*, 15 (15 April 1899): 130-31.

—. "Petites Expositions: Galerie Georges Petit." *La Chronique des Arts et de la Curiosité* (25 February 1899): 70.

Le Senne, C. "Les petits Salons: cycle moderniste." *L'Événement*, 16 February 1899.

Mangeant, P.-E. "Les petits salons: Exposition Besnard, Cazin, Monet . . ." *Le Journal des Artistes*, 19 February 1899.

Mayence, Raoul. "Notes d'art. Galerie Durand-Ruel." *Le Révolutionnaire*, 22 April 1899.

Michel, André. "Causerie artistique. Paysages et Paysagistes." *Journal des Débats*, 21 February 1899.

Natanson, Thadée. "Spéculations sur la peinture, à propos de Corot et des impressionnistes." *La Revue blanche*, vol. 19 (15 May 1899): 123-33.

[Py, Michael]. "Herbes de la Saint-Jean: Corot, Sisley, Renoir, Monet, Pissaro [sic]." *La France*, 22 April 1899, reprinted in *Le Voltaire*, 23 April 1899.

Rambosson, Yvanhoe. "La promenade de Janus: Causerie d'art." *La Plume*, 1 May 1899.

Raynal, Jean. "La Vie artistique, Monet, Sisley, Casin, etc. . . . à la Galerie Petit." *Le Siècle*, 24 February 1899.

Saunier, Charles. "Trois expositions." *La Revue populaire des Beaux-Arts*, 1 March 1899.

Schneider, Gustave. "Beaux-Arts: Exposition des maîtres impressionnistes – exposition des tableaux de Corot." *Le Petit bleue de Paris*, 29 April 1899.

—. "Expositions des peintres impressionnistes." *Le Petit bleue de Paris*, 28 February 1899.

Silvestre, Armand. "Notes d'art: Plein Air." *La Petite Gironde*, 3 February 1899.

Thiébault-Sisson, François. "Une histoire de l'impressionnisme." *Le Temps*, 17 April 1899.

1900

Anon. "Claude Monet's Works." *The New York Herald*, 22 November 1900.

—. "Exposition de Claude Monet." *Les Partisans* (5 December 1900): 131-32.

—. "Les Monets chez Durand-Ruel." *La Vie Parisienne*, 8 December 1900.

—. "Notes d'art. L'Impressionnisme – Exposition d'oeuvres nouvelles de Claude Monet." *La Justice*, 5 December 1900.

—. "XXX." *Le Petit Parisien*, 29 November 1900.

Alexandre, Arsène. "La Vie artistique: Exposition Claude Monet." *Le Figaro*, 23 November 1900.

Aubry, Louis. "Notes d'art; L'impressionnisme – Exposition d'oeuvres nouvelles de Claude Monet." *Le Soir*, 3 December 1900.

Bretonne, Restif de la [Jean Lorrain]. "Pussyres de Paris, Féeries Peintres." *Le Journal*, 10 December 1900.

Calonne, Alphonse de. "Beaux-Arts: M. Claude Monet." *Le Soleil*, 26 November 1900.

D., G. "Tribune Artistique: Petits Salons." *Le Voltaire*, 4 December 1900.

Darges, Henry. "Carnet Mondain: Visions et Sensations: Claude Monet." *L'Événement*, 6 December 1900.

Denoinville, G. "Tribune artistique: Petits Salons." *Le Voltaire*, 4 December 1900.

Dewhurst, Wynford. "A Great French Landscapist Claude Monet." *The Artist*, 29 (October 1900): 57-66.

Dourliac, Louis. "L'Exposition Claude Monet." *Le Balzac*, December 1900.

Fontainas, André. "L'Exposition Centennale de la peinture française." *Mercure de France*, NS 35 (July 1900): 132-60.

Fourcaud, Louis de. "L'Exposition Universelle: La Peinture; I. L'École française." *La Revue de l'art ancien et moderne*, 8 (10 September 1900): 145-58.

Gale, Martin. "La Vie qui passe: le carnet des heures." *La Pruse*, 4 December 1900.

Geffroy, Gustave. "L'Art d'aujourd'hui: Claude Monet." *Le Journal*, 26 November 1900, reprinted in *L'Écho de la Semaine* and *L'Europe artistique*, 2 December 1900.

Guyon-Verax, A.E. "Le Bassin aux Nymphéas: Exposition Claude Monet, Galerie Durand-Ruel." *Le Journal des Artistes*, 9 December 1900.

Haber. "La Semaine artistique: peinture et sculpture; exposition Claude Monet." *La Fronde*, 3 December 1900.

Hire, Jean de la. "Enquête sur l'Impressionnisme." *La Revue impressionniste*, 1 (May-June 1900): 59.

Hoffman, François. "L'Exposition Claude Monet: Galerie Durand-Ruel, rue Laffitte." *Le Journal des Arts*, 1 December 1900.

Kahn, Gustave. "L'Art à l'Exposition: La Centennale." *La Plume*, no. 272 (15 August 1900): 504-10.

Leclercq, Julien. "Le Bassin aux Nymphéas de Claude Monet." *La Chronique des Arts et de la Curiosité* (1 December 1900): 363-64.

Le Senne, Camille. "Les Petits Salons." *L'Événement*, 17 December 1900.

Marx, Roger. "Un Siècle d'art [1900]," in *Maîtres d'hier et d'aujourd'hui*. Paris: Calmann-Levy, 1914, 100.

Mellerio, André. *L'Exposition de 1900 et l'Impressionnisme*, Paris: H. Floury, 1900.

Michel, André. "Les Arts à l'Exposition Universelle de 1900: L'Exposition Centennale: La Peinture Française." *Gazette des Beaux-Arts*, 3rd series, vol. 24 (November 1900): 463-82.

Montmisciot. "Notes d'un badaud." *Le Gaulois*, 11 December 1900.

Morot, F. George. "XXX." *La Pruse*, 12 December 1900.

Mortier, Robert. "L'Art à Paris: Exposition des Impressionnistes: Claude Monet." *La Petite Monegasque*, 26 December 1900.

P[ellier]., H[enri]. "Échos du jour: les lettres et les arts." *La Petite République Socialiste*, 24 December 1900.

Quolobet. "Chez Durand-Ruel." *Le Tintamarre*, 9 December 1900.

Rais, Jules. "Petites Expositions: M. Claude Monet. Le Bassin aux nymphéas." *Le Siècle*, 25 December 1900.

Saunier, Charles. "Petit Gazette d'art: Claude Monet." *La Revue blanche*, vol. 23, no. 181 (15 December 1900): 624.

—. "Petit Gazette d'art: Notes sur l'exposition centennale de l'Art français. Les Oubliés et les Dédaignés." *La Revue blanche*, (November 1900): 379-82.

Sizeranne, Robert de la. "L'Art à l'Exposition de 1900. II. Le Bilan de l'Impressionnisme." *Revue des Deux-Mondes*, vol. 70 (1 June 1900): 628-51.

Thiébault-Sisson, François. "Claude Monet: Les Années d'Épreuves." *Les Temps*, 26 November 1900.

Checklist of the Exhibition

1. (Plate 6)
Valley of the Creuse. (Sunlight effect.) 1889*
W.1219
Signed and dated lower left: Claude Monet 89
Oil on canvas; 25⅝ x 36⅜ in. (65.1 x 92.4 cm.)
Museum of Fine Arts, Boston. Juliana Cheney Edwards
Collection (25.107)

2. (Plate 8)
Valley of the Creuse. (Gray day.) 1889
W.1221
Signed and dated lower left: Claude Monet 89
Oil on canvas; 25⅜ x 32 in. (64.5 x 81.3 cm.)
Museum of Fine Arts, Boston. Denman Waldo Ross Collection (06.115)

3.
Valley of the Creuse. 1889
Signed and dated lower left: Claude Monet 89
Oil on canvas; 26½ x 32¼ in. (67.3 x 81.9 cm.)
Private Collection

4. (Plate 7)
Valley of the Creuse. (Evening effect.) 1889
W.1225
Signed and dated lower right: Claude Monet 89
Oil on canvas; 25⅝ x 31⅞ in. (65 x 81 cm.)
Musée Marmottan, Paris (5176)

5. (Plate 9)
The Creuse. (Sunset.) 1889
W.1226
Signed and dated lower left: Claude Monet 89
Oil on canvas; 29⅛ x 27¾ in. (74 x 70.5 cm.)
Musée d'Unterlinden, Colmar (M/3-1975)

6. (Plate 13)
Study of Rocks; Creuse. 1889
W.1228
Signed and dated lower left: Claude Monet 89
Oil on canvas; 28½ x 36 in. (72.4 x 91.4 cm.)
By gracious permission of H.M. Queen Elizabeth, The Queen
Mother

7. (Plate 10)
Valley of the Petite Creuse. 1889
W.1230
Signed and dated lower left: Claude Monet 89
Oil on canvas; 25¼ x 32 in. (65.4 x 81.3 cm.)
Museum of Fine Arts, Boston. Bequest of David P. Kimball in
memory of his wife, Clara Bertram Kimball (23.541)

8. (Plate 11)
The Petite Creuse. 1889
W.1231
Signed lower left: Claude Monet
Oil on canvas; 25⅞ x 36½ in. (65.7 x 92.7 cm.)
The Art Institute of Chicago. Potter Palmer Collection
(1922.432)

9. (Plate 12)
The Petite Creuse. (Sunlight.) 1889
W.1232
Signed lower left: Claude Monet
Oil on canvas; 28¾ x 36¼ in. (73 x 92.1 cm.)
Anonymous loan

10. (Plate 17)
Poppy Field. (Giverny.) 1890
W.1251
Signed and dated lower right: Claude Monet 90
Oil on canvas; 23½ x 39½ in. (59.7 x 100.3 cm.)
Smith College Museum of Art, Northampton, Massachusetts.
Gift of the Honorable and Mrs. Irwin Untermyer in the name
of their daughter, Joan L. Untermyer ('40), 1940 (1940:10)

11. (Plate 18)
Poppy Field. (Giverny.) 1890
W.1252
Signed and dated lower right: Claude Monet 90
Oil on canvas; 23⅞ x 39¾ in. (60.6 x 101 cm.)
The White Fund, Lawrence, Massachusetts (1328.12)

12. (Plate 19)
Poppy Field. (Giverny.) 1891
W.1253
Signed and dated lower right: Claude Monet 91
Oil on canvas; 24 x 36⅝ in (61 x 93 cm.)
The Art Institute of Chicago. Mr. and Mrs. W. W. Kimball
Collection (1922.4465)

13. (Plate 16)
Oat Fields. (Giverny.) 1889
W.1258
Signed lower left: Claude Monet
Oil on canvas; 25⅝ x 36¼ in. (65 x 92 cm.)
Musée d'Art Moderne de Strasbourg (1750)

14. (Plate 14)
Oat Fields. (Giverny.) 1890
W.1259
Signed and dated lower right: Claude Monet 90
Oil on canvas; 25⅝ x 36¼ in. (65.1 x 92.1 cm.)
Private Collection

15. (Plate 15)
Oat Fields. (Giverny.) 1890
W.1260
Signed and dated lower left: Claude Monet 90
Oil on canvas; 25¼ x 35¾ in. (64.1 x 90.8 cm.)
Private Collection

16. (Plate 5)
Grainstacks. (Sunset.) 1889
W.1213
Signed and dated lower left: Claude Monet 89
Oil on canvas; 25⅝ x 36¼ in. (65 x 92 cm.)
The Museum of Modern Art, Saitama (595 [0-23])

*Titles are translated from Monet's own, and the punctuation is his.
Discrepancies in dates are due to Monet's occasional practice of signing and dating his canvases several years after their completion.*

17. (Plate 20)
Grainstacks. (End of summer.) 1890-91
W.1269
Signed and dated lower left: Claude Monet 91
Oil on canvas; 23¼ x 33½ in. (59.1 x 85.1 cm.)
The Art Institute of Chicago. Gift of Arthur M. Wood in memory of Pauline Palmer Wood (1985.1103)

18. (Plate 21)
Grainstacks. (End of day; autumn.) 1890-91
W.1270
Signed and dated lower left: Claude Monet 91
Oil on canvas; 25⅞ x 34¾ in. (65.7 x 88.3 cm.)
The Art Institute of Chicago. Mr. and Mrs. Lewis L. Coburn Memorial Collection (1933.444)

19. (Plate 2)
Grainstacks. (Mid-day.) 1890
W.1271
Signed and dated lower left: Claude Monet 90
Oil on canvas; 25⅞ x 39⅝ in. (65.6 x 100.6 cm.)
Australian National Gallery, Canberra (1979.16)

20. (Plate 25)
Grainstacks. (Snow effect; gray day.) 1890-91
W.1274
Signed and dated lower left: Claude Monet 91
Oil on canvas; 23 x 39 in. (58.4 x 99.1 cm.)
Shelburne Museum, Shelburne, Vermont (27.1.2-106)

21. (Plate 22)
Grainstacks. (Snow effect; sunlight.) 1890-91
W.1277
Signed and dated lower right: Claude Monet 91
Oil on canvas; 25⅝ x 36¼ in. (65.1 x 92.1 cm.)
National Galleries of Scotland, Edinburgh (2283)

22. (Plate 26)
Grainstacks. (Sunset; snow effect.) 1890-91
W.1278
Signed and dated lower right: Claude Monet 91
Oil on canvas; 25 x 39½ in. (63.5 x 100.3 cm.)
The Art Institute of Chicago. Potter Palmer Collection (1922.431)

23. (Plate 23)
Grainstacks. (Winter.) 1890-91
W.1279
Signed and dated lower left: Claude Monet 91
Oil on canvas; 32¼ x 32⅛ in. (81.9 x 81.6 cm.)
Lent by The Metropolitan Museum of Art. Bequest of Mrs. H.O. Havemeyer, 1929. The H.O. Havemeyer Collection (29.100.109)

24. (Plate 29)
Grainstack. (Snow effect.) 1890-91
W.1280
Signed and dated lower left: Claude Monet 91
Oil on canvas; 25¾ x 36⅜ in. (65.4 x 92.4 cm.)

Museum of Fine Arts, Boston. Gift of Misses Aimée and Rosamond Lamb in memory of Mr. and Mrs. Horatio A. Lamb (1970.253)

25. (Plate 24)
Grainstack. (Snow effect; overcast day.) 1890-91
W.1281
Signed and dated lower right: Claude Monet 91
Oil on canvas; 26 x 35⅝ in. (66 x 90.5 cm.)
The Art Institute of Chicago. Mr. and Mrs. Martin A. Ryerson Collection (1933.1155)

26. (Plate 28)
Grainstack. (Sunset; winter.) 1890-91
W.1282
Signed and dated lower right: Claude Monet 91
Oil on canvas; 25½ x 36¼ in. (64.8 x 92.1 cm.)
Private Collection, England

27. (Plate 30)
Grainstack. 1890-91
W.1283
Signed and dated lower left: Claude Monet 91
Oil on canvas; 25⅞ x 36¼ in. (65.7 x 92.1 cm.)
The Art Institute of Chicago. Restricted gift of the Searle Family Trust; Major Acquisitions Centennial Endowment; through prior acquisitions of the Kate L. Brewster, Potter Palmer and Martin A. Ryerson Collection (1983.29)

28. (Plate 27)
Grainstack. (Thaw; sunset.) 1890-91
W.1284
Signed and dated lower left: Claude Monet 91
Oil on canvas; 25½ x 36⅜ in. (64.8 x 92.4 cm.)
The Art Institute of Chicago. Gift of Mr. and Mrs. Daniel Searle (1983.166)

29. (Plate 31)
Grainstack. 1890-91
W.1285
Signed and dated lower left: Claude Monet 91
Oil on canvas; 25⅝ x 36¼ in. (65.1 x 92.1 cm.)
Collection Pierre Larock-Granoff, Paris

30. (Plate 32)
Grainstack. (Sunset.) 1890-91
W.1289
Signed and dated lower left: Claude Monet 91
Oil on canvas; 28⅞ x 36½ in. (73.3 x 92.7 cm.)
Museum of Fine Arts, Boston. Juliana Cheney Edwards Collection (25.112)

31. (Plate 39)
Poplars. (Giverny. Cloudy day.) 1891
W.1291
Signed and dated lower right: Claude Monet 91
Oil on canvas; 36¼ x 28¾ in. (92 x 73 cm.)
MOA Museum of Art, Atami (1635)

32. (Plate 37)
Poplars. (Banks of the Epte. Twilight.) 1891
W.1296
Signed and dated lower right: Claude Monet 91
Oil on canvas; 39⅜ x 25⅝ in. (100 x 65.1 cm.)
Private Collection, New York

33. (Plate 33)
Poplars. (Banks of the Epte.) 1891
W.1298
Signed and dated lower right: Claude Monet 91
Oil on canvas; 39½ x 25⅝ in. (100.3 x 65.2 cm.)
Philadelphia Museum of Art. Bequest of Anne Thomson as a
memorial to her father, Frank Thomson, and her mother,
Mary Elizabeth Clarke Thomson (54-66-8)

34. (Plate 38)
Poplars. (Banks of the Epte. Cloudy day.) 1891
W.1299
Signed and dated lower right: Claude Monet 91
Oil on canvas; 36 x 32 in. (91.4 x 81.3 cm.)
Ise Cultural Foundation, Tokyo

35. (Plate 36)
Poplars. (Banks of the Epte.) 1891
W.1300
Signed and dated lower right: Claude Monet 90
Oil on canvas; 36⅜ x 29 in. (92.4 x 73.7 cm.)
The Trustees of the Tate Gallery (4183)

36. (Plate 40)
Poplars. (Wind effect.) 1891
W.1302
Signed and dated lower right: Claude Monet 91
Oil on canvas; 39⅜ x 28⅞ in. (100 x 73.5 cm.)
Collection Durand-Ruel, Paris

37. (Plate 41)
Poplars. (Spring.) 1891
W.1304
Signed and dated lower left: Claude Monet 91
Oil on canvas; 36⅞ x 29⅛ in. (93.7 x 74 cm.)
Private Collection

38. (Plate 34)
Poplars. (Summer.) 1891
W.1305
Signed and dated lower right: Claude Monet 91
Oil on canvas; 36⅝ x 29 in. (93 x 73.5 cm.)
The National Museum of Western Art, Tokyo. Matsukata
Collection (P.1959-152)

39. (Plate 43)
Poplars. (Autumn.) 1891
W.1307
Signed and dated lower right: Claude Monet 91
Oil on canvas; 36¼ x 28⅜ in. (92 x 72 cm.)
Philadelphia Museum of Art. Gift of Chester Dale (59-109-1)

40. (Plate 42)
Poplars. (Autumn.) 1891
W.1308
Signed and dated lower right: Claude Monet 91
Oil on canvas; 36¼ x 28¾ in. (92 x 73 cm.)
Private Collection

41. (Plate 35)
Poplars. 1891
W.1309
Signed and dated lower left: Claude Monet 91
Oil on canvas; 32¼ x 32⅛ in. (81.9 x 81.6 cm.)
Lent by The Metropolitan Museum of Art. Bequest of Mrs.
H.O. Havemeyer, 1929. The H.O. Havemeyer Collection
(29.100.110)

42. (Plate 45)
Poplars. (Banks of the Epte. View from the marsh.) 1891
W.1312
Signed and dated lower left: Claude Monet 91
Oil on canvas; 34¾ x 36½ in. (88.3 x 92.7 cm.)
Private Collection

43. (Plate 44)
Poplars. (View from the marsh.) 1891
W.1313
Signed lower right: Claude Monet
Oil on canvas; 35 x 36¼ in. (88.9 x 92.1 cm.)
Lent by the Syndics of The Fitzwilliam Museum, Cambridge,
England (PD.9-1966)

44. (Plate 52)
Ice Floes. (Bennecourt.) 1893
W.1334
Signed and dated lower right: Claude Monet 93
Oil on canvas; 23⅝ x 39⅜ in. (60 x 100 cm.)
Private Collection

45. (Plate 53)
Ice Floes. (Bennecourt.) 1893
W.1336
Signed and dated lower right: Claude Monet 93
Oil on canvas; 25½ x 39⅜ in. (64.8 x 100 cm.)
Anonymous loan

46. (Plate 54)
Ice Floes. (Morning haze.) 1893-94
W.1338
Signed and dated lower right: Claude Monet 94
Oil on canvas; 25⅞ x 39½ in. (65.7 x 100.4 cm.)
Philadelphia Museum of Art. Bequest of Mrs. Frank Graham
Thomson (61-48-2)

47. (Plate 50)
Rouen Cathedral. Cour d'Albane. 1892-94
W.1317
Signed and dated lower right: Claude Monet 94
Oil on canvas; 36½ x 29 in. (92.7 x 73.7 cm.)
Smith College Museum of Art, Northampton, Massachusetts.

Gift of Caroline R. Wing '96 and Adeline F. Wing '98, 1956 (1956:24)

48. (Plate 46)
Rouen Cathedral. Façade. (Gray day.) 1892-94
W.1321
Signed and dated lower left: Claude Monet 94
Oil on canvas; 39⅜ x 25⅝ in. (100 x 65 cm.)
Musée d'Orsay, Paris (RF 1999)

49. (Plate 64)
Rouen Cathedral. Façade. 1892-94
W.1323
Signed and dated lower left: Claude Monet 94
Oil on canvas; 39⅜ x 25⅝ in. (100 x 65 cm.)
National Museum of Wales, Cardiff (795)

50. (Plate 51)
Rouen Cathedral. Façade. (Sunset.) 1892-94
W.1327
Estate stamp lower right: Claude Monet
Oil on canvas; 39⅜ x 25⅝ in. (100 x 65 cm.)
Musée Marmottan, Paris (5174)

51. (Plate 49)
Rouen Cathedral. Façade. 1892-94
W.1328
Signed and dated lower left: Claude Monet 94
Oil on canvas; 39⅜ x 25⅝ in. (100 x 65.1 cm.)
Galerie Katia Granoff, Paris

52. (Plate 47)
Rouen Cathedral. Façade and Tour d'Albane. (Morning effect.) 1892-94
W.1346
Signed and dated lower left: Claude Monet 94
Oil on canvas; 41¼ x 29 in. (106 x 75 cm.)
Musée d'Orsay, Paris (RF 2001)

53. (Plate 55)
Rouen Cathedral. Façade and Tour d'Albane. (Morning effect.) 1892-94
W.1347
Signed and dated lower left: Claude Monet 94
Oil on canvas; 42 x 29 in. (106.7 x 73.7 cm.)
Collection Ernst Beyeler, Basel

54. (Plate 62)
Rouen Cathedral. Façade and Tour d'Albane. (Morning effect.) 1892-94
W.1348
Signed and dated lower left: Claude Monet 94
Oil on canvas; 41¼ x 29⅛ in. (106 x 74 cm.)
Museum of Fine Arts, Boston. The Tompkins Collection (24.6)

55. (Plate 63)
Rouen Cathedral. Façade. 1892-94
W.1356

Signed and dated lower left: Claude Monet 94
Oil on canvas; 39⅝ x 26 in. (100.6 x 66 cm.)
Museum of Fine Arts, Boston. Juliana Cheney Edwards Collection (39.671)

56. (Plate 48)
Rouen Cathedral. Façade. 1892-94
W.1358
Signed and dated lower right: Claude Monet 94
Oil on canvas; 41¾ x 29 in. (106 x 73.7 cm.)
Sterling and Francine Clark Art Institute, Williamstown, Massachusetts (1967.1)

57. (Plate 59)
Mount Kolsaas. (Norway.) 1895
W.1406
Estate stamp lower right: Claude Monet
Oil on canvas; 25⅝ x 39⅜ in. (65 x 100 cm.)
Musée Marmottan, Paris (5100)

58. (Plate 61)
Mount Kolsaas. (Norway.) 1895
W.1408
Signed and dated lower left: Claude Monet 95
Oil on canvas; 25⅝ x 39⅜ in. (65.1 x 100 cm.)
Private Collection, Chicago.

59. (Plate 60)
Mount Kolsaas. (Foggy day.) 1895
W.1411
Signed and dated lower left: Claude Monet 95
Oil on canvas; 25⅞ x 39⅝ in. (65.7 x 100.6 cm.)
Private Collection

60. (Plate 67)
Cliffs at Pourville. (Rain.) 1896
W.1426
Signed and dated lower left: Claude Monet 86
Oil on canvas; 25¾ x 39⅜ in. (65.4 x 100 cm.)
Private Collection

61. (Plate 65)
Cliffs at Pourville. (Morning.) 1896-97
W.1441
Signed and dated lower left: Claude Monet 97
Oil on canvas; 25½ x 39 in. (64.8 x 99.1 cm.)

62. (Plate 66)
Cliffs at Pourville. (Morning.) 1896-97
W.1442
Signed and dated lower left: Claude Monet 97
Oil on canvas; 25⅞ x 39⅝ in. (65.8 x 100.6 cm.)
The Montreal Museum of Fine Arts.
Purchase, John W. Tempest Fund (1918.126)

63. (Plate 77)
Headland of the Petit Ailly. 1896
W.1428
Estate stamp lower right: Claude Monet

Oil on canvas; 28¾ x 36¼ in. (73 x 92.1 cm.)
Private Collection, Switzerland

64. (Plate 78)
Headland of the Petit Ailly. 1896-97
W.1429
Signed and dated lower left: Claude Monet 82
Oil on canvas; 25⅝ x 36¼ in. (65.1 x 92.1 cm.)
Private Collection

65. (Plate 80)
Headland of the Petit Ailly. 1896-97
W.1445
Signed and dated lower left: Claude Monet 97
Oil on canvas; 28¾ x 36¼ in. (73 x 92.1 cm.)
Private Collection, Baltimore

66. (Plate 79)
Headland of the Petit Ailly. (Gray day.) 1896-97
W.1447
Signed and dated lower left: Claude Monet 97
Oil on canvas; 29 x 36 in. (73.7 x 91.4 cm.)
Private Collection, Washington D.C.

67. (Plate 72)
Gorge of the Petit Ailly. (Varengeville.) 1896-97
W.1451
Signed lower right: Claude Monet
Oil on canvas; 25 x 32 in. (63.5 x 81.3 cm.)
Lent by The Metropolitan Museum of Art. Gift of Mr. and
Mrs. Richard Rogers, 1965 (65-21)

68. (Plate 73)
Gorge of the Petit Ailly. (Varengeville.) 1896-97
W.1452
Signed and dated lower left: Claude Monet 97
Oil on canvas; 25¾ x 36¼ in. (65.4 x 92.1 cm.)
Fogg Art Museum, Harvard University, Cambridge,
Massachusetts. Gift of Ella Milbank Foshay (1972-31)

69. (Plate 76)
Customs House at Varengeville. 1896-97
W.1455
Signed and dated lower left: Claude Monet 97
Oil on canvas; 25¾ x 36½ in. (65.4 x 92.7 cm.)
The Art Institute of Chicago. Mr. and Mrs. Martin A.
Ryerson Collection (1933.1149)

70. (Plate 74)
Customs House at Varengeville. 1896-97
W.1456
Signed and dated lower left: Claude Monet 97
Oil on canvas; 24¼ x 35¾ in. (61.6 x 90.8 cm.)
Private Collection

71. (Plate 75)
Customs House at Varengeville. (Fog.) 1896-97
W.1458
Signed and dated lower left: Claude Monet 97
Oil on canvas; 27⅞ x 36½ in. (70.8 x 92.7 cm.)
Private Collection

72. (Plate 68)
Val-Saint-Nicolas, near Dieppe. (Morning.) 1896-97
W.1433
Signed and dated lower right: Claude Monet 86
Oil on canvas; 25¾ x 36⅜ in. (65.5 x 92.5 cm.)
Private Collection, Switzerland

73. (Plate 71)
Val-Saint-Nicolas, near Dieppe. (Morning.) 1896-97
W.1465
Signed and dated lower right: Claude Monet 97
Oil on canvas; 25½ x 39¼ in. (64.8 x 99.7 cm.)
Private Collection

74. (Plate 70)
Val-Saint-Nicolas, near Dieppe. (Morning.) 1896-97
W.1466
Signed and dated lower right: Claude Monet 97
Oil on canvas; 25⅝ x 39⅜ in. (65.1 x 100 cm.)
The Phillips Collection, Washington D.C. (1377)

75. (Plate 69)
Val-Saint-Nicolas, near Dieppe. (Overcast day.) 1896-97
W.1467
Signed and dated lower right: Claude Monet 97
Oil on canvas; 25⅝ x 39⅝ in. (65 x 100.5 cm.)
The Hermitage Museum, Leningrad (N8992)

76. (Plate 86)
Morning on the Seine, near Giverny. 1896
W.1435
Signed and dated lower left: Claude Monet 96
Oil on canvas; 29 x 36⅝ in. (73.7 x 93 cm.)
Museum of Fine Arts, Boston. Juliana Cheney Edwards
Collection (39.655)

77. (Plate 83)
Morning on the Seine, near Giverny. (Mist.) 1896-97
W.1474
Signed and dated lower left: Claude Monet 97
Oil on canvas; 35 x 36 in. (88.9 x 91.4 cm.)
North Carolina Museum of Art, Raleigh. Purchased with
Funds from the Sarah Graham Kenan Foundation and the
North Carolina Art Society (G.75.24.1)

78. (Plate 82)
Morning on the Seine, near Giverny. (Mist.) 1896-97
W.1475
Signed and dated lower left: Claude Monet 97
Oil on canvas; 35⅜ x 36½ in. (89.9 x 92.7 cm.)
The Art Institute of Chicago. Mr. and Mrs. Martin A.
Ryerson Collection (1933.1156)

79. (Plate 84)
Morning on the Seine, near Giverny. (Mist.) 1896-97
W.1476
Signed and dated lower left: Claude Monet 97
Oil on canvas; 36½ x 35 in. (92.7 x 88.9 cm.)
Private Collection, Washington D.C.

80. (Plate 85)
Morning on the Seine, near Giverny. (Mist.) 1896-97
W.1477
Signed and dated lower left: Claude Monet 97
Oil on canvas; 32¼ x 36¾ in. (81.9 x 93.3 cm.)
Mead Art Museum, Amherst College. Bequest of Miss Susan
Dwight Bliss (1966-48)

81. (Plate 81)
Morning on the Seine, near Giverny. 1896-97
W.1479
Signed and dated lower left: Claude Monet 97
Oil on canvas; 32 x 36¼ in. (81.3 x 92.1 cm.)
Hiroshima Museum of Art, Hiroshima (1974)

82. (Plate 87)
Morning on the Seine, near Giverny. 1897
W.1480
Signed and dated lower left: Claude Monet 97
Oil on canvas; 31⅞ x 36¼ in. (81 x 92.1 cm.)
Private Collection

83. (Plate 88)
Morning on the Seine, near Giverny. 1897
W.1481
Signed and dated lower left: Claude Monet 97
Oil on canvas; 32 x 36½ in. (81.3 x 92.7 cm.)
Museum of Fine Arts, Boston. Gift of Mrs. W. Scott Fitz
(11.1261)

84. (Plate 89)
Morning on the Seine, near Giverny. 1898
W.1499
Signed and dated lower left: Claude Monet 98
Oil on canvas; 28¾ x 36 in. (73 x 91.5 cm.)
The National Museum of Western Art, Tokyo (P.1965-4)

85. (Plate 90)
Charing Cross Bridge. 1899
W.1522
Signed and dated lower right: Claude Monet 99
Oil on canvas; 25⅞ x 32⅛ in. (65.7 x 81.6 cm.)
Santa Barbara Museum of Art. Bequest of Katherine Dexter
McCormick in memory of her husband, Stanley McCormick
(68-20-4)

86. (Plate 92)
Charing Cross Bridge. (Overcast day.) 1899-1900
W.1526
Signed and dated lower right: Claude Monet 1900
Oil on canvas; 23⅞ x 36 in. (60.6 x 91.4 cm.)
Museum of Fine Arts, Boston. Given by Janet Hubbard
Stevens in memory of her mother, Janet Watson Hubbard
(1978.465)

87. (Plate 93)
Waterloo Bridge. 1899-1900
W.1555
Signed and dated lower left: Claude Monet 1900

Oil on canvas; 25¾ x 36½ in. (65.4 x 92.7 cm.)
Santa Barbara Museum of Art. Bequest of Katherine Dexter
McCormick in memory of her husband, Stanley McCormick
(68.20.7)

88. (Plate 91)
Waterloo Bridge. (Cloudy day.) 1899-1900
W.1556
Signed and dated lower right: Claude Monet 1900
Oil on canvas; 25 x 36½ in. (63.5 x 92.7 cm.)
The Hugh Lane Municipal Gallery of Modern Art, Dublin
(115)

89. (Plate 95)
The Water Lily Pond. [Japanese Bridge] 1899
W.1516
Signed and dated lower right: Claude Monet 99
Oil on canvas; 34¾ x 36¼ in. (88.3 x 92.1 cm.)
The Trustees of the National Gallery, London (4240)

90. (Plate 94)
The Water Lily Pond. [Japanese Bridge] 1899
W.1518
Signed and dated lower right: Claude Monet / 99
Oil on canvas; 36½ x 29 in. (92.7 x 73.7 cm.)
Lent by The Metropolitan Museum of Art. Bequest of Mrs.
H.O. Havemeyer, 1929. The H.O. Havemeyer Collection
(29.100.113)

91. (Plate 98)
The Water Lily Pond. [Japanese Bridge] 1900
W.1628
Signed and dated upper right: Claude Monet / 1900
Oil on canvas; 35 x 39 in. (88.9 x 99.1 cm.)
The Art Institute of Chicago. Mr. and Mrs. Lewis L. Coburn
Memorial Collection (1933.441)

92. (Plate 96)
The Water Lily Pond. [Japanese Bridge] 1900
W.1629
Signed and dated lower left: Claude Monet 1900
Oil on canvas; 35¼ x 39⅜ in. (89.5 x 100 cm.)
Musée d'Orsay, Paris (RF 2005)

93. (Plate 97)
The Water Lily Pond. [Japanese Bridge] 1900
W.1630
Signed and dated lower left: Claude Monet 1900
Oil on canvas; 35⅛ x 36½ in. (89.2 x 92.7 cm.)
Museum of Fine Arts, Boston. Given in memory of Governor
Alvan T. Fuller by the Fuller Foundation (61.959)

16a.
Grainstacks. (Morning effect.) 1888-89
W. 1214
Signed and dated lower left: Claude Monet 89
Oil on canvas; 25⅝ x 36½ in. (65.1 x 92.7 cm.)
Private Collection, U.S.A.

Index